ART NOUVEAU
PRINTS, ILLUSTRATIONS AND POSTERS

Jacket front: Ludwig von Zumbusch, Title page for the journal JUGEND, NO. 40.

Jacket back: Peter Behrens, The Kiss. 1898.

ART NOUVEAU
PRINTS, ILLUSTRATIONS AND POSTERS

Hans H. Hofstätter
with contributions by
W. Jaworska and S. Hofstätter

OMEGA BOOKS

CONTENTS

DEDICATION AND PREFACE 5

THE BACKGROUND OF ART NOUVEAU 7
 The Artistic Aim 7
 Symbolism 8
 The Transformation of Nature 9
 Planning the Picture Area 11
 The Spiritual Model 12
 Line and Colour 12
 Choice of Motif 13
 Art in the Living Context 14
 Printing Techniques 14
 Text and Illustration 16

FRANCE 19

ENGLAND 59

BELGIUM AND HOLLAND 97

SCANDINAVIA 111

GERMANY 123

ITALY 201

AUSTRIA 209

EASTERN EUROPE (Hungary, Czechoslovakia, Poland and Russia) 251

BIBLIOGRAPHY 287

INDEX 293

This edition published 1984 by Omega Books Ltd,
14 Greville Street, London EC1N8SB, under
licence from the proprietor.

© German edition Holle Verlag GmbH.
Baden-Baden 1968
© English translation Omega Books Ltd

ISBN 0-907853-41-2

Printed and bound in Austria

PREFACE

This book attempts to document one of the most important areas of Art Nouveau and so to take stock of those aspects of the movement which will still be worth knowing and preserving even after Art Nouveau has passed through its present fashionable phase. The book also takes note of the research which has been done on the subject. Up to now, research work has by no means entirely covered this extensive topic, and there are still gaps in the documentation of many of the details. For instance, we have often been unable to gain access to biographical data. The reason for this is to be found in the structure of the whole Art Nouveau movement, as many of the artists who created works of high quality during this period later fell into such oblivion that no information is now available about them. However, this could not be allowed to prevent us from including those works of theirs which contributed to the effect of Art Nouveau and to its significance as one "of the foundations for the creative approaches being employed in our time"(Bauch).

It was intended that one of the main principles of this book should be to let the works of art speak for themselves. It was for this reason that a format was selected which made it possible to avoid extreme reduction in size and to reproduce almost all the works in their original sizes; in a large number of examples, the original format itself has been used. This does not of course apply to those few posters which were included in order not to leave certain gaps but which ideally require their own special means of large-scale reproduction. Although it is very rewarding to create a book about works of art which, by their nature, were designed to be printed and are therefore hardly falsified at all when reproduced, many such subjects are nevertheless difficult to reproduce in facsimile form in a book. As the originals were often printed in colours which were specially mixed for a particular printing, and differ from the normal range of four colours, it would have been necessary to print such a book using forty or more colours to obtain an accurate match. In cases such as these, certain compromises had to be made, but this was only done when the colouring of the original enabled us to make a slight change or replacement of one colour by another. Many Art Nouveau artists themselves published their printed works in varying colours. In those cases where it was not appropriate to make use of this substitution, the publisher has spared no expense in employing extra colours in order to achieve the effect of the original.

The co-operation of many elements in the creation of a single work was a principle of Art Nouveau, and the same claim may be made for this present book. Thanks are due initially to Eberhard Knoch, the Head of the Berlin-Charlottenburg Art Bureau, who enabled the author to carry out the initial compilation of the material for an exhibition held on the occasion of the Berlin Festival Weeks in 1966, and who himself made indefatigable efforts to obtain the loan of both publicly and privately owned works. In this book, we have been been successful in achieving what the exhibition was unable to do, namely showing the works of Eastern European Art Nouveau artists. For this purpose, the Polish art historian, W. Jaworska, has made a considerable contribution in connection both with the pictures and with the documentation of the artists. The publisher, the reproduction firm, the printer and the bookbinder co-operated actively and sympathetically with one another in the technical production of the book. The

author was able to contribute to every aspect of the production process, and the book is the result of genuine teamwork. We want all those who worked on the book, and also all the public and private owners of material used and all those who gave their advice on this work, to regard the result as a visible token of gratitude for their efforts.

This book is dedicated to Kurt Bauch. After the war Bauch developed his Professor's chair in Freiburg into a point of departure for new research into Art Nouveau. Some of the results became the subjects of academic dissertations. One result of the research is the great extent to which the era has once again made its influence felt after being almost forgotten or "superceded" as a result of the beginning of the era of Expressionism. The author today feels more closely attached than ever to the spirit of the Art Nouveau school. He would therefore like to express in this dedication the gratitude and respect which he feels towards Kurt Bauch, one of the great researchers and stimulators of German art history. To Kurt Bauch, art history has never been an end in itself. On the contrary, for him, art history has always been a sterile subject whenever it has not provided any insight into man's fundamental nature.

THE BACKGROUND OF ART NOUVEAU

Like every style of art, Art Nouveau gave expression to a certain vital consciousness and, in doing so, made use of all opportunities for creative activity in the fields of art and the artistic handicrafts. A striking feature of Art Nouveau, when compared with other artistic epochs, is the brief period of time during which it was in vogue. However, the brief life of this style should not be given too exaggerated an interpretation: Art Nouveau as a movement cannot be compared with a sequence of cultural occurrences such as the Gothic period. At best, it could be compared with one of the phases of that period, such as the "Soft Style" of around 1400. In the same way, Art Nouveau is an episode in the overall context of the development of art in the 19th and 20th centuries. This particular episode seems to be harnessed between two poles, namely the traditionally-orientated afunctional principle on the one hand, and the future-orientated functionalist principle on the other hand. Each of these two poles has had an equal influence in the particular areas in which art has been developing over the last hundred years.

When we try to characterize the special features of the style of this epoch, we cannot merely dwell on only one characteristic feature such as the undulating line used, however typical this may have been in some Art Nouveau products. Nor can our attention be directed solely towards a single genre such as artistic handicrafts, whose influence is said to have permeated the other art forms. It is especially inappropriate to emphasize that aspect of Art Nouveau which is represented by artistic handicrafts, because the very idea of separating artistic activity into two areas, namely higher art and industrial art, is basically opposed to the ideals and feelings of the period. This idea of separation would mean that Art Nouveau was having standards applied to it that were derived from a slightly earlier period of romantic idealism, a period which Art Nouveau wished to excape from and in a sense actually did.

THE ARTISTIC AIM

The special feature of the Art Nouveau period and its style consists of the mental attitude and the real feeling which affected every medium of expression: the music of Richard Strauss, the poems of Rainer Maria Rilke, the paintings of Segantini, the drawings of Beardsley, the posters of Toulouse-Lautrec, the glass vases of Gallé, the Metro entrances of Gallimard, the chairs of Van de Velde and the wallpapers of Leistikow. Each of these manifestations of art was equally able to express itself in the Art Nouveau style, and each of them equally expressed a common idea, namely, the wish to create a counterweight to oppose the soulless mechanization and industrialization which, from the middle of the 19th century onwards, had started to dominate the entire world. There was no aim to put a stop to this development; on the contrary, the idea was to utilize the potentialities of industrial activity. However, there was also an aim to ensure that the conditions of industrial manufacturing, and the necessity to rationalize and thus also to socialize the products, did not mean that the final consumer, that is to say the human being for whom all these things were manufactured, was ever forgotten. It was recognized that the objects by which people are surrounded have an influence on the way in which they think and live, and there was therefore a desire to ensure that neither human beings nor human nature were too greatly influenced by mechanical operations or mechanical purposes. The art of this period really did try to emphasize man's inner life and to unite it with the new technology in a certain symbiosis; this art also wished to achieve co-existence between the functional work environment and the contrasting intimacy of private life. It is not without good reason that we have used the word "aim", because this word also characterizes the epoch in question: since the Art Nouveau period, the phrase "stylistic aim" has come into use. This phrase refers to a deliberate approach, a determined subjugation of material items and a conscious changing of the environment. From this unexpected juxtaposition of a realism—which was frequently not admitted, but was always part of the actual experience—on the one hand, and an emphatically cultivated anti-rationalism on the other hand, there resulted the particular atmosphere which was peculiar to the whole generation. This enabled the recognition of a particular phase in the history of thought, namely the process of becoming aware of one's soul at a time of general rationalization and loss of individuality. This finally led to the aim of ensuring that the process of becoming aware of one's soul was a conscious one, particularly where it threatened to remain unobserved in the whirl of events. Cheap extravagances and sentimental exaggerations occurred in all those cases where the real aim was not properly understood and where superficial appearance was exploited for fashionable purposes. This led to resentment on the part of the original innovators of the movement who now started stressing the importance of a functionalist approach. However, this was not the reason why Art Nouveau fell into decline after little more than two decades. The actual reason for this was that a general change had come about in the intellectual climate prevailing at that time. Art Nouveau expressed its aims by employing certain artistic methods, some of which were rooted in the past, and for this very reason it could be appreciated by people who had received a formal artistic training. These aims had now been thoroughly absorbed and provided the point of departure for a continuing process of further development. A part of this development was carried on by the same people who had begun working during the Art Nouveau period and who were continuing to do so in the arts and crafts societies, in the Bauhaus design centre, in the Viennese workshops and in other similar places.

SYMBOLISM

The manifestation of the soul was of course not limited solely to Art Nouveau, but was a widespread need of the times, a need which found in the movement one of its strongest expressions. It was for this reason alone that there was such a general readiness to accept the ideas expressed by the movement. All spheres of the arts had for a considerable period been developing a counterweight to oppose positivism and to oppose that morality and ideology of positivism which was directed towards pure functionalism, usefulness and purposeful thinking. To an ever-increasing extent, the idea developed that it was possible to regard visible manifestations as being reflexes and symbols of another reality which was not accessible through rational thought, and which had a considerably more determining effect on life and on the course of affairs than did the superficial reality of rationally measurable facts. It was at this time that significant progress was achieved in anthropology, which is the science of man, and also in psychology. Both these sciences recognized that human appearances and modes of behaviour displayed characteristics of man's innermost being. The scientific discovery and evaluation of graphology by Créprieux-Jamin in the 1880's was of great significance and had a not inconsiderable influence on artistic developments. Crépieux-Jamin recognized that people's handwriting left visible graphic traces not only of their unalterable character traits and inclinations, but also of their passing psychological moods. He also realised that these characteristics could then be ascertained and interpreted from their handwriting. Art Nouveau profited from these developments: psychological phenomena could be expressed by the use of agitated lines. To give only one example, in Peter Behrens' woodcut "The Kiss" (illustrated on page 139), the profile of the loving couple is surrounded with entangled and coiled arabesques whose strokes, when interpreted from a graphological point of view, signify complete introversion and the absence of any connection with the world around.

However, the most decisive advance into previously unknown areas of the mind was undertaken by Sigmund Freud in his development of the science of psychoanalysis. Not only apparitions in dreams but also apparently inexplicable substituted actions, as well as actions which are errors when regarded from the standpoint of positivist thinking in terms of success, were defined by Freud as being symptoms of a specific psychological condition. Psychology became a combination of religion and ideology for many people who, as a result of secularization and of the atheism which later became a modern fashion, had lost all belief in and all thought of a life beyond. In the fields of theology and ideology, Swedenborg and later Rudolf Steiner endeavoured to achieve a theosophical type of cultural and ideological synthesis. However, this general endeavour also gave rise to a cluster of concomitant products of a more popular nature: circles of spiritualists organized séances in which spirits were called up from the world beyond or, in response to knocking on tables, gave answers to questions posed by mortals. Fortune-telling, mysticism, cabbalas and private sects endeavoured to pierce the hard wall of scientific rationalism.

Aesthetic circles directed their attention beyond the limits of that world which had up to then been regarded as civilized, and searched for messages transmitted from an alien body of thought. Certain codes were discovered in the art of primitiive peoples. Gauguin had made the Europeans aware of such art by his realization that its lack of reflection meant that it was even more closely related to the impulses of the soul than was the entire European artistic tradition. However, it was especially in the intellectual life of the East that codes were discovered which seemed to provide information about another reality which Eastern thinkers, free from a commitment to any particular purpose, had entered by means of their exercises in meditation, and they had done so at an earlier period than the speculative Western philosophers. It was around the turn of the century that the Indian stories of Rabindranath Tagore · and the meditative narrations of Lafcadio Hearn rapidly became known. Hugo von Hofmannsthal wrote the introductions to these works. This endeavour to gain from Buddhism some insights relevant to European thinking is reflected in such novels as 'Sidharta' by Herman Hesse. Japanese woodcuts had a very prolific influence on artistic development and provided a stimulus for the West to come to grips with the intellectual life of the Far East. Japanese literature soon became known in the West and stimulated some European poets into empathizing with it. An example of how this empathy took shape is seen in "Eight Faces by the Biwa Lake" by the Austrian writer Max Dauthenday. All these intellectual contacts and endeavours experienced their first strong impulse in the generation born around or after 1860. Between 1890 and 1900, when the members of this generation were about thirty years old, they were able to demonstrate the value of the early creative abilities which they had possessed in their youth and which had later matured.

By so doing, this generation was reverting to a tradition which, starting from the end of the preceding century, had been pervading the entire 19th century: this was the tradition of Symbolistic art. This tradition, since the Romantic period, had lost none of its topicality, and it contrasted with the representation of reality used for those works of art which enjoyed official public acknowledgement and esteem during that century. However, the decisively new factor about Art Nouveau was that symbolistic ideas were expressed by the formal language of an abstract style, whereas the Symbolists had previously employed those naturalistic means of representation which were also used in officially recognized works of art. For the Symbolists, the vocabulary of the form still remained tied to the correctness of the reproduction, while the symbolic character was expressed by the alienation of reality. However, one advantage of this was that the symbolic substance could be used to appeal to those people

who could only understand art which accurately depicted the nature of the object represented. Novalis is known to have provided one of the first "prescriptions" explaining how to penetrate through visible nature and how to break down the mental image of nature. He did this by recommending that visible things should be depicted in an unclear way and thereby alienated, the object of this being to communicate the idea of the "background" which surrounds visible objects. It was not only the Romantics who enveloped their landscapes in early morning mists or in the shades of dusk; it was particularly Whistler and Carrière who, in contrast to the naturalism of the second half of the century, also resorted to this alienation of the world of concrete objects. Even the art of photography, which was in its early stages at that time, did not by any means wish merely to reproduce nature. Most of the artists using this new technology were trained in painting and, with the aid of transfer papers, they created nebulous and indistinct views which left it to the onlooker's imagination to provide a wider range of different interpretations than would have been the case if the subject had been clearly depicted as for a news report.

However, the Symbolists also made use of another technique for alienating their natural artistic subjects, and they did this by placing natural objects, which were portrayed in detail, in a context impossible in nature. In earlier artistic epochs, as for example in medieval art, an artistic approach such as this corresponded to the natural system of the world in those days, a system where the objects depicted had their place and were part of the world; and everyone understood this artistic approach. However, a positive logic of spatial relationships and of basic correctness had developed in the 19th century. This logic dominated the existing general image of art to such a great extent that any deviation from it was taken, if not as a provocation, then at least as a signal to be alert and take notice. This tradition continued from the time of Piranesi and Hogarth, through Blake and the Pre-Raphaelites, and through Böcklin and Klinger, right up to the Surrealism of the 20th century, and it still lives on in photography, in films and, more recently, even in art once again. From this position it is again possible to take a step into the world of mythology, and the centaurs and fishwives of Böcklin lead to a new logic by which it is once again possible to understand a picture of a nude woman playing a harp between the rocky cliffs and the sea surf. For the same reason that the positivist schoolmasterly school had also included mythology in its curriculum, artists were not prevented from inventing new myths and, in particular, from couching in the form of old and new myths some topical psychological problems of the times; to mention these problems in public would have violated strictly guarded taboos. The boundary between the symbolistic painting of the period prior to Art Nouveau on the one hand, and Art Nouveau itself on the other, was undefined too: the centaurs and nymphs of Böcklin live on in the works of Stuck, Erler, Putz, Klimt and others, but they are clothed in a new art

form which had a decisive effect on the essence of the movement.

Historicism and Positivism, which Art Nouveau wished to replace, were nonetheless perfectly able to point the way to artistic ideas which Art Nouveau followed. This was because, in the second half of the century, a greater effort than before was being made to gain knowledge of past epochs in which ideas were more important than reality and in which people were able to find confirmation of their own ideology and their own mental state. Thus, access to the Middle Ages was gained via Historicism, while access to Indian, Far Eastern and Egyptian art was achieved via the scientific discipline of ethnology. However, the contrast with Historicism and Positivism consisted in the fact that there was now a readiness to empathize, not merely to observe and collect the facts. As a result of the affinity of the 19th century with the realism of the ideas generated in the previous epoch with which these 19th-century artists were trying to come to terms, these discoveries began to speak and to reveal a nature which was not tied to their epoch, their race or their art, but which simply had a compelling influence on human beings. People then also began to understand that the formal styles of those various periods were especially suitable for the particular psychological statements that were being made, and they allowed themselves to be inspired by them.

THE TRANSFORMATION OF NATURE

The essential feature of the artistic form taken by those creative works providing this stimulation was their movement away from the exact portrayal of nature which had by that time been acknowledged as the sole yardstick of art. It is today hardly possible to realise the extent to which the requirement regarding this truth to nature so dominated the public's artistic judgement. It must be appreciated that the landscapes of Caspar David Friedrich were objected to on the grounds that the precise viewpoint of the individual landscapes could not be determined and that it was impossible to tell from the pictures whether they represented an evening or a morning setting. One critic objected to the famous work "Source" by Ingres because the legs of the allegorically depicted girl in the picture were too short. In the second half of the century, the public considered that only medical doctors were competent to assess the nude in art, and these doctors did not hesitate, even in the works of the old masters, to calculate which of the models suffered from consumption or rachitic defects. The doctors considered that it was an artistic error for the painter or sculptor even to select such a model. We must be aware of these judgements in order to understand that even pictures such as "Sin" by Stuck or "Judith" by Klimt, which seem so naturalistic to us today, were a crime against creation in the eyes of many contemporaries.

Art Nouveau did not refuse to make use of physical objects; on the contrary, it allowed its structures to be identified with

Moronobu, Lovers. c.1682. Woodblock print.

natural shapes at all times. However, even when it resorted to classical models, it was independent of the requirement which stipulated truth to nature, applicable at the time of the new movement. This was because the real truth demanded by Art Nouveau lay not in the natural form of its models or subjects, but rather in the correctness of the artistic structure created. According to this structure, it was perfectly possible, or even necessary, for a natural object to be "transformed". When such transformation revealed a spiritual element, it was in particular medieval art and Japanese woodcuts which provided the supreme models. These depictions were independent of any relationship to space or time as regards the way in which these two factors determined everyday life. A medieval picture was able, in the space of a single portrayal, to depict events which took place at different times with the purpose of making clear a certain spiritual relationship actually existing between the events; like the landscape pictures in Japanese woodcuts, medieval pictures also depicted events which were independent of any time sequence and possessed absolute validity. Examples are the famous "Wave" by Hokusai or the manifold views of the snow-covered holy mountain of Fujiyama. In both these fields of art, it was also possible to depict items which did not exist in the reality experienced by the beholder, or which only existed in pictures: these were visions, apparitions and insights into hidden matters. Spacelessness, and thus indirectly also timelessness, became one of the most prominent characteristics of the pictorial Art Nouveau. In art, however, spacelessness, that is to say the absence of dependence on perspectively constructable space - not the absence of any dependence on the spatial experience as such - means that the two-dimensional surface, and also the section formed from that surface, is acknowledged as being the basic external plan of the picture. Thus, non-perspective representation is characteristic of all Art Nouveau pictures and often includes a horizon placed at a very high level, with the result that objects are shown as if seen from an elevated standpoint, and the objects remain linked to the surface of the scene depicted. An illusion is given of things standing behind one another in space: this is achieved by reducing the size of the objects depending on how high up the picture they are, or else by means of diagonal lines or diagonal arrangements. However, the important factor in most cases is the pure and equal co-existence of all the forms. Similarly to the manner in which spatial constructions were abandoned, modelling, particularly the modelling of the human form, was also abandoned in favour of the two-dimensional surface. In those cases where the human form was modelled, as for example in the works of Stuck or Khnopff, this modelling was in deliberate contrast to the airless spacelessness of the surroundings, and this meant that the popular law of correct truth to nature was again being disregarded.

PLANNING THE PICTURE AREA

Few periods of Western art have paid as much attention as did Art Nouveau to the use of pictorial cut-out sections as an integral part of two-dimensional representation. The basic principle of this representation, whether it consisted of a horizontal arrangement, vertical graduation or central concentration, was often expressed by the use of extreme pictorial shapes. The semicircular shape of Japanese fan covers, with the segment of a circle cut out of them, was also used by Art Nouveau, but without any intention of painting an actual fan; the shape was used solely as an element in the composition. Another way of incorporating a pictorial cut-out section as one of the basic elements of the two-dimensional surface was derived from the Impressionist painting method of making the edge of the picture overlap some of the figures; this gave shape to a random element in the movement. The edge of the picture overlapped some of the figures in Art Nouveau too, but this had a different compositional significance from that in Impressionism. The intention was not to include fleeting movements in the picture but to dematerialize the figures and to include in the picture only that part of their forms or faces which was significant to the spiritual message. For example, this was done by Munch, when he made a head look despairingly out of the edge of the picture, or by Khnopff when he positioned the edge of a picture round the very edge of a face. This method of composition contrasted very sharply with everything that had been practised up until then and was consequently a shock to the public. However, it is clear that this means of employing pictorial cut-out sections made it possible to direct the intellectual statement in a direction which the viewer was involuntarily compelled to consider provided that his response was not deliberately passive.

It was thus necessary, within the cut-out section that had been selected, to fill the two-dimensional surface with a representation which recognized this surface as being the framework of the picture without wishing to make it into an illusionist peep-show. However, two-dimensional depiction is only possible if the artist acknowledges the basis structure of the two-dimensional surface. This means that the flat surface remains flat under all circumstances, but can be divided up by contouring lines and separated into surface areas which adjoin one another. The outline of these surface areas can take on the shape of known objects, and the areas can have the colour of those objects. The relationship between colour and line has been handled in many different ways: in French art the importance of the coloured surface was dominant, while in English art the linear outline was prevalent, and colour was added later as an element to fill out the structure. (It was in this way that children's painting books with shapes outlined in a linear style came to be created; today such books would horrify any art teacher.) A woodcut by Hans Christiansen entitled "L'Heure du Berger" (illustrated on p.13), taken from "L'Estampe Moderne", clearly shows the relationship which

exists between the outline and the coloured surface and which is an example of a harmonious mutual balance: this woodcut was put on to the market both as a black-and-white plate and as a colour print. The black-and-white plate of the drawing is a complete piece of work. It is harder to read than the colour print (illustrated on p.160), but its effect is more understated and more spiritual. It is possible in both these works to see clearly the role which medieval glass windows played in the work of Art Nouveau painters. In France, Emile Bernard, who was one of the earliest such painters, confirmed that this influence existed in his own works. The relationship between the surface and the subject being represented is ideally handled by giving the surface of the objects or of the figures the same colouristic and formal significance as the surface that lies betwen the objects. Thus the positive and negative forms complement one another directly. This means that everything in the picture, both the objects and the spaces between them, has basically become part of the representation. This principle led Maurice Denis to formulate that frequently-quoted law of painting which states that a picture, whatever it represents, is initially a surface divided up according to a certain arrangement. Of course, this law permits of deviation and does not always have to be strictly followed. However, every Art Nouveau picture demonstrates this principle of making its representation obey a law which subjects the whole surface to a definite regular arrangement. It is for the sake of this arrangement that an object's truth to life is sacrificed for the first time in art; the object becomes transformed.

THE SPIRITUAL MODEL

On the other hand, this transformation also follows another and much more essential law, and this is the law of the spiritual concentration of the subject matter in a two-dimensional form. Here too, Emile Bernard in France laid down the basic principles at the very beginning of the Art Nouveau period. Bernard was previously a member of the Impressionist school but, in contrast to the Impressionists, he now no longer did any open-air easel painting surrounded by nature or with his model, but worked in his studio from sketches made from memory. He advised his friends to immerse themselves in the model or the landscape by means of meditation, and then later to paint from memory what they had seen. Memory, or the power of recollection, clarifies things by eliminating the minor details and retains the essential features, even emphasizing their importance. When someone is painting from memory, he will therefore automatically paint those features of his motif which have particularly impressed him. The viewer of the picture, in this concentrated simplification of the image, will then simultaneously be able to sense the painter's meditative experience.

Not only children's drawings, but also East Asian art, are based on this principle, and the aesthetics of Art Nouveau state that both these areas of art provide ideal examples. Schopenhauer is frequently quoted by Emile Bernard, and in his work "The World as Will and Idea" Schopenhauer provided some basic reflections concerning not only contemplation but also the fact that man's mind and memory have a purifying effect on the object contemplated. Perhaps it is by these means, even more than by the means of formal imitation, that the ideas of Far Eastern painters became productive in Western art.

LINE AND COLOUR

However, what is the manner in which the personal experience, the subjective feeling for the spiritual content, is expressed in the reproduction of simplified forms? In addition to the choice of motif, a choice which is usually subjective and therefore significant, this experience was again expressed by means of lines and surfaces, but in particular by means of the equally subjective handling of those lines and surfaces. In the outlines and internal patterns, the artist's personal handwriting is directly expressed, almost as in graphology: this expression is not a guide to interpreting the artist's character, but is to be understood as the artist's empathy with the feeling of his motif. It is as a result of a psychological reflex that a soulful, an aggressive, a hypocritical, an arrogant or a musingly searching line is understood by the viewer and transferred by him from a visual impression into a subsequent feeling. This is done in the same way that a trumpet signal or a vibrating violin sound, an aggressive rhythm and a soft melody, are understood in terms of their value and their significance. The same applies to colours when they are related to one another in a manner which, as far as possible, is clear and unblurred and accentuates their particular significance. It is in this way that the complex configuration of an Art Nouveau picture is created from the contrast and interplay between the lines themselves, between the colours themselves and between the lines and colours in relation to one another. In accord with the atmosphere of the period, a certain line keeps recurring, an undulating arabesque-like line which is found in nature in the upward reaching of plants, in the foaming crests of waves, in reflections in water, and in long-necked birds such as swans or cranes. In the same way as, in the work "Girl by the Water", the standing girl almost takes on the bending rambling shape of the tree trunk, as many other things as possible are subjected to this organic law of upward twisting and undulation, and everything becomes an integral part of an organic and natural vibrating unity which that era dreams of as a contrast to the machine workshops existing at the time. An organic and rhythmical weaving effect surrounds the lovers in "The Kiss" by Peter Behrens (illustrated on p.139). Even in the gruesome sheet by Käthe Kollwitz, which seems to be only slightly reminiscent of Art Nouveau and which depicts a girl who has been raped and murdered and left in the undergrowth, it is clear that Nature once again

takes possession of man, who had elevated himself above her for a short time, and she here masks everything that has taken place with the timeless cover of a green oblivion. In Art Nouveau, a certain coloration with milky transparent tones corresponds to the undulating lines of concave and convex curves. Along with pure white and pure black, and with gold and silver, the colour tones preferred by Art Nouveau are: the blue of the water and the sky in their many graduations and reflexes in blue flowers and crystals; the green of grasses and leaves, often in tones moving towards blue; and variations from red towards mauve and lilac. Blue, with its characteristic relation to distance and twilight and its inclination towards introversion and melancholy, was in fact the atmospheric colour symbol of those times: the blue dreamy hour after sunset when memories and wishes come alive, while at the same time the contour and consistency of objects begin to grow hazy and become intangible and gradually invisible. Wherever luminous colours were used, they took up only a small space, resting like precious stones within a muted surrounding, and increasing the charm of the unreal.

Thus even the very lines and colours characterize the Art Nouveau period as an epoch which, while not avoiding the requirements of the day - that would have been impossible because this age achieved so much in other fields of research and progress - nevertheless continually withdrew from those requirements into an atmosphere of intimacy, of unreality and of fairy-tales, which was also an atmosphere of social and private taboo. The changes taking place in the economic, technical and social fields had also long been demanding a radical transformation in man himself, a transformation consisting of his release from old-fashioned conventions. However, the entire epoch resigned when faced with such a transformation, and to this extent it is obvious that there is a close link between Art Nouveau and the Wilhelminian period of the 19th century. Progress in one area was combined with a very drab convention in another, but this was accompanied by a gradual change caused by the conventions finally being burst apart from within. However, by this time the Art Nouveau period was already at an end.

CHOICE OF MOTIF

When an attempt is made to draw up an iconography of Art Nouveau, that is to say a listing of the pictorial subjects which the movement chose to depict, then this must not only be done by a comparison with the epochs that preceded and followed Art Nouveau. Rather, such an iconography must be compiled in the context of the contemporaneous art of Wilhelminian drawing rooms and pictures of garden arbours. The aim is to demonstrate how close Art Nouveau is to this Wilhelminian art and how they both have a relationship to a similar problematic situation. However, Art Nouveau retains this relationship while aiming

Hans Christiansen, L'heure du berger. Lithograph. 1st version (cf p.160).

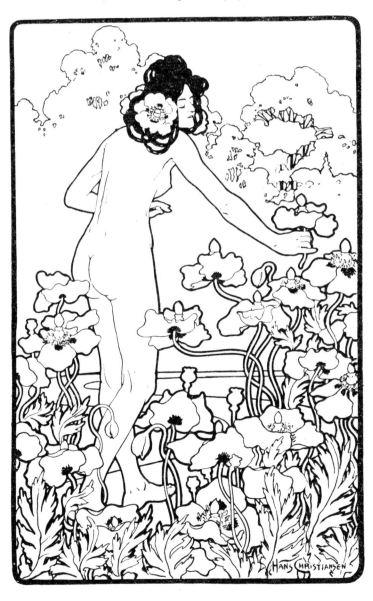

to show the underlying characteristics of this situation, but not without suffering from the insolubility of the problems and the inadequate means of expression available, and also not without enjoying this suffering. In the first issue, in 1896, of the Munich weekly magazine "DIE JUGEND", which was in many respects a provocative publication (we shall discuss it later, on page 125), the editor organized a competition to obtain in good time some illustrations for the colour title pages which changed weekly. He wrote the following guiding principles on the choice of subject: "The theme of the drawings should relate in some way to the concept of 'youth', interpreted in the broadest possible sense. The brochure describes such a concept. Thus the pictures can relate to springtime, love, childhood, marriage bliss, maternal happiness, play, masquerade, sport, beauty, poetry, music and so on." When reading this list, one would not wish to claim that Art Nouveau represented a leap into the 20th century from the point of view of the themes here stated, as almost all such theses can also be found in paintings which were rejected by Art Nouveau. An example of such a thesis can be found in the motif of girlish longing beginning with Feuerbach's "Iphigenia" and not ending until the advent of Expressionism. Art Nouveau confined itself almost exclusively to stating old themes in new forms; however, these forms gradually led away from the themes because they became increasingly independent of the physical object depicted and finally, without the actual depiction of the object, attempt an expression which could previously only have been attempted through the portrayal of such an object and its empirical associations. However, no sooner was this expression achieved in the first decade of the new century than Art Nouveau had ended.

ART IN THE LIVING CONTEXT

Despite its ties to traditional ideas, the Art Nouveau epoch felt itself to be youthful and revolutionary because it was trying to understand familiar problems by using new means of gaining access to them. A particularly youthful characteristic was the élan with which the movement seized all the opportunities of artistic expression and used art in order to try to change the outlook on life prevalent at the time. All objects which surrounded people, and with which people came into contact, lived by the same breath of undulating shapes and soft colour harmonies. This applied more to the rooms in the house than to external architecture. It applied to furniture, carpets, crockery and cutlery and to the carpets, the wallpapers and the stucco ceiling decorations. Clothes, particularly women's clothes, harmonized with each other. Apartments which had already been decorated in a earlier fashion were now frequently provided with a "style room" where all details of decoration were subordinated to the same basic decorative principle. Art Nouveau paintings, when used as wall decoration, had a definite place in the room. They were co-ordinated with

the scheme where colour was concerned, and accentuated the spatial limitations in the same way as the rest of the walls in the room. These paintings were not illusionist views of sunny river landscapes, but were focal points for the occupant's meditations. According to the ideas of the day, the soul of a human being was supposed to discover its real nature in such rooms: in reality, though, the soul was directed into channels which had been previously determined by the interior decorator through the design of the entire contents of the room.

If a living room, with all its elements, was one of the main centres in which Art Nouveau was developed, the wide field of printed art was another area of opportunity for some of the best work of the time. Printed art with its manifold outlets was ideally suited to the social tendency of Art Nouveau, a tendency which consisted in the broad dissemination of the new taste. The intention was not merely to create works of art which were of benefit only to a wealthy stratum of society, even though costly interior decoration usually led to such a result; there was the additional purpose of using the new possibilities of industrial manufacture and mass production to distribute the new forms and products as widely as possible. Where the manufacture of utilitarian articles was concerned, this rarely led to any very satisfactory results, but rather to a flood of cheap mass-produced articles with wave-shaped design characteristics. This flood of goods gave Art Nouveau a poor reputation at an early stage. Things were different in the field of printed art, where the printed result remained relatively close to the artist's intention, and the unity of artistic creation and technical production was ensured by the very nature of the product even when the print run was large. This was because mass production is in any case a specific feature of printed art.

PRINTING TECHNIQUES

Art Nouveau artists worked in practically all the printing techniques which had by then been developed. No new reproduction technique actually grew up alongside Art Nouveau, but the movement generated from the adopted techniques some new developments which suited the new artistic form. The woodcut, the oldest form of printing technique, was subjected to a particularly radical transformation, The possibilities provided by woodcuts had been almost forgotten since the 17th century. They had previously been widely used in old German graphic art during a period which, like Art Nouveau, aimed at popularizing artistic works by means of wide circulation and low prices. Since that period woodcuts had been used almost vicariously in the form of wood engravings for the reproduction of paintings and sculptures or for the depiction of topical or historical events. The technical skill of the wood engravers was so great that, in a similar way to the matrix printing of today, they were able completely to transfer their illustrations into very small dots and thereby to translate

the reproduction from the original onto the grey scale; compared with photographic reproduction, these illustrations have a certain stiffness but also, in many cases, a better definition of form than is possible in photography. In the woodcuts of those days almost nothing but so-called cross-grain wood was used. This was wood which was sawn diagonally from the branch, making it possible to cut out very small pieces without little particles breaking off at the same time. However, the Art Nouveau artists were the first to revert to the use of so-called long-grain wood, that is to say wood which was sawn in the longitudinal direction of the branch and, in contrast to cross-grain wood, showed the run of the grain. Unlike cross-grain wood, it is not possible in this technique to work in very small detail, because the adjoining shapes would immediately splinter off. Thus the very technique makes it necessary to arrange the picture in large coherent surfaces and shapes which preclude any illusionism. Woodcuts of this kind were evidently first re-used by the French artists Bernard and Gauguin, and it was particularly Gauguin who also dispensed with smoothing the grain of the wood and instead used it as part of the picture's effect. Here, Nature herself was drawing those wave-shaped lines which corresponded to the idea of an organic interrelationship permeating all things. In England, wooodcuts were used as book decoration in direct imitation of medieval block books, and the text and the pictures were completely integrated with each other. We shall return to this topic later.

A factor of very great significance was the restriction to pure black or white. This restriction was a technical result of the concentration of forms and it meant that no intermediate or grey tones were used (and, in colour woodcuts, it meant that there were no intermediate colour surfaces). It was the Swiss artist Félix Vallotton, naturalized in France, who made the most consistent use of the new contrast between black and white. He did this in works of mainly satirical content, and the satire is interpreted precisely by means of this contrast, as for example in the woodcut "L 'Argent" (illustration on p.42). The dominant feature of his design is usually the large black surface against which figures and objects show up as lightning-like illuminations; the sharpened significance of the subject being depicted is always strengthened by the contrast of colours. In a similar fashion, but with a stronger social tendency, Käthe Kollwitz divided the pictorial area of her woodcuts into black and white and used this division for a decision regarding subject matter. The etching technique is almost as old as the woodcut technique but never became as far removed from its own inherent possibilities as did the latter. Art Nouveau was here able to relate much more directly to an already existing tradition and it particularly favoured this technique because it offered two possibilities which were in accord with the new artistic style. Firstly, the etching needle was able to achieve the fine web of lines which increased the sensibility of the arabesque Art Nouveau line, and secondly, with the aid of the aquatint technique, it was possible to etch the surface in such a way as to give it an inner structure which was organically connected to the pure graphic elements of the illustration. It was Armand Séguin in France who created the first examples of such graphic art, and after that Edvard Munch, the Norwegian artist, was its main exponent. Finally, those works by Walter Leistikow, for which Munch provided a stimulus, should be mentioned.

Among the printing techniques suited to large print runs, lithography played an especially important part at this time, particularly since it is the most adaptable technique and permits the reproduction of practically any kind of handwritten, two-dimensional, grained or linear artistic creation. The lithograph "Sadness" by Ranson (illustrated on page 35) could, in this form, also have been designed for a woodcut. Apart from individual graphic sheets, it was particularly in poster art that lithography had a large part to play, because it was at that time not really possible to print such large-sized sheets in any other technique. Lithography - especially in France since the time of Daumier - also played a traditional role in the reproduction of magazine illustrations: those in the REVUE BLANCHE were also reproduced by this method.

Along with lithography, autotype, a technique suitable for large print runs, was also included within the domain of Art Nouveaau. This was the first time that such extensive use had been made of autotype, which is not a system of printing graphics in the usual sense, but was from the outset intended for the mechanical reproduction of drawings created by pen or brush. However, the drawing need not be more than a draft for a preparatory drawing, as is shown by the work "Dance of Peacocks" by Albert Weisberger (illustrated on page 188). We are reproducing this here in a facsimile form, that is to say with all those structural irregularities of a pen drawing which can no longer be seen in the later print in two colours, whilst to produce the white of the peacock no ink is applied to the paper.

In the above-mentioned competition for the JUGEND magazine, Dr. Georg Hirth, the publisher of the magazine, made the following express condition: "The designs should be monochromatic or in more than one tone but should be such that they can be reproduced by two or at most three plates by autotypographical or zincographical means". Thus the printing plate which is then made reproduces only the basic tone, without any surface structure or colour modulations, while the designs contain these modulations. These do not, however, have any intrinsic value and are only a result of the artist's method of working with the knowledge that these deviations from the basic tone will disappear from the print when it is reproduced. It is thus not possible to refer to the autotype as producing a mechanical reproduction of a drawing, as it should rather be considered as an independent process for manufacturing works of printed art. Because the drawings were not produced for any other purpose than that of block-making and printed reproduction, many of the illustrations published in JUGEND and VER SACRUM are therefore expressly provided

with the note "Book decoration for JUGEND" or "Drawn for V.S."

Because of this, we do not refer to printed graphics in this book but speak of printed art in a more general sense, because our ideas of printed graphics are being considerably expanded. Even before Art Nouveau, Wilhelm Busch and his picture stories ("Max and Moritz", 1865) became known due to this process which enables the artist to work more quickly than if he were manually transferring the preparatory drawing on to the wood block of the woodcut. Irrespective of whether the wash drawing is in pen or brush, it is laid out in pure lines or surfaces and is then photomechanically etched onto a zinc plate. The result looks similar to a woodcut, because only pure black or white tones can be reproduced; however, the particular flow of the lines and of the surface contouring has more variety than is the case with woodcuts, because the typical effect of the brushwork can also be captured. However, this technique is frequently used in colour prints too: as Weisberger's example has shown, autotype permits the creation of multi-coloured prints which correspond to the traditional woodcut in which the individual zinc plates are used in different colours. The colour prints are then not made using the four-colour scale as is usual today, but as two or three-colour prints containing specially prepared colour tones in which, making use of the colour of those parts of the paper which are left blank, it is often possible to achieve colouristic effects in which it is difficult any longer to see the few basic colours. As was the case with lithography in poster art, autotype was widely used in magazine and book illustration, where it soon replaced the expensive techniques of woodcut and lithography. A particular feature was that the time saved by the autotype technique greatly benefited the publisher's production schedule which, then as now, was constantly suffering from lack of time. While, in England, William Morris and Edward Burne-Jones still had their book illustrations cut from wood blocks, often doing it themselves, Walter Crane and in particular Aubrey Beardsley worked almost exclusively by the autotype method. This method also established itself very rapidly on the Continent. If the zinc etching technique had not immediately transformed illustrations by Melchior Lechter and Heinrich Vogeler into blocks from which prints could be made, the woodcutter and the publisher would have had to develop the patience of Job. The Munich magazine JUGEND and the Viennese VER SACRUM used autotype almost exclusively. However, we must, in our definition of the concept of printed art, go a step further and include four-colour screen printing which practically does away with any colour limitations. It was not until 1881 that this technique was invented by Meisenbach and Schmädel and, in its early period, it was by no means exclusively regarded as a reproduction technique. Artists such as Edmond Dulac, Arthur Rackham or Ernst Kreidolf —to name only a few well-known names—created designs in colour especially for this technique; these were mainly for illustrations in children's books. The only pictures which must be regarded as mere reproductions are the reproductions of independently created watercolours or paintings. In the field of printed art, we are thus confronted by a broad range of activities which includes the most varied elements.

TEXT AND ILLUSTRATION

One of the most important problems for the printed work of Art Nouveau was achieving uniformity in the combination of words and pictures in book and magazine illustration. Since the great epoch of illustrated books in the Late Middle Ages and the Renaissance, this relationship between text and illustrations had become increasingly lost, or had become stiff and no more than a dry juxtaposition of text and illustrations. Although the stylistic treatment of words and pictures had been extensively developed, success was evidently no longer being achieved in combining the two. William Blake was one of the first to try to re-establish this connection, and in his "Songs of Innocence" of 1789 he provided the first significant example of a new form of typography. He designed for these poems a new type face which he etched on to the same printing plate as the flaming and undulating ornaments accompanying the text. This anticipated one of the most important statements of Art Nouveau: pictures or ornaments were not to be associated with one of the traditional type faces but had to be newly invented by the same artist as designed the type face and, from the outset, this had to be done with a view to the harmony between the two elements. However, these ideas of Blake's did not really come to fruition until the second half of the 19th century, when they led to the development of a contemporary typography in England. This began by modelling itself on medieval patterns, but soon gave rise to the independent cultivation of new artistic type faces and thereby had a lasting effect on Continental art.

While the development of book and magazine illustration had its main origin in England, the impulses for another branch of printed art, namely the creation of posters, came from France. This lent clear expression to the differences between the national contribution of the two countries. England always preferred linear graphic design, while France showed an increasing tendency towards strongly-coloured shapes extending over large areas. However, although poster art also spread to England and led to significant results there, the new Art Nouveau book style found few adherents in France.

The rest of the Continent accepted both these developments to an equal degree. Posters became popular over the whole of Europe, not so much for their artistic importance but because of their genuine influence as a medium linking supply and demand. Advertising by means of posters was in any case still a very new form of displaying merchandise, and had until then been done with the "tristesse" of

Wilhelminian lack of imagination, using allegorical figures and naturalistic details. Baroque textual cartouches were also used which were difficult to read and therefore did not make the merchandise on offer attractive. The Art Nouveau posters introduced a brightly-coloured element to the streets, and the advertisement pillars which had been known to the public since 1855 then became places where passers-by would stop. The advertising on these pillars thereby became so striking that the curiosity of the passers-by was aroused. Since that time, economic life has been unimaginable without the use of poster advertising with its typical characteristics. These are: firstly, the simplification which consists of large formats and strong colours and which is effective when seen at a distance; and secondly, the optimism inherent in the tenor of the advertising. Book art met with no less responsive an echo in Europe, where it was supported by the initiative of a few large publishing firms. It was particularly in Germany and Austria that important illustrated editions appeared, and children's books played a particularly large part in these developments. One form of publication which had previously been of only slight significance to bibliophiles also supported these artistic developments. The publications in question were weekly and monthly magazines. In 1891 France had made a start in this direction in the original graphic supplement to the REVUE BLANCHE, and this was soon followed by publications which were even moe gorgeously designed. Examples of such works were: in England, THE YELLOW BOOK in 1894 and THE SAVOY in 1896; in Germany, PAN from 1895 onwards, JUGEND and SIMPLIZISSIMUS from 1896 onwards and INSEL from 1898 onwards; and in Austria, VER SACRUM, also from 1898 onwards. In these best-known examples of such magazines, there appeared the first literary contributions by important lyric poets and storytellers, some of whom were still unknown, and also illustrations and decorative elements created especially for the magazine. Many such magazines were so exclusive that they had a very limited lifetime. On the other hand, such magazines as JUGEND and SIMPLIZISSIMUS gained such popularity that they survived for decades.

These magazines, which were joined by a number of new art magazines containing exhibition reviews and special articles, were not the least significant factor leading to an international exchange in the field of the new style and the new taste which made Art Nouveau into a phenomenon which was accepted over the whole of Europe, but in which each country nevertheless displayed its own national viewpoint. The intention of the present book is to show the achievements of the individual nations and of individual groups in those nations.

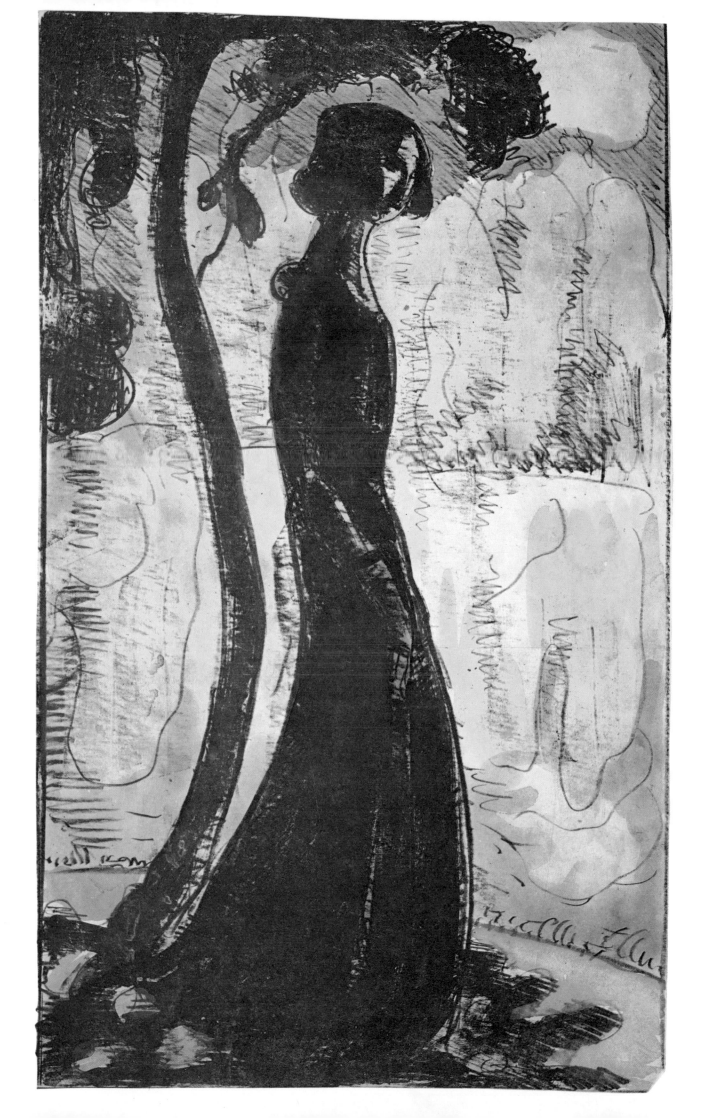

FRANCE

The French contribution to Art Nouveau painting was based on a simplified style consisting of extensive areas of flat colour. The first pointer in the direction of this new art form came from a group of artists who worked in the Breton fishing village of Pont-Aven. In summer, artists liked to move away from Paris and go to this village where the climate was pleasanter, and the cost of living lower. Emile Bernard and Paul Gauguin met there in 1888. They were both visiting Pont-Aven for the second time, though previously they had not taken serious notice of one another.Systematic preparatory sketches and a youthful lack of inhibition led Bernard to produce some of the first results in the new style. The work of Paul Gauguin, some twenty years his elder, had become rooted in an Impressionist version of large areas of flat colour, but he at once took over the results of Bernard's first efforts, developing from them his own archaizing, expressive style; for Gauguin, the work of the younger man had clearly become the key to an art form which Gauguin had himself been seeking and working towards, but had not found. Bernard, in his picture "Bretonnes dans la Prairie", a scene with Breton peasant women standing together in a meadow after going to church, had reduced his palette to three colours: the yellowish-green of the meadow, the blue of the clothing and the white of the bonnets. But he also simplified the structure of his painting by virtually dispensing with any modelling or perspective and, instead, reducing the specific motif of standing or sitting to a simple formula which he placed as a silhouette against the meadow-ground and repeated several times, thereby building up his scene.

The 'Pont-Aven group' held its first joint exhibition on the occasion of the Paris World Exhibition of 1889. It was held in a café belonging to an Italian named Volpini and was located on the fringe of the exhibition area because permission to hold it in the official exhibition pavilion of Modern French Artists had not been granted. The reaction of the members of the public frequenting the café was not particularly friendly, but that of the press was at least critically appreciative. However, a significant development was the contact gained by the Pont-Aven group with a circle of young artists consisting of friends who were students at the private Académie Julian. Among the most important of them were Maurice Denis, Paul Sérusier and Paul Ranson, while Pierre Bonnard, Eduard Vuillard, Aristide Maillol and others later joined a group calling itself 'Nabi' (prophet). This group acknowledged the new style of the Pont-Aven artists, but continued working in Paris and did not reject the civilized city atmosphere as being inimical

to art. Paul Sérusier was the only member of their circle to visit these new friends in Brittany, and he in turn passed on their ideas to the Nabis who had remained at home. This "stayhome" attitude on the part of the Nabis was not entirely uncharacteristic of their art, which did not necessarily seek the archaizing contact with the currents deriving from folk art or from overseas. As students at a classicist academy, they were strongly aware of the tradition of French art from which they were continually drawing inspiration. Their motifs are generally more spiritual than the naturalist subjects favoured by the Pont-Aven artists. The Nabis preferred to paint pictures in the realm of religion or pantheist romanticism, and they were fond of dreamlike fairy-tale themes.

This choice of motifs meant that literary and ideological subjects became one of the major concerns of the Nabis, and led them to seek contact with contemporary intellectual life. Their regular meetings were frequented not only by painters, but also by musicians, poets and philosophers; some members of their circle became converted to Catholicism. Maurice Maeterlinck, André Gide, Francis Jammes, Claude Debussy and others were closely associated with them. Thadée Natanson, the publisher and editor of the literary magazine REVUE BLANCHE, enlisted the Nabis to work on his magazine, publishing their graphic works as original supplements to the magazine issues, and holding their exhibitions in his editorial offices, whose furnishings had been designed by Henri van de Velde. The social circle surrounding Natanson, with the worldly and liberal-minded Misia Sert at the centre of it, was conducive to intellectual contacts. The circle of the Nabis and the beautiful Misia was frequented by one of the most significant outsiders in the world of art: this was the aristocratic Count Henri de Toulouse-Lautre, whose hereditary disposition to deformity had become permanent through several accidental falls. Deeply sensitive, he developed a sarcastic manner, always concealing his personal despair from a world which admired him while keeping him at a distance. He recognized that he belonged to this world of outcasts in the field of art too. His name is inseparably connected with the development of the modern poster, although he was certainly not its initiator. The posters of Fred Walker in London and of Eugène Grasset and Jules Chéret in Paris, paved the way for the art of Toulouse-Lautrec, whose friends had developed the new style years before him. However, he was the first artist to realise clearly the poster component in Art Nouveau and therefore was able to utilize it in such a way as to give its full effect both as a picture and as an advertisement. The colourfulness of his posters amid the grey tone of the city of Paris, the unusual suggestiveness emanating from the simple silhouette shapes—and the text display which was as simple as it was impressive—all served to create a sensation. It was for this reason, and not just because their intrinsic artistic values had been perceived, that exhibitors and cabaret owners ordered these posters and paid high prices for them.

◁ **Emile Bernard,** Girl by the water, from the cycle "Les Cantilènes" by Jean Moréas. 1892. Coloured zinc etching. 32.1×19 cm.

The posters of Toulouse-Lautrec had a lasting effect on the whole of artistic development, in both a positive and a negative sense. Some imitators of his art even transferred this poster style on to their own paintings, and reduced their pictures to the level of posters. But Toulouse-Lautrec himself never used in his pictures this clear definition of shapes which was effective in street posters. Instead, his pictures were decidedly "open", both in form and in expression. In contrast to the posters, his pictures do not stress any meaning, but they ask questions of the viewer—often embarrassing ones which could become very disturbing to the public and therefore led to defensive reactions. However, his posters also had a great creative effect because they clearly showed a certain principle of the application of Art Nouveau forms, one which could be adapted to any individual style and type model.

A broadly-based developing artistic process, characterized by an international exchange of forms and ideas, began in France, as in other European countries, in the 1890's. In the same way that the stimulus provided by the Gauguin–Bernard circle and the Nabi group, and by Vallotton and Toulouse-Lautrec had its effect outside France, impulses from other countries now came pouring back into France and reached fruition there. Although the influence of England on France did not go so far as to lead to the adoption of the block book there, nevertheless an adaptation followed of that typically English emotional and lyrical art which, due to the influence of the Pre-Raphaelites, was still flourishing in the English Art Nouveau of the 1890's. Among the Nabis, Maurice Denis in particular reached a great pitch of intensity in the mood of his creations, which later became associated with those of his works dealing with the fanciful ideas of New Catholicism. However, Bernard's "Girl by the Water" (illustrated on page 18) and Aman-Jean's "Ophelia(?)" (illustrated on p.45) also show this relationship between France and the English Art Nouveau, and it is especially in the latter picture that we see the associations that affected Edvard Munch, who visited Paris several times during this decade; Séguin's sheets will also have influenced him.

However, the typography used by the English, and the Medieval-style page with its integrated text panel and illustration which the English strove to emulate had repercussions in France too, although the illustration was not so strictly subordinated to the typographical aspects there and the pictures retained more of their independence from the text. Maurice Denis in particular designed books in which text and illustration were closely interwoven. Occasionally, as in Fioretti's "Petits Fleurs de Saint François d'Assis", he even framed the picture on two sides with flat floral borders in olive and mauve. However, in contrast to English book illustration, he emphasizes the following: "Trouver cette décoration sans servitude du texte, sans exacte correspondance de sujet avec l'écriture, mais plutôt de broderie d'arabesque sur les pages, un accompagnement de lignes expressives."

The illustrative system used by Denis found almost no imitators in France, because the decorative ensemble was never so completely developed there as it was in England and later in the German-speaking countries. However, Pierre Bonnard, who was also from the Nabi circle, carried out a further development which was highly significant for book graphics in the 20th century. In 1900 he illustrated Verlaine's volume of poems entitled "Parallelement" by using lithographs of a reddish tone, and he allowed his pencil to play about the printed text as if his decorations were chance inventions or picturesque, graphic glosses made during the course of reading. Bonnard did not continue with this particular method. Instead, in "Daphnis and Chlöe", he localized his dreamlike fantasies by giving them a tectonic frame, and placed the fantasies in a classical proportion to the text. But his earlier ideas were taken over by Dufy, Picasso, Miro and others. Aristide Maillol, also a member of the Nabi circle, took up the thread of Bonnard's academic illustrations and related them still more closely to the appearance of the text, thereby creating a new classical illustrative art in which the impulses arising from Art Nouveau could still be seen.

Ambroise Vollard published most of these books. Born in 1865, he belonged to the same generation as the Art Nouveau artists. After passing his examinations, he suddenly gave up his plans to become a lawyer in Paris, and in 1890 started a picture shop in his lodgings in an attic in Montmartre. He was able to move this shop to the Rue Lafitte in 1893. Like his regular "basement dinners", his gallery became a meeting place for everyone involved in cultural life. Together with Samuel Bing's shop, which from 1896 onwards was representative of the Art Nouveau style in interior design, and together with the REVUE BLANCHE, Vollard's gallery became one of the great centres from which the new ideas of the epoch radiated outwards. Visitors came from many countries and acquainted themselves with the very newest pictures and graphic works which had been created in France and especially in Paris. By awarding commissions to illustrators, Vollard the publisher had a decisive share in the development of book art in France. The end of Art Nouveau, and its almost unbroken transition into the expressive Fauve period which followed, can be seen particularly clearly in French printed graphics, as we shall finally show by means of a comparison of similar motifs in Maillol and Matisse. All the means of abstraction were elaborated during the Art Nouveau period, and linear expression was the main argument of artistic creation for the Fauvists too. But the harmony was broken, and the euphony of arabesque lines became perverted and turned into a shrill dissonance. The characteristics that had both united and separated two different epochs suddenly became visible.

Emile Bernard, Breton peasant women doing washing. 1888. Coloured zinc etching. 10.5×39 cm.

EMILE BERNARD

Emile Bernard, a painter, draughtsman and writer, was born in Lille on 28 April 1868 and died there on 16 April 1941. He was ten years old when he first visited Paris, and there he was introduced to museums in the company of his parents. In 1880 he returned to Lille and stayed in the house of his grandmother, a washerwoman. He copied Franz Hals's witch in the Lille Museum. At the age of thirteen he painted his first picture, a pastel. In 1884 he began his painting studies in the studio of Fernand Cormon in Paris; it was there that he met and made friends with Louis Anquetin and Henri de Toulouse-Lautrec. In 1886 he was "expelled" from Cormon's studio and quarrelled with his parents. He met Van Gogh and went on his first trip to Normandy and Brittany where he made the acquaintance of Gauguin through the introduction of Schuffenecker, the painter. Bernard made his second trip to Brittany in 1887. He worked with Van Gogh in Asmières, first making pointillist experiments and then developing the "cloisonnist style". In 1888 he spent a long period in Pont-Aven in Brittany, working with Gauguin, carrying on an intensive correspondence with Van Gogh, and working on theoretical writings. His first lithographs were then created in Asnières. In 1889, the Pont-Aven group of painters gave their first exhibition in the Café Volpini on the occasion of the Paris World Exhibition, and Bernard contributed some twenty five paintings. His article "Aux Palais des Beaux Arts, notes sur la peinture" was published. The Pont-Aven group caused a public sensation. Bernard travelled to Brittany again in the summer and his first religious pictures were painted. In 1890 he commenced his writing activities for "Théâtre d'Art" and "Livre d'Art".

In 1891 he quarrelled with Gauguin, spent some time in Brittany in the summer and turned his attentions to picture subjects of a romanticising nature. Bernard gave an exhibition in Paris together with the Nabi group.

In 1893 Bernard went to Egypt where he spent ten years. He was able to dissociate himself from his symbolist painting and he based his subsequent work on classical models. In 1904 and 1905 he visited Cézanne in Provence. And in 1905 he founded the magazine RENOVATION ESTHETIQUE, which continued until 1910. He was active as a writer, his chief works being the publication of his correspondence with Van Gogh, Gauguin and Cézanne.

Of all Bernard's graphic works, the sheet, "Breton peasant women doing washing", bears the most similarity to a key work of his, namely the "Bretonnes dans la Prairie", which was created in the same year of 1888 and is an oil painting on canvas in the Denis Collection in St. Germain-en-Laye. In particular, the women facing one another at the right hand edge of the picture are almost identical; one of them is shown in three-quarter view with her arms akimbo, and the other is seen from the back, hanging up her washing. For his depiction, Bernard chose a small broad-type format such as he occasionally saw in Japanese woodcuts whose frequently bizarre picture formats had a strong influence on Art Nouveau graphic works in general. The picture area makes it almost impossible to achieve that direct linking of the groups which is seen in the above-mentioned painting; following the additive principle, Bernard therefore arranged for his depiction to be read off from left to right.

The "Girl by the water", which is another coloured zincograph created in 1892, shows a very different later phase in Bernard's work. The thematic sentimentality of the lonely figure of the girl and the affinity between her

21

form and that of the tree, give rise to the idea of an encounter with Pre-Raphaelite painting which is also clearly visible in some works by the Nabis, particularly those of Maurice Denis: we see the same modelling of the contours, the same limbless stretching of the silhouettes and the same solitude in front of the space which is dissolving in an unclear haze. Such ideas must have made a strong impression on Munch, who later used similar forms.

BIBLIOGRAPHY: LES CAHIERS D'ART-DOCUMENTS: Emile Bernard 1868 to 1941, Issue No. 100, Geneva 1959. – Gauguin, Paul, "Lettres de Paul Gauguin à Emile Bernard 1888–1891"; ed. by M.A. Bernard-Fort, Geneva 1954. – Hofstätter, Hans H., "Emile Bernard – Schüler oder Lehrer Gauguins?" DAS KUNSTWERK XI. 1957, p. 3ff. – Mornand, Pierre, "Emile Bernard et ses amis". Geneva 1957.

EXHIBITIONS: Paris, Galerie Durand-Ruel, "Emile Bernard, époque de Pont-Aven" 1959. – Mannheim Städtische Kunsthalle, "Die Nabis und ihre Freunde". 1964 – Milan, Galleria del Levante, "Emile Bernard". 1964. – London, Tate Gallery, "Gauguin and the Pont-Aven group". 1966. Munich, Galleria del Levante, "Pont-Aven und Nabis". 1967. – New York, Hirschl & Adler Galleries, Inc.: Emile Bernard. 1957. – Paris, La Guilde Internationale de la Gravure, "Emile Bernard à Pont-Aven et en Orient". 1960.

WORKS: Woodcuts and zincographs in particular. In addition to individual sheets, mainly depicting the life of the Breton country people, he also executed some isolated religious pictures, eg. the adoration of the shepherds and motifs from the Passion, stimulated by the Breton folk pictures of Mount Calvary. The following cycles should also be mentioned: Bretonneries, 1889. Series of 7 water-colour zincographs. These are Bernard's first known zincographs. – Jean Moréas, Les Cantilènes. Series of 7 water-colour zincographs. 1892. – Les Amours de Pierre de Ronsard Cinquante sonnets de Pierre de Ronsard Vendômois. Bois et cuivres dessinés et gravés par Emile Bernard. Ambroise Vollard, éditeur. Paris 1915. (Series of 50 woodcuts and 16 etchings). – Les petites fleurs de Saint-François. Traduites de l'italien par Maurice Beaufreton, illustrées de bois par Emile Bernard et éditées en 1928 par Ambroise Vollard, Paris. (412 woodcuts).

PAUL GAUGUIN

Paul Gauguin, a painter and draughtsman, was born in Paris in 1848 and died in Antuana in La Dominique (the Marquesas) in 1903.

He emigrated to Peru with his family in 1849 and returned to France in 1855. From 1859 onwards he attended the "Petit Séminaire" in Orléans. Gauguin joined the merchant marine in 1865 and followed the sea for two years. In 1871 he became a bank clerk in Paris. He married Mette Sophie Gad, a Danish girl, in 1873. He made the acquaintance of Schuffenecker, the painter, and painted pictures as an amateur. From 1874 onwards he was a friend of Pissarro's and attended the Colarossi Academy. In 1876 he had a share for the first time in an exhibition in the "Salon", and also took part in exhibitions given by the Impressionists. In 1883 Gauguin gave up his post at the bank in order to devote himself entirely to painting. He moved to Rouen in 1884, and later to Denmark, returning to Paris in 1885. In June 1886 he went on his first trip to Pont-Aven (Pension Gloanec) in Brittany, and here he had his first short meeting with Emile Bernard. In the autumn of that year he made the acquaintance of Van Gogh in Paris. In 1887 he travelled with Laval to Panama and Martinique, returning in November; being almost penniless, Gauguin stayed with the Schuffenecker family. In the spring of 1888 he went on his second trip to Brittany, made friends with Emile Bernard who was twenty years younger than himself, and worked with him. He carried on a correspondence with Van Gogh. He painted his picture "Vision after the Sermon" ("Jacob's Fight with the Angel"), in which he found the route to his new style. It was through Bernard that he made the acquaintance of Sérusier, whom he introduced to the new style of painting. He signed a contract with Theo Van Gogh and held an exhibition in the latter's gallery. In the autumn, he spent some time with Van Gogh in Arles, but after a violent quarrel, Gauguin left him and returned to Paris. In 1889 he was once again in Pont-Aven together with Laval and Sérusier. He had a share in "Les Vingt" exhibition in Brussels and in the Café Volpini exhibition (Groupe impressioniste et synthésiste). He was in Pouldu in the autumn. Bernard introduced him to Aurier, the critic, for whose magazine MODERNISTE Gauguin wrote articles. In the summer of 1890 he was in Pouldu again, together with some painter friends, and subsequently he was again at the Schuffeneckers' in Paris. Gauguin attended the Symbolists' meetings in the Café Voltaire; he made friends with Mallarmé and the "Nabis". In 1891 he gave an exhibition in the Salon du Champ de Mars, and another exhibition at "Les Vingt" in Brussels. His pictures were sold at the Hotel Drouot. He quarrelled with Bernard, broke off relations with him and departed for Tahiti in April 1891. It was almost at the same time that Aurier's article on symbolist art appeared, and in this article the leading role was assigned not to Bernard but to Gauguin. In summer 1893 Gauguin returned to France. He gave an exhibition

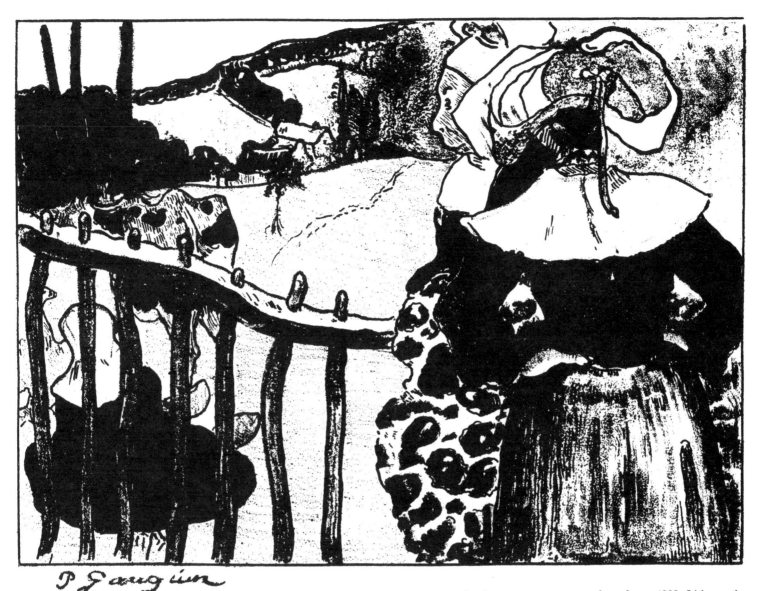

P Gauguin

Paul Gauguin, Breton peasant women by a fence. 1889. Lithograph. 16.5 × 21.5 cm.

at the rooms of Durand-Ruel in Paris. In 1894 he once again went to Brittany where he visited Pont-Aven and Pouldu. In February 1895 his pictures were once again auctioned at the Hotel Drouot. He returned to Tahiti in 1895 and left in 1901 in order to move to La Dominique (the Marquesas), where he died in 1903.

In similar fashion to Bernard's zincographs, Gauguin's graphic works from his Breton period show scenes from rural life. Two peasant women are seen talking by the fence of a field with cows, and behind the fence there is a girl sitting in the grass. The hilly landscape of Pont-Aven can be seen in the background. The motif of the two women, who are standing opposite one another at the right-hand side of the picture and whose forms overlap, had been adopted from Bernard. However, the composition as a whole is more

dynamic: the surface is divided up by wavy lines which provide an effective contrast between the enclosed intermediate spaces which are the colour of the paper, on the one hand, and the surfaces which are printed in a solid tone, on the other.

The colour woodcut from the later South Sea period is similar in only a few respects to the Breton pictures. The idyll has been completely renounced in favour of a portentous icon with a mysterious-sounding inscription in the language of the natives and equally enigmatic hieroglyphs, the lower part of which ends in the artist's initials. The body of the native girl is modelled in a physically realistic way and gives an almost carved impression; this is in contrast to the flat and flaming landscape in which she is standing. As if in a trance, the

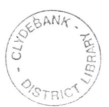
23

girl is reaching for the blossoms that are growing in front of her, while a dark, panther-like animal seems to be pouncing on her. However, everything around her is happening as if in a dream which promises happiness through the flowers of love and makes the branches soar up in ecstasy, while she simultaneously anticipates a threat to her happiness. It is by these means that Gauguin, through the world of feelings experienced by the natives, found his way to a new mythology which has its roots in the sensations felt by unsophisticated, naive people.

In NOA NOA, Gaugin describes the "simple life" of the South Sea natives. For Gauguin, their way of thinking and feeling, which is still closely related to their origin, becomes an ideal which he regards as being in sharp contrast to the decadent life of the over-civilized European cities.

"My neighbours have become friends to me. I eat and dress in the same way as they do. When I am not working, I share their life of simplicity and joy, a life which sometimes becomes abruptly very serious.

"In the evenings we congregate in groups at the foot of the bushy shrubs above which there rise the tousled tops of the coconut trees, or men and women, old people and children meet together.

"Things are improving for me day by day. I am now quite good at understanding the language of the Maoris and shall soon be able to speak it without difficulty. All my neighbours—three of whom live very nearby while many others are dispersed over a larger area—regard me as one of themselves.

"My feet have become hardened and accustomed to the ground as a result of continuous contact with the pebblestones. My almost perpetually naked body no longer suffers from the effects of the sun. Civilization is gradually falling away from me. I am beginning to think in a simple way, feeling only a little hatred towards my neighbour—in fact I love him rather than hate him.

"I am enjoying all the animal and human joys of life. I am free of all artificial constraint, all conventions and all habits. I am coming closer to truth and nature. Peace comes upon me in my certainty that tomorrow will be just as free and beautiful as today. I am developing normally and am not concerning myself with unprofitable things.

"I have gained a friend. He came to me of his own accord and I may be certain that it was not base self-interest that caused him to do so. He is one of my neighbours, a straightforward and very good-looking lad. My colour pictures and wood carvings aroused his curiosity, and my answers to his questions were instructive to him. Not a day passes on which he does not watch me painting or carving...

"Today, now that it was all such a long time ago, I still like to remember the true and genuine feelings which I aroused in this true and genuine nature.

"In the evenings, when I was resting after my work, we used to chat together. Being an inquisitive young savage, he used to ask me about European life and particularly about affairs of love, and his questions caused me embarrassment on more than one occasion. But his answers were even more naive than his questions.

"One day I gave him my tools and a piece of wood. I wanted him to try to do some carving. At first he looked at me in confused silence, then he gave the tools and wood back to me and said simply and guilelessly that I was not like the others, that I understood things of which other people were incapable and that I was useful to others.

"I believe that Jotéfa was the first person to say that to me. It was the language of a savage or of a child. Is it not a fact that one has to be one of these in order to believe that an artist is a human being?"

BIBLIOGRAPHY: Barth, W., "Paul Gauguin". Basle 1929. – Cogniat, R, "Gauguin, ses amis, l'école de Pont-Aven et l'académie Julian". Paris 1934. – Dorra, H., "The first Eves in Gauguin's Eden", in:

GAZETTE DES BEAUX ARTS, 1953. – v. Dovski, L., "Paul Gauguin". Paris 1948. – Gauguin, P., "Lettres de Gauguin à sa femme et à ses amis". Paris 1946. – Gauguin, P., "Lettres à Daniel Monfreid". Paris 1950. – Guérin, M., "L'Oeuvre gravé de Gauguin". Paris 1927. – Malingue, M., "Paul Gauguin". Paris, London, Toronto 1938. – id., "Gauguin's Drawings". New York 1958. – id., "Post–Impressionism". – Rotonchamp, J. de, "Paul Gauguin". Weimar and Paris 1925.

WORKS: Woodcuts, zincographs and lithographs, illustrations and vignettes for Noa-Noa, Le Sourire, Racontars d'un Rapin (1902), Avant et Après (1903 publ.).

◁ **Paul Gauguin**, Nave Nave Fenua. Colour woodcut. Reduced.

ARMAND SEGUIN

Armand Séguin, a painter and draughtsman, was born in Brittany in 1896 and died in Chateauneuf-du-Faou in 1903. He made the acquaintance of Gauguin in 1888; in the winter of 1889 he spent some time with him in Pont-Aven, which was also visited by Bernard, Sérusier, Mayer de Haan, Filiger and others. Gauguin introduced Séguin to the new painting style, and in 1889 Séguin took part in the exhibition held in the Café Volpini (Groupe impressioniste et synthétiste). In 1892/3 he was again in Pont-Aven where he again met Gauguin. In 1903 Séguin published a report on the artists in Pont-Aven in the magazine L'OCCIDENT. Because of his early death, Armand Séguin was unable to make the fullest use of his talents. In addition to his painted works, of which only a few examples have been preserved, his graphic works show an unprecedented sensitivity for linear means of expression. Séguin's line keeps almost exactly to a middle path between the decorative ornamentation of the later Art Nouveau on the one hand, and personal emotion on the other, When looking at his work, one is reminded of the discussions which were held in Pont-Aven and Pouldu and on which he himself reported in the artistic press. According to these reports, the new science of graphology, with its new insights into the symbolism of the line, was one of the main topics of converstion.

The introverted character of this artist, who was described as such even by his friends, can be seen in both the sheets which we are reproducing here. In the "Landscape by the sea", the onlooker can see a sudden impetuous movement

Armand Séguin, Landscape by the sea. 1893. Lithograph. 22.5×30.5 cm.

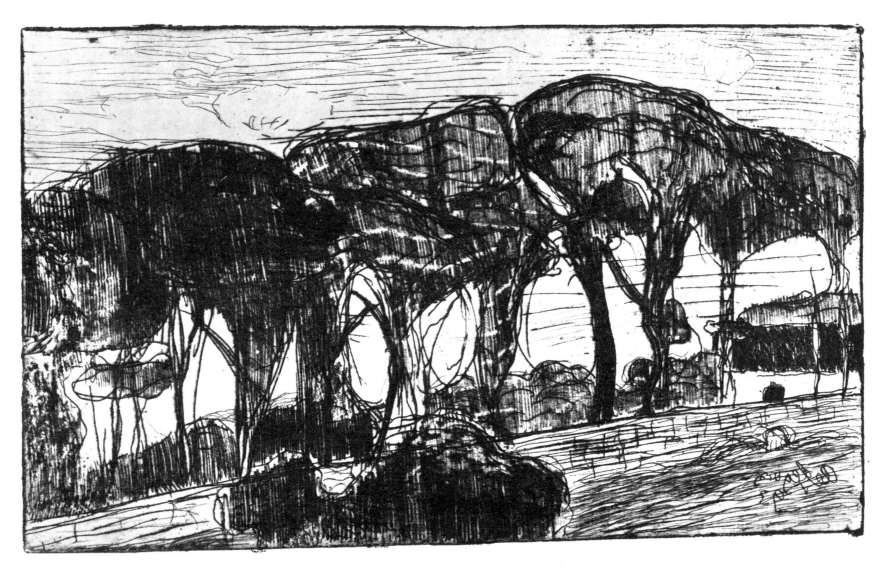

Armand Séguin, Avenue of trees. 1893. Etching. 18×30 cm.

reaching from the foreground to the swirling, tangling lines of the centre ground. Before the line of the beach is reached—a line which the artist repeats twice more in the parallels of the horizon and of the upper limit of the picture—this impetuous movement ebbs away and rather gives the impression of flowing back to its source. The far distance in the picture is like an insurmountable barrier which the artist does not even dare to tackle. In Séguin's picture depicting a landscape with trees, nearly all the action once again takes place in the centre ground whose formations quickly take over from the foreground and cause the background to become submerged. The group of trees, which rises from the left of the picture and which, after reaching its highest peak, suddenly sinks back into itself, has been depicted by the artist in similarly impulsive movements which, however, continually revert into themselves. If one imagines the picture as being the mirror image of itself, which is how the artist painted it, the inherent

pessimism becomes clearer still because, after rising up only briefly, the landscape sinks down again. These writing movements provide the graphologist with a clear image of the psychological landscapes experienced by the artist. It is no mere accident that the modelling of the lines is reminiscent of the graphic work of Munch, who probably saw these sheets by Séguin at Vollard's rooms. However, the present sheet keeps a masterly balance: the combined tree-tops are seen in relation to the glimpses through the trees, and the abrupt upwards shooting movement of the tree-trunks is expressed as a contrast to the manner in which their upwards motion ends in the leafy tops.

WORKS: Illustrations for "Gaspard de la Nuit" by Bertrand and for "Manfred" (incomplete), executed to a commission awarded by Vollard. Individual sheets (zincographs and lithographs) with landscape and human motifs taken from Brittany.

HENRI DE TOULOUSE-LAUTREC

Henri de Toulouse-Lautrec, a painter and graphic artist, was born in Albi on 24 November 1864 and died in Malromé on 9 September 1901. He came from one of the oldest and most famous French aristocratic families. In 1872 he went to the Lycée Concordet in France, which was also being attended by Maurice Joyant, with whom Toulouse-Lautrec later became friends, and who wrote the definitive biography of Toulouse-Lautrec. Between 1878 and 1879 he became permanently crippled as the result of two accidents, which had a decisive effect on his life. In 1880/81 he studied under the painters Princeteau, Bastien-Lepage and Lewis-Brown. From 1882 to 1883 he studied in the Bonnat studio, while from 1883 to 1887 Cormon was his teacher. In 1886 he met Van Gogh, Anquetin and Bernard, and the group of artists called "Ecole du Petit Boulevard" was created. Toulouse-Lautrec frequented the artistic cabarets of the Montmartre district, where he had also set up his studio. In 1889 he took a share for the first time in exhibitions given by the "Indépendants" and in the "Cercle Volnay". In 1890 he gave an exhibition and travelled to Brussels; it was in this year that he turned to lithography. In 1891 he painted "Moulin Rouge", his first important poster, and in 1892 he painted posters for Aristide Bruant. He gave an exhibition in the Galerie Goupil in 1893, while in 1894 he travelled to Brussels and London, had a share in the "Libre Esthétique" exhibition in Brussels and visited Henri van de Velde, and also published the Yvette Guilbert album.

In 1895 he travelled to Normandy, Lisbon, and visited London where he visited Oscar Wilde and Aubrey Beardsley. He also worked on the magazines LE RIRE and REVUE BLANCHE. He held an exhibition at Goupil's rooms in London in 1898. In 1899 he fell seriously ill and was taken to the Saint-James mental hospital in Neuilly. As a result of a campaign in the press, his friends had him released from the hospital after a few months, but his health deterioratd in 1901. Shortly before his death he arranged to be taken to his mother's residence in the Château Malromé where he died on 9 September at the age of thirty seven. He left a total of thirty two posters which influenced poster style not only in France, but in the whole of Europe. If Toulouse-Lautrec is regarded from the outset as being one of the chief exponents of Art Nouveau, the fact should not be overlooked that he was the artist who ignored the decorative rules which pinned down his imitators. From his earliest youth onwards he was as ice-cold an observer as he was a precise draughtsman. He knew how to use his resources economically and in the place where he needed them in order to achieve his effect. It was by these means that he avoided the caricature which featured in the pictures by his imitators. Thus he lent expression to the biting ballads of Aristide Bruant by giving an overlarge, dark shape to the coat which fills almost the entire surface of the picture and which has a shawl hanging over it like a hangman's bloody scarf; the sleeve is swinging like the lash of a whip. The singer and cabaret artist has turned his back, but is still looking back attentively to await the effect which he has achieved.

It was not least as a result of these posters that Bruant became immortal, and it is also believed that the singer and the painter needed one another: one one occasion when a cabaret owner refused to pay for Toulouse-Lautrec's expensive posters, the singer refused to appear in cabaret there.

BIBLIOGRAPHY: Adhémar, J., "Lautrec peintre graveur et Répertoire Lautrec dans Toulouse-Lautrec". Paris 1952. – AMOUR DE L'ART: Numéro spécial consacré à H. de Toulouse-Lautrec. April 1931 (Lautrec special issue). – Astre, A., "H. de Toulouse-Lautrec". Paris 1926. – Bellet, Ch., "Le Musée d'Albi". Albi 1951. – Bonmariage, A., "Henri de Toulouse-Lautrec". Paris 1926. – Bouret, J., "Toulouse-Lautrec, l'homme et son oeuvre". Paris 1964. – Catalogue de Musée d'Albi. Etabli par E. Julien. Albi 1939/1963. – Cain, J., "Préface du catalogue de l'exposition 'Oeuvre graphique de Toulouse-Lautrec'", Bibl. Nat. 1951. – Cooper, D., "Toulouse-Lautrec". Paris 1955. – Coquiot, G., "Toulouse-Lautrec". Paris 1913. Crespelle, J.-P., "Toulouse-Lautrec,

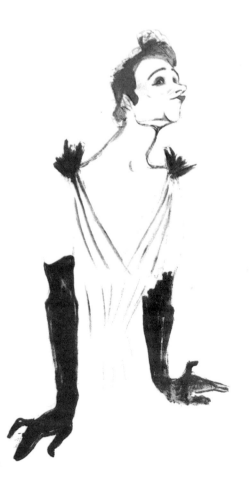

Henri de Toulouse-Lautrec, Yvette Guilbert. 1894. Watercolour. Design for a poster. 186×93 cm.

Henri de Toulouse-Lautrec, Poster for Aristide Bruant (text not ▷ printed). 1893. Lithograph. 65.6×48 cm.

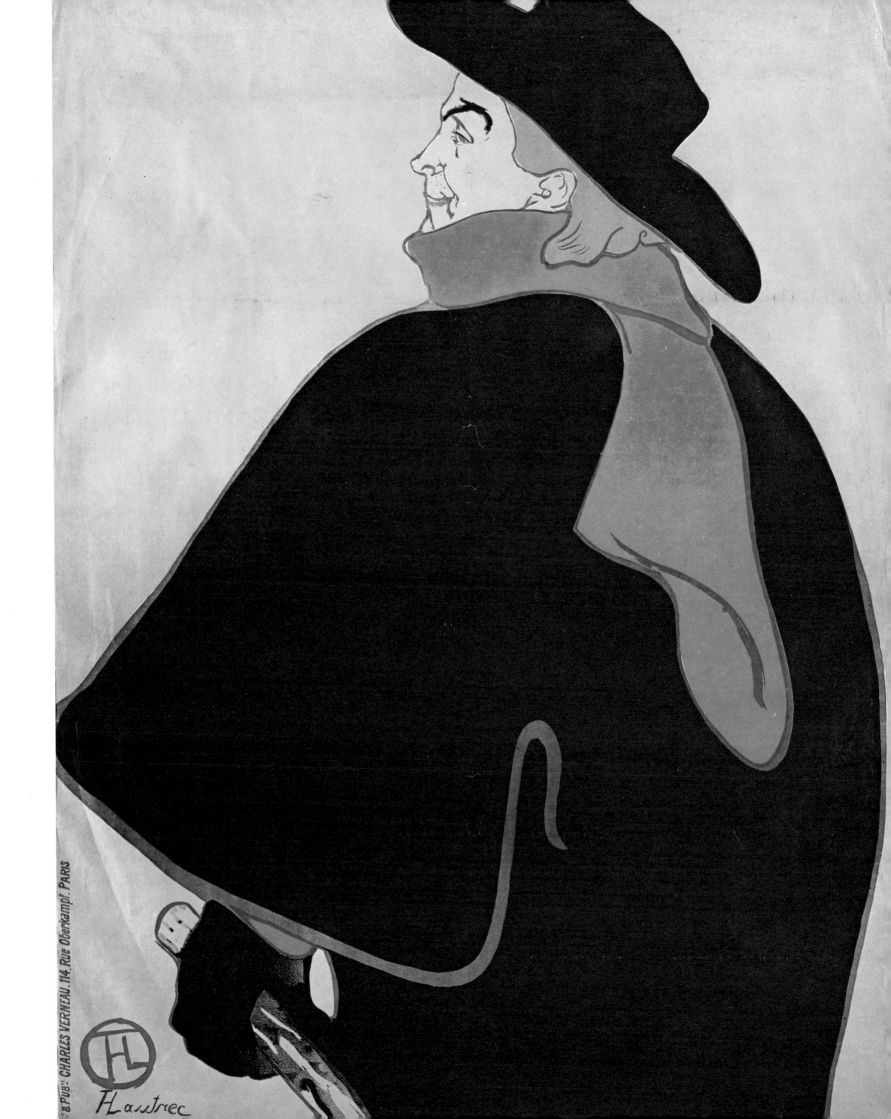

& PUB. CHARLES VERNEAU, 114, Rue Oberkampf, PARIS

HLautrec

feuilles d'études", Paris 1962. – Delaroche-Vernet-Henraux, M., "Toulouse-Lautrec dessinateur". Paris 1948. – Delteil, L., "Le peintre-graveur illustré". Vol. X/XI. Paris 1920. Complete catalogue of the printed graphic works of Toulouse-Lautrec. – Devoisins, L., " Henri de Toulouse-Lautrec; Albi 1955. – Dumont, H., "Lautrec". Paris 1949. – Duret, Th., "Lautrec". Paris 1920. – Esswein, H., "Toulouse-Lautrec". Munich 1904. – FIGARO ILLUSTRE: Numéro spécial: Le peintre Toulouse-Lautrec. April 1902. – Fosca, F., "Notices pour l'album Lautrec". Paris 1928. – Focillon, H., "Lautrec", in GAZETTE DES BEAUX ARTS, June 1931. – id., "Toulouse-Lautrec, Dessins". Geneva 1959. – Gauzi, F., "Lautrec et son temps". Paris 1954. – Gerstle, M., "Toulouse-Lautrec" (Engl. text) New York 1938. – Hanson, L. & E., "La vie tragique de Toulouse-Lautrec". Paris 1957. – Huisman, P., Dortu, M.G., "Lautrec par Lautrec". Lausanne/Paris 1964. – Jedlicka, G., "Henri Toulouse-Lautrec". Berlin 1929, 2nd edition 1943. – Jourdan, F., "Toulouse-Lautrec". Lausanne 1948. – Joyant, M., "Henri de Toulouse-Lautrec, peintre". Paris 1926. – id., "Henri de Toulouse-Lautrec, Dessins, Estampes, Affiches". Paris 1926. – Julien, E., "Dessins de Toulouse-Lautrec". 1950. – id., "Les affiches de Toulouse-Lautrec". 1951. – id., "Lautrec, vu par ses contemporains", 1951. – id., "Toulouse-Lautrec, Au Cirque". 1956. – id., "Toulouse-Lautrec". Paris 1959. – Kern, W., "Toulouse-Lautrec". Berne 1948. – Landholt, H., "Toulouse-Lautrec. Farbige Zeichnungen". Basle 1954. – Lapparent, P. de, "Toulouse-Lautrec". Paris 1927. – Larpade, J. de, "Lautrec". Paris 1951. – Lassaigne, J., "Toulouse- Lautrec, Paris 1939 (with detailed bibliography). – id., "Toulouse Lautrec, Coll. Le goût de notre temps. Geneva 1953. – La Tourette, G. de, "Toulouse-Lautrec. Paris 1939. – Leclercq, P., "Autour de Toulouse-Lautrec". Paris 1920. 2nd edition Geneva 1954. – Leonardo, B., "Toulouse-Lautrec". Milan 1945. – MacOrlan, P., "Toulouse-Lautrec, peintre de la lumière froide". Paris 1934. – Roger-Marx, C., "Les lithographies de Toulouse-Lautrec". Paris 1948. – id., "Toulouse-Lautrec", Coll. Témoins du XXᵉ siècle. Paris 1957. – Rotzler, W., "Affiches de Henri de Toulouse-Lautrec". Basle 1946. – Schaub-Koch, E., "Psychoanalyse d'un peintre moderne: Henri de Toulouse-Lautrec". Paris 1935. – Symons, A.: From Toulouse-Lautrec to Rodin. London 1929. – List of the most important exhibitions in the catalogue of the Musée Albi, 1963.

WORKS: Among other activities, he worked on the magazines LE RIRE and REVUE BLANCHE (Nib.). – Posters for Moulin Rouge, Aristide Bruant, May Belfort, Mlle. Lender, Yvette Guilbert, Revue Blanche, Divan Japonais. Series of coloured lithographs "Yvette Guilbert" (16 sheets, 1894) and "Elles" (11 sheets, 1896). – Individual sheets, theatre programmes, menu cards. – Illustrated books: Clemenceau, Au Pied du Sinai. 1898. – Goffroy, G.: Le plaisir de Paris. 1893. – Goncourt, E. de: La Fille Elisa. Paris 1931, facsimile edition in accordance with a design left to posterity by the artist. – Renard, J.: Histoires Naturelles. 1899.

PAUL SERUSIER

Paul Sérusier, a painter and draughtsman, was born in Paris in 1863 and died in Morlaix (Huelgoat, Brittany) on 6 October 1927. He first attended the Licée Concordet, and from 1886 onwards he studied under Lefebre at the Académie Julian in Paris; he was the best pupil at the "little studio" in the Rue de Fauberg St. Denis. In 1888 he travelled to Brittany where he made the acquaintance of Bernard and Gauguin. Under the latter's instruction, Sérusier painted a small landscape above Pont-Aven; Sérusier took this picture to the Nabis in Paris as a message from Gauguin, and they called it "Le Talisman". After returning to Paris, Sérusier introduced his friends, the Nabis, to the new developments in painting. In 1889/90 he spent some more time in Brittany and again met with Gauguin, Laval and Meyer de Haan.

Sérusier and Denis were the theorists of the Nabi group in Paris. Sérusier studied intensively in the fields of philosophy, theosophy and theology. He spent some summers during the next few years in Huelgoat in Brittany. In 1891 he met Jan Verkade, who later entered the Benedictine monastery of Beuron and became a leading personality in the school of painting there. Sérusier worked on decorations for the "Théâtre d'Art" and the "Théâtre Libre" and had a share in the Nabis' first exhibition in the Galerie le Barc de Boutteville. In 1893 he went on a trip to Italy with Bernard and there worked at the "Théâtre de l'Oeuvre". He made further trips to Italy with Denis in 1895 and 1899. In 1895 he went to Prague where he saw Verkade and in 1897 and 1890 he visited him at the Beuron monastery, where Verkade introduced him to the teachings of the Beuron school. In 1903 he moved to Chateauneuf-du-Faou in Brittany. He made another trip to Italy with Denis in 1904, visiting Rome and Monte Cassino. In 1908 Sérusier began teaching at the Académie Ranson in Paris, while from 1914 onwards he led a solitary life in Brittany. In 1921 his book "L'ABC de la Peinture" appeared, in which he expounded his artistic theories.

The sheet reproduced here is typical of this artist's early period after his first meetings with the Pont-Aven group. He created folk scenes depicting peasant women and market women in the new silhouette-like style, but the artist made no attempt to ensure that there was a strict and programmed coherence between the lines. As a result, his sheets are more draughtsmanlike and relaxed, preserving more of the Impressionist view of objects than those created by his friends. This artist later turned to fabulous and fairy-tale subjects which he drew from Breton tradition.

BIBLIOGRAPHY: Denis, M., "Paul Sérusier, sa vie, son oeuvre". 1942.

Paul Sérusier, Market woman. 1889/90. Lithograph. 22×13.6 cm. ▷

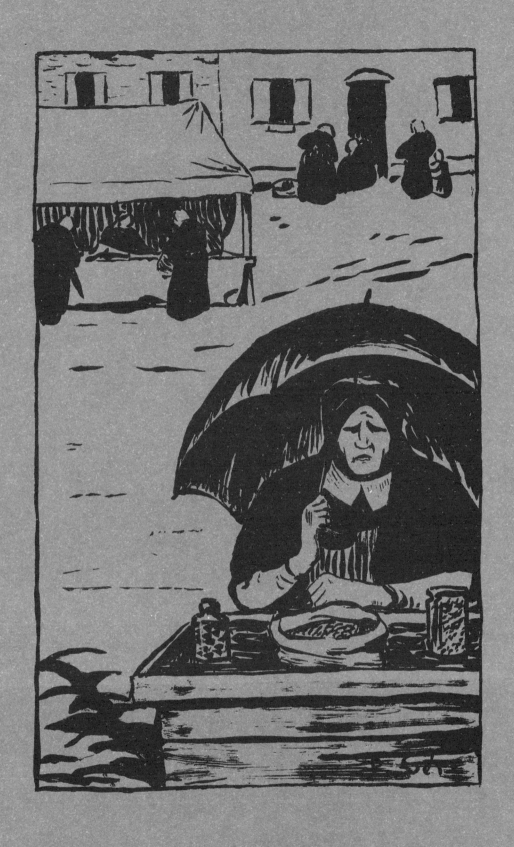

MAURICE DENIS

Maurice Denis, a painter, draughtsman and writer, was born in Grandville (Manche) in 1870 and died in Paris in 1943. He spent his childhood in Saint-Germain-en-Laye. Attended the Lycée Concordet in Paris from 1881 to 1885, and Vuillard, Roussel and Lugné-Poë were among his schoolfellows there. In 1888 he entered the Académie des Beaux Arts as the pupil of Gustave Moreau and also became a member of the Académie Julien, where he met Bernard, Bonnard, Ranson and Sérusier. He became friends with Sérusier, who introduced him to the Pont-Aven group and the Nabis. Along with Sérusier, Denis was the spokesman and theorist of the Nabi group. He took a share in the exhibition in the Café Volpini in 1889; in 1890 he published an article on the aesthetics of the Nabis; and in 1891 he shared a studio with Bonnard, Lugné-Poë and Vuillard. In 1892 and 1893 he designed some stage scenery and decorations for the "Théâtre d'Art" and the "Théâtre de l'Oeuvre". From 1894 onwards he obtained some large commissions to carry out theatre decorations. In 1895 he made his first trip to Italy and in 1897 he travelled to Rome with André Gide. In 1903, together with Sérusier, he visited P. Willibrod Verkade at the Beuron monastery; in 1905 he travelled to Spain. In 1906, together with Emile Bernard and K.X. Roussel, he visited Cézanne in AixProvence (Denis had painted the picture "Hommage à Cézanne" in 1901). He went to Germany in 1907 and spent some further periods in Italy during 1907-8. In 1909 he travelled to Russia. He published his "Théories" in 1912; in 1913 he created the decorations for the "Théâtre des Champs-Elysées"; in 1914 he carried out paintings in the apse of St. Paul's Church in Geneva; and in 1917 he did some stained glass for the Notre Dame church in Geneva. Together with Desvallières, Denis founded the "Ateliers d'Art Sacré" in Paris in 1919. The "Nouvelles Théories" were published in 1921. In 1927/8 he went to Canada and the USA. As a result of an accident he died in Paris in 1943. In the years preceding his death, Denis led a solitary, almost monastic life.

It is in the works of Maurice Denis that the real trends of the art of the Nabis finds its strongest expression. These Parisian artists were more sensitive than the painters of the Pont-Aven group; unlike the Pont-Aven artists, the Nabi group did not pass through the Impressionist school. The literary and academic training, which absorbed some special influences from the emotional art of the English Pre-Raphaelites, is noticeable in all the works created by the Nabis. The choice of colours in the works reproduced here is characteristic of Denis: the colour tones harmonize delicately with one another and lend expression to a certain soft feeling about the persons depicted. Even in the sheet which must almost be regarded as a black and white drawing, Denis selects a clay-coloured background and prints the drawing in dark blue. His people are portrayed in a flexible and sensitive style. The main figure in these depictions, which is almost always dominant, is shown with a large round face, defined by delicate draughtmanship, and shows the clearly identifiable features of Denis's wife.

BIBLIOGRAPHY: Barazzetti, S., "Maurice Denis". Paris 1945 (with detailed bibliography). – Brillant, M., "Maurice Denis". Paris 1945. – Fosca, F., "Maurice Denis et son oeuvre". Paris 1924. – Jamot, P., Maurice Denis. Paris 1945.

EXHIBITIONS: Maurice Denis. Clemens-Sels-Museum Neuß, 1954. – Maurice Denis, Galleria del Levante, Munich 1966.

WORKS: Colour lithographs, among them the "Amour" series of 1899 (Vollard). Illustrated books, particularly 'Sagesse' by P. Verlaine, 72 coloured woodcuts dated 1889 (published in 1911), 216 woodcuts for "L'Imitation de Jésus Christ", 1903 (Vollard), "Le Voyage d'Urien" by André Gide, 1893, "Dénis au Vesinet" by Désfosses, 1903. "Fioretti" – Petites Fleurs de Saint François d'Assise, traduites de l'italien par André Peraté, woodcuts, 1913.

Maurice Denis, Martha. Woodcut. Enlarged.

Maurice Denis, Les attitudes sont faciles et chastes, from the series ▷ "Amour". Ed. Vollard 1898. Colour lithograph. 37.9×27.6 cm.

Les altitudes sont faciles et chastes

PAUL RANSON

Maurice Denis, Girl's head, Lithograph. 14.1×8.2 cm.

Paul Ranson, a painter, draughtsman and craft designer, was born in Limoges in 1862 and died in Paris on 20 February 1909. In 1884 he studied at the Ecole des Beaux Arts in Limoges, while from 1888 onwards he was a student at the Académie Julian in Paris. It was here that Ranson made the acquaintance of Sérusier, Denis, Bonnard, Ibels and others and he became a founder member of the Nabi group. From 1890 onwards, his studio in the Boulevard de Montparnasse was the meeting place for this group, and became known as its "temple". Discussion evenings, music evenings, puppet theatre performances, etc., were held here. Ranson was also a member of the "Symbolistes" and the "Indépendants", and some of his work was influenced by Gauguin. He created theatrical decorations for the Théâtre de l'Art, and designed tapestries which his wife then wove. He worked on the REVUE BLANCHE. His book "L'Abbé Prout, guignol pour les vieux enfants", which he illustrated, was published by MERCURE DE FRANCE in 1902. Ranson founded a painting school in Paris in 1908. This was the Académie Ranson, where Bonnard, Denis, Maillol, Roussel, Vallotton and Van Rysselberghe were all teachers. After his death in 1909 the work of the Académie was continued by his wife. Like his painter friends Sérusier and Denis, Ranson also worked in the sensitive Nabi style. Similarly to those of Denis, Ranson's motifs are often women in trailing garments walking across parklike landscapes. The scene of this type which is shown in the sheet reproduced here is a clear example of one of the main tendencies of the early French Art Nouveau: this is the monochromatic colouration which Emile Bernard and Louis Anquétin preferred. In harmony with the white of the paper, the colours are structured as nuances of a chord consisting of yellow, green and olive. This chord strikes a sentimental tone and finds an echo in the outlines of the human figures and in the lines of the natural objects depicted. In the initials on the picture depicting the life of Mary, on the other hand, another of the components can be seen which gave a stimulus to Art Nouveau. This consists of the twisting dragon shapes of Chinese and Japanese art, whose motifs form ornaments that are linked together within themselves. There is something of a comic caricature about the way in which the two sea monsters are shrinking back in fear when faced by the little child on the shore.

BIBLIOGRAPHY: Denis, M., "Paul Ranson". in: "Théories". Paris 1920. –

EXHIBITIONS: Paul Ranson – Erste Retrospektiv-Ausstellung. Galleria del Levante Munich, Catalogue No. 25, June 1967. Introduction to catalogue by Patrick Waldberg.

WORKS: He worked on the REVUE BLANCHE: lithographs and vignettes. Illustrations for his book "L'Abbé Prout, guignol pour les vieux enfants". 1902. – Illuminated letters for a Life of the Virgin Mary.

Paul Ranson, Sadness. Colour lithograph. 23×17.8 cm. ▷

HENRI-GABRIEL IBELS

Henri-Gabriel Ibels, a painter and graphic artist, was born in Paris on 30 December 1867 and died in Paris in 1936. He was self-taught initially, but then attended the Académie Julian in Paris in 1889; he made the acquaintance of the Nabis and joined their group. In 1892, together with Toulouse-Lautrec, some Neo-Impressionists and various Nabis, he took part in an exhibition held in the rooms of Le Barc de Boutteville in Paris. He created not only designs for the theatre, but also programmes for the "Théâtre Libre" and the "Théâtre de l'Art". In 1893 he gave an exhibition in the reception room of the magazine LA PLUME, and in 1894 he took part in the exhibition held in the Salon du Champs de Mars. In 1898/99, at the time of the Dreyfus affair, Ibels published the political-satirical magazine LE SIFFLET.

The work reproduced here shows Ibels as having completely absorbed the artistic spirit of Toulouse-Lautrec; this is usually the case in Ibel's work. He created many motifs based on the world of the theatre. In doing so he always showed penetration by using his keen power of observation, which had been trained to observe differing human forms, in order to express the stage characters of the actors and their different portrayals. He was probably one of the few French artists to adhere so closely to the traditional vanishing perspective. As a result, there was often an inevitable slight discrepancy between the expanded space and the stylized, silhouette-like human figures. In these sheets the onlooker can also sense Ibels's love for Degas's work, whose example he followed.

BIBLIOGRAPHY: Saunier, Ch., "Henri-Gabriel Ibels", in LA PLUME No. 91, 1893.

WORKS: In 1893, together with Toulouse-Lautrec, he worked on the "Le Café-Concert" portfolio of lithographs; he worked on the magazines LA REVUE BLANCHE, L'ESCARMOUCHE and LE SIFFLET.

Henri-Gabriel Ibels, Scene on stage, from the series "Le Café Concert". 1893. Lithograph.

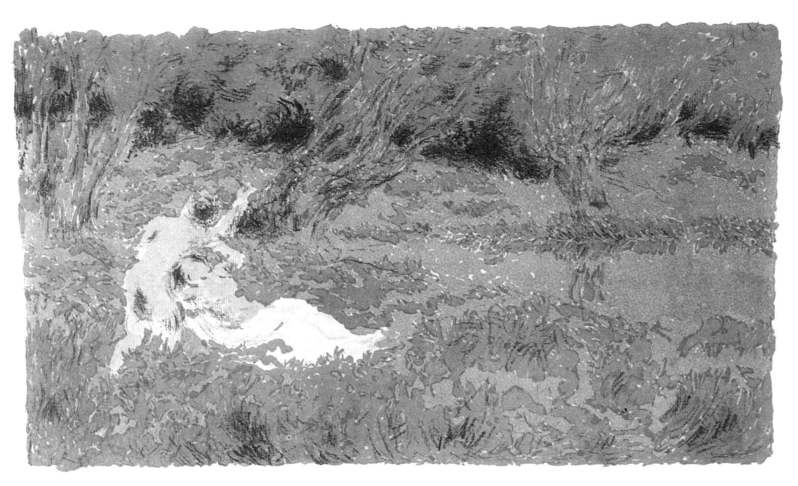

Ker-Xavier Roussel, Landscape with two girls, from "L'Album de Paysage". Vollard Album No 9, 1899. Colour lithograph 22.5 × 38.6 cm.

KER-XAVIER ROUSSEL

Ker-Xavier Roussel, a painter and draughtsman, was born in Chène (Lorry-les-Metz) on 10 December 1867, and died in L'Etang-la-Ville on 5/6 June 1944. From 1883 on he attended the Lycée Concordet together with Lugné-Poë and Vuillard, with whom he soon commenced a lifelong friendship. Roussel and Vuillard became pupils at the Maillard studio in 1887. From 1888 onwards Roussel studied at the Académie Julian where he met the painters of the Nabi group and joined their membership. In 1891 he shared in the Nabis' first exhibition in the gallery of Le Barc de Boutteville. From 1893 onwards he worked on the REVUE BLANCHE. He married Vuillard's sister. In 1903 he gave an exhibition in the Galerie Druet with Bonnard, Denis and Sérusier. Together with Denis, he visited Paul Cézanne in AixProvence in 1906. In 1908 he became a teacher at the Académie Ranson. His decorations for the "Théâtre des Champs-Elysées" were created in 1911-13. Roussel spent the years from 1914-18 in Switzerland, where he painted the staircase at the Winterthur Art Museum. Roussel was awarded the Carnegie prize in 1926. In the following years he produced some large-scale decorations, some of them for the Palais Chaillot and for the Palace of the League of Nations in Geneva. In 1941 Roussel arranged for the "Donation Vuillard" to be awarded to the Musée d'Art Moderne, Paris.

In his works, Roussel achieved a peculiar but successful combination between the after-effects of Impressionism on the one hand and the unreal fantasy world of the Nabi group on the other. His semi-bucolic, semi-mythological scenes give the impression of his having observed them directly from nature. An odd feature of his work is his manner of bunching groups of Impressionist-style pen-strokes together and arranging them in flowing compositions.

Pierre Bonnard, Illustration for "Daphnis and Chloé" by Longus. Ed. Vollard 1902. Lithograph.

BIBLIOGRAPHY: Cousturier, Lucie, "K.-X. Roussel". Paris 1924. – Fargue, L.-P., "K.-X. Roussel, Catalogue of the Galerie Charpentier", Paris 1947. – Werth, Léon, "K.-X. Roussel", Paris 1930.

EXHIBITIONS: Ker-Xavier Roussel. Galerie Maratier, Paris 1944. Ker-Xavier Roussel. Galerie Charpentier, Paris 1947. – Roussel, Bonnard, Vuillard. Marlborough Gallery, London 1954. – Bonnard, Roussel, Vuillard. Galerie Huguette Berès, Paris 1957. – Bonnard, Roussel, Vuillard. Modern Arts Galerie Munich 1959. – K.-X. Roussel. Wildenstein London 1964 (Catalogue with articles by J. Salomon and D. Sutton). – K.-X. Roussel. Kunsthalle Bremen 1965 (with articles by Günter Busch, Jacques Salomon, Arsène Alexandre, Cl. Roger-Marx and a list of the graphic works by C. v. Heusinger). Edouard Vuillard, Xavier Roussel. Haus der Kunst, Munich 1968; Orangerie des Tuileries, Paris 1968 (Catalogue).

WORKS: Mainly lithographs, among them: Five sketches (Cinq sujets) around 1893. – Ten sketches (Dix sujets) around 1893. – The education of a dog, 1893. – Two women in the wood, 1894 (published in the "Dépêche de Toulouse exhibition catalogue", illustrated with 17 original lithographs). – L'Album de Paysage, 1899. Series of 12 coloured lithographs (planned by A. Vollard, but not edited). – Nymphs in a landscape (Album Vollard No. 9). – Two girls by the water (Album Vollard No. 12). – In addition: etchings, and also work on the REVUE BLANCHE.

PIERRE BONNARD

Pierre Bonnard was born in Fontenay-aux-Roses in 1867 and died in Le Cannet in 1947. He worked as a painter and draughtsman. He studied law from 1885 to 1888, and passed his junior legal partner's examinations. In 1888 he studied at the Académie Julian and at the Ecole des Beaux-Arts. He made friends with Sérusier, Denis, Ranson, Vallotton and Vuillard. He became a founder member of the Nabi group in 1889. Bonnard sold his first poster (France-Champagne) and then devoted himself entirely to painting. In 1890 he shared a studio with Denis and Vuillard. In 1891 he gave an exhibition with the Nabis in the gallery of Le Barc de Boutteville. He made the acquaintance of Toulouse-Lautrec. In 1892 Bonnard exhibited two paintings at the rooms of the "Indépendants". In 1893 he published his first lithographs in REVUE BLANCHE, and also created theatre sets and designed costumes for the Théâtre de l'Oeuvre, which had been designed by Lugné-Poë. He made the acquaintance of Vollard. In 1896 he gave his first one-man exhibition in the rooms of Durand-Ruel, displaying paintings, posters and lithographs. In 1898 he created the puppets for a performance of Jarry's "Ubu-Roi" at the "Théâtre des Pantins". In 1903 he contributed three paintings to the first Salon d'Automne and to the Viennese Secession. From 1907 to 1911 he travelled in Belgium, Holland, England, Italy, Spain and Tunisia. He refused the Légion d'honneur in 1912. In 1913 he went to England with Vuillard. He gave a large number of exhibitions in Europe from about 1911 onwards. In 1918 he became the Honorary President of the group called "Jeune peinture française". In 1923 he was awarded the Carnegie prize in Pittsburgh. A large retrospective exhibition of Bonnard's works was held in the Galerie Druet in Paris in 1924. In 1925 he acquired a house in Cannet near Cannes. In 1926 he went to the USA and became a member of the Carnegie Jury. From 1932 to 1938 he visited Deauville and Trouville in the summer months. In 1936 Bonnard was awarded the Carnegie prize for a second time. A retrospective exhibition of his work was given in the rooms of Bernheim-Jeune in 1946.

The lithograph by Bonnard which is reproduced here is more closely related to his posters than to his paintings, which became very rapidly transformed from the strict "cloisonnist" style of the early works into a cultivated pictorial conception that no longer tolerated any strict limitations and was based purely on colour. In these works, everything remains open, full of desire for movement, and dynamically rhythmical. The silhouette of the girl, which is tilted to the right and is thus urging itself forwards, almost gives the impression of a collage; the heavy laundry basket and the large umbrella are in moving contrast to this.

Pierre Bonnard, The little laundry carrier. 1896. Colour lithograph. ▷ 29.2×20 cm.

Pierre Bonnard, Illustration for "Marie" by Peter Nansen. Publ. La Revue Blanche, 1898. Lithograph. About original size.

BIBLIOGRAPHY: Beer, F.-J., "Pierre Bonnard". Marseille 1947. – Besson, G., "Pierre Bonnard". Paris 1934. – Coquiot, G., "Bonnard". Paris 1922. – Courthion, P., "Bonnard, peintre du merveilleux". Lausanne 1945. – Cousturir, L., "Pierre Bonnard", in L'ART DECORATIF, Paris 1912, pp. 367. – Fontainas, A., "Bonnard". Paris 1928. – Fosca, B., "Bonnard". Paris, Geneva 1919. – Jedlicka, G., "Pierre Bonnard. Ein Besuch". Erlenbach-Zurich 1949. – Jourdan, F., "Pierre Bonnard, ou les vertus de la liberté". Geneva 1946. – Laprade, J. de, "Bonnard". (Couleur des Maîtres). Paris, Lyon 1944. – Lhote, A., "Bonnard"; 16 peintures 1939–1043. Paris 1944. – Natanson, Th., "Le Bonnard que je propose". Geneva 1951. – Rewald, J., "Pierre Bonnard". New York 1948 (Catalogue of the Bonnard Exhibition, Museum of Modern Art. containing a detailed bibliography on the artist up until 1948, compiled by B. Karpel). – Raynal, M., "Histoire de la peinture moderne. De Baudelaire à Bonnard". Geneva 1949. – Roger-Marx, C., "Pierre Bonnard", in NOUVELLE REVUE FRANCAISE, Paris 1924. – id., "Pierre Bonnard". Paris 1950. – id., "Bonnard, lithographie". Monte Carlo 1952. – Rumpel, H., "Bonnard". Berne 1952. – Terasse, Ch., "Bonnard". Paris 1927. Avec: Essai de catalogue de l'oeuvre gravé par J. Floury. – Vaillant, Anette, "Pierre Bonnard". Neuchâtel 1965, Munich 1966. – Werth, L., "Bonnard". Paris 1923 (first edition 1919). Bonnard, Pierre, Correspondances. Paris 1944. – Bonnard-Mappe. 23 plates (L'Art d'aujourd'hui) Paris 1927. – Bonnard. Special issue LE POINT. Lanzac 1943/XXIV. – Pierre Bonnard. Special issue FORMES ET COULEURS. Lausanne 1944/II. – Couleur de Bonnard. Special issue VERVE. Paris 1947.

EXHIBITIONS: Pierre Bonnard, New York and Cleveland 1948. – Pierre Bonnard, Musée Boymans, Rotterdam 1953. – Pierre Bonnard, Musée de Lyon 1954. – Bonnard, Vuillard et les Nabis. Paris 1955. – Pierre Bonnard, Kunsthalle Basle 1955. – Die Nabis und ihre Freunde, Kunsthalle Mannheim 1964. – Pierre Bonnard, Munich and Paris 1966/1967.

WORKS: Posters, including: La Revue Blanche, 1894, Le Salon des Cents, 1896. Lithographs. – illustrated books: in particular, Claude Terrasse, "Petites scènes familières", 1893. – Claude Terrasse, "Le Petit Solfège", 1893. – Peter Nansen, "Marie" (Editions de La Revue Blanche), 1898. – Alfred Jarry, "Petit Almanach du Père Ubu", 1899. – Paul Verlaine, "Parallèlement. (Vollard) 1900. – Alfred Jarry, "Grand Almanach du Père Ubu" (XXᵉ siècle), 1901. – Longus, "Dapnis et Chloé. (Vollard) 1902. – Jules Renard, 'Histoires naturelles. 1904. – Octave Mirbeau, "La 628 – E 8", 1908. – Victor Barrucand, "D'un pays plus beau," 1910. – "Quelques aspects de la vie de Paris", 1899. Published by A. Vollard, Paris 1899, title page and 12 lithographs.

EDOUARD VUILLARD

Edouard Vuillard was born in Cuiseaux (Saône et Loire) on 11 November 1868 and died in Paris on 21 June 1940. He worked as a painter and draughtsman. From 1877 onwards he was in Paris. He attended the Lycée Concordet together with Roussel and others. He began by preparing for a military career. In 1888 he entered the Académie Julian and attended the Ecole des Beaux-Arts. He was on friendly terms with Bonnard and Sérusier. He joined the Nabi group in 1889. In 1891 he gave a small exhibition in the rooms of the REVUE BLANCHE. He shared a studio with Denis, Bonnard and Lugné-Poë. In 1892, together with some other Nabis, he gave an exhibition in the rooms of Le Barc de Boutteville. In 1893 he had a share in founding the "Théâtre de l'Oeuvre", and produced the designs for Ibsen's "Rosmersholm". He continued work on theatrical designs from 1894 to 1900. From 1908 onwards he taught at the Académie Ranson. From 1903 to 1914 he paid summer visits to Brittany and Normandy. In 1913 he travelled with Bonnard to Holland and England. He created decorations for the "Théâtre des Champs-Elysées". In the period from 1925 to 1937 he received several commissions to paint portraits; he executed portraits of his friends, Denis, Bonnard, Roussel, Maillol and others. In 1938 he created decorations for the Palais Chaillot, and in 1939 for the Palace of the League of Nations in Geneva. He became a member of L'Institut de France in 1938.

Edouard Vuillard, La partie de dames, from "Paysages et Intérieurs". ▷ Publ. Vollard 1899. Colour lithograph, third and final stage. 34 × 26.5 cm.

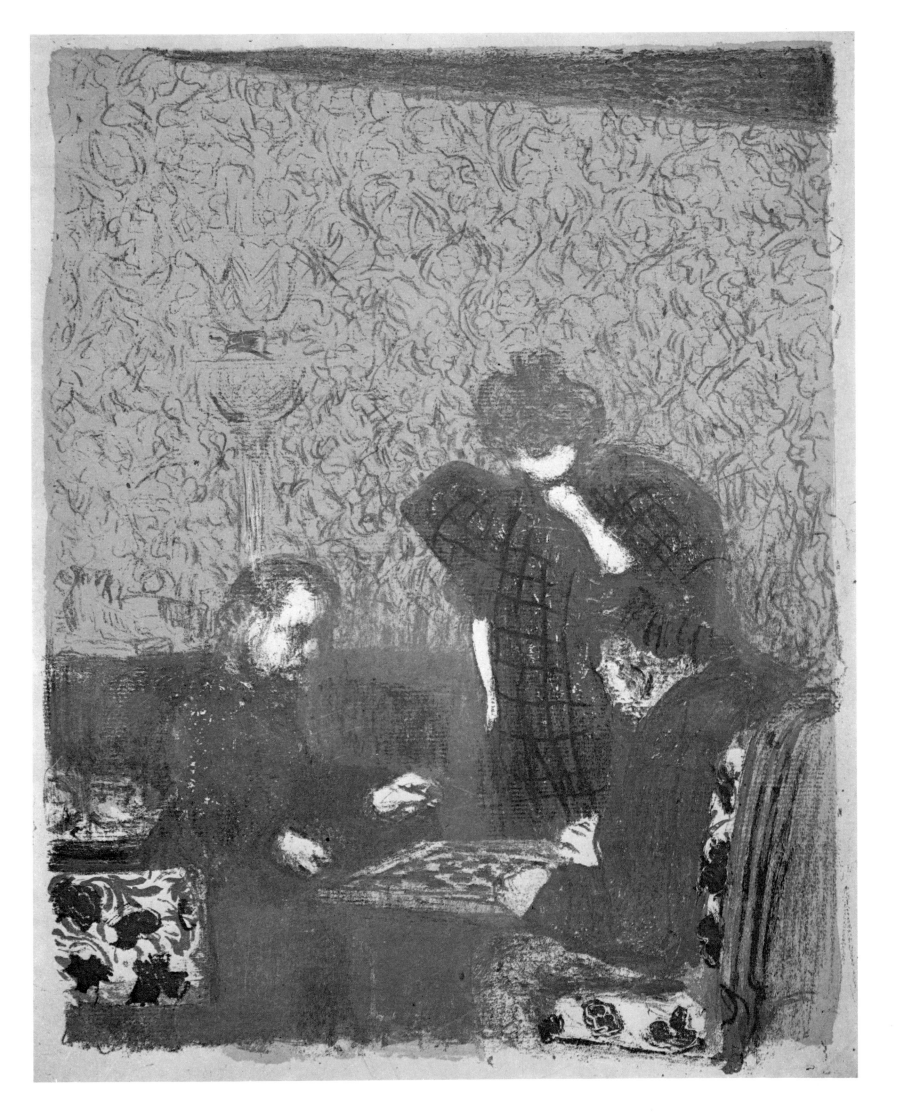

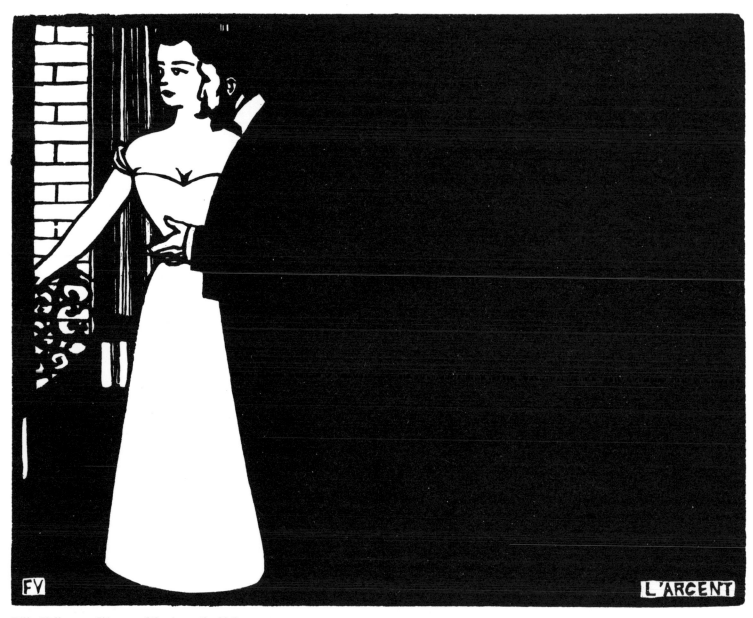

Félix Vallotton, L'Argent. Woodcut. 18×22.5 cm.

Printed graphic art was another area in which Vuillard showed himself to be a master of the intimate interior. His treatment of colour fills these interiors with an atmosphere which is clearly conveyed to the onlooker. Monochromatic colouring was being used with increasing frequency in Art Nouveau and it played a leading role in these works by Vuillard as well: the dominant chord is struck by a reddish-violet tone with a few complementary shades of green. The scene shown in this intimate atmosphere comes from the salon of Misia Sert, whose standing figure is watching the two draughts players; the player on the left has been identified as Tristan Bernard.

BIBLIOGRAPHY: Cahier de dessins. Préface de Annette Vaillant. Notices de J. Salomon. Quatre Chemins, Paris 1950. – Chastel, A., "Vuillard", Paris 1946. – Hepp, P., "Edouard Vuillard", 1912. – Marguery, H., "Les Lithographies de Vuillard", 1935. – Roger-Marx, C., "L'Oeuvre gravé de Vuillard", 1948. – Roger-Marx, C., "Vuillard et son temps", 1945. – Salomon, J., "Vuillard", 1945. – Salomon, J., "Auprès de Vuillard", 1953. – Sweicher, C., "Die Bildraumgestaltung, das Dekorative und das Ornamentale im Werke von Edouard Vuillard". Diss. Phil. I. Zurich. Trier 1949. Edouard Vuillard, Xavier Roussel. Haus der Kunst, Munich 1968; Orangerie des Tuileries, Paris 1968 (Catalogue).

WORKS: Contribution to the REVUE BLANCHE, numerous lithographs.

FELIX VALLOTTON

Félix Vallotton, a painter and draughtsman, was born in Lausanne on 28 December 1865 and died in Paris on 29 December 1925. From 1882 to 1885 he studied under Boulanger and Lefebre at the Académie Julian in Paris, and also pursued studies at the Ecole des Beaux-Arts. In 1885 he took part for the first time in an exhibition, held at the salon of the Société des Artistes Français. In 1889 he travelled to Austria and Italy and made friends with the painters Cottet and Maurin. He worked part-time for a restaurant owner. During his studies Vallotton was engaged in making copies from paintings in the Louvre, chiefly the works of Holbein, da Messina, da Vinci and Dürer. He then turned to graphic art, particularly woodcuts. From 1891 to 1893 he wrote art reviews for the GAZETTE DE LAUSANNE. He worked on the REVUE BLANCHE in Paris from 1894 to 1903. He had a share in the first exhibition held in the Salon de la Rose-Croix in 1892, at which Hodler's works were also shown. Rousseau showed enthusiasm for Vallotton's pictures. Vallotton was on friendly terms with the painters of the Nabi group. In 1899 Vallotton married Gabrielle Bernheim-Jeune (her widowed name was Rodrigues-Henriques), and in 1900 he became a naturalized Frenchman. In 1901 he spent some time in Marseilles, Cannes, Nice and Honfleur. In 1902, together with Bonnard, Vuillard, Denis, Roussel, Maillol and others, Vallotton took part in the exhibition held in Paris in the rooms of Bernheim-Jeune, his brother-in-law. Also in 1902 he took part in the exhibition in the Salon des Indépendants. In addition, Vallotton was a member of the Founders' Committee of the "Salon d'Automne". His first group picture, "Les cinq peintres" (Bonnard, Vuillard, Roussel, Cottet and Vallotton), was exhibited in the first "Salon d'Automne" in 1903. In 1904 he paid a summer visit to Honfleur. The première of his play, "L'Homme Fort", was held in the Théâtre Grand Guignol in 1908. He taught at the Académie Ranson. He first met the Hahnloser family when on a journey to Switzerland. Vallotton's first exhibition in Switzerland was held in Zurich in 1910. Vallotton was strongly critized in Switzerland, and young girls were not admitted to his exhibition. In 1913 he travelled to Russia, Germany and Italy. He visited the front at Verdun in 1917 and created his series of war pictures. He was in Cagnes in 1921 and 1922. The artists of western Switzerland organized a retrospective exhibition in Lausanne in 1925. In 1927, two years after his death, his autobiographical novel, "La vie meurtrière", was published in LE MERCURE DE FRANCE. In 1965, on the occasion of his centenary, the Kunsthaus in Zurich organized the largest Vallotton exhibition held to date.

Felix Vallotton's graphic works are far more expressive than his paintings. He played an important part in the development of modern wood-engraving. He was consistent in separating his design into surfaces of pure black and white. On the other hand, he gave very sharp characteristics to the object being depicted, and did so by representing the object in outline or silhouette shape. This sharpening technique, which often makes a grotesque impression, corresponds to a pessimistic attitude adopted by the artist, who was in the habit of commentating critically upon his environment without attacking it directly. Laconically formal picture captions draw attention to seemingly unalterable sets of circumstances. His artistry became known all over Europe as a result of his work on the REVUE BLANCHE, and it was later to influence German Expressionism.

Félix Vallotton, Le Bain. 1894. Woodcut. 18×22.5 cm.

Félix Vallotton, La Paresse. 1896. Woodcut. 18×22.5 cm.

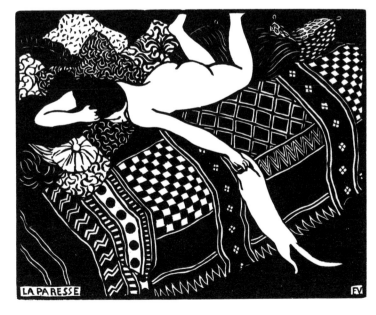

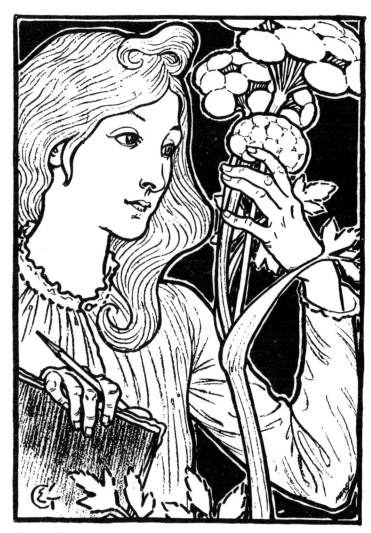

Eugène Grasset, Study for the poster "Salon des Cent", 1894. Lithograph. Reduced.

BIBLIOGRAPHY: Budry, P., "Félix Vallotton. Special issue of PAGES D'ART. Geneva 1917. – Fegdal, Ch., "Félix Vallotton". Paris 1931. – Godefroy, L., "L'Oeuvre gravé de Félix Vallotton". Lausanne 1932. – Hahnloser, Hedy, "Félix Vallotton, I. Der Graphiker". Neujahrsblatt der Züricher Kunstgesellschaft 1927. – id., "Félix Vallotton, II. Der Maler". Neujahrsblatt der Züricher Kunstgesellschaft 1928. – id., "Félix Vallotton et ses amis". Paris 1936. Jedlicka, G., "Félix Vallotton", in NEUE SCHWEIZER RUNDSCHAU, N. F. V., 1937/38, p. 220–240. – Jourdain, F., "Félix Vallotton". Geneva 1953. – Meier-Graefe, J., "Félix Vallotton (French and German text), Paris 1898. – Martini, A., "Félix Vallotton: Classicist manqué", in APOLLO, November 1963. – "Livre de Raison", chronological list of works compiled by Vallotton himself (in Hahnloser 1936 and in Catalogue Zurich 1938).

WRITINGS: La vie meurtrière (novel). 1927 and 1966. – Les soupirs de Cyprien Morus (novel). 1945.

EXHIBITIONS: Rétrospective Vallotton, Galerie Druet, Paris 1935. – Félix Vallotton, Kunstmuseum Lucerne 1938. – Félix Vallotton, Kunsthaus Zurich 1938. – Félix Vallotton, Kunsthalle Basle 1942. – Exposition Félix Vallotton, Musée de La ChauxFonds 1944. – Peinture de Félix Vallotton, Lausanne 1953. – Félix Vallotton, Museum Boymans, Rotterdam 1954. – Ausstellung Félix Vallotton, Kunsthalle Basle 1957. – Félix Vallotton, Kunstverein f. d. Rheinlande u. Westfalen, Dusseldorf 1957. – Félix Vallotton, Galleria del Levante, Milan 1963 (Catalogue Foreword by Franco Russoli). – Félix Vallotton, Kunsthaus Zurich 1965.

WORKS: Bierbaum, Otto Julius, "Der bunte Vogel" of 1897; a calendar book. Berlin 1896. – id., "Die Schlangendame". Berlin and Leipzig 1906. – Dolbeau, "Une belle journée". Paris 1898. – Flaubert, Gustave, "Un coeur simple", in, "Trois Contes". Paris 1924. – Gourmont, Rémy de, "Le Livre des Masques. MERCURE DE FRANCE. Paris 1896. Le II^{me} Livre des Masques. MERCURE DE FRANCE. Paris 1898. – Insel-Buch: Insel. Leipzig 1902. – Renard, Jules, "La maîtresse". Paris 1896. – id., "Poil de Carotte". Paris 1903. – Scheerbart, Paul, "Rakkox der Billionär". Berlin and Leipzig 1900. – Uzanne, Octave, "Rassemblements". Paris 1898. – Vallotton, Félix, "La Vie Meurtrière". 1927/1946.

EUGENE SAMUEL GRASSET

Eugène Samuel Grasset worked as a sculptor, architect, painter, draughtsman, and designer in the applied arts. He was born in Lausanne on 25 May 1841 and died in Sceaux on 23 October 1917. He began by studying architecture, and travelled to Egypt. He moved to Paris in 1871 and studied under Viollet-le-Duc. He showed enthusiastic interest in Japanese art. In 1891 he became a naturalized Frenchman. In the 1890's he gave various exhibitions, and he had an influence on American art. In his graphic work, Grasset used a combined technique made up of lithography and wood-engraving, and his pictures often look like glass windows. His posters were of great influence even before the Art Nouveau period, and it is probably largely due to him that poster design was to become an area of artistic activity.

BIBLIOGRAPHY: Alexandre, A., "Eugène Grasset et son oeuvre", Paris 1901.

WORKS: Posters, including Librairie Romantique (1887), Jeanne d'Arc-Sarah Bernhardt (before 1894), Le trèfle à 4 Feuilles-Cycles & Automobiles (before 1899), Exposition Falguirere (before 1899). – Illustrations for "Le Petit Nab" (1877/78), "L'Histoire des Quatre Fils Aymon" (1881–83). Calendars, book-bindings, artistic type-faces, vignettes, postage stamps.

EDMOND AMAN-JEAN

Edmond Aman-Jean, a painter and graphic artist, was born in Chevry-Cossigny in 1860 and died in 1936. He attended the Ecole des Beaux-Arts; his works were influenced by Carrière and the Pre-Raphaelites. From 1885 onwards he gave exhibitions in the Salon de la Nationale des Beaux-Arts, where he also became a member of the jury. During the 1890's, he executed lithographs and copper etchings. He made several trips to Italy. In 1914, 1921 and 1922 Aman-Jean was President of the Section de Peinture, which he,

Edmond Aman-Jean, Ophelia(?). Colour lithograph. 34.3 × 26.5 cm. ▷

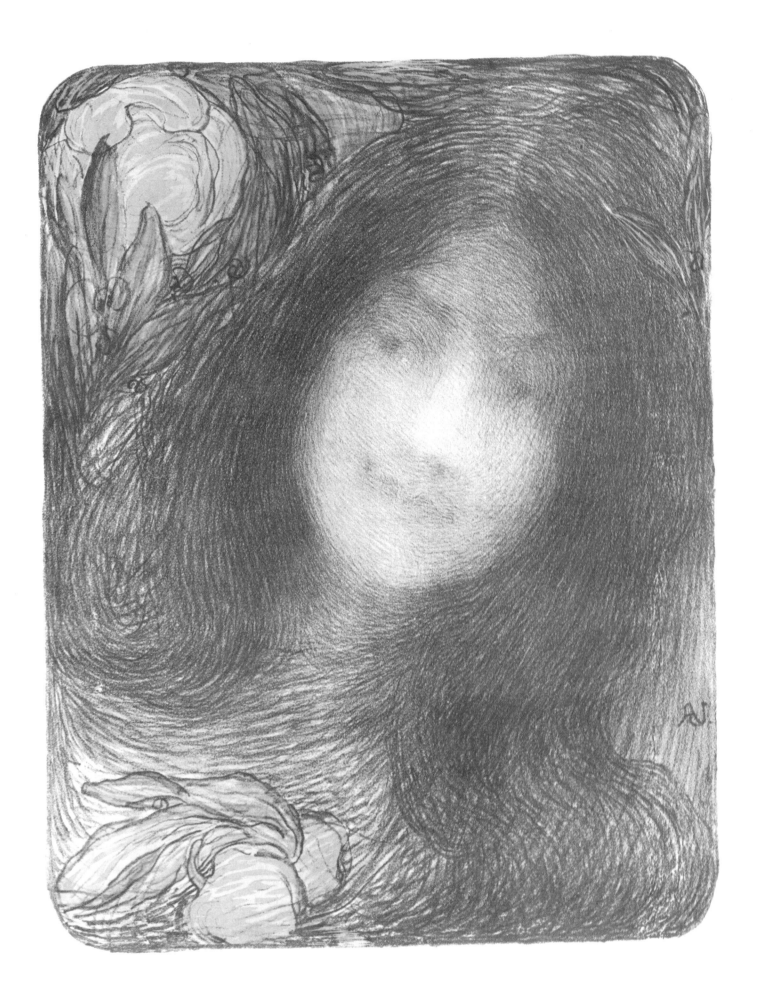

however, then left in order to found the Salon des Tuileries together with his friend the painter Albert Besnard. He wrote theoretical essays, Velasquez and Japanese art being among the subjects he covered. Aman-Jean was a highly esteemed painter of female portraits; his portraits are notable for the melancholy and reticent atmosphere which they possess and also for their subdued and finely shaded colouring. Contours and details become distanced through his arabesque style of drawing.

BIBLIOGRAPHY: Exposition Aman-Jean et René Menard, Galerie Georges Petit, Paris 1925 (Catalogue). – Langlade, E., "Artistes de mon temps". 1936. – ART ET DECORATION II (1902/I) pp. 133–142. – THE STUDIO 40 (1907), pp. 285–290. – id., 61 (1914), pp. 89–96. – REVUE DE L'ART ANCIEN ET MODERNE 43 (1923), pp. 396ff. – id., 49 (1926), pp. 36ff.

LOUIS ANQUETIN

Louis Anquetin, who worked as a painter and graphic artist, was born in Etrepagny in 1861 and died in Paris in 1932. In 1887 Anquetin became a student at the Académie Cormon, where he made the acquaintance of Emile Bernard, Vincent van Gogh and Henri de Toulouse-Lautrec. These friends united to form the "Groupe du Petit Boulevard". After some brief experiments in the field of Impressionist painting, which he carried out jointly with Emile Bernard, his further development tended towards the cloisonnist style and towards monochrome atmospheric painting in which one colour predominated; this latter style was an "invention" of Anquetin's. He took part in the exhibition of the "Vingt" in Brussels in 1888. Became acquainted with painters from the Pont-Aven group and with the Nabis. In 1889 he had a share in the exhibition held in the Café Volpini (Groupe Impressioniste et Synthésiste), while from 1888 to 1893 he took part in the exhibitions held by the Indépendants. Anquetin's works had an influence on Van Gogh and Toulouse-Lautrec, while he himself was stimulated by English graphic art, particularly that of Rickett. In the 1890's he reverted to a pompous New Baroque style, with studio settings in the manner of Markart.

The work reproduced here shows Baroque tendencies arising even during the early Art Nouveau period. The concentration of the shapes within the areas of the shadows and the way in which the landscape undulates together with the human figures are features reminiscent of some later works by Munch.

THEOPHILE STEINLEN

Théophile Steinlen, a painter, graphic artist and industrial artist, was born in Lausanne on 10 November 1859 and died in Paris on 14 December 1923. He studied initially at the Lausanne School of Applied Arts. He then became a textile designer in Mulhouse in Alsace. Steinlen lived in Paris from 1882 onwards, and in 1901 he became a naturalized Frenchman. In his etchings and lithographs

Louis Anquetin, Three seated figures in a landscape. 1896. Lithograph. About half size.

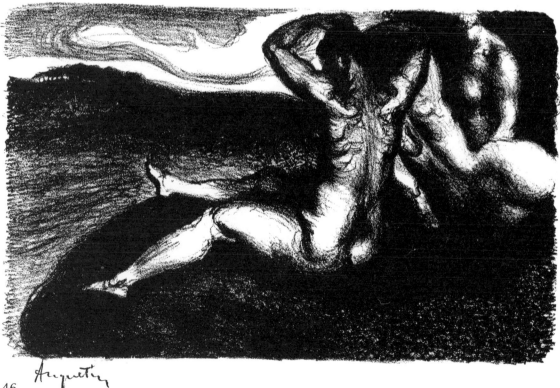

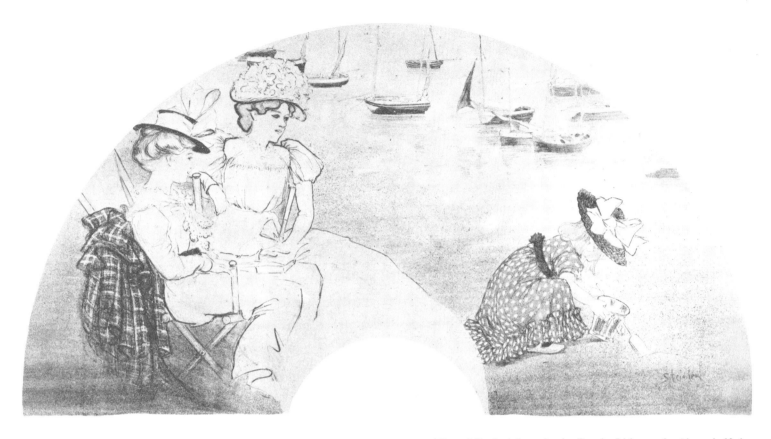

Theophile Steinlen, At the Beach. Lithograph. About half size.

Steinlen commented ironically on the social conditions prevailing in Paris. He published in various newspapers pictures of a socialist nature taken from the life of the proletariat. He worked under the pseudonyms Petit Pierre and Jean Caillou. In addition to his graphic work he also created murals, posters and industrial art works.

Before Toulouse-Lautrec, Steinlen was the social critic who chronicled the life of Montmartre. Being an eclectic, he took a position between the different styles: while not maligning the academic tradition, he simultaneously acknowledged Impressionism. He arrived at Art Nouveau as a result of his encounter with Toulouse-Lautrec, but did not adopt the latter's sharp characterization. Instead of this, Steinlen devoted his attention to an elegance of outline and to a flatteringly enveloping arabesque which gave his illustrations created around the turn of the century a fashionable character bringing him the approval of the ladies of the salons. It is therefore hardly surprising that the critics of those days, who were in sympathy with moderate forms of modernism, regarded Steinlen as the greatest French painter since Delacroix.

BIBLIOGRAPHY: Auriol, G., "Steinlen". Paris 1917. – Contat-Mercanton, L., "Th. A. Steinlen 1859–1923". Berne 1959. – de Crauzat, A., "Steinlen, peintre, graveur, lithographe". (Extr. de l'oeuvre et l'image). Paris 1902. – Ders., "L'Oeuvre gravé et lithographé de Steinlen". (Catalogue descriptiv et analytique suivi d'un essai de bibliographie et d'iconographie de son oeuvre illustré. Prof. de Roger-Marx). Paris 1913. – Jourdain, F., "Th. A. Steinlen, un grand imagier". Paris, Cercle d'Art 1954. – Pica, V., "Theophile Steinlen". Bergamo 1908. Puech, L., "Steinlen intime". Paris no date. – Sachs, H., "Th. Steinlen", Monograph in Das Plakat, 5th year. 1914, pp. 175ff.

WORKS: He worked on many magazines, among them CHAT NOIR, LE MIRLITON, LA CARICATURE, LE RIRE, LE REVE, LE GIL BLAS ILLUSTRE. He illustrated books, including: Aristide Bruant, "Dans la Rue" (1888), Anatole France, "Histoire du Chien de Jean Brisquet" (1900), "L'Affaire Crainquebille" (1901), "L'Almanach du Bibliophile" (1901), Guy de Maupassant, "Le Vagabond" (1902). His portfolios included: Dessins sans paroles des chats (1898), Contes à Sarah (1899), Croquis de temps de guerre (1914/15).

ALBERT BESNARD

Albert Besnard, a painter and etcher, was born in Paris in 1849 and died there in 1934. Besnard studied under J. Brémond, and also under A. Cabanel at the Ecole des Beaux-Arts. From 1868 onwards he had a share in the exhibitions held in the Paris salons. His work displays a mixture of academic tradition on the one hand, with modern stylistic tendencies such as Impressionism and the later Art Nouveau on the other. His chief importance was as a teacher to the younger generation of artists. He won the Rome prize in 1874, and stayed in Rome in 1878. From 1881 to 1883 he was in England, where he met Alphonse Legros and Anders Zorn. He created his first etchings and was

47

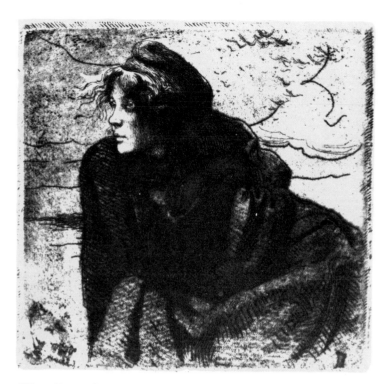

Albert Besnard, Melancholy. Etching. About half size.

stimulated by the English Pre-Raphaelites. He founded the "Société Nationale des Beaux-Arts" in Paris in 1890; in 1895 he took part in the exhibition held in Bing's shop called "Art Nouveau"; some other works by him include the frescos in the Ecole de Pharmacie, in the Nouvelle Sorbonne, in the 'Théâtre Français' and in the Petit Palais. From 1913 to 1922 Besnard was the Director of the French Academy in Rome, and from 1922 onwards he was the Director of the Ecole des Beaux-Arts in Paris.

In his printed graphic works, Besnard loved to create a traditional chiaroscuro effect, which was derived from his appreciation of Rembrandt's works and which he combined with the large shapes of the silhouette-like manner employed by Art Nouveau. He was an eclectic like Steinlen: he took a stance between the different styles and made use of stimuli derived both from Degas and from Toulouse-Lautrec. He nevertheless—as in the work reproduced here—achieved a tone of his own, one which is a prelude to the atmosphere from which Picasso's Blue Period was later derived.

BIBLIOGRAPHY: Cochin, H., "L'oeuvre de guerre du peintre Albert Besnard". Paris 1918. – Coppier, A.-Ch., "Les Eaux-fortes de A. Besnard". Paris 1920. – Godefroy, L., "L'Oeuvre gravé d'Albert Besnard". Paris 1926. – Grautoff, O., "Albert Besnard", in: DIE KUNST 25, 1912. – Mauclair, C., "Albert Besnard, l'homme et l'oeuvre". Paris 1914. – Mourey, G., "Albert Besnard". Paris 1906. – Roger-Marx, C., "A.B." Paris 1893.

EXHIBITIONS (WITH CATALOGUES): Paris, Galerie Georges Petit: Exposition Albert Besnard, 1905 (Catalogue Forword by Charlotte Besnard). –

Exposition Albert Besnard, pastels, aquarelles et dessins, gravures. Préface d'André Salmon. Paris 1927. – Exposition de l'oeuvre gravé du maître Albert Besnard, (catalogue), Brussels 1928. – Bibliothèque Nationale, Paris: Albert Besnard, l'Oeuvre gravé, peintures, dessins, pastels. Exposition organisée à l'occasion de centenaire de sa naissance, 1949. Catalogue par Jean Adhémar. Avant-propos par Juline Cain. Besnard graveur par Jean Vallery-Radot. Paris 1949.

JULES CHERET

Jules Chéret, a painter and draughtsman, was born in Paris on 31 May 1836 and died in Paris (or Nice) on 23 September 1932. He served an apprenticeship in a lithographic establishment in Paris; after this he spent some time in London where he worked in various lithographic establishments. He was a self-taught artist. In 1866 he returned to Paris and founded his own printing works, where he was soon producing three-coloured posters. Not only did he supply the designs, but he himself also cut them on the stone. Chéret was the leading master of the Impressionist poster and is generally referred to as the "father of the poster". In 1983, under the influence of Toulouse-Lautrec, he went over to a decorative, flat-surfaced style. However, after 1900, he reverted to the use of Impressionist stylistic devices. He created some 1,200 posters over a period of activity lasting almost forty years.

Chéret was able to express the feel of the Parisian salons, whose atmosphere was determined by the ladies, and during his Art Nouveau period he used partly frivolous and partly piquant means in order to convey this. It is easy to believe that his female figures in their champagne-coloured dresses are in a champagne mood. Although his vivid drawings were skilfully wrought, his works are nevertheless to be counted amongst those phenomena which gradually caused a certain disenchantment with the Art Nouveau style, because they took that style into a mannered phase which was not capable of any further development to make it accord with the period that followed. The same applies to the posters of de Feure, whom we are introducing to the reader in the next illustration.

Chéret's poster art is closely related to the theatre, to the music hall, to chanson and to can-can. Apart from Yvette Guilbert, one of the most fascinating phenomena of popular art was Loïe Fuller, the veil-dancer for whom Chéret drew one of his most famous posters and who was described as follows by a contemporary admirer.

"Loïe Fuller developed a significant personal style based on the general can-can style. Loïe Fuller has a lyrical nature. During the period when she was only performing the skirt-dance which she herself created, her lines of movement seemed to be making a sacrifice to colour. However, in her most recent developments these lines have become positively priestly and solemn. These lines too were originally can-can lines; it is only that they were wonderfully well-rounded

and well-balanced so as to form rainbows of drapery which passed through one another; the froufrou seemed to have become visible in a frenzy of red, yellow, green, blue, bluish-red, reddish-yellow, yellowish-green, greenish-blue and all the other innumerable transitions and blends; and even at that time, Loîe Fuller's infinite artistry consisted in the fact that she knew how to create and maintain an exact harmony between her own movements on the one hand and the changes in the streams of colours hurrying across her body on the other hand. Today, these original can-can lines are no longer recognizable except in the outline of her dancing rhythm. In all other respects the lines are kept in check by

the magic of a mastery in which Apollo reveals himself: the lines rise up like a swelling paean and show a steep, high-soaring ornamentation which gives an impression of the purest sculpture."

It is significant that this transition to a sculptural form was instinctively discovered by that very danseuse who, to judge by the entire formation of her art and its mode of expression, must have had the closest relationship with modern painting. Her type of Impressionism, being formed from the reproduction of a series of different stimuli, precludes the possibility of catharsis, which is the concentration of all the objective stimuli of a work of art into a single subjective

Jules Chéret, Book jacket for Marcel Prévost, Pariserinnen, Paris, Leipzig, Munich, 1896. Colour lithograph. 19 × 26.5 cm.

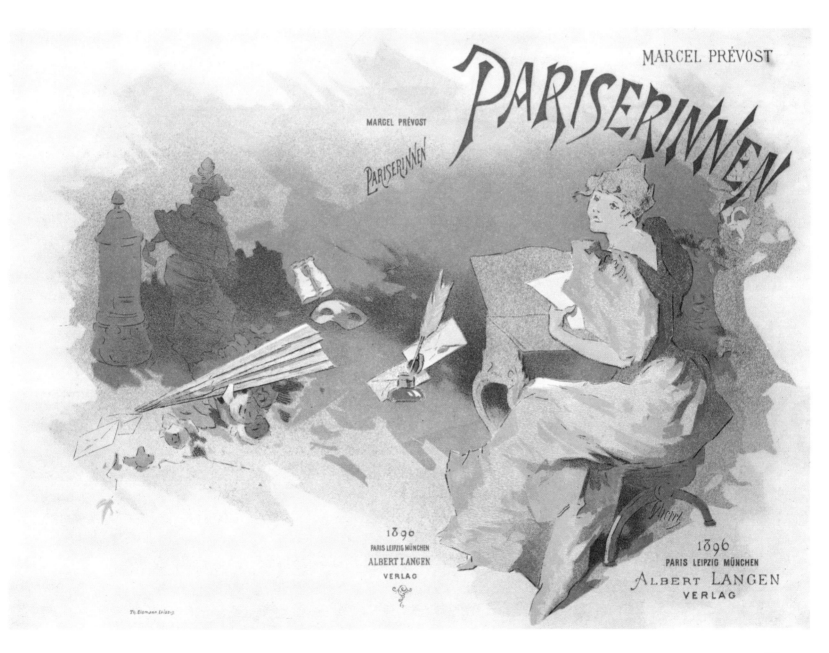

stimulus. All that Impressionism is able to do, again and again, is to bring about a series of impressions, and if these impressions follow so closely upon one another that they are felt to be a single whole, then this shows that the principle of Impressionism must have been abandoned and been replaced by some stylistic principle. However, Impressionism prepares the way for such an artistic style and renders that style possible. When regarded in this way, Impressionism has a certain primitiveness, an impulse which lends variety to painting and sets the painter the task of taking the above-mentioned series of stimuli, or rather the series of dots which give rise to the stimuli, and uniting them into a new line.

It is almost impossible to find any intellectual or moral associations in the art of Loîe Fuller. It might be emphasized that she actually only appeals to those aspects of life which are under control and not to those uncontrolled aspects which are still full of longing, and also that she demonstrates the complete alienation of the female body through art

Jules Chéret, Poster for the dancer Loîe Fuller. Lithograph. Much reduced.

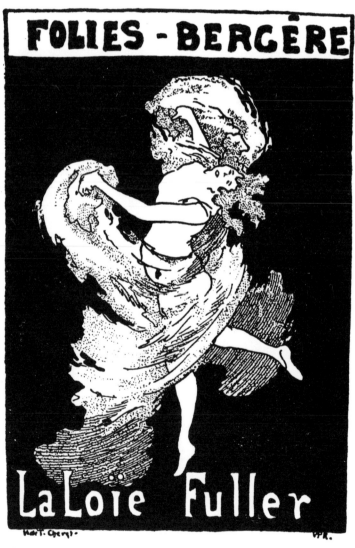

with the only stimulus to the onlooker being a gloriously agitated coloured surface. However, this is after all self-evident: Loîe Fuller seems to have brought the living line, as seen on the stage of the variety theatre, into a new phase where the only possible next step is to translate that line into a great work of art, or rather to make use of the line as part of such a work of art, whether the art form in question is sculpture, painting or drama. By utilizing the resources of sculpture and painting, this living line would have to provide the decorative background and framework for dramatic works. Loîe Fuller's artistry seems unsurpassable, at least so far. A particular reason for this is that the raw material which she supplies is so infinitely rich and varied. The amount of work which has actually been done on this is relatively small when one considers the wealth of the material. Even though the entire so-called Secession style lives by the can-can line, whether this style is expressed by pure means or by means of applied art as seen in the rooms and objects of day to day living, this particular style is as yet no more than an attempt to unite the characteristic traits, and the significant and lasting successes in this field have yet to come.

WORKS: Posters, including Thé-trophone (1890), Saxoléine-Pétrole de Sûreté (1891 and 1892), Olympia (1892), Palais de Glace (1894), Eldorado (1894), Job (1895), Quinquina Dubonnet (1895), Pastilles Poncelet (1896) and dust jackets.

GEORGES DE FEURE

Georges de Feure was a painter, draughtsman, theatrical designer and industrial art designer. He was born in Paris on 6 September 1868 and died there in 1928. He was of Dutch and Belgian descent. In Paris he studied under Jules Chéret from 1890 onwards and he was sponsored by Puvis de Chavannes. Feure created theatre designs for "Chat Noir" and worked for various newspapers. Some of his works were shown at the exhibition of the Munich Secession in 1896. In 1898 he designed the furniture for the Fleury house in Paris, and in 1900 he did the interior design for Bing of the "Art Nouveau" house at the Paris World Exhibition. He was later appointed Professor of Decorative Art at the Ecole Nationale des Beaux-Arts in Paris.

BIBLIOGRAPHY: Puaux, R., "Georges de Feure". Paris 1902.

WORKS: Posters, including some for Loîe Fuller, in "Jeanne d'Arc" and "Salon des Cents", ca. 400 lithographs and etchings for L'Estampe originale and illustrations for the newspapers COURRIER FRANCAIS and LE BOULEVARD.

Georges de Feure, Poster. Thermes Liègeois. Colour lithograph. ▷ 105×79 cm.

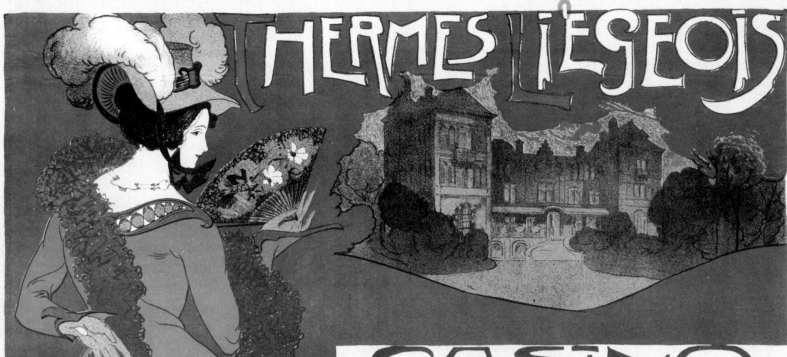

THERMES LIÉGEOIS

CASINO

IMP. BOURGERIE & Cᴵᵉ 83, Faubᵍ Sᵗ Denis, PARIS.

GASTON DE LATENAY

Gaston de Latenay, a painter and draughtsman, was born in 1859 and died in Toulouse. He was particularly well-known as a landscape painter in his time, and won prizes at the world exhibitions of 1886, 1889 and 1900. In his book illustrations, which are not so well-known, he combined Japanese influences with a lyricism derived from the Nabis. His work is of varying quality. In the field of printed graphics, he produced colour etchings and book illustrations.

Gaston de Latenay, Frontispiece for Nausica. Ed. d'Art. H.Piazza et
Cie, Paris 1909. Autotype. Each 25.4×22.2 cm.

EDMOND DULAC

Edmond Dulac, a painter and draughtsman, was born in Toulouse on 22 October 1882 and died in London on 15 May 1943. After attending art school in Toulouse, he continued his education at the Académie Julian in Paris. He later worked in England as a highly-regarded illustrator. In addition to illustrations for books of fairy-tales, he also designed postage stamps and banknotes; he worked as painter, costume designer and theatrical designer. His portraits were held in great esteem.

Dulac was one of the most sensitive fairy-tale illustrators of the Art Nouveau movement. He painted in his own hybrid watercolour technique which is difficult to reproduce. This technique is closely related to Arthur Rackham's working method. In addition to the influences of Japanese woodcuts and Beardsley's drawings, a close association with the Pre-Raphaelites and their mysterious concept of femininity can also be sensed in his work. This enabled him to reproduce a genuine eastern atmosphere which is peculiar to most of his illustrations and is the reason for the magical, fairy-tale feeling which they evoke.

BIBLIOGRAPHY: Frequently mentioned in THE STUDIO 1915, 1916, 1921, 1926, 1936, 1939 and 1941 (with illustrations in some cases).

WORKS: His most significant works are his illustrations for, amongst others, "The Arabian Nights", 1907 (German edition published by Müller and Co., Potsdam), Andersen's fairy-tales, poems by Edgar Allen Poe, Shakespeare's "Tempest" (English edition published by Hodder and Stoughton, London), Grimm's fairy-tales (German edition published by Georg W. Diedrich, Munich). Portfolio: Edmond Dulac's Picture Book for the French Red Cross. London 1916. Illustrations for the magazines L'ESTAMPE ORIGINALE, LE RIRE, L'EPREUVE, LA PLUME and JUGEND. Posters, playing cards, book ornamentation. Illustrations for, "Le Livre de la Naissance" by A.F. Hérold.

Edmond Dulac, Illustration for The Story of the Stone Prince, from "The 1001 Nights". Verlag Müller u. Co. Potsdam (no date). Autotype. 14.2×12 cm.

Henri Jossot, Evening glow, from the journal 'JUGEND' Nr.39 p.652. 1897. Autotype. 20×18.2 cm.

HENRI GUSTAVE JOSSOT

Henri Gustave Jossot, a painter and draughtsman, was born in Dijon in 1866. He worked mainly as an illustrator for certain newspapers in Paris. Exhibitions of his works were held in the Salon de la Société Nationale in 1895, in the rooms of the Indépendants in 1910 and 1911, and in the Salon d'Automne from 1908 to 1911. He was later converted to Islam and called himself Abdul Karim Jossot. After his conversion he worked in brush and Indian ink and used oriental motifs.

Jossot's strong points were caricature and the grotesque.

Inspired by Vallotton, he preferred to use a pure black and white contrast without any intermediate tones, but his positive and negative shapes were closely interrelated. In our present example, monochromatic atmospheric painting has stimulated him into making elemental use of colours: the bluish-green ground suggests the coolness of the wood, and the red sky gives an impression of the setting sun.

BIBLIOGRAPHY: Géniaux, CH., "Abdoul Karim Jossot", in L'ART ET LES ARTISTES 1923/24, pp 18–24 (with 11 illustrations).

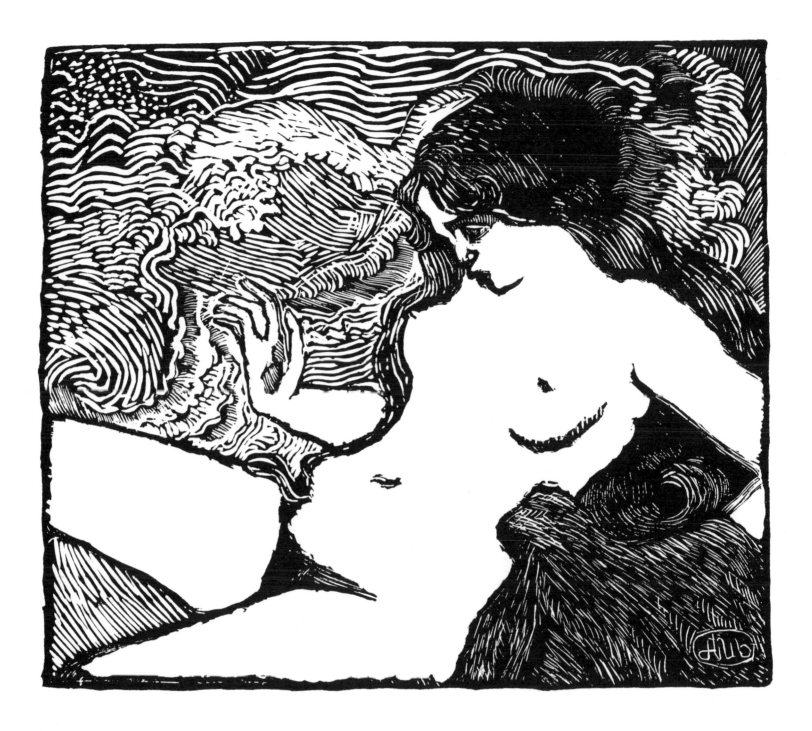

ARISTIDE MAILLOL

Aristide Maillol was born on 25 December 1861 in Banyuls-sur-mer, and he died in Banyuls on 24 September 1944. He worked as a sculptor, painter and draughtsman. He went to school in Perpignan, returning to Banyuls in 1879. From 1885 onwards he attended the Ecole des Arts Décoratifs and also studied under Cabanel at the Ecole des Beaux-Arts in Paris. In 1889 Maillol made friends with Bourdelle the sculptor, and also met Gauguin. In 1893 he opened a carpet-weaving shop and regularly exhibited tapestry carpets at the salon of the Société Nationale des Beaux-Arts in Paris. In 1896 he began to sculpt, in 1899 he moved to Villeneuve-Saint-Georges, and in 1903 to MarlyRoi. He held an exhibition at the "Méditerranée" in 1905, and 1908 he travelled to Greece with Harry Graf Kessler and Hugo von Hofmannsthal. He founded a small paper factory in Montval near Marly in 1910. In 1912 Maillol was awarded the commission for a monument to Cézanne, and met Barlach and Einstein, and in 1936 he travelled to Italy.

◁ **Aristide Maillol**, The Wave. After 1900. Woodcut. 17×19.5 cm.

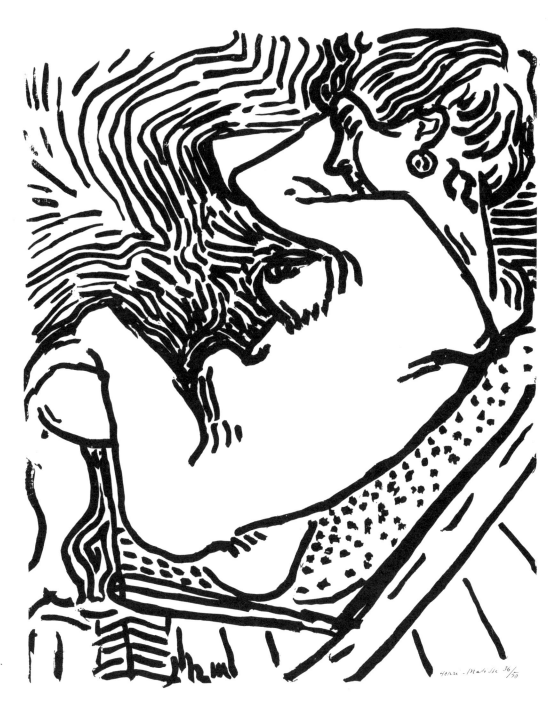

Henri Matisse, Female nude. Linocut. . 47.3×38.5 cm.

BIBLIOGRAPHY: Camo, P., "Aristide Maillol". 1922. – id., "Aristide Maillol, mon ami". 1950. – Cladel, J., "Aristide Maillol, sa vie, son oeuvre". Paris 1937. – Denis, M., "Aristide Maillol". Paris 1925. – Keiser, H.W., "Aristide Maillol. Das Meisterwerk". Berlin no date. – Kuhn, A., "Aristide Maillol". Leipzig 1925. – Mirbeau, O., "Aristide Maillol". 1922. – Rewald, J., "Maillol". 1939. – id., "The Woodcuts of Aristide Maillol". New York 1951. – Roy and Karquel, "Maillol vivant". Geneva 1947.

WORKS FROM THE ART NOUVEAU PERIOD: Hero and Leander (Rewald 1), nude lying down (Rewald 4), the wave (Rewald 5), the sea (Rewald 6).

HENRI MATISSE

Henri Matisse, a painter, draughtsman and sculptor, was born in Cateau on 31 December 1869 and died in Nice on 3 November 1954. Matisse studied law initially, but from 1890 onwards he attended the Académie Julian; from 1895 to 1898 he studied under Gustave Moreau at the Ecole des Beaux-Arts, together with Rouault, Camoin and Marquet. During his studies he made copies of a great number of old masters at the Louvre; he went through a transitional

57

Impressionist period. Around 1900, under the influence of Cézanne's painting, Matisse turned away from Impressionism and began working in his two-dimensional style with colours that were sharply graduated against one another. His Fauve period commenced in 1905 and continued until about 1908. He founded an academy in an old monastery. From 1911 to 1912 he was in Morocco. In 1919 he achieved general international success and Nice became the residence of his choice.

BIBLIOGRAPHY: Barr, A. H., "Matisse". New York 1951. – Barnes, A. C., and V. De Mazia, "The Art of Henri Matisse. New York 1933. – Basler, A., "Henri Matisse". Leipzig 1924. – Bertram, A., "Matisse". London, New York 1930. – Besson, G., "Matisse". Paris 1943. – Cassou, J., "Matisse". Paris 1939. – Courthion, P., "Henri Matisse". Paris 1934. – Diehl, G., "Henri Matisse". Paris 1954. – Escholier, R., "Matisse". Paris 1937. – Fels, F., "Henri Matisse". Paris 1929. – Fry, R., "Matisse". New York 1930. – George, W., "Dessins de Henri Matisse". Paris 1925. – Jedlicka, G., "Henri Matisse". Stockholm 1944. – Lassaigne, J., "Matisse". Geneva 1960. – Leymarie, J., "Le Fauvisme". Geneva 1959. – Liebermann, W. S., "Matisse: 50 Years of His Graphic Art". New York 1956. – Purrmann, H., "Aus der Werkstatt Henri Matisse", in: KUNST UND KÜNSTLER 20, 1922. – Schacht, R., "Henri Matisse". Dresden 1922. – Sembat, M., "Henri Matisse". Paris 1920. – Swane, L., "Henri Matisse". Stockholm 1944. – Valsecchi, M., "Disegni di Matisse". Milan 1944.

The end of the Art Nouveau period in France can clearly be seen in the works by MAILLOL and MATISSE which are shown here for comparison. In the works of many artists, particularly those who were active in the poster field, the final stage reached by the style of that period consisted of mannered interlacings and an exaggerated arabesque elegance. On the other hand, artists such as Maillol helped to form that expressive urge for movement which was characteristic of the new generation, and they pointed to a new direction in which artistic style might go. The reversion to archaic ideas, and the new manner in which the vigorous lines of the Art Nouveau were being expressed and thought out, led to a new world of experience which had its parallels in the works of Munch, in the creation of the early Expressionists in Germany and in the production of Kokoschka and Schiele in Austria. Matisse, in his early lino cuts, seems to be entering into direct association with these tendencies. However, the features which, in Maillol's works, were harmonious and were in accord with the ideas of the Art Nouveau, make a dissonant impression in the works of Matisse. The beauty of the line and the soft form of the human body seem to have been deliberately discarded. The expressive period of the Fauves, the extravagant artists, now began. However, Matisse's work also shows that the memory of Art Nouveau never entirely disappeared.

ENGLAND

In England, in contrast to other European countries, the new style in printed art developed from a long tradition. The typographical design of printed works was also given more importance here than elsewhere. The artistic tradition of England includes, from the very outset, a decorative element which embroiders and partly disguises the sober, tectonic structure. As a result, artistic endeavours in the field of typography are not exclusively restricted to the arrangement of the type, but rather to ensuring that this arrangement is an integral part of a real type face.

The typesetting of the late 18th century had a classical balance but tended to be somewhat sterile. In contrast to this, William Blake—a romantic Symbolist who prepared the way for a large number of trends which led to modern styles of art—employed a new textual design in which, for the first time since the Middle Ages, text and decoration were combined to form a joint illustrative whole. Arabesques resembling wisps of smoke rise up from a lower corner of the sheet and permeate the entire page, making full use of the surface area available. These arabesques enclose the text in their interstices and apostrophize that text in an appropriate fashion; dreamlike, floating figures are included in an arabesque-like movement, from which certain leaf-stems crystallize as if by chance. The letters of the text are derived from Roman characters, and their deviations from the formal pattern are in sympathy with the mood of the entwining decorations and thus form a distinct unity with those decorations: swelling loops in the descenders, and undulating extensions of the beginnings and ends of horizontal strokes. The atmospheric element which is perceptible in a type style such as this was preserved throughout the 19th century in England, and the leading designs, stimulated by some creative inner force, lived on in the Pre-Raphaelite art of the mid-19th century. Despite this, decades passed before Blake's advances in the typographical field were developed any further. McNeill Whistler discovered Japanese woodcuts. Shortly after the middle of the century, on the basis of this discovery, he continued his work on the problem of brush writing, by including inscriptions in his painted pictures, based on his Far Eastern models. An example was the name of Connie Gilchrist, inscribed on a portrait Whistler did of him, dated 1876. The problem of the integration of text and illustration was thus once again open for discussion, though for the time being only in the field of painting. However, it was also in 1876 that the first Blake exhibition was held at the Burlington Fine Arts Club, and Alexander Gilchrist, who was a friend of the pre-Raphaelite painter, Dante Gabriel Rossetti, wrote the first monograph on Blake, the second edition of which was published as early as 1880.

A significant step was taken in 1882 when H. Mackmurdo, Herbert P. Horne and Selwyn Image formed a group of artists called the "Century Guild". Their goal was to revive and increase the value of arts and crafts in the machine age. In contrast to the traditionalist William Morris, who had a similar intention but wished to re-establish links with tradition, this group endeavoured to break with tradition and to put into effect their image of the future. The HOBBY HORSE, the magazine issued by this association of artists, appeared for the first time in 1884. Its title page, designed by Selwyn Image, displayed the new concept of text and illustration. Mackmurdo was probably the most significant member of this group, and he was the main initiator of the magazine. He had previously executed a woodcut for the title page of a book entitled "Wren's City Churches", and here Blake's flame-like arabesques, with their symbolic floral blossomings, are used once again. No attention is paid to the textual tectonics which had previously been customary, and the letters, accompanied by the arabesques, rise up on banners that resemble banderoles. The deformation of the Roman characters matches the dynamism of the entire picture and now even suggests a three-dimensional version of the shapes which were conceived as purely two-dimensional. As in Blake's works, all the undulations make use of the space and fill the entire surface.

In 1889 the two friends Charles Ricketts and Charles Shannon founded THE DIAL, a new magazine which continued to appear until 1897. This also displayed various trends in the fields of typography and illustration, but these cannot be associated exclusively with Art Nouveau. It is rather the case is that the works created during these years—in printed art, in all the handicrafts and, of course, also in the visual arts—reveal an intensive effort to build a bridge joining the old tradition to the new style, and so to prevent traditional norms from suffering the collapse that was beginning to come about in the wake of the accepted method of cultivating and imitating already existing works of art.

However, the most consistent output of printed art created at the beginning of the Art Nouveau period was the work of William Morris in quasi-historical imitation of late medieval letterpress printing. No one before Morris had regarded a book in this way as being an integral work of art. This is clearly shown by the open double-page spread with the title page on the left, which includes both text and illustrations, and the beginning of the chapter on the right. These two pages show a variety of motifs which at first glance makes a bewildering impression, caused mainly by the plant motif with its flowing character but unsophisticated form. This variety is offset by clearly defined, harmoniously balanced proportions in symmetrical co-ordination. The equal size of the left- and right-hand panels is offset by the fact that the breadth of the frame is different on each side, the broadest frame being at the foot of the page, the narrowest at the joint of the two pages. The red decorations of the chapter heading clearly represent an element of tension because they simultaneously point the way to the beginning of the text.

The production of a book such as this must at all stages

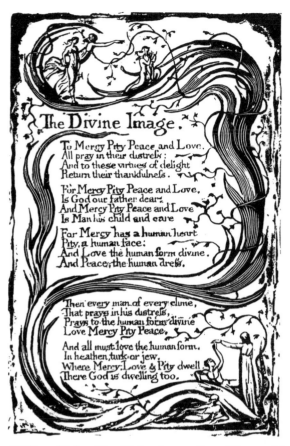

William Blake, The Divine Image, from "Songs of Innocence and Experience". 1789–1794. Woodcut. About original size.

be supervised by the artist. The artist cannot submit the book to a publisher, but must publish it himself. Thus, Morris founded his own publisher's printing house, the Kelmscott Press, in Hammersmith, London, in 1891. Here he published his works, which had in the meantime become famous and were known by the name of "Morris Prints". When Morris died in 1896, over twenty of his most important books had appeared. Up until 1898, books which he had begun were completed by his friends. The artist had himself designed the type face and decorative strips; this applies particularly to his three most important type faces, Golden Type, Troy Type and Chaucer Type. Like-minded colleagues, such as Edward Burne-Jones, contributed illustrations. The texts of the books were often written by Morris himself, or else he used classical poems or medieval and Icelandic heroic sagas.

The foundation by Morris of an artistic printing house set an important pattern for further development, not only in England but in the whole of Europe. Many of the publishing houses which were founded at that time have retained their good name up to the present. In England, they include the following: the Eragny Press, 1894 to 1914, which was founded by Lucien Pissarro together with his wife; the Essex

House Press, 1898-1910, founded by C. R. Ashbee in Upton, which acquired the hand-press of the Kelmscott Press after the latter wound up its affairs; the Carado Press, 1899-1909, which was founded by the wood engraver H.G. Webb and his wife and used a type face derived from a 15th-century text; the Vale Press, 1896-1904, founded by Charles Ricketts; and the Dove Press, 1900-1916, founded in Hammersmith by Thomas James Cobden-Sanderson and Emery Walker, who had worked for Morris as printers and bookbinders. They went in for pure textual typography with simple initials, and made sparing use of decorations in red. The 51 works printed include a five volume edition of Goethe's works in German. Cobden-Sanderson was in sole charge of the Dove Press from 1909 onwards, and in 1916 he threw the type and stencils into the Thames. In addition, there were the Abbey Press (1902), the Chiswick Press, which was founded in 1789 but reached its peak as a publishing house around 1904, and others. In some cases, these presses kept their traditions alive until the late 1920's and early 1930's, before then going over to modern production methods and publishing works that were of no interest to bibliophiles. The artistic revival in the field of book production spread from England to America. In 1895, William Bradley founded the Wayside Press in Springfield (Mass). Apart from his own prints, it also published several illustrated magazines, the most significant being HIS BOOK, which became the centre of American Art Nouveau illustration. Elbert Hubbard also adopted the Morris tradition and founded the Roycraft Press in East Aurora (N.Y.) in 1896. The Macmillan Company of New York came into being in 1896 after being split off from its parent company in London, and in the 1890's it also published works in the Art Nouveau style that were of interest to bibliophiles. In the above, mention has been made only of the most imporpant firms in the English speaking world to have played a significant role in the development of Art Nouveau. The English art of book production had a great influence on Continental Art Nouveau, not so much on France and the Scandinavian countries as on the German speaking area and on Eastern Europe. In this connection, the magazine THE STUDIO, which appeared from 1893 onwards and kept its readers in touch with the latest developments in England, played an important role in transmitting these ideas. In its first year, the magazine published works by Beardsley. In similar fashion to the posters of Toulouse-Lautrec, Beardsley's works transcended the bounds of book art and became symbols of the epoch at the turn of the century. He combined the most refined formalism with a pronounced characterization of the underlying feelings of his time, its wishes, longings, and profundities. The works of Walter Crane, England's most significant theorist, were translated into many languages. Like Morris, but with the didactic aim of an academic, he sought for basic design principles determining not only the works of the past but also those of the present; in Crane's reinterpretation, even the metopes of the Pantheon became Art Nouveau works.

One of Walter Crane's main works is called "Basic Principles of Drawing"; the art of drawing is in fact one of the fundamental aspects of English Art Nouveau. The affinity with lines, and the interlacing and accumulation of those lines in order to fill up the surface available, had been a peculiarity of the art of the British Isles since Celtic times. Consequently, this art makes only sparing use of colour in order to make its statements, and lives by the simple contrast between the printing ink and the paper. In those cases where the enhancement of colour is used, this is again done only for the purposes of drawing, and the paint is used to draw a picture, as for example in the red ochre lithograph by Shannon (illustration on page 81); in the illustrations by Crane (illustration on pages 85 and 86); and others. English art frequently prefers to produce monochromatic colour drawings or to print single-colour graphic works in different shades.

It is particularly in the field of poster art that the use of line is not sufficiently effective; coloured surfaces are more emphatic and can be seen from further away. In 1894, three years later than in France, the artistic poster was created in England, and its clearest influences were those of Toulouse-Lautrec and Chéret. In that year, Dudley Hardy drew a poster for the operetta "A Gaiety Girl" being performed at the Prince of Wales Theatre, and Maurice Greiffehagen drew his poster for the "Pall Mall Budget". The style in which the outlines and human figures are drawn is derived almost exclusively from the contiguous coloured areas. Art Nouveau posters reached their culmination in England through the works of the "Brothers Beggarstaff", a pseudonym concealing the names of James Pryde and William Nicholson. They had both attended the Académie Julian in Paris, where they made contact with French Art Nouveau artists of their own age. They created silhouettes which were small in size but whose outlines were extraordinarily concentrated and expressive. The silhouettes were set against a spaceless, two-dimensional background and the text made an almost hieroglyphic contribution to the stabilization of the two-dimensional surface. These artists produced an almost classical advertisement for HARPERS MAGAZINE. It was Nicholson in particular who showed a special sense for the expressive gesture and for the almost pantomime-like characterization of certain living persons who, despite all the abstraction, were immediately recognized by contemporaries. Nicholson made use of the principles of caricature in the same way as Toulouse-Lautrec, but did so with a pronounced sensitivity to the peculiarities of his subject, as is shown by our example depicting Sarah Bernhardt (illustrated on page 82).

Unlike France or Germany, the end of the Art Nouveau period in England was not marked by a transition to more expressive forms. In the same way in which examples of Art Nouveau forms appeared in earlier epochs of English art, the after-effects of such forms continued for a long time after the period ended; the factor which found special expression in the English Art Nouveau style was not so much a phenomenon of the times, but rather the basic national character. One illustration by Harry Clarke shows the almost mannered continuation of Beardsley's ideas, while a title page by Robinson points the way to a new direction which influenced typography and book illustration in the new century - an influence which applied to France as well. The direction in question was towards the classical clarity of Italian Renaissance typography, where the emphasis was laid on the clarity of the type matter, with the illustration subordinate to it. In the period from 1900 to 1916, the Dove Press published some unillustrated works which show the recourse being taken to the master achievements of Italian typography at the beginning of the 19th century. These works were characteristic of the impersonal beauty which was now required in the art of book production.

Edward Burne-Jones, (on the following double-spread), "The Well at the World's End". Book design W. Morris (Chaucer type), illustrations by E. Burne-Jones, Kelmscott Press, Hammersmith 1896. Wood engraving. 24×17.5 cm.

Arthur H. Mackmurdo, Title-page for "Wren's City Churches". 1883. Woodcut.

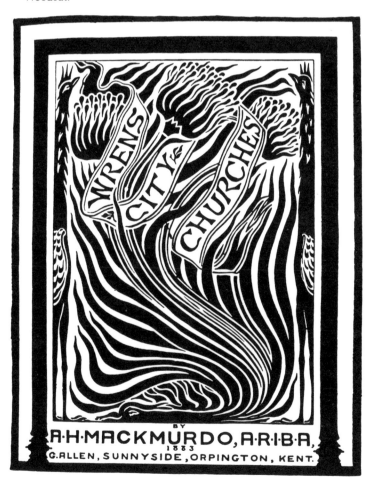

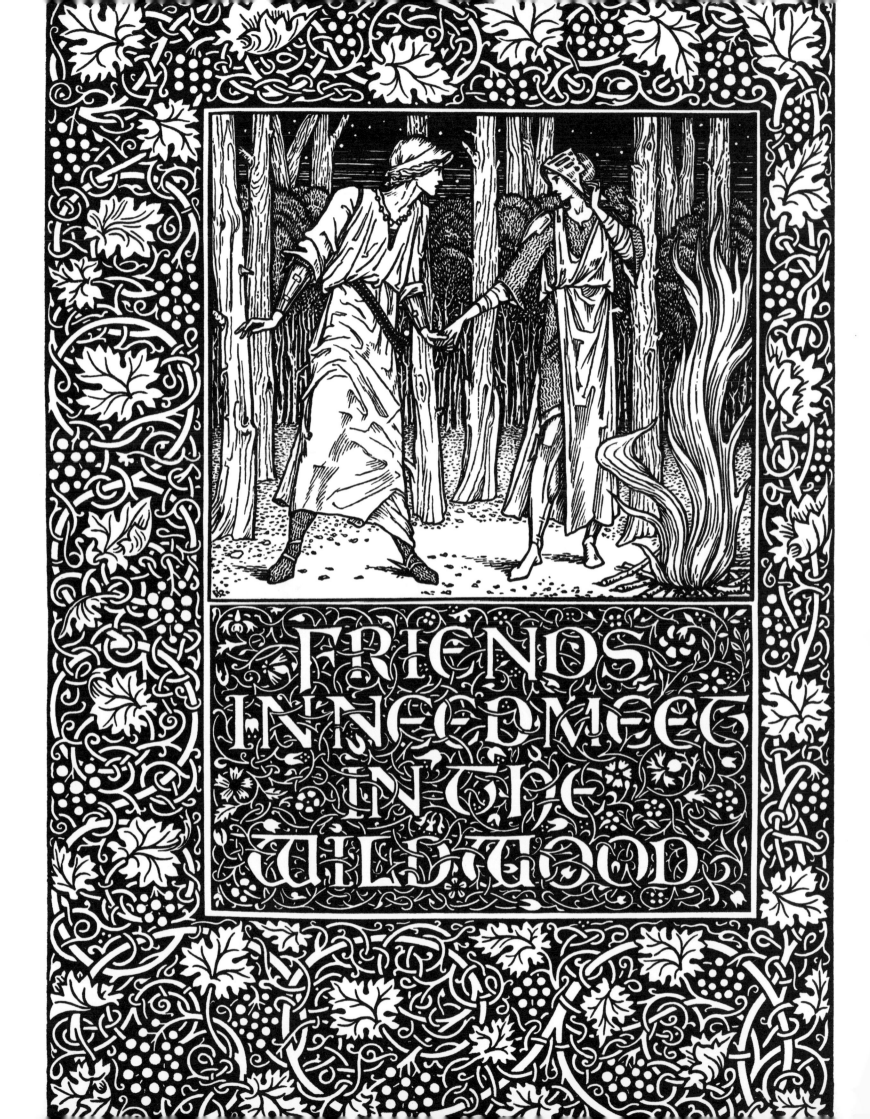

FRIENDS IN NEED MEET IN THE WILD WOOD

Chapter I. An Adventure in the Wood under the Mountains ✿

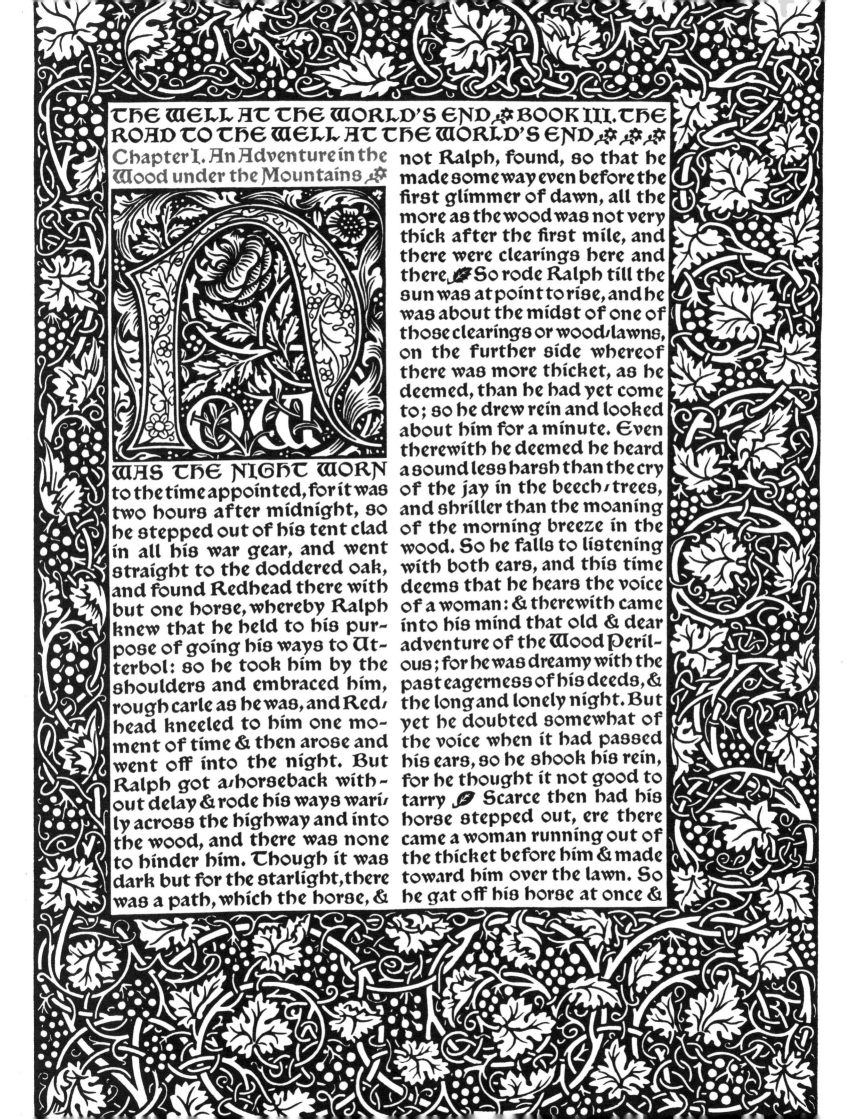

A WAS THE NIGHT WORN to the time appointed, for it was two hours after midnight, so he stepped out of his tent clad in all his war gear, and went straight to the doddered oak, and found Redhead there with but one horse, whereby Ralph knew that he held to his purpose of going his ways to Utterbol: so he took him by the shoulders and embraced him, rough carle as he was, and Redhead kneeled to him one moment of time & then arose and went off into the night. But Ralph got a-horseback without delay & rode his ways warily across the highway and into the wood, and there was none to hinder him. Though it was dark but for the starlight, there was a path, which the horse, & not Ralph, found, so that he made some way even before the first glimmer of dawn, all the more as the wood was not very thick after the first mile, and there were clearings here and there. So rode Ralph till the sun was at point to rise, and he was about the midst of one of those clearings or wood-lawns, on the further side whereof there was more thicket, as he deemed, than he had yet come to; so he drew rein and looked about him for a minute. Even therewith he deemed he heard a sound less harsh than the cry of the jay in the beech-trees, and shriller than the moaning of the morning breeze in the wood. So he falls to listening with both ears, and this time deems that he hears the voice of a woman: & therewith came into his mind that old & dear adventure of the Wood Perilous; for he was dreamy with the past eagerness of his deeds, & the long and lonely night. But yet he doubted somewhat of the voice when it had passed his ears, so he shook his rein, for he thought it not good to tarry. Scarce then had his horse stepped out, ere there came a woman running out of the thicket before him & made toward him over the lawn. So he gat off his horse at once &

WILLIAM MORRIS

William Morris, a draughtsman, applied artist, poet and social politician, was born in Walthamstow, Essex, on 24 March 1834 and died in London on 3 October 1896. He attended Exeter College, Oxford, together with Burne-Jones, with whom he was connected by a lifelong friendship from that time onwards. In 1854 he travelled with Burne-Jones to Belgium and northern France, where he came into contact with the paintings of Van Eyk and Memling, as well as becoming familiar with French Gothic art. After this journey he began writing poetry and prose. Apart from their activities in the fields of art and handicrafts, he and his friends were also interested in social reform and they called themselves a brotherhood, meaning a union with an ideological and social orientation. It was under the influence of Rossetti that Morris, together with Burne-Jones, decided to become an artist. However, his special attention was directed towards applied art, whose forms he intended to revive. He also intended to use applied art in opposition to machine work, of which he disapproved. He felt that the disciplined form of Gothic art, and the Gothic treatment of line, were his artistic models. In 1861 he founded Morris, Marshall, Faulkner & Co., a company for the applied arts, in which Burne-Jones, Rossetti and Ph. Webb had a share. The crafts produced by this firm provided an example for other countries too. In 1891, Morris founded the Kelmscott Press in Hammersmith, London, for which he designed three type faces, Golden Type, Troy Type and Chaucer Type. Apart from Morris, other important artists also worked for the Kelmscott Press, which produced lavishly ornamented books of very high quality by hand. One of the most important of such works is the edition of Chaucer's works with illustrations by Burne-Jones (1896). Morris wrote an Arthurian and a Nibelung epic poem, some verse narratives after the manner of Chaucer, and some prose novels in the style of the Icelandic sagas.

His efforts in the social field were in support of the working class. He felt that the division of society into employers and employees might have fatal effects, and he wished to abolish it.

BIBLIOGRAPHY: The Collected Works of William Morris, with introduction by May Morris, 24 Vols. 1910–1915. – Selected Writings, ed. by G.D.H. Cole, 1934. Selected Writings and designs, ed. by Asa Briggs, 1963. – The Letters of William Morris to His Family and Friends, ed. by Ph. Henderson, 1950. – The Typographical Adventure of William Morris. (Catalogue of exhibition 1957). – Morris-Drucke u. andere Meisterwerke engl. u. amerikanischer Privatpressen. Exhibition Mainz 1954. – Ashbee, C.R., "An Endeavour towards the Teaching of John Ruskin and William Morris" 1901. – Bloomfield, P., "William Morris". London 1934. – Clutton-Brock, A., "William Morris, His Work and Influence". 1914. – Cockerell, S.C., "A Note by William Morris on His Aims in Founding the Kelmscott Press" (with list of publications of the press) 1898. – Cole. G.D.H., "William Morris as a Socialist", in: TRANSACTIONS OF THE WILLIAM MORRIS SOCIETY. 1960. –

Crane, W., "From William Morris to Whistler". 1911. – Crow, G.H., "William Morris, Designer", in: THE STUDIO, 1934. – Forman, H.B., "The Books of Wlliam Morris". 1897. – Grennan, M.R., "William Morris". New York 1945. – Grey, L.E., "William Morris". London 1949. – Henderson, Ph., "William Morris". 1952. – Küster, E., "Mittelalter und Antike bei William Morris". 1928. – Lewis, C.S., "William Morris", in "Rehabilitations". 1939. – Mackail, J.W., "The Life of William Morris". 2 Vols. 1899, new edition 1950. – Morris, M., "William Morris, Artist, Writer, Socialist". 2 Vols. 1936. – Noyes, A., "William Morris", English Men of Letters Series. 1908. – Pevsner, N., "Pioneers of Modern Design from Morris to Gropius". New York 1936 and 1948. – Schleinitz, W.v., "William Morris, sein Leben und Werken", in ZEITSCHRIFT FÜR BÜCHERFREUNDE 1907/08. – Schmid-Künsemüller, F.A., "William Morris und die neuere Buchkunst". 1955. – Scott, T., "A bibliography of the works of William Morris". 1897. – Halliday, Sparling, H., "The Kelmscott Press and William Morris, Master-Craftsman". 1924. – Vallance, A., "William Morris, his art, his writings and his public life". London 1897. – Zapf, H., "William Morris. Sein Leben und Werk in der Geschichte der Buch- und Druckkunst. 1949.

WORKS: William Morris, "Poems by the Way". 1891. Printed in black and red. – W.S. Blunt, "The love, lyrics and songs of Proteus". 1892. Printed in black and red. – John Ruskin, "The nature of Gothic", with a foreward by William Morris. 1892. – William Morris, "A dream of John Bull. A king's lesson". 1892. – Woodcut by Burne-Jones. – Jacobus de Voraigne, "Legenda Aurea". English by William Caxton. Edited by F.S. Ellis. Illustrated by Burne-Jones. 3 Vols. 1892. – Raoul Lefèvre, "Die Geschichte von Troya". English by William Caxton. Printed in black and red. Two Vols. 1892. – William Caxton, "The history of Reynard the foxe". Printed in black and red. 1892. – "The order of Chivalry". Translated from French into English by William Caxton. Printed in black and red. Woodcut by Burne-Jones. 1893. – Alfred Lord Tennyson, "Maud", a monodrama. Printed in black and red. 1893. – "The tale of king Florus and the fair Jehane". English by William Morris. Printed in black and red. 1893. – William Morris, "The story of the glittering plain". With woodcuts by A. Lervertett after drawings by by Walter Crane. Printed in black and red. 1894. – "Of the friendship of Amis and Amile". Translated into English from the old French by William Morris. Printed in black and red. 1894. – John Keats, Poems. Edited by F.S. Ellis. Printed in black and red. 1894. – "The tale of emperor Coustans and of over sea". Translated into English from the old French by William Morris. Printed in black and red. 1894. – William Morris, "The wood beyond the world". Title page woodcut by W. Spielmayer after a drawing by Burne-Jones. Printed in black and red. 1894. – "The book of wisdom and lies". English by Oliver Wardrop. Printed in black and red. 1895. – "Psalmi penitentiales". A rhymed English version of the seven penitential psalms. Edited by F.S. Ellis. Printed in black and red. 1894. – "Syr Perecyvelle of Gales". Edited by F.S. Ellis. Printed in black and red. 1895. – William Morris, "The life and death of Jason". Two woodcuts by W. Spielmeyer after drawings by Burne-Jones. 1895. – William Morris, "Child Christopher and Goldilind the fair". 2 Vols. Printed in black and red. 1895. – "The tale of Beowulf". Edited by William Morris. Printed in black and red. 1895. – William Morris, "The well at the world's end". With four woodcuts made by by Burne-Jones. Two column, Printed in black and red. 1896. – The Works of Geoffrey Chaucer. Edited by F.S. Ellis. With 87 illustrations by Burne-Jones with woodcuts by W.H. Hooper. Numerous

Edward Burne-Jones, Illustration for "The Golden Legend" (Legenda ▷ Aurea) by Jacobus de Voraigne. Kelmscott Press, Hammersmith 1892. Wood engraving. 24×17.5 cm.

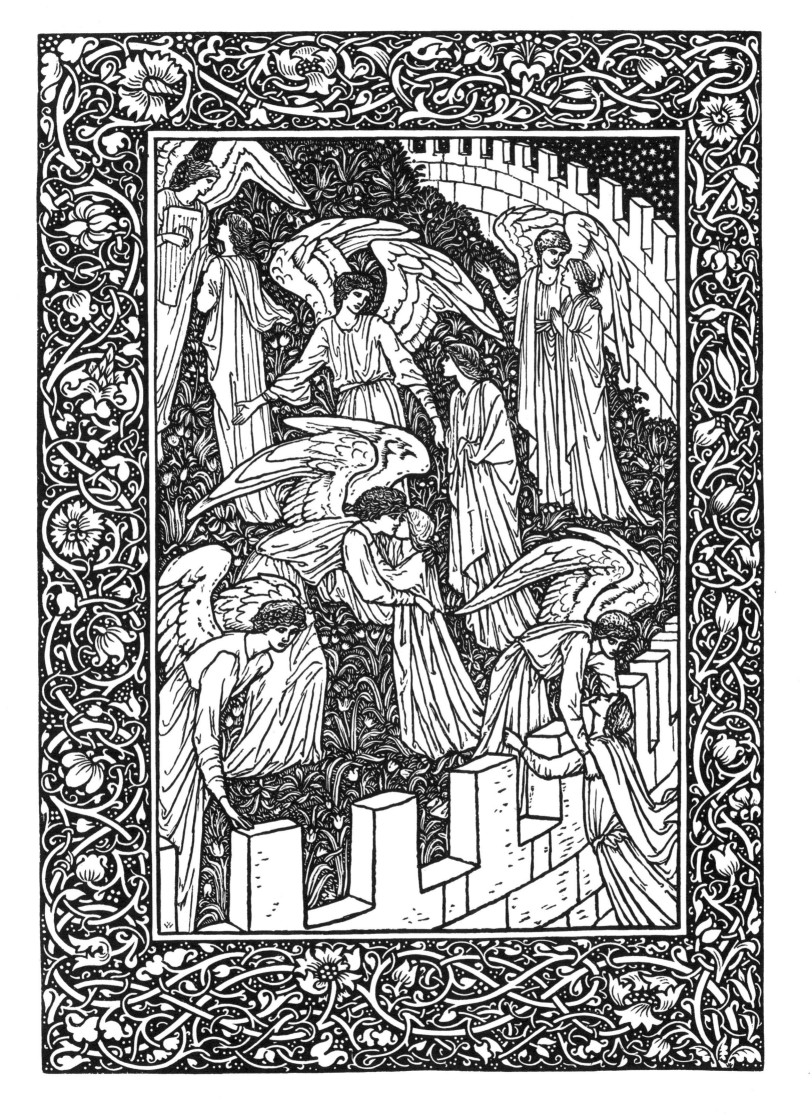

woodcut borders. Folio. 1896. Morris's main work and the last he completed himself. In two columns Printed in black and red. – "Laudes beatae Mariae Virginis". Edited by S.C. Cockerell. Printed in black, red and blue. 1896. – "The floure and the leafe, and the boke of Cupide" – edited by F.S. Ellis. – Printed in black and red. 1896. – Edmund Spenser, "The Shepheardes Calendar". Edited by F.S. Ellis. Twelve full-page illustrations by A.J. Gaskin. Printed in black and red. 1896. – William Morris, "The water of the wondrous isles". In two columns, printed in black and red. 1897. – "Sire Degrevaunt". Edited by F.S. Ellis. Woodcut after a drawing by Burne-Jones. 1897. – "Syr Ysambrace". Edited by F.S. Ellis. Woodcut after a drawing by Burne-Jones. Printed in black and red. 1897. – Some 15th century German woodcuts. From the collection of William Morris edited by S.C. Cockerell. Printed in black and red. 1898. – William Morris, "The story of Sigurd the Volsung and the fall of the Niblungs". (The Siegfried Saga) Two woodcuts after drawings by Burne-Jones. Printed in black and red. 1898. – William Morris, "The sundering flood". Printed in black and red. 1898. – William Morris, "Love is enough, or the freeing of Pharamond". Two Woodcuts after drawings by Burne-Jones. Printed in black, red and blue. 1898. – A note by William Morris on his aims in founding the Kelmscott Press. With a short description by S.C. Cockerell and a list of the books printed there. Printed in black and red. With samples of illustrations and border strips. The last book to be printed at the Kelmscott Press. Completed 24th March 1898. – Jean Froissart, "Chronicles". Morris planned a de luxe edition in two folio volumes. Only two sample pages were published, printed on parchment and showing the coats of arms of France, Germany and England.

SIR EDWARD C. BURNE-JONES

Sir Edward C. Burne-Jones, a painter, draughtsman and skilled crafts designer, was born in Birmingham on 28 August 1833 and died in London on 17 June 1898. It was orginally intended that he should join the clergy, and he commenced theological studies. In 1853 he went to Exeter College, Oxford, together with William Morris, with whom he made friends, a friendship which lasted a lifetime. In 1854, Burne-Jones's attention was drawn to the Pre-Raphaelites by some lectures given by the art critic Ruskin, and also by some exhibitions which were held. After a meeting with Rossetti in London, Burne-Jones decided to become a painter. In 1855 he went to France with Morris, and also moved from Oxford to London, where he remained with Morris for a while. In 1859 and 1862 he travelled to Italy; on his second trip there he was accompanied by Ruskin. In 1865 he moved to Kensington, and shortly thereafter to Fulham. He was almost exclusively a water-colour painter until 1870, and was a member of the "Society of Painters in Water Colours". After this period he also executed graphic works, particularly illustrations for the Kelmscott Press books. Burne-Jones and William Morris have become famous for the revival of the art of book production in England. He received a baronetcy in 1894. His style was determined by the combination of Pre-Raphaelitism and Art Nouveau, and it was through his influence that this combination had a particular effect on Art Nouveau in Munich and Vienna.

BIBLIOGRAPHY: Burne-Jones, G., "Memorials of Edward Burne-Jones". 2 Vols. 1904. – Bell, M., "Sir Edward Burne-Jones". London 1903. – Schleinitz, O.v., "Burne-Jones". Leipzig 1901. – Aymer, Vallance, "The Decorative Art of Sir Edward Burne-Jones, Baronet". THE ARTS JOURNAL 1900.

WORKS: Illustrations for: Morte d'Arthur, by Sir Thomas Malory; Idylls of the King, by Tennyson; The Golden Legend by Jacobus de Voraigne and works for Kelmscott Press books; in particular the 87 drawings for the edition of Chaucer (published 1897).

ARTHUR J. GASKIN

Arthur J. Gaskin, who worked as a painter, graphic artist and craftsman, as born in Birmingham on 16 March 1862 and died in Chipping Campden on 4 June 1928. He was the son of the painter Henry Gaskin. He attended the Birmingham School of Art and was influenced by the Pre-Raphaelites; he worked with Emery Walker and William Morris. Gaskin went to Italy in 1897, where he was very impressed by early Italian panel-painting. In the 1890s he worked mainly as a painter but then turned to the skilled crafts and became the Principal of the Jeweller's School of Art in Birmingham (until 1924). He moved to Chipping Campden for health reasons.

The style of his illustrations was determined by the style of the Kelmscott books. Compared with the works of Morris and Burne-Jones, his drawings show a softer and more arabesque-like line, which makes his style close to that of the French Nabi group. The pictorial impact of his illustrations is emphasized by the absence of any ornamental strips in the borders of the pictures.

BIBLIOGRAPHY: Southall, J., "In Memoriam Arthur Joseph Gaskin". Atelier I, in: THE STUDIO, April 1931, p. 253–255.

WORKS: Contributions to the ENGLISH ILLUSTRATED MAGAZINE, published by Emery Walker, and illustrations for Kelmscott Press books. Illustrations for: E. Spenser, 'The Shepheardes Calendar'. (London 1896, Kelmscott Press), in addition a fairy-tale by Andersen (Birmingham 1893 and London 1894); for Neale, Good King Wenceslas (Birmingham 1895). – Illustrations for Georgina Cave Gaskin, the wife of the artist, "Divine and moral Songs for Children" (1896), "Little Girls and little Boys (1898)", et al.

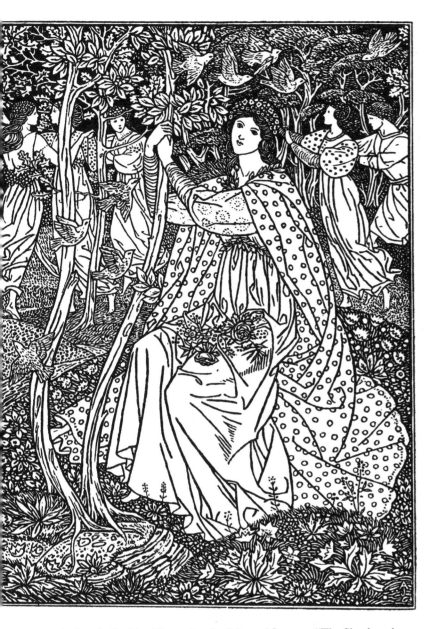

Palinode. Piers.

Palinode S not thilke the mery moneth of May,
When love-lads masken in fresh aray?
How falles it, then, we no merrier bene,
Ylike as others, girt in gawdy greene?
Our bloncket liveryes bene all to sadde
For thilke same season, when all is ycladd
With pleasaunce: the grownd with grasse, the woods
With greene leaves, the bushes with bloosming buds.
Yougthes folke now flocken in every where,
To gather May bus-kets and smelling brere:
And home they hasten the postes to dight,
And all the kirke pillours eare day light,
With hawthorne buds, and swete eglantine,
And girlonds of roses, and sopps in wine.
Such merimake holy saints doth queme,
But we here sitten as drownd in a dreme.
Piers For younkers, Palinode, such follies fitte,
But we tway bene men of elder witt.
Palinode Sicker this morrowe, no lenger agoe,
I sawe a shole of shepeheardes outgoe
With singing, and shouting, and jolly chere:
Before them yode a lusty tabrere,
That to the many a horne-pype playd,
Whereto they dauncen, eche one with his mayd.
To see those folkes make such joyysaunce,

29

Arthur J. Gaskin, Illustration for Edmund Spenser, "The Shepheardes Calender". Printed by Emery Walker and Sydney C. Cockerell in Golden Type. Kelmscott Press, Hammersmith 1896. 15.7×11.6 cm.

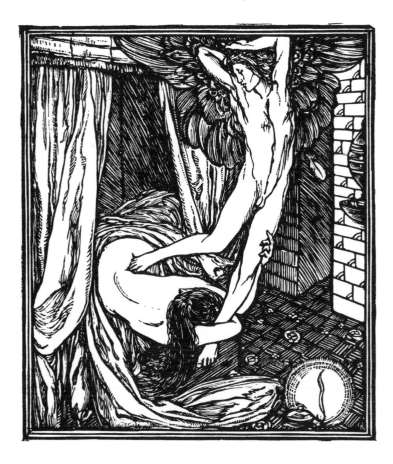

CHARLES RICKETTS

Charles Ricketts, a painter, draughtsman, applied artist and writer on art, was born in Geneva on 2 October 1866 and died in London in 1931. Ricketts spent his youth in France and came to England in 1879 where, at the age of sixteen, he was apprenticed to a well-known wood engraver and etcher in London. From 1889 to 1897 he and Charles Shannon published the magazine THE DIAL. In 1896 he founded the Vale Press for bibliophile book production. He himself produced many of the illustrations for these books. In 1922 he became a member of the Royal Academy. Ricketts belonged to the same school of artists as William Morris and the Pre-Raphaelites and, together with Beardsley, he is reckoned among the most important English Art Nouveau artists. The style of his illustrations was initially associated with the Italian renaissance art of book production and included vigorously contoured human figures and an emphatic distinction beween light and shade. In his later period he abandoned the style of the sharp outline and modelled himself on Dürer's woodcut technique; the richly differentiated graphic linear structure of his work thereby became more important. He had great success with his work for the theatre, for which he created stage settings and figures, His theatrical productions, which included "Salome" by Oscar Wilde, gave the English theatre new inspiration.

BIBLIOGRAPHY: Sutton, D., "Neglected Virtuoso: Charles Ricketts and His Achievements" in APOLLO, February 1966, p. 138ff. - Sturge Moore, T., "Charles Ricketts" London 1933. - Theatrical Designs by C. Ricketts, in BRITISH MUSEUM QUARTERLY, July 1933, p. 6.

WRITINGS OF CH. RICKETTS: "A defence of the Revival of Printing". 1899. - "Recollections of Oscar Wilde". 1932. - "Self Portrait". 1939. - Ricketts and L. Pissarro, "De la Typographie et de l'Harmonie de la page imprimée". William Morris et son influence sur les Arts et Métiers". 1898.

WORKS: Illustrations for the Fairy-tales of Oscar Wilde, A House of Pomegranates (1891, together with Ch. Shannon), Daphnis and Chloe (1893), De Cupidinis et Psyches amoribus (1901), The Parables from the Gospels (1903), Hero and Leander by Marlowe (1894), The Sphinx by Oscar Wilde, Danae (1903), Cupid and psyche (1897). Title pages for: Early Poems of John Milton, Spiritual Poems by John Gray, Second poems by Henry Vaugham, Book of Thel by Blake.

Charles Ricketts, De Cupidinis et Psyches Amoribus. Ed. Vale Press 1901. Wood engraving. Original size.

ARTHUR HEYGATE MACKMURDO

Arthur Heygate Mackmurdo, who worked as an architect, draughtsman and applied artist, was born in London in 1851 and died in Wickham Bishops in 1942. He studied at the Ruskin School in Oxford and then went on a trip to Italy with Ruskin. After his return he settled in London and opened an architectural office. Mackmurdo was a pioneer of modern English architecture and of the "Arts and Crafts Movement". In 1882, together with H.P. Horne and S. Image, he founded the "Century Guild of Artists". He was on friendly terms with William Morris. In 1884 he founded the magazine, THE HOBBY HORSE, England's first well-printed art magazine. Mackmurdo was a founder member of the "Society for the Protection of Ancient Buildings".

Charles Ricketts, The Great Worm, from "The Dial" No. 1, 1889. ▷ Colour lithograph. About original size.

Arthur H. Mackmurdo, Page ornament for "The Hobby Horse". 1884. Woodcut.

BIBLIOGRAPHY: Pevsner, N., "A.H. Mackmurdo", in ARCHITECTURAL REVIEW, 1938, p. 141–143. - Vallance, A., "A.H. Macmurdo", in THE STUDIO XVI, 1899. - Wilson, A., "A.H. Mackmurdo and the Century Guild", in APOLLO, Nov. 1961, p. 137–139.

Lucien Pissarro, Illustration for "Aucassin et Nicolate". Publ. Macmillan & Co. London 1897. Final print in Vale type, printed by E. & L. Pissarro at the Eragny Press, Hammersmith. Coloured wood engraving. 12.2 × 11.9 cm.

"ET DE LE FOILLE AUTRESI, UNE BELLE LOGE EN FIST."

◁ **L. Fairfax Muckley**, Illustration to "Frangilla" by R.D.Blackmore. Ed. Elkin Matthews, London. Wood engraving.

L. FAIRFAX MUCKLEY

L. Fairfax Muckley, a painter and draughtsman, was born in Stourbridge. He studied in Manchester. He gave exhibitions in London between 1890 and 1901. Little research has as yet been done into Muckley's work, and the amount of information available concerning him is scanty. He was part of the circle of artists which included Morris and Burne-Jones, who both had an influence on his style. In a similar way to the works of Gaskin, the lyrical component was more prominent in his illustrations. He creates significant contrasts between pure white surfaces and the surrounding areas; Eve, standing at the tree of knowledge, is suddenly confronted by her mirror image.

LUCIEN PISSARRO

Lucien Pissarro, a painter and draughtsman, was born in Paris in 1863 and died in 1944. He was the eldest son of Camille Pissarro, the painter. He studied painting under his father and drawing under Auguste Lepère. After his studies he emigrated to England where he worked for the Vale Press, owned by Charles Ricketts and Charles Shannon, executing mainly woodcuts. In 1894 he set up his own printing establishment, the Eragny Press; it was named after the Pissarro home in Normandy. Between 1894 and 1914 he published 32 books; his wife, Esther Bensuan, co-operated with him in his work.

Pissarro combined two different stylistic components in his

illustrations. His pictorial representation is related to the simplistic manner of drawing human figures which was used by the Pont-Aven group; the onlooker is reminded of the Breton motifs in the works of Bernard and Sérusier. On the other hand, the coupling of the illustration with the decorative strips in the border and with the type area follows the Morris tradition, with Pissarro simplifying the ornamental motifs and striving for clear and lucidly arranged inter-relationships between the different parts of the picture.

WORKS: Illustrations for the Vale Press and for the Eragny Press. Eg. The Queen of the Fishes, with 12 woodcuts, Aucassin et Nicolate.

Francis D. Bedford, Illustrations for "The Battle of the Frogs and Mice", translated into English by Jane Barlowe. Publ. Methuen & Co. London 1894.
Above: Vignette, original size. Below: Illustrations. Autotype, 14×10.2 cm.

FRANCIS DONKIN BEDFORD

Francis Donkin Bedford, a painter and draughtsman, was born in London in 1864 and died after 1934. He studied at the South Kensington School and the Royal Academy. He was well-known as a landscape painter and gave an exhibition in the Royal Academy in London in 1892.

WORKS: Book illustrations for: Ch. Dickens, A Christmas Carol in Prose, and The Magic Fishbone; G. MacDonald, Princess and the Goblin; E.V. Lucas, Book of Shops, and Four and Twenty Toilers; The Battle of the Frogs and Mice and others. A large number of his illustrated works were published by Methuen in London.

JOHN DUNCAN

John Duncan was a painter of portraits and historical and legendary scenes, as well as an illustrator. He was born in Dundee in Scotland in 1866 and died in Edinburgh in 1945. From 1902-1904 he was in Chicago, USA, where he taught art at the university. His activities included contributing illustrations for THE EVERGREEN, which from 1895 onwards was published by Patrick Geddes.

In contrast to the artists of the Morris circle, who concentrated on the medieval art of book production, Duncan's works show a closer association with Japanese wood-engraving. The bucolic motif and the economic use of lines and dark areas mean that his works resemble Maillol's illustrations stylistically.

AUBREY V. BEARDSLEY

Aubrey V. Beardsley, a graphic artist and illustrator, was born in Brighton on 21 August 1872 and died in Mentone on 16 March 1898. In 1888 he worked for a short period as an apprentice in an architectural studio, and after this he was employed at the Guardian Insurance Office until 1892. He was a self-taught artist, and initially used such models as Dürer, Michelangelo and Botticelli for guidance. In 1891/92 he made the acquaintance of William Morris and Burne-Jones; this led to his decision to become a freelance artist. On the advice of Burne-Jones he went to Westminster School, but soon left it again. He was publicly acknowledged for the first time in 1893 in an article by W. Pennell in THE STUDIO. In 1894-95, Beardsley and Henry Harland published THE YELLOW BOOK, a quarterly magazine dealing with art and literature. He later worked with A. Symons for the magazine THE SAVOY. Most of his works executed from 1894 onwards were illustrations, and also designs for book jackets.

Beardsley created a wealth of artistic works in the few years in which he was able to be active. Pre-Raphaelite influences, the two-dimensional art of Japanese woodcuts, imitations of Greek vase painting and some characteristics of the French Rococo can all be detected in his works, but he very soon found his own unmistakable style in which the undulating outlines and the broad, shadow-less surfaces are the dominating element. The influence of his purely black and white art extended beyond England both to America (see Bradley) and to Europe. Especially in Germany, book illustration developed a style which clearly shows Beardsley's influence.

John Duncan, Illustration for "The Evergreen". Publ. Geddes & Co. London 1895. Autotype. Reduced.

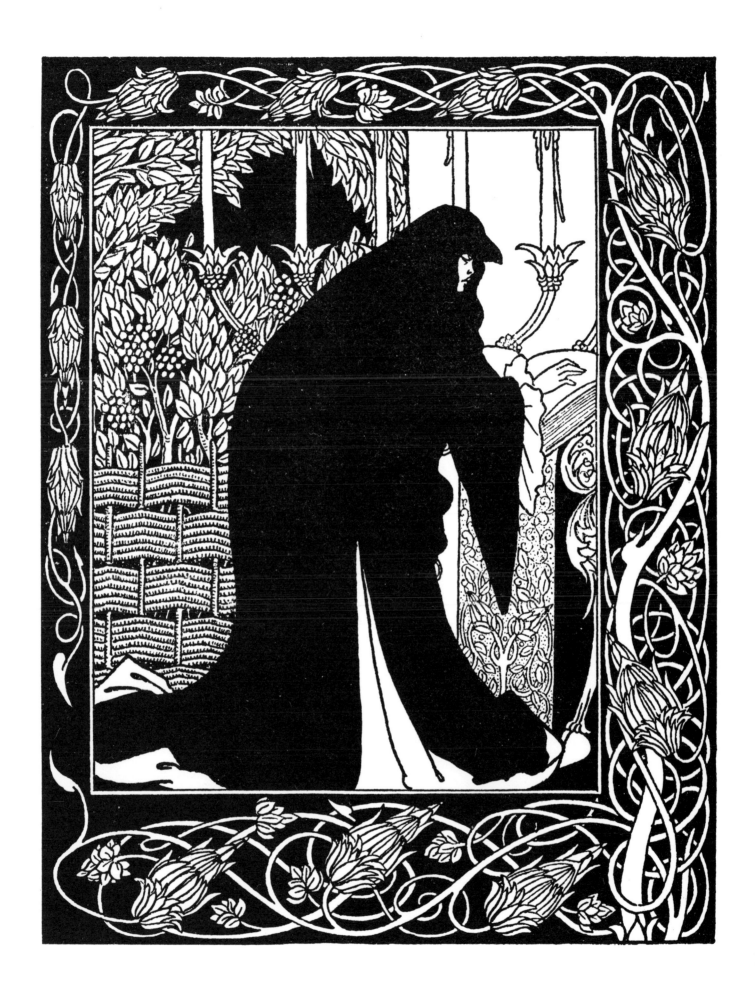

Arthur Symons wrote the following in his monograph on Beardsley:

"Pierrot is one of the types of our century, of the moment in which we live, or of the moment, perhaps, out of which we are just passing. Pierrot is passionate; but he does not believe in great passions. He feels himself to be sickening with a fever, or else perilously convalescent; for love is a disease, which he is too weak to resist or endure. He has worn his heart on his sleeve so long, that it has hardened in the cold air. He knows that his face is powdered, and, if he sobs, it is without tears; and it is hard to distinguish, under the chalk, if the grimace which twists his mouth awry is more laughter or mockery. He knows that he is condemned to be always in public, that emotion would be supremely out of keeping with his costume, that he must remember to be fantastic if he would not be merely ridiculous. And so he becomes exquisitely false, dreading above all things that 'one touch of nature' which would ruffle his disguise, and leave him defenceless. Simplicity, in him, being the most laughable thing in the world, he becomes learned, perverse, intellectualising his pleasures, brutalising his intellect; his mournful contemplation of things becoming a kind of grotesque joy, which he expresses, in the only symbols at his command, tracing his Giotto's O with the elegnce of his pirouette.

"And Beardsley, with almost more than the Parisian's deference to Paris, and to the moment, was, more than any Parisian, this 'Pierrot gamin.' He was more than that, but he was that: to be that was part of what he learnt from France. It helped him to the pose which helped him to reveal himself; as Burne-Jones had helped him when he did the illustrations to the 'Morte D'Arthur,' as Japanese art helped him to free himself from that influence, as Eisen and Saint-Aubin showed him the way to the 'Rape of the Lock.' He had that originality which surrenders to every influence, yet surrenders to absorb, not to be absorbed; that originality which, constantly shifting, is true always to its centre. Whether he learnt from M. Grasset or from Mr. Ricketts, from an 1830 fashion-plate, or from an engraved plate by Hogarth, whether the scenery of Arques Bataille composed itself into a pattern in his mind, or, in the Casino at Dieppe, he made a note of the design of a looped-up window-blind, he was always drawing to himself, out of the order of art or the confusion of natural things, the thing he wanted, the thing he could make his own. And he found, in the French art of the moment, a joyous sadness, the service to God of Mephistopheles, which his own temperament and circumstances were waiting to suggest to him.

"At times he attains pure beauty, has the unimpaired vision; in the best of the 'Salome' designs, here and there afterwards. From the first it is a diabolic beauty, but it is not yet divided against itself. The consciousness of sin is always there, but it is sin first transfigured by beauty, and then disclosed by beauty; sin, conscious of itself, of its inability to escape itself, and showing in its ugliness the law it has broken. His world is a world of phantoms, in whom the desire of the perfecting of mortal sensations, a desire of infinity, has overpassed mortal limits, and poised them, so faint, so quivering, so passionate for flight, in a hopeless and strenuous immobility. They have the sensitiveness of the spirit, and that bodily sensitiveness which wastes their veins and imprisons them in the attitude of their luxurious meditation. They are too thoughtful to be ever really simple, or really absorbed by either flesh or spirit. They have nothing of what is 'healthy' or merely 'animal' in their downward course towards repentance; no overwhelming passion hurries them beyond themselves; they do not

Aubrey Beardsley, (above and right), Chapterhead vignettes for "Le Morte d'Arthur" by Thomas Malory. Original size.

Aubrey Beardsley, (left), Illustration for "Le Morte d'Arthur" by Thomas Malory. 1893/94. Autotype. About 18.2×12.7 cm.

capitulate to an open assault of the enemy of souls. It is the soul in them that sins, sorrowfully, without reluctance, inevitably. Their bodies are faint and eager with wantonness; they desire more pleasure than there is in the world, fiercer and more exquisite pains, a more intolerable suspense. They have put off the common burdens of humanity, and put on that loneliness which is the rest of saints and the unrest of those who have sinned with the intellect. They are a little lower than the angels, and they walk between these and the fallen angels, without part or lot in the world.

"Here, then, we have a sort of abstract spiritual corruption, revealed in beautiful form; sin transfigured by beauty. And here, even if we go no further, is an art intensely spiritual, and, art in which evil purifies itself by its own intensity, and by the beauty which transfigures it. The one thing in the world which is without hope is that mediocrity which is the sluggish content of inert matter. Better be vividly awake to evil than, in mere somnolence, close the very issues

and approaches of good and evil. For evil itself, carried to the point of a perverse ecstasy, becomes a kind of good, by means of that energy which, otherwise directed, is virtue; and which can never, no matter how its course may be changed, fail to retain something of its original efficacy. The devil is nearer to God, by the whole height from which he fell, than the average man who has not recognised his own need to rejoice or to repent. And so a profound spiritual corruption, instead of being a more 'immoral' thing than the gross and pestiferous humanity of Hogarth or of Rowlandson, is more nearly, in the final and abstract sense, moral, for it is the triumph of the spirit over the flesh, to no matter what end. It is a form of divine possession, by which the inactive and materialising soul is set in fiery motion, lured from the ground, into at least a certain high liberty. And so we find evil justified of itself, and an art consecrated to the revelation of evil equally justified; its final justification being that declared by Plotinus, in his treatise

Aubrey Beardsley, Double page spread for "Le Morte d'Arthur", by Thomas Malory. 1893/4. Autotype.

Aubrey Beardsley, Illustration for "Salome" by Oscar Wilde. Publ. ▷ Clowes and Sons. London 1907. Autotype. 17.8×12.6 cm.

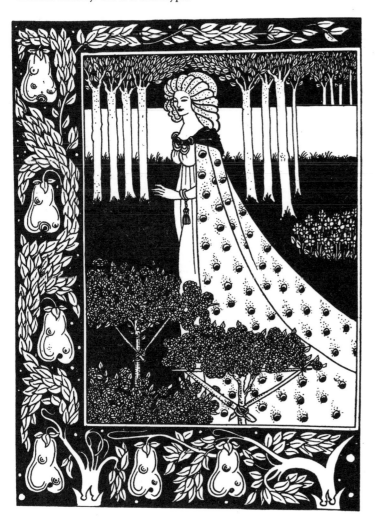

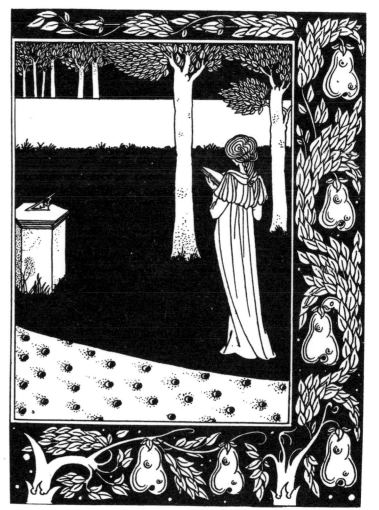

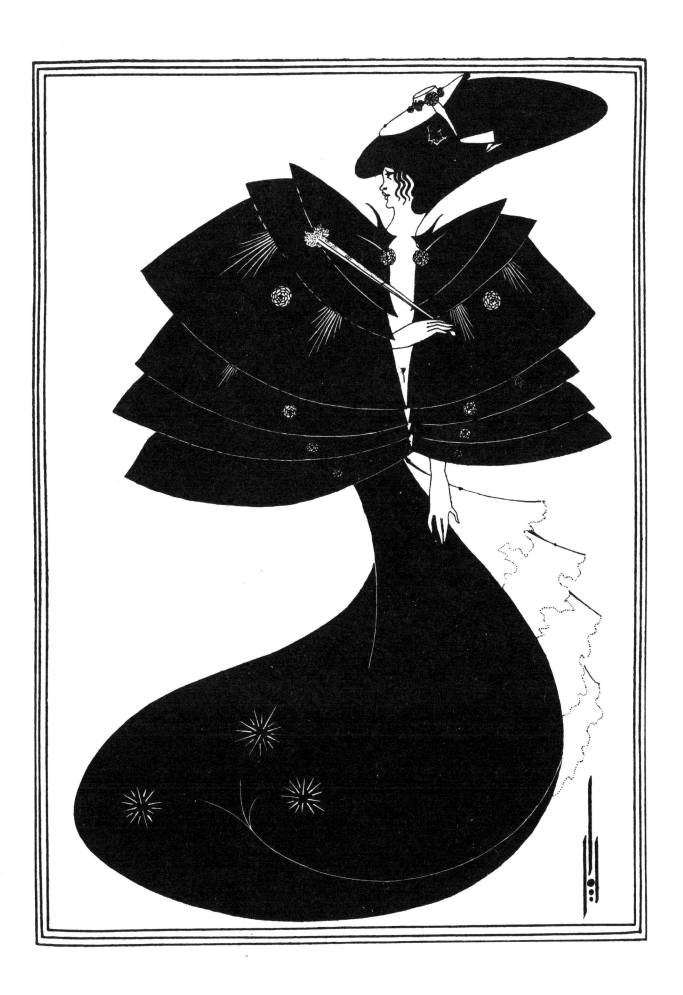

The Chap-Book

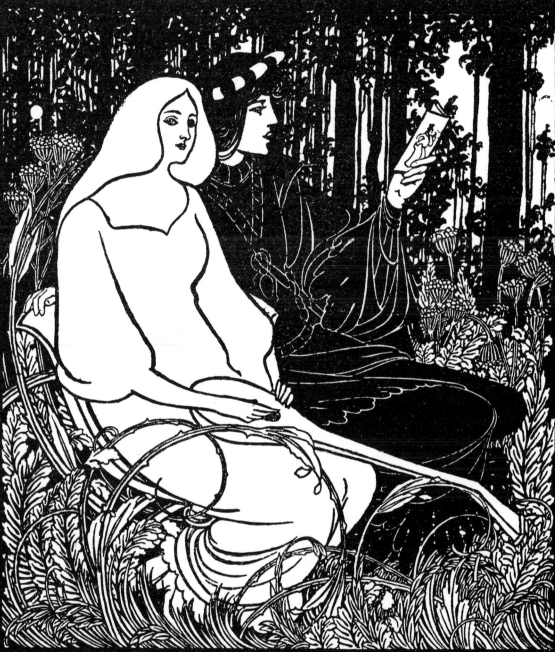

Being A MISCELLANY of Curious and Interesting Songs, Ballads, Tales, Histories, &c.; adorned with a variety of pictures and very delightful to read; *newly composed* by MANY CELEBRATED WRITERS: To which are annex'd a LARGE COLLECTION of Notices of BOOKS

WILL H BRADLEY·1895·

'On the Nature of Good and Evil': but evil is permitted to remain by itself alone on account of the superior power and nature of good; because it appears from necessity everywhere comprehended and bound, in beautiful bands, like men fettered with golden chains, lest it should be produced openly to the view of divinity, or lest mankind should always behold its horrid shape when perfectly naked; and such is the supervening power of good, that whenever a glimpse of perfect evil is obtained we are immediately recalled to the memory of good by the image of the beautiful with which evil is invested."

IBLIOGRAPHY: Aubrey Beardsley. Darmstädter Galerie, L.A. Bergsträsser. Darmstadt (no date) – Esswein, H., "Aubrey Beardsley". 1908. – Hind, G.L., "The uncollected work of Aubrey Beardsley". London 1925. – Hölscher, E., "Aubrey Beardsley". Hamburg 1949. – Macfall, H., "Aubrey Beardsley: The Man and his Work". 1928. – Marillier, H.C., "Early Work of Aubrey Beardsley". 1899. – Penell, J., "A new illustrator". STUDIO year 1, Issue I, 1893. – Ross, R., "Aubrey Beardsley". 1909. – Symons, A., "Aubrey Beardsley". 1898. – Walker, R.A., "The Best of Beardsley". 1948. – id., "Letters from Aubrey Beardsley to Leonard Smithers". 1937. – Vallance, A., "Fifty Drawings by Aubrey Beardsley". 1897. – Catalogue of the Aubrey Beardsley exhibition at the Victoria and Albert Museum London, 1966 (Text by Brian Reade).

WORKS: Illustrated books: Brighton Grammar School. Annual Entertainment. 1888. Past and Present. The Magazine of Brighton Grammar School. 1889. – Le Morte d'Arthur by Thomas Malory. 1893/94. – Salome by Oscar Wilde. 1894. – Lucinas true history. 1894. – THE YELLOW BOOK. Vols. 1–13. 1894–1897. Tales of mystery and wonder, by E.A. Poe. 1895. – Lysistrata, by Aristophanes. 1896. – The Rape of the Lock, by A. Pope. 1896. – THE SAVOY, ed by A. Symons. 3 Vols. 1896. – The Pierrot of the minute, by E. Dowson. 1897. – Mademoiselle de Maupin, by Théophile Gautier. 1898. – Volpone, by Ben Jonson. 1898. – The story of Venus and Tannhäuser, and numerous individual sheets, etc.

WILLIAM H. BRADLEY

William H. Bradley, draughtsman and illustrator, was born in Boston (Mass.) on 10 July 1868, and died in 1962. He was the son of a draughtsman. From 1881 onwards he served an apprenticeship in a printing establishment in Northern Michigan, and from 1885 onwards he worked in various printing houses in Chicago. Bradley worked as a draughtsman and illustrator from the early 1890's onwards, and soon became a leading artist in the field of American posters.

William H. Bradley, Title-page for THE INLAND PRINTER.

◁ **William H. Bradley,** Title-page for "The Chap-Book". Chicago 1895.

Thomas Sturge-Moore, The Pan Peak. From the journal
JUGEND No. 45, p. 760, 1897. Woodcut. 12.2×12.1 cm.

After the publication of an article on Bradley and his posters in THE STUDIO in 1895, Bradley was invited to the first exhibition held at S. Bing's "Salon de l'Art Nouveau".
In 1895 he founded his own printing establishment in Springfield (Mass.) but, although its artistic value was recognized, it soon went out of business, or rather was taken over by the University Press of Cambridge, where Bradley worked for a time as an art teacher. It was in these years that he executed his best and most characteristic works in the Art Nouveau style, and he became its leading exponent in America. After giving up his own printing establishment he worked for a type foundry called The American Type Founders Company. From September 1904 to 1905, he published a monthly book of patterns called THE CHAP BOOK for this company. Apart from numerous commissions for well-known newspapers and printing houses, and apart from his book illustrations, Bradley also provided modern and artistically designed children's toys. During the first quarter of the 20th century, Bradley was the best-paid artist in the States; he worked until the end of his life and in his last years he was given the honorary title of "Dean of American Typographers". His style was close to that of Beardsley.

BIBLIOGRAPHY: Koch, R., "Will Bradley", in ART IN AMERICA, Fall 1962, p. 78f. – id., "Artistic Books, Periodicals and Posters of the 'Gay Nineties'", in ART QUARTERLY, Winter 1962, p. 373–376. – Rowland, S., "Masters of the Poster", in COMMERCIAL ART, Jan. 1934, p. 34–35.

WORKS: Illustrations and posters for the following journals: THE CHICAGO TRIBUNE, THE ECHO and THE INLAND PRINTER. Designs for book and sheet music bindings. Illustrations for, "Columbian Ode" by Harrie Monroe, 1893, THE CHAP-BOOK, "Fringilla" by Richard Blackmore, 1895, and numerous children's books.

THOMAS STURGE MOORE

Thomas Sturge Moore was a draughtsman, poet and writer on art. He was born in Petersfield, Hampshire, on 4 March 1870. He occasionally worked on the magazine JUGEND.

BIBLIOGRAPHY: Birdge, U., "W.B. Yeats and Th. Sturge Moore. Their Correspondence 1901–1937". 1953. – French, C., " Thomas Sturge Moore". 1921. – Gwynn, F.L., "Sturge Moore and the Life of Art". 1952. – The Writings of Sturge Moore: Albrecht Altdorfer, Little Engravings. 1903. A Brief Account of the Origin of the Eragny Press. 1903. Art and Life. 1910.

CHARLES H. SHANNON

Charles H. Shannon, a painter and draughtsman, was born in Quarrington on 26 April 1863 (1865, according to Thieme-Becker), and died in Kew, Surrey, on 18 March 1937. He was apprenticed to a xylographer and wood-engraver at whose premises he met Charles Ricketts. He developed a life-long friendship with him and the two constantly worked together. Shannon became known primarily as an illustrator and xylographer.

From 1889 onwards he published the magazine THE DIAL together with Ricketts. His paintings are somewhat imitative of the Italian Renaissance. After 1904 he turned to lithography and by 1919 had executed 46 lithographs. He was a member of the Royal Academy in London from 1911 onwards.

The charm of Shannon's illustrations lies in the finely differentiated linear circumscription of his subjects which in other respects are drawn direct from nature. The manner of his graphic dissolution of the modelled shapes goes beyond the Impressionist effect to achieve a mysteriously attractive type of alienation.

BIBLIOGRAPHY: Derry, G., 'The Lithographs of Charles Shannon". 1920. – Masters of Modern Art, Charles Shannon. 1920 – George E.B., "Charles Shannon". 1924. – Ricketts, Ch., "A Catalogue of Mister Shannon's Lithographs". 1902.

WORKS: Contributions to HARRY QUILTER'S UNIVERSAL REVIEW, the journal THE DIAL, works for the Vale Press. Daphnis and Chloë (1893) – Illustrations (together with Rickett) and illustrations for Hero and Leander (1894). Individual sheets, mainly lithographs: White Nights, The three sisters, The white Robe, Mother and Child, The fantastic dress, Sea and Breeze, The ruffled sea. Portraits of his friends; Ricketts, Legros, Pissarro and others.

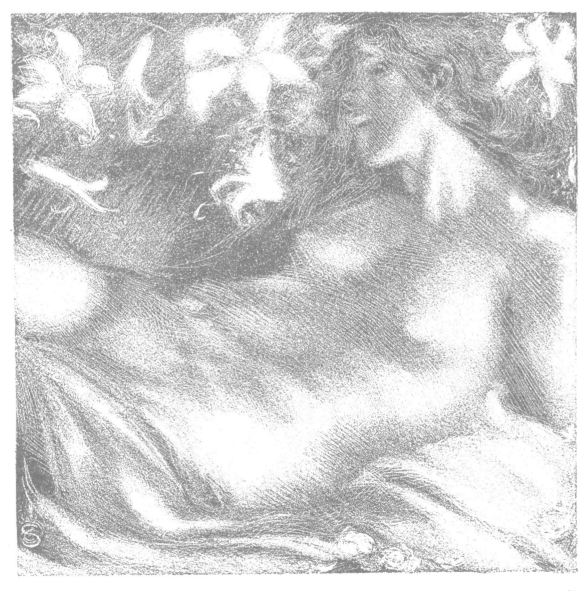

Charles Shannon, Female nude. From the journal JUGEND No. 48, p. 811. 1897. Lithograph. Original size.

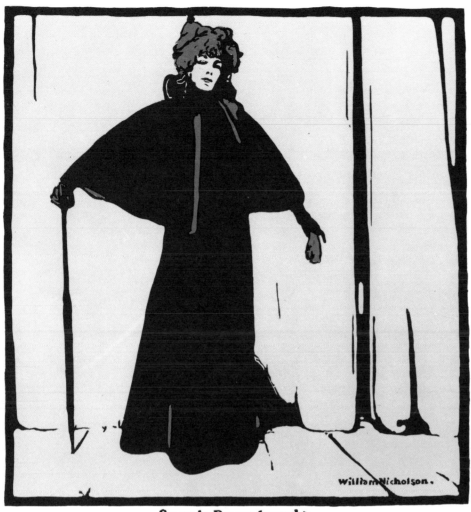

Sarah Bernhardt.

William Nicholson, Sarah Bernhardt. From "Twelve Portraits". 1899. Lithograph. 26 × 25 cm.

WILLIAM NICHOLSON

William Nicholson, who worked as a painter, draughtsman and wood engraver, was born in Newark, Trent on 5 February 1872 and died in Blewbury, Berkshire, on 6 May 1949. He attended the Académie Julian in Paris for a short period, but was otherwise self-taught. The first of his woodcuts to be published appeared in the period from 1896 onwards. In collaboration with James Pryde, whom he met at Herkomer's School in London, he designed woodcut posters which appeared under the pseudonym "The Brothers Beggarstaff". These posters made a decisive contribution to the development of English woodcut posters, and also influenced graphic art in Europe. Nicholson also worked on theatrical designs as well as creating still-lifes and landscapes. In 1936 he was made a peer. He was recognized as a painter on the basis of his portraits of members of London society.

The success of his graphic work is based on his remarkable talent for observing characteristic attitudes, movements and physiognomies which, making economical use of resources,

he expressed in pure contrasts of surfaces. The frame is set closely around the human figures and thereby lends concentrated force to the statement being made. In Nicholson's posters, the contrast between the negative and positive surfaces is a vital element in achieving the required result of being visible at a distance.

BIBLIOGRAPHY: Browse, L., "William Nicholson". 1956 (with bibliography). White, G., "The coloured prints of William P. Nicholson" in THE STUDIO 12, 1898.

WORKS: Woodcut posters for "J. and W. Beggarstaff". – Douze Portraits par William Nicholson, H. Fleury, Editeur, Paris. (Queen Victoria, Sarah Bernhardt, Kaiser Wilhelm II., Bismark and others). – An Alphabet (1898). – Almanach of Twelve Sports (1898). – London Types (1898). – Illustrations for Peter Pan (1904). – The Square Book of Animals (1856). – Character of Romans (1900).

William Nicholson, Poster for the "Lyceum Don Quixote". Lithograph. ▷ 22.5 × 21.7 cm.

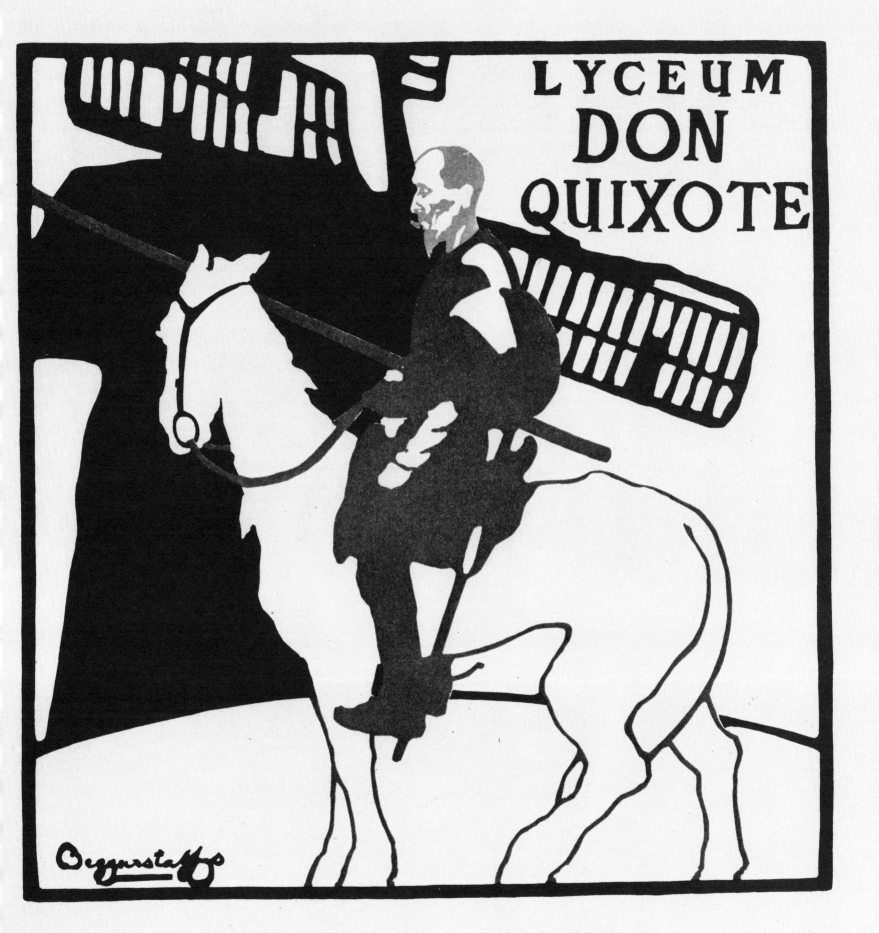

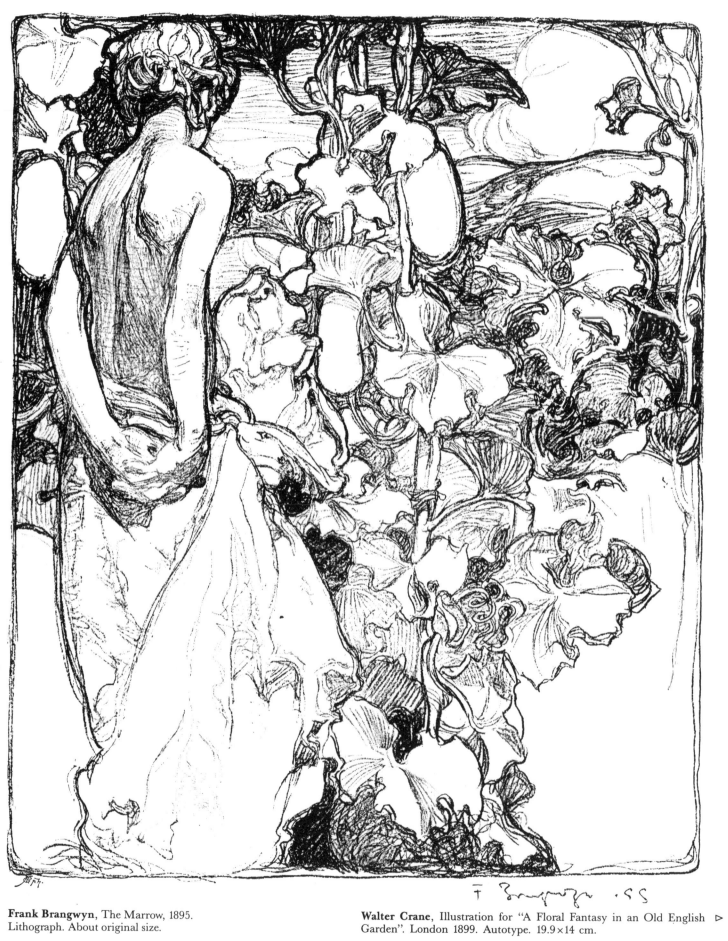

Frank Brangwyn, The Marrow, 1895.
Lithograph. About original size.

Walter Crane, Illustration for "A Floral Fantasy in an Old English ▷
Garden". London 1899. Autotype. 19.9×14 cm.

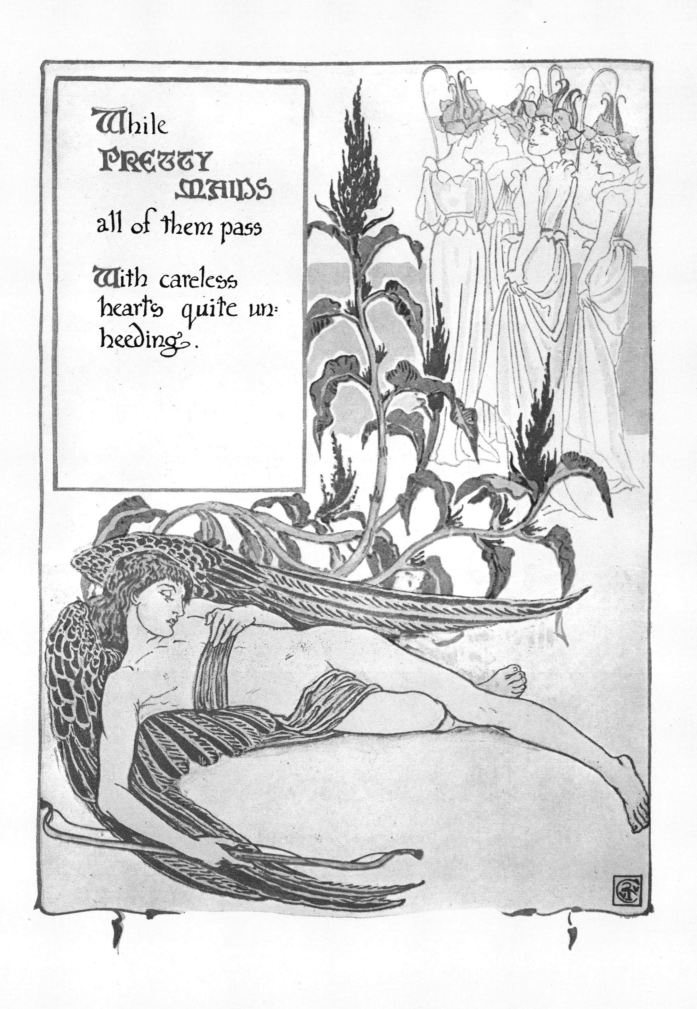

While
PRETTY
MAIDS
all of them pass

With careless hearts quite un=heeding.

FRANK BRANGWYN

Frank Brangwyn, a painter, draughtsman, architect and applied artist, was born in Bruges on 15 May 1867 and died in Ditchling, Sussex, on 11 June 1956. He attended the South Kensington Art School in London and then worked for three years in William Morris's studio. In the period from 1887 onwards he went on study trips to the Orient, Spain, Italy and Africa. Oriental art provided him with inspiration. From 1885 onwards he submitted pictures to the Royal Academy in London. From 1891 to 1895 he studied at the Académie Julian in Paris, where he made the acquaintance of the Nabis and exhibited his works at the Salon d'Automne. In 1904 he was appointed an associate of the Royal Academy in London. From 1897 to 1910 his pictures were shown at the Biennale in Venice. In the field of graphic art he was of importance chiefly as an etcher and lithographer. In 1952 he became the first living artist to be honoured with a retrospective exhibition of his works at the Royal Academy in London.

BIBLIOGRAPHY: "Frank Brangwyn, A Master of Watercolor", in AMERICAN ARTIST, March 1959, p. 40–41. – Brangwyn Catalogue, in AMERICAN ARTIST, January 1957, p. 6. – Belleroche, W. de., "Brangwyn Talks", 1944. – id., "Brangwyn's Pilgrimage", 1949. – Furst, H., "The Decorative Art of Frank Brangwyn", 1924. – Gaunt, W., "The etchings of Frank Brangwyn". London 1926. – Kent, N., "Frank Brangwyn", in AMERICAN ARTIST, May 1956, p. 18–23. – Macer-Wright, P., "Brangwyn". 1940. – Shaw-Sparrow, W., "Frank Brangwyn and his work". London 1915. – Stanley, J., "Frank Brangwyn and his Art", in THE STUDIO 12, 1898. – Catalogue of the etched work of Frank Brangwyn. London fol. 1912.

WALTER CRANE

Walter Crane, a painter, draughtsman, applied artist and writer on art, was born in Liverpool on 15 August 1845 and died in Horsham, Sussex, on 14 March 1915. He was the son of Thomas Crane, the miniature-painter. His family moved to London in 1857. He studied the writings of Ruskin the art critic, and came into contact with Pre-Raphaelite pictures. From 1859 to 1862 he worked as an apprentice in the studio of W.J.Linton, the xylographer. His first picture, "The Lady of Shalott", was critically acknowledged by the Royal Academy in 1862. From 1864 onwards he worked with Edmund Evans, the xylographer and printer. Crane's graphic work was strongly influenced by his studies of Japanese colour prints, and partly adopted the methods used in them. In the period between 1869 and 1875 he created a series of books for children and books of fairy-tales. As a painter he was a disciple of the new Pre-Raphaelite movement. In the period between 1871 and 1888 he travelled to Italy, where quattrocento art provided him with new ideas. Crane was the founder and president of the "Art Workers' Guild" and, in 1888, also of the "Arts and Crafts Exhibition Society". From 1893-96 he was Principal of the Manchester School of Art; from 1896-98,

Walter Crane, schematic drawing of a Parthenon metope. From "Rudiments of Drawing", 1898. Reduced.

Principal of Reading College and, finally, from 1898-99 he was Principal of the Royal College of Art, South Kensington. In 1894 he worked with William Morris and this association resulted in illustrations for "The Story of Glittering Plain"; these were in the style of 16th century German and Italian woodcuts and were printed by the Kelmscott Press. Crane's significance lies mainly in the graphic works which he produced for books. He was also a champion of the English reform movement in all areas of applied art.

Crane was important both because of his theoretical works in which he established the aesthetics of Art Nouveau, and also because of his activity as a book illustrator. It was particularly in his fairy-tale illustrations that he captured the atmosphere of the time, an atmosphere which showed a great preference for metamorphoses of a fairy-tale and dreamlike character. His human figures undergo transformations into a state bordering on the figurative and the floral. These transformations are just as real and unreal as the shapes that appear in dreams and hallucinations. The effect of these illustrations was based on on the close unity existing between narrative and fantasy. Crane had an obvious influence on Ernst Kreidolf, the Swiss artist. Between 1865 and 1876, Routledge and Sons published two or three books of fairy-tales each year, and these books resulted in Crane having a great influence in Germany too.

BIBLIOGRAPHY: "The Work of Walter Crane", in ART JOURNAL EASTER ANNUAL, 1898. – Berlepsch, H.E. von, " Walter Crane", in KUNST FÜR ALLE II, 1896. – Konody, B.G., "The Art of Walter Crane", London 1902. – Schleinitz, O. Von, "Walter Crane". Leipzig 1902.

WRITINGS OF WALTER CRANE: Claims of decorative Art. London 1892 (German, Berlin 1896). – An Artist's Reminiscences. 1901 (1907). – Decorative Illustration of Books. London 1896 (German, Leipzig 1901).

Fred Hyland, Female face (Ophelia?) from
THE SAVOY, 1896. Autotype. Slightly reduced.

– The Base of design. London 1898 (German, Berlin and Leipzig, no
date). – Linie und Form, German edition, Leipzig 1901.

WORKS: Contributed to the socialist journal JUSTICE AND THE
COMMONWEALTH. Cartoons for the Cause (1896). Numerous illustrations
for fairy-tales, picture books and nursery rhymes. Illustrations for:
Edmund Spenser's The Fairie Queen, A Floral Fantasy in an Old English
Garden, The Shepheard's Calendar. The Song of Sixpence (1865). –
The Baby's Opera (1877). – Pan Pipes (1882). – Household Stories
(1882). – Echoes of Hellas (1888). – Flora's Feast (1889). – Queen's
Summer (1891). – Illustrations for Shakespeare (1893/94). – Illustrations
for the Bible (1901 ff.) and others.

FRED HYLAND

It was not possible to discover any biographical data
concerning Fred Hyland, although drawings by him
appeared in Beardsley's SAVOY and he must, therefore, have
belonged to that artist's circle of acquaintances. However,
the fact that Hyland displayed a new nuance of the English
Art Nouveau seems to us to be of more decisive importance
than any data which one might be able to catalogue. The
enigmatic face with the accentuated eyes is a Pre-Raphaelite

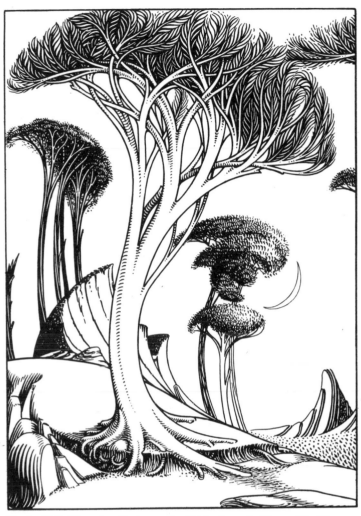

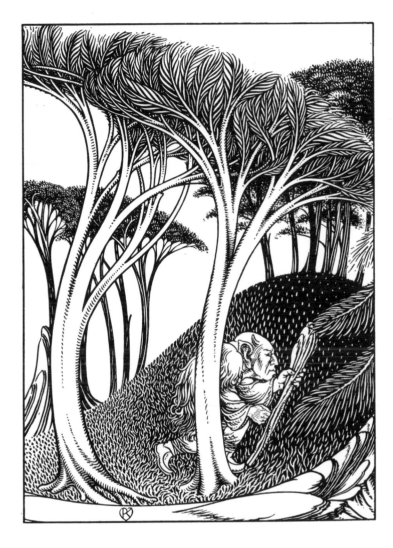

Reginald L. Knowles, Endpaper for "Tales from the Norse. The Haunt of the Troll". Publ. G. Routledge and Sons Ltd. c. 1910. About original size.

tradition. The hair flows around the face in stylized linearity, and this is evidently the first time that this had happened in the English movement. The flow of the hair, and the fact that it becomes mingled with flowers, gives rise to the idea of Ophelia appearing in a dream. Two years later, in 1898, Peter Behrens made still more of an abstraction out of the hair motif.

REGINALD L. KNOWLES

Like the artist just discussed, not much is known about R.L. Knowles, even though THE STUDIO, in a special number published in 1914 on the subject of book illustration, gave an example of his work by printing the illustration reproduced here. It shows a late period of the Art Nouveau style and displays a mannered hardness but also a clear arrangement which emphasizes the comic subject and consists of the repetition of identical shapes and complementary linear movements.

ARTHUR RACKHAM

Arthur Rackham, a draughtsman and illustrator, was born in London on 19 September 1867 and died in Surrey on 6 September 1939. He studied at the Lambeth School of Art in London. Rackham soon made his name as an illustrator, and won gold medals in Milan in 1906 and in Barcelona in 1911. He beame a member of the Société Nationale des Beaux-Arts in 1912, and in 1919 he was appointed Master of the Art Workers' Guild. He was one of the most important illustrators of fairy-tales working at the turn of the century.

The techniques he employed were, firstly, pen drawings which formed a silhouette as if the paper had been cut out with scissors, and secondly, a technique using a combination of watercolour and gouache; this latter technique was also

Arthur Rackham, Illustration for "A Midsummer Night's Dream". 1908. ▷ Autotype. Original size.

used by Dulac who was influenced by Rackham. The intermediate colour tones achieved by this technique are almost impossible to reproduce, even though Rackham created them exclusively for reproduction by autotype.

"Perhaps the most admirable feature of Rackham's art is his inexhaustible imagination. He is never at a loss for an idea and never becomes boring. Further factors which must be acknowledged are his unfailing steadiness of hand and his familiarity with all living things in the wide world of nature. He acquired this knowledge as a result of the studies which he pursued eagerly in his early youth. The onlooker delights in the sparklinghumour which is to be found in many of his pictures, which never becomes coarse and is also an essential trait of this artist's aimiable character.

"His power of depiction is no less deserving of praise than is his inventiveness. All his works display a technical perfection and an emotional content such as are found only in the creations of the greatest artists. This applies to all of Rackham's art, whether in the field of watercolours, pen drawings, or those coloured drawings which Rackham particularly preferred to use in his book illustrations and with which he had such great success. He reached that high technical level which it is possible to achieve in any art form and in which the artist is in such command of his hand and eye that he is able to reproduce every thought and every vision. The true master can also be recognized from the fact that the difficulties of his art, which nevertheless always have to be overcome, remain invisible to the eye of the onlooker beholding the finished work. The nature studies which Rackham pursued in his youth were a necessary precondition for his astonishing technique; without this deep knowledge of nature he would never have been able to invent those wonderful grotesques which play such an important role in his art."

(E.M.Chadwick)

Arthur Rackham, Illustrations for "The Sleeping Beauty". Publ. William Heinemann, London/J.B. Lippincott and Co. Philadelphia. 18.9×15 cm.

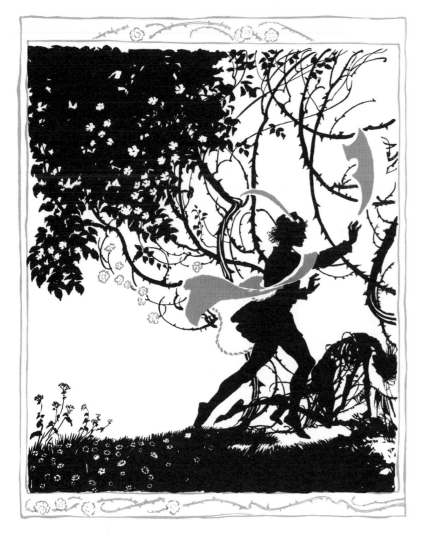
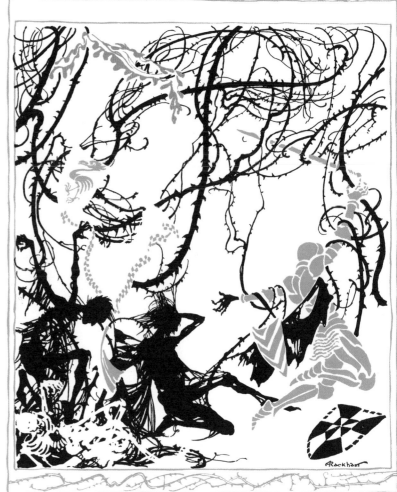

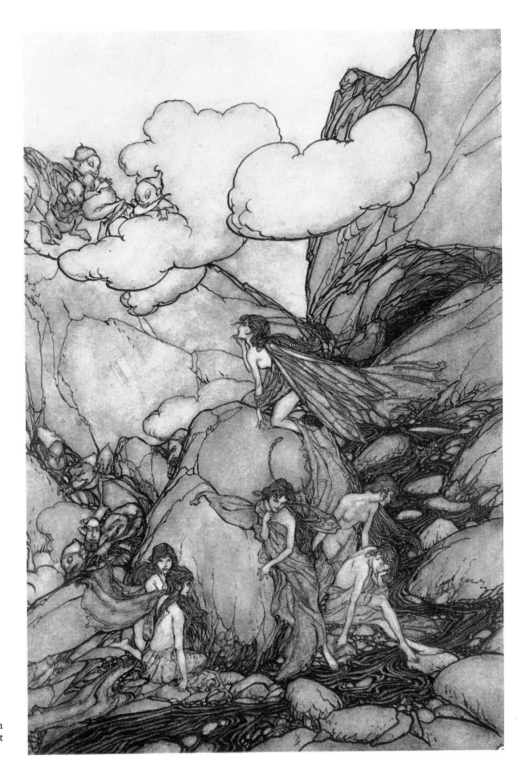

Arthur Rackham, Illustration for "Rip van Winkle". W. Irving. London. Autotype. About original size.

BIBLIOGRAPHY: Chadwick, E.M., "Arthur Rackham", in DEKORATIVE KUNST XIII. Dec. 1909, p. 105–110. – Dereck, H., "Arthur Rackham. His Life and Work". 1960.

WORKS: Illustrations for: Rip van Winkle, Peter Pan, Alice in Wonderland, Ingoldsby Legends, The Sleeping Beauty, Midsummer Night's Dream, Undine, Grimm's Fairy-Tales, Aesop's Fables, Dickens's A Christmas Carol, The Tempest, The Compleat Angler, Tales of Mystery and Imagination by Poe, The Rubáiyát, Peer Gynt, as well as illustrative work for the journals: PUNCH, THE GRAPHIC, ST. NICHOLAS, LITTLE FOLKS, BLACK AND WHITE, THE SKETCH and others.

WILLIAM THOMAS HORTON

William Thomas Horton, a painter and draughtsman, was born in 1864 and died in 1919. He began by working as an architect and did not turn to art until he was twenty nine years old. He was very interested in spiritualism and was inspired by the works of William Blake. Horton worked on Beardsley's magazine SAVOY and his artistic output was influenced by Beardsley. Like Beardsley, Horton had Roman Catholic leanings.

BIBLIOGRAPHY: Horton, W. Th., "a Selection of his work", with a Biographical Sketch by Roger Ingpen. London (no date).

WORKS: A Book of Images. Unicorn-Press 1898.

William Th. Horton, The Norns, from THE SAVOY. 1896. Autotype. Slightly enlarged.

HARRY CLARKE

Harry Clarke, an illustrator and applied artist, was born in Dublin, Ireland, in 1890 and died in 1931. He studied at the Metropolitan School of Art in Dublin. In 1911, 1912 and 1913 he won gold medals for his stained-glass windows, which were significant examples of the new art of stained-glass painting. Clarke's illustrations were evidence that the after-effects of Beardsley's influence had continued for a long time in England.

WORKS: Pope, The Rape of the Lock; The Ancient Mariner; E.A. Poe, Tales of Mystery and Imagination; H. Ch. Andersen, Fairy Tales; Goethe, Faust (English edition 1925).

Harry Clarke, Illustration for "Tales of Mystery and Imagination" by ▷ Edgar Allan Poe. Publ. George G. Harrap & Co. Ltd. London (no date). Autotype. About original size.

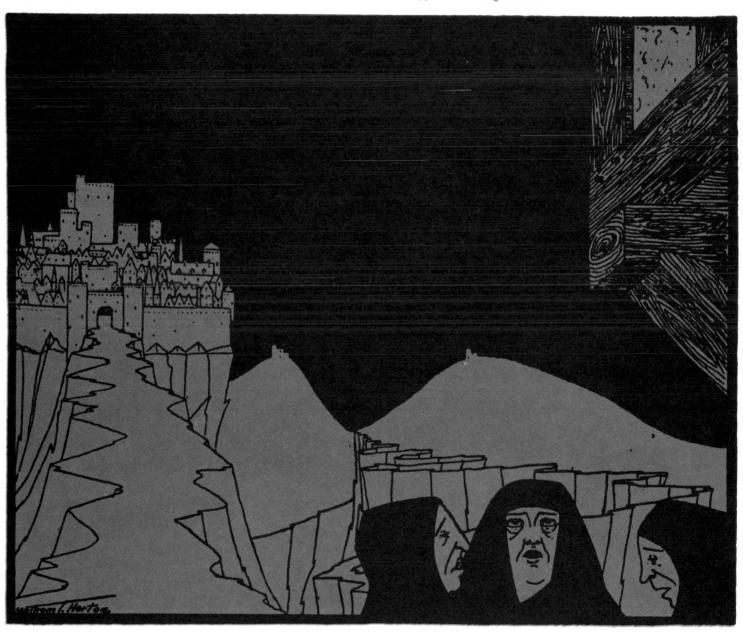

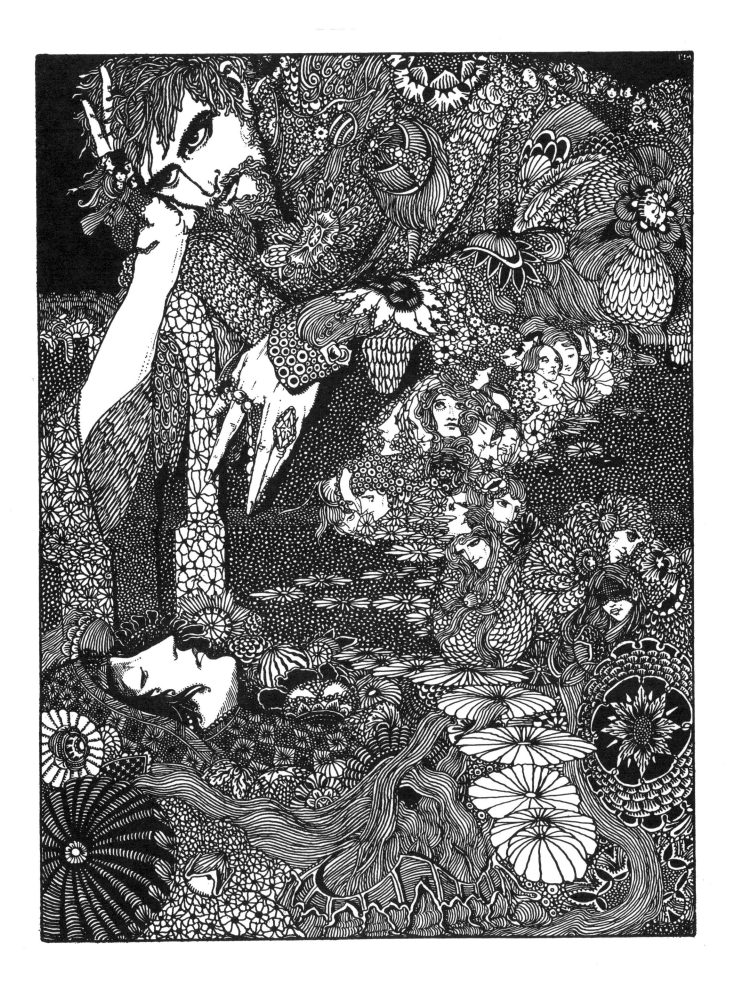

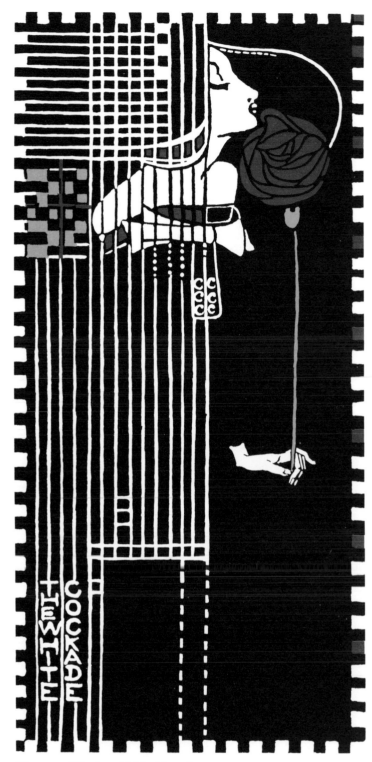

Margaret Macdonald-Mackintosh, Menu for a tea room. 1901. Autotype. 20.9×10.3 cm.

MARGARET MACDONALD

Margaret Macdonald, who worked as a graphic artist and was also involved in applied art, was born in 1865 and died in Chelsea in 1933. She studied at the Glasgow School of Art. She collaborated with her sister Frances in the fields of metalworking and embroidery. She was influenced by the Pre-Raphaelites. In 1900 she married C.R.Mackintosh, the Scottish architect and craftsman, and from that time on her artistic work was done in collaboration with him. Our illustration shows not only the typical tendency towards abstraction displayed by Scottish Art Nouveau, but also the close relationship with architecture. The ornamentation of the menu card whose title page is reproduced here corresponds to the decorative forms that characterized the interior of the restaurant where this menu was laid out. We can be certain that the crockery and cutlery in this room were decorated with identical motifs.

JESSIE MARION KING

Jessie Marion King, a graphic artist engaged in arts and crafts, was born in 1876 and died in 1949. From 1894 to 1900 she studied at the Glasgow School of Art, and later became head of its book binding department. She travelled to Germany and Italy, having won these trips as school prizes. The characteristics of her graphic works are the thin and widely undulating line, which is only slightly contrasted to the white of the paper and the delicately applied infillings of the surfaces. This is a clear indication that Jessie Marion King is a typical representative of the Glasgow school, but she also shows influences of Burne-Jones and Beardsley.

BIBLIOGRAPHY: Watson, W.R., "Miss Jessie M. King and her work", in THE STUDIO Vol. 26, 1902, p. 177 ff.

WORKS: Illustrations for Epics of the Middle Ages etc. The Holy Grail and works by Milton, Comus; Oscar Wilde, The House of Pomegranates; R. Kipling, The Jungle Book; W. Morris, The Defence of Guinevere (Kelmscott); F. Spenser, The Fairie Queene; The gray City of the North (Portfolio with 24 drawings of Edinburgh). Designs for book bindings, Ex Libris plates, wallpapers, silk curtains and jewellery.

CHARLES ROBINSON

Charles Robinson, a painter, graphic artist and writer, was born around 1870. He lived in London and became well-known as a result of his illustrations for children's fairy-tales, for 'The Happy Prince' by Oscar Wilde, for Shakespeare's sonnets and for 'The Sensitive Plant' by Shelley.
The example illustrated here shows a typical late phase of the English Art Nouveau, with a return to classical Renaissance formations. The book title and the illustrations are framed by a Roman triumphal arch.

Jessi M. King, Illustration for "The Magic Grammar" from THE STUDIO, ▷ Vol 26, p. 181, 1902. Autotype. About original size.

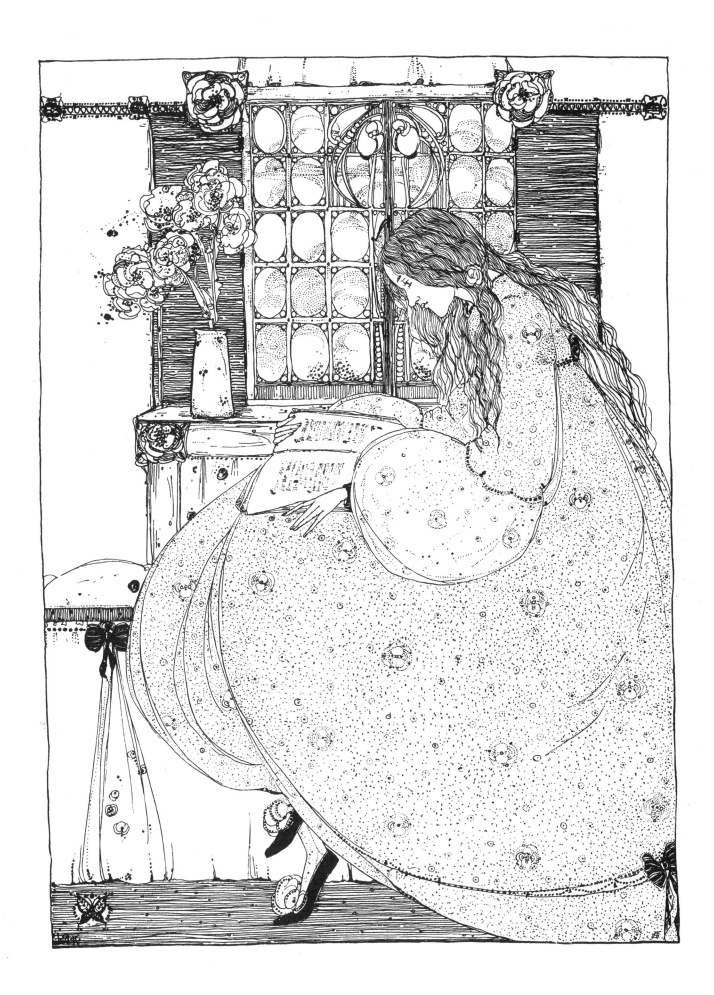

Charles Robinson, Title page for "Bee, the princess of the dwarfs" by Anatole France. Retold in English by P. Wright. London/New York 1912. Autotype. Slightly reduced.

BELGIUM AND HOLLAND

The Art Nouveau movement in Belgium crystallized around the two local centres of Brussels and Liège. Brussels had become a centre of new artistic endeavour in the 19th century even before the Art Nouveau period began. In 1884, twenty Belgium artists united to form Les Vingt (The Society of Twenty), whose rules stated that a new artist could not join the Society until another artist had left it. However, at their annual exhibitions they sought to establish contacts with foreign countries and they invited foreign artists to meet their members. In the second half of the 1890's, the importance of Les Vingt Society for Belgium was equal to that of the Nabis for France. Even though the members certainly did not all work in the Art Nouveau style, they nevertheless included the most significant exponents of that style. One of the hallmrks of their exhibitions was that each artist himself designed the page in the catalogue which listed his pictures. This meant that there was a very impressive array of individual typographic styles. In 1893, some of the artists belonging to this circle founded the magazine VAN NU EN STRAKS, which became the most important publication for Belgian Art Nouveau. Some of the artists working here in Brussels were Henry van de Velde, whose influence spread abroad and was as significant in France as it was in Germany, which in a sense became the country of his choice, Ferdnand Khnopff, Georg Lemmen, Theo van Rysselberghe, Victor Mignol and Henri Meunier, a nephew of Constantin, the sculptor. in Liège, Emile Berchman and Armand Rassenfosse were the most important artists and they achieved prominence by important contributions in the field of poster art.

The importance of Van de Velde to the entire Art Nouveau movement was similar to that of William Morris. Like Morris, Van de Velde made use of the whole potential of artistic creativity, but did so in an even more comprehensive way, because he was also a painter. His contribution to printed art was concentrated on typography, on the arrangement and ornamental decoration of the type face. One single poster, designed for the Tropon works in 1897, was symbolic in pointing the way to a particular tendency of the Art Nouveau style, and was as indicative as the Moulin Rouge poster by Toulouse-Lautrec. (We are not reproducing it here, because it has been shown in almost all the Art Nouveau publications.) This was the first time that an artist had obtained a commission to produce advertising for a company. It was very rapidly followed by other commissions, and became the beginning of applied industrial graphics, which today is an obviously accepted art form.

This artist clearly related his work to the new English typography, to the idea of enclosing the text within an ornamental framework. Unlike the English artists, Van de Velde did not use ornamental flora in the motifs for these frames, but rather sought to depict the principle of the organic rhythm of movement as a concept in itself; he did this with abstract configurations associated with expansion, growth and movement. This was a first and significant step towards the development of non-representational art. A horizontal decorative strip, which appeared in VAN NU EN STRAKS in 1893, might almost be regarded as a forerunner of Paul Klee's picture "Rich Harbour", dated 1938 (Public Art Collection, Basle). The initial letters and vignettes clearly show the softly swelling line of the text painted with the brush, and the white area between the drawn elements is just as expressive of movement as are those elements themselves. In the initial letters of "Déblaiement d'Arts" it can also be seen how the artist is able to create a link between the almost abstract letters he drew on the one hand, and the running text fulfilling the requirements of legibility on the other, in order to form the whole into a harmonious unity.

Apart from Van de Velde, we should also like to draw particular attention to the importance of Fernand Khnopff, who was certainly one of the strangest personalities of the Art Nouveau period, being as level-headed as he was profound. His symbolic style had a particular influence on Art Nouveau artists in the southern part of the German-speaking area, among them being Hodler, Stuck and Klimt. He intensified simple elements of nature and formed them into heavily emotional associations of ideas. This can be seen in our example, which depicts female inscrutability together with the snowy heights of an unconquerable mountain peak (illustrated on page 102). His symbolistic imagination has the same roots as that of James Ensor, but he works with an icily level-headed intellect and is dominated to a greater extent by natural phenomenon, thus unexpectedly directing the onlooker away from the superficial subject of the picture and towards its enigmatic character. A quick glance at the typography in the catalogue of the VINGT group is also instructive on the subject of Khnopff's artistry. The title makes a sober impression and

a realistic appearance is created by the use of ligature, printed letters, strips and framed panels and by the accentuation of the system of co-ordinates, but the combination of all these elements is nonetheless surprising. Here a printed image has been created of a kind that was not achieved again until much later, in the work of Hendrik Nikolaas Werkman. The graphological treatment reveals traits which are also characteristic of Khnopff's paintings and drawings. These traits are, firstly, the unconnected letters which spell the word BRUXELLES and are hard to read in their vertical arrangement and, secondly, the unexpected curls in the writing of the date: this was a solitary, hermetic thinker who sought to conceal himself and his thought from the world. "One has only oneself" was his motto, or "Mihi", on his Ex Libris (illustration on page 101).

Through Vincent van Gogh, Holland had established close connections with the development of modern painting. Van Gogh's collaboration with Emile Bernard and Paul Gauguin, two Parisian Art Nouveau artists, meant that his work left ample traces of the new style, even though his own artistry impelled him from the very outset to make a more expressive statement. The flowing lines of strength and linear groupings which permeate Van Gogh's pictures have their origin in the same impulses which initiated the arabesque-like linear gestures of the Art Nouveau style. Meyer de Haan, who was also Dutch and the son of a biscuit manufacturer, had joined Gauguin's group and admired that artist so greatly that he even paid his debts. Jan Verkade was another Dutch artist who later, under the name of Pater Willibrod, became well-known as the painting Benedictine monk of Beuron. He was a member of the Nabi group in Paris and remained closely associated with Paul Sérusier and Maurice Denis until the end of his days.

It was certainly no accident that Vincent van Gogh introduced the modern movement in Holland. The strict and insensitive Calvinism of that country was suddenly opposed by forces which did not wish to accept religious faith as mere rationality, but which yielded to an irresistible urge to conceive the supernatural in the form of experiences and deep feelings. The Neo-Catholic circles in Paris, with whom Verkade had associated himself, were of great influence here and instrumental in Verkade's eventual conversion to Catholicism. Symbolism thus had a very pervasive effect on the young generation of Dutch artists. A clear example of this is Roland Holst in his work "Hommage à Vincent", depicting a sunflower bent withering towards the earth (illustrated on page 104). However, the Symbolists were headed by Jan Toorop, in whose imagination all the religions of the West and the Far East merged into a single unity. We have reproduced here one of his less problematical sheets, a work of pure Art Nouveau. This is the "Girl with the Swans" (illustrated on page 106), which shows his outstanding qualities as a draughtsman and his perfect and elegant command of the pregnantly symbolic arabesque. The seated girl is simultaneously Leda and the Madonna of the Annunciation, the swans are divine regenerative forces, and the butterfly in the girl's lap is a symbol of transformation and ephemerality both at the same time; in the restrained colour of this print, the butterfly is a fleeting vision created by the imagination.

Toorop kept to an traditional style in his drawings after the end of the Art Nouveau period. His countryman Jan Thorn-Prikker, on the other hand, contributed decisively to the further developments which led towards Expressionism. The poster reproduced here (illustated on page 109) is almost reminiscent of Kokoschka. Thorn-Prikker was also associated with Neo-Catholicism and the symbolic nature of its identity, and after emigrating to Germany he provided a significant artistic stimulus to this religious movement in the Rhineland, and was also one of the most important revivers of contemporary stained-glass. Art Nouveau in Belgium and Holland was to a large extent determined by developments in England. This can be seen in the importance which was attached to graphic expression created by drawing techniques, and in the manner in which this expression was combined with a tendency to depict supernatural events which are communicated to the beholder by means of emotional values. Belgian and Dutch Art Nouveau passed on to the German-speaking area these influences which had emanated from England.

Henry van de Velde, border for VAN NU EN STRAKS. 1893. 4.4×14.8 cm.

Theo van Rysselberghe, Title vignette "August" from an almanac. Brussels 1895.

THEO VAN RYSSELBERGHE

Theo van Rysselberghe, a painter and draughtsman, was born in Ghent on 23 November 1862 and died in Saint-Clair (Var) on 13 December 1926. He studied under Canneel at the Academy in Ghent. His first official exhibition was held in 1880. From 1881 onwards he studied at the Academy in Brussels, and was a pupil of Portaels and Leo Herbo. In 1882 he made the acquaintance of Verhaeren in Brussels. He was a member of 'L'Essor', which was a society of Brussels artists, and he was also a founder member of the "Cercle des Vingt". From 1886 onwards Rysselberghe was regarded as an exponent of Neo-Impressionism (Pointillism) in Belgium. He travelled to Italy in 1890. He held his first exhibition at the Salon des Indépendants, together with Denis, Seurat, Signac and Van Gogh. He spent some time in Holland in 1892 and had numerous exhibitions in Europe. From 1898 onwards he was in Paris, and in 1908/09 he stayed in Naples. In 1910 he settled in Saint-Clair (Var). He was on friendly terms with Van de Velde and G. Lemmen. His works showed some influences of William Morris and, like Morris, he also endeavoured to be innovative in his art.

BIBLIOGRAPHY: Dreyfus, A., "Théo van Rysselberghe", in KUNST FÜR ALLE XXIX 1914.

HENRY VAN DE VELDE

Henry van de Velde worked as a painter, draughtsman, architect, craftsman and writer. He was born in Antwerp on 3 April 1863, and died in Zurich on 27 October 1957. He studied at the Academy in Antwerp from 1881 to 1883, and then in the studio of the painter Durant in Paris from 1884 to 1885. He returned to Belgium in 1885 where he first worked as a journalist. Van de Velde's paintings were influenced by Japanese wood-engraving, and also received inspiration from Van Gogh, Anquetin and Bernard. From 1889 onwards he was a member of the "Vingt" in Brussels. He was acquainted with Finch and Rysselberghe, through whom he gained a knowledge of English arts and crafts and of William Morris's reform movement. After suffering a nervous breakdown he decided to give up painting. He studied architecture and turned his attention to the arts and crafts. In 1893, at an exhibition given by the "Vingt", Van de Velde displayed his first furniture designs, some illustrations for the magazine VAN NU EN STRAKS, and the appliqué embroidery "The Guard of Angels". In 1895 he designed, built and furnished his house which was called Bloemenwerf and was located in Uecle near Brussels. In 1896, together with Lemmen, Denis, Besnard and Ranson, he furnished and decorated the four rooms of Bing's "Art Nouveau" shop in Paris. These rooms, with an additional fifth room, were shown in 1897 at the Dresden Exhibition of Applied Art, and Van de Velde became internationally known as a result. There then followed various commissions in Germany, among them the interior design of the Folkwang Museum in Hagen, Westphalia, from 1898 to 1902. In 1901 Van de Velde was appointed artistic advisor to the Grand Duke in Weimar. In 1906 he founded and built the Academies of Applied Art in Weimar, where he put into effect some new methods of art teaching. His treatise on

Henry van de Velde, Doublespread title to "Ecce Homo" by Friedrich
Nietzsche. Publ. Insel-Verlag, Leipzig 1908. Autotype. 19.3×37.3 cm.

art theory entitled "A Layman preaches Applied Art" was
published in 1902, and "On the New Style" appeared in
1907. Van de Velde played a considerable part in the
development of Art Nouveau in Germany as far as the field
of applied art was concerned. In 1907 he became a founder
member of the German Arts and Crafts Society; in 1914
he built the theatre for the exhibition held by the German
Arts and Crafts Society in Cologne; in 1917 he moved to
Switzerland and in 1921 to Holland. In 1925, on behalf of
the Belgians, he founded the "Institut Supérieur
d'Architecture et des Arts Décoratifs" in Brussels. He
became the head of that Institute, which after 1938 was given
the more exalted title of "Ecole Nationale". In 1937 and
1939/40 he created designs for the Belgian pavilions at the
World Exhibitions. In 1947 he settled in Oberägeri,
Switzerland.

Apart from some posters which he created, Van de Velde's
contribution to the printed art of the Art Nouveau period
was mainly limited to the design of texts and book
decorations. This decorative style does not display any

organic motifs and is thus in contrast to the so-called floral
Art Nouveau of artists such as Eckmann. Van de Velde
developed all his decorative elements from the logic of the
curve and reverse curve and by covered surfaces and plain
surfaces. This brings the text and the decorations into an
ideally close connection with each other. Van de Velde did
not use pictorial illustrations.

BIBLIOGRAPHY: Bodenhausen, E. V., "Van de Velde und die
Eisenkonstruktionen", in INNENDEKORATION XIV year. Oct. 1903. –
Casteels, M., "Henry van de Velde", Zum Neuen Stil, aus seinen
Schriften ausgewählt und eingeleitet von H. Curjel. Munich 1955. –
Deventer, S.v., "Eröffnungsansprache zur van de Velde-Ausstellung im
Karl-Ernst-Osthaus-Museum, Hagen 1958. – Hüter, K.H., "Henry
van de Velde als Künstler und Erzieher bis zum Ende seiner Tätigkeit
in Weimar". Diss Weimar 1961. – Meier-Graefe, J., "Henry van de
Velde", in DEKORATIVE KUNST, II year Munich 1898. – Mesnil, J.,
"Henry van de Velde et le Théâtre des Champs Elysées". Brussels–Paris
1914. – Osborn, M., "Henry van de Velde", in INNENDEKORATION, XI.
year January 1900. – Osthaus, K.E.., "Henry van de Velde – Leben
und Schaffen des Künstlers". Hagen 1920. – Palos, C., "Henry van
de Velde et l'évolution de l'Architecture et des Metiers d'Art en Belgi

Henry van de Velde, Vignette.

FERNAND KHNOPFF

Fernand Khnopff, a painter, draughtsman, sculptor and writer on art, was born in Grembergen Castle on 12 August 1858 and died in Brussels on 12 November 1921. He initially studied law, and then turned to painting. In 1878 he studied under X. Mellery at the Academy in Brussels, and in 1879 he was the pupil of J.J. Lefebre in Paris. At the Paris World Exhibition, Khnopff acquainted himself with the works of the English Pre-Raphaelites and came under their influence as well as that of Gustave Moreau. Khnopff was a member of the societies "L'Essor" and "Les Vingt", and from 1894 onwards he also belonged to the "Libre Esthetique". He frequently exhibited his works at the Vienna Secession and the Munich Secession. As a writer he championed the works of Joseph Hoffman and L. Fréderics.

In his own artistic output there was a particular emphasis on Symbolism. In a style free of any observation of nature, and based on a pure physiognomical construction, he created female faces with an enigmatic sphinx-like expression. Khnopff achieved the idealist, rigid lines of these creations by engraving directly onto the metal plate.

que", in BATIR, Brussels, January 1933. – Rességuier, C., "Die Schriften Henry van de Veldes". Zurich Diss. New York 1955. – Scheffler, K., "Henry van de Velde – Vier Essays". Leipzig 1913. – Tierlinck, H., "Henry van de Velde. Monographies de l'Art Belge", Brussels 1959. – Voort, J. van de, "Henry van de Velde – Gedenkboek" (with contributions by C. Huysmans, A. Vermeylen, R. Verwilghen and others) 1933. – LA CITÉ, Numéro consacré à Henry van de Velde. April/May 1933, Brussels. – OPBOUWEN: 1st May 1933. Henry van de Velde zeventig Jaar. Antwerp 1933.

EXHIBITIONS AND CATALOGUES: Around 1900. Exhibition in the Kunstgewerbemuseum Zurich 1952. – Henry van de Velde, Persönlichkeit und Werk. Exhibition in the Kunstgewerbemuseum Zurich 1958. Guide to the exhibition by H. Curjel. – Der junge van de Velde und sein Kreis. Exhibition in the Karl-Ernst-Osthaus-Museum, Hagen/Westf. 1959. – Henry van de Velde: Gebrauchsgraphik, Buchgestalt, Textilentwurf. Exhibition in the Karl-Ernst-Osthaus-Museum, Hagen/Westf. 1963.

THE WRITINGS OF VAN DE VELDE: Geschichte meines Lebens. Munich 1962 (with a list of Van de Velde's essays and books, as well as a detailed bibliography).

WORKS: Illustrations for: Max Elskamp, "Dominical", Woodcut – Max Elskamp's volume of poems, "Salutations dont d'angéliques", woodcut; contribution to the journal VAN NU EN STRAKS; book decoration to Déblaiement d'Art (publication of a lecture 1894), Die künstlerische Hebung der Frauentracht (1900), A. Solvay, Pensées et maximes glanées, Die Renaissance im modernen Kunstgewerbe, Friedrich Nietzsche, Dionysos-Dithyramben, Ecce Homo and Also Sprach Zarathustra, Turgenev, prose proems, Goethe, Iphigenia auf Tauris, Les Heures du Soir und zu seinen eigenen Schriften. Inserat der Société van de Velde, in L'ART DÉCORATIF 1898; packaging design for "Tropon" and "Tropon"-poster; book bindings, vignettes and borders

Fernand Khnopff, Ex Libris. Autotype. Original size.

BIBLIOGRAPHY: Bahr, H., "Fernand Khnopff", in VER SACRUM 1898. –
Dumont-Wilden, "Fernand Khnopff", Brussels 1907. – Eemans, N.,
" Fernand Khnopff, Antwerp 1950. – Neter, R., "Fernand Khnopff",
in KUNST FÜR ALLE. XXIX, 1914. – Mont, Pol de, "Fernand Khnopff", in
Elsevier's maandblad. Amsterdam 1901. – Shaw-Sparrow, W., "English
Art and Fernand Khnopff", in THE STUDIO 21, 1894. – Schultze-
Naumburg, P., "Fernand Khnopff", no place or date of publication. –
Verhaeren, E., "Quelques Notes sur l'Oeuvre de Fernand Khnopff.
Brussels 1887.

WORKS: Contributions to the journals PAN and VER SACRUM. Individual
sheets: Méduse au chef tranché, La sphynge, La Balle d'or, Une aile
bleue and others (engravings). Etude de cheveur, Un masque, Une geste
d'offronde, En souvenir and others. Illustrations to Péladan, la Vie
Suprême, – to poems by P. Verhaeren and George Rodenbach. – Ca.
4–5 Ex Libris. Only a few copies were published of all these works.

Fernand Khnopff, Le Sommet. from PAN, 1, 1895/96. Etching (in PAN
a lithograph), 10.3×18 cm.

HENRI EVENPOEL

Henri Evenpoel, a painter and draughtsman of Belgian
origin, was born in Nice on 2 October 1872 and died in
Paris on 27 December 1899. He studied under Blanc-Garin,
Acker and A. Crespin at the Academies of Sainte-Josse-
Noode and Brussels. In 1893 he studied with Matisse and
Rouault in Gustave Moreau's studio in Paris. In 1897/98
he travelled to northern Africa. Evenpoel preferred as his
themes scenes from daily life in Paris and Algiers. After
returning to Paris, he died of a typhoid fever in 1899, his
work as an artist having spanned only six years.

BIBLIOGRAPHY: Hellens, F., "Henri Evenpoel". Antwerp 1947. – Fierens,
P., "Evenpoel et l'Algerie", in ETUDES D'ART, Algiers 1947/8.

EXHIBITIONS: Rétrospective Henri Evenpoel, Galerie Giroux, Brussels
1932. – Rétrospective Henri Evenpoel, Musée Royale des Beaux Arts,
Antwerp 1953.

Henri Evenpoel, At the Playground. Coloured lithograph, from ▷
"L'Estampe Moderne". 33.2×23 cm.

RICHARD NICOLAS ROLAND HOLST

Richard Nicolas Roland Holst, a painter and draughtsman, was born in Amsterdam in 1868 and died there in 1938. He studied at the Académie des Beaux-Arts in Amsterdam. From 1918 onwards he taught at the Academy in Amsterdam, and was its Principal from 1926 to 1934. His creative activity was influenced by Walter Crane. His work consisted mainly of lithographs, mural paintings and stained-glass windows and it has a strongly symbolic character as well as lending reality a metaphorically enigmatic appearance. Our illustration, which is a sheet in memory of Van Gogh, is characteristic of Holst's style: the withered sunflower with its halo, and the setting sun.

BIBLIOGRAPHY: Roland Holst von der Schalk, H., "Kinderjaren en jeugd van R.N. Roland Holst". 1940.

WORKS: Among others, illustrations to, J.v.d. Vondel, Gijsbreght van Aemstel.

Richard N. Roland Holst, Title page for the catalogue of the legacy of Vincent van Gogh. Amsterdam 1892. Lithograph. 16.3×18 cm.

Antoon Johan der Kinderen, Title page for "Gedenkboek". 1893. Colour lithograph. 23.1×19.9 cm. ▷

GEDENBBOEB·

KEVZE·TENTOONSTELLING
VAN·HOLLANDSCHE
SCHILDERKVNST
VIT·DE·JAREN·1860·1892
GEHOVDEN·TE·AMSTERDAM
IN·ARTI·ET·AMICITIAE

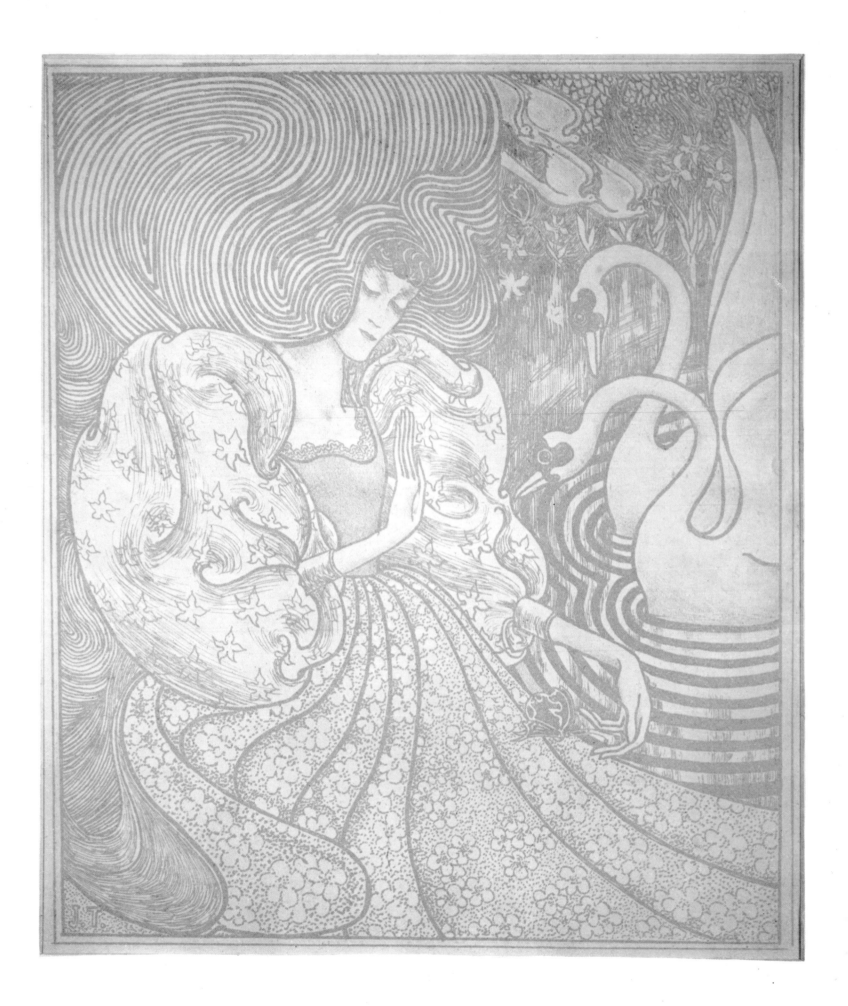

ANTOON JOHAN DER KINDEREN

Antoon Johan der Kinderen worked as a painter, draughtsman, craftsman and art critic. He was born in s'Hertogenbosch on 20 December 1859 and died in Amsterdam on 2 November 1925. From 1907 onwards he was the Principal of the Ryksacademie in Amsterdam. He was on friendly terms with the Dutch writer J. A. Alberdingk Thijm. As a painter he worked particularly in the fields of mural painting and stained-glass, and as a draughtsman his main preoccupation was with book illustrations and graphic art.

JAN TOOROP

Jan Toorop, a painter, draughtsman and craftsman, was born in Poerowoedjo in Java in 1858 and died in The Hague on 3 March 1928. The son of a Dutch government official in Java, he lived in Holland from 1869 onwards. He studied for one year at the Polytechnic School in Delft. In 1880/81 he studied at the Academy in Amsterdam, and from 1882 to 1885 at the Academy in Brussels. From 1886 onwards he was a member of the "Les Vingt" society. He was on friendly terms with J. Ensor. He visited London frequently between 1885 and 1889. In 1889 he executed his first Pointillist pictures under the influence of Seurat and Ensor. He returned to Holland, was in Kwarijk until 1891, and then spent some time in The Hague. He was a member of The Hague Ring of Artists. From 1890/91 onwards he was inspired by the poems of Maeterlink and Verhaeren. He turned his attention to Symbolism. His drawings reveal influences derived from Beardsley. From 1899 to 1902 he was once again in Kwarijk and he lived in Amstersdam from 1903 to 1909. In 1905 he was converted to Roman Catholicism. In 1908 he had a share in the St. Luke exhibition held in Amsterdam. In the following year he spent some time in Nijmegen and in 1910 he founded an exhibition hall in Doburg, where Mondrian and Kart Nibbrig also exhibited. He returned to The Hague in 1916 and worked in the field of religious art.

The nature of Toorop's work is determined entirely by the statement generated by an arabesque-like, undulating linear language with which he circumscribes symbolic and significant figures. The Art Nouveau style reaches its limit in Toorop's works; the object depicted sometimes becoms meaningless, with the substance of the work being sustained only by the linear interplay. Pale faces and elongated hands undulate mysteriously.

◁ **Jan Toorop**, Meisje met de zwanen (Leda). Colour lithograph. 23.1×19.9 cm.

Theo van Hoytema, Winter. 1894. Lithograph. About original size.

BIBLIOGRAPHY: Boor, J. de, "Jan Toorop". Amsterdam 1911. – Eeckhout, F.J.R. van den, "Jan Toorop". Amsterdam 1925. – Hoek, K. van, "Jan Toorop, Herdenking. Amsterdam 1930. – Janssen, M., "Schets over het leven en enkele Werken van Jan Toorop". Amsterdam 1920. – Knipping, J.B., "Jan Toorop". Amsterdam 1945. – Plasschaert, A., "Jan Toorop". Amsterdam 1925. – Zileken, Ph., "Jan Toorop", in ELSEVIER'S GEILLUSTREERD MAANDSCHRIFT. Amsterdam 1898.

WORKS: Contributions to the journal VAN NU EN STAKS; individual sheets and portfolios lithographs, etchings, posters.

THEO VAN HOYTEMA

Theo van Hoytema, a painter and draughtsman, was born in 1863 and died in 1917. He made his name chiefly by his lithographs, illustrating fairy-tales and other children's books. His decorative simplified depictions of animals are particularly remarkable. One feature of his style which is new to Holland is that he incorporates the captions in the lithographs; this can be traced to the inspiration of Japanese woodcuts. His works include the illustrations for "Hoe de vogels aaneen koning Kwamen" and "Het leelijke jonge eendje". In his book illustrations he frequently prefers to use a tall, narrow type area and thus occasionally is able to print two motifs on one page.

JAN THORN PRIKKER

Jan Thorn Prikker, a painter, draughtsman and craftsman, was born in The Hague on 6 June 1868 and died in Cologne on 5 March 1932. From 1882 to 1887 he studied at the Academie voor beeldende Kunsten den Haag. From 1893 onwards he created Symbolist pictures. He was on friendly terms with Van de Velde and took part in the exhibitions given by "Les Vingt". He had an association with Verkade. In 1895 he began his work as a craftsman in the fields of typography, book design, textile work and so on. In 1898 he designed the Art Nouveau façade for the Arts Building in The Hague. He designed and manufactured furniture. From 1904 to 1910 he taught at the School of Applied Art in Krefeld. He travelled to Italy in 1906 and to Denmark in 1908. In 1910 he executed his first stained-glass window in the booking hall of the railway station in Hagen i.W.. From 1910 to 1919 he stayed with Karl Ernst Osthaus in Hagen, teaching at the School of Applied Art in Essen from 1913 to 1918. He travelled to France with G. Heimersdorff in 1913 and in 1919 he worked for a year in Überlingen, Lake Constance. From 1920 to 1923 he taught at the School of Applied Art in Munich and from 1923 to 1926 he was Professor at the Academy of Art in Dusseldorf. He taught at the School of Applied Art in Cologne from 1926 to 1932. He created stained-glass windows, mosaics and murals, some of them for the exhibition building in the Ehrenhof in Dusseldorf, for the Kaiser Wilhelm Museum in Krefeld, for the Church of St. George in Cologne and for the Church of the Resurrection in Essen. He was on friendly terms not only with Van de Velde, but also with Toulouse-Lautrec and G. Minne the sculptor. Thorn Prikker was close to the Rhineland Catholic movement, and set an important trend in modern church art. His expressive linear style opened up new vistas which deviated from Art Nouveau but led directly into the art forms of the younger generation whom he was teaching.

BIBLIOGRAPHY: "Brieven van Johan Thorn Prikker", edited by Henri Borel, Amsterdam 1897. – "J. Thorn Prikker", Kölnischer Kunstverein 1920. Text and list of works up to 1918, by August Hoff. – Creutz, Max, "Johan Thorn Prikker", in CHRISTLICHES KUNSTBLATT, 56th year. Stuttgart 1914, p. 332–340. – id., "Johan Thorn Prikker", in CHRISTLICHES KUNSTBLATT, 57th year, Stuttgart 1915, p. 73–75. – Hesse-Frielinghaus, H., "Jan Thorn Prikker. Ein Dokumentation zum Leben und Werk des Künstlers in den Jahren 1904–1921, nach den Beständen des Osthaus–Archivs im Karl-Ernst-Osthaus-Museum. Hagen 1967. – Hoff, A., "Die religiöse Kunst Johan Thorn Prikkers". Dusseldorf 1924 (Weißer Reiter series). – id.., "Thorn Prikker und die neuere Glasmalerei, Essen 1925. – id. Nachruf Johan Thorn Prikker. 1932. – Joosten, E., "Thorn Prikker", in MUSEUMJOURNAAL, Series 3, Amsterdam 1957, p. 129–132. – Leuring, W.J.H., "Gedächtnisrede für Johan Thorn Prikker". Cologne 1932. – Hoff, A., "Johan Thorn Prikker". Recklinghausen 1958.

EXHIBITIONS AND CATALOGUES: Johan Thorn Prikker. List of early works in the catalogue "Linie und Form". Kaiser-Wilhelm-Museum Krefeld 1904. – Johan Thorn Prikker. List of early works in the catalogue "Erste Ausstellung des Krefelder Künstlerkreises". Kaiser-Wilhelm-Museum Krefeld 1904. – J. Thorn Prikker und Arbeiten seiner Klasse an den Kölner Werkschulen. Exhibition catalogue Duisburg, 1928. Text A. Hoff. – Johan Thorn Prikker. Memorial exhibition, Utrecht 1932 ("Voor de Kunst") list and text. – Johan Thorn Prikker. Tentoonstelling uit de periode van 1886–1906 The Hague 1938. – P. Wember, Johan Thorn Prikker in, "Jan Thorn Prikker/Wilh. Schmurr" exhibition catalogue. Recklinghausen 1956. – id., "Thorn Prikker zum Gedächtnis", in "Deutscher Künstlerbund", exhibition catalogue Berlin 1957. – id., "Die Plakate Thorn Prikkers", in "Die Jugend der Plakate". Catalogue of the works held by the Kaiser-Wilhelm-Museum, Krefeld 1961. – id., "Johan Thorn Prikker", in "Krefelder Künstler und Künstler vom Niederrhein. Catalogue of works held by the Kaiser-Wilhelm Museum, Krefeld 1962. – id., "Johan Thorn Prikker" Catalogue of works held by the Kaiser-Wilhelm-Museum, Krefeld 1966.

WORKS: Principally posters: L'Art Appliqué, before 1899. Dutch art exhibition 1903, Posters for the exhibition of the same name in the Kaiser-Wilhelm-Museum Krefeld. "Schwertfisch" 1904, poster designs for the exhibition "Linie und Form" Krefeld. Niederrheinisches Künstlerfest, 1905. Dutch-Indian art exhibition. 1906

Johan Thorn Prikker, Poster for "Revue Bimestrielle pour L'Art Appliqué". 1896. Lithograph. 133×98 cm. ▷

REVUE BIMESTRIELLE POUR L'ART APPLIQUÉ

EDITEUR IMPRIMEUR

H. KLEINMANN ET Cie. KENAUPARK 9. HARLEM, HOLLANDE.

PRIX 45 FRANCS PAR AN. 15 ESTAMPES LA LIVRAISON.

J THORN PRIKKER.

SCANDINAVIA

In Norway, Sweden and Denmark, Art Nouveau was used extensively in the field of applied graphics, particularly poster art. Influences from France and England were equally predominant. A group of artists in Copenhagen formed a society dating from 1888 onwards. The most important of them were Thorvald Bindesböll and the Skorgaard brothers. In 1891 they officially appeared as a group calling itself "Frie Udstilling" (Free Exhibition), and they were soon joined by other like-minded artists; in particular, Jens Ferdinand Willumsen, who had made the acquaintance of Gauguin in Paris, and became one of the leading Art Nouveau artists. This group became the centre of Danish Art Nouveau.

The relatively broad basis of Scandinavian Art Nouveau produced two especially prominent artists from that region: these were Edvard Munch, a Norwegian, and Axel Gallén, a Finn. Both of these came into immediate contact with the new artistic currents prevailing in Paris and related to the artistic style of the metropolis on the Seine, a style which laid special emphasis on creating a picturesque quality. Munch and Gallén combined this style with the specific emotional situation of their own countries: Gallén's creations had their roots in the world of the Nordic saga, and Munch's pictures were founded on the inner visions seen on the periphery of consciousness. In the same way as Emile Bernard and Armand Séguin, whose works he must have known in Paris, Munch did not proceed on the basis of freely invented ideas, but painted the scene which spread out before his eyes. In this respect, he was continuing the Art Nouveau style employed by the French artists, which was derived from Impressionism. However, Munch did not enclose the depicted events within a formal decorative system, but transposed them instead to an emotional level on which the object being regarded becomes clear and lucid for the purposes of a second reality which is stronger than any superficial reality. Being the main exponent of Art Nouveau, Munch advanced to its very limits both in content and form; it is here that his greatness and his significance lie. There is one particular situation which plays a more important role in Munch's works than in any other works of Art Nouveau, and this is one which is familiar to everyone, namely the fundamental experience of a "borderline situation". Without giving the matter an enigmatic symbolic nature, and without disguising it in myths and fairy-tales, Munch formulates his subjects as allegories in which natural images, such as the hours of twilight and sunset, also have a part to play. His subject matter is nevertheless not tied to any particular period, and in this he is unlike the writers who are close to him, namely Strindberg and Ibsen: many issues raised by these writers, such as the emancipation of women which is today an accepted fact, have in the meantime been decided by the course of events. Munch's subjects are basic human situations which everyone must experience. The suject matter with which Munch is concerned in his pictures thrusts itself into an external form to such an extent that this external form can never become a decorative end in itself, as is so often the case in Art Nouveau, but always serves to illustrate a statement. On the other hand, the external-force of the statement never becomes an Expressionist form in Munch's works and it avoids the pathos of deformation and simplification, a pathos which often also degenerates into an end in itself and is such a common characteristic of the later generation of Expressionists. Thus Munch appears to us today to be much less related to any particular period of time than many artists before and after him.

However, even in Scandinavia and even in his native Norway, Munch was an outsider who followed a different course from that pursued by the rest of the Art Nouveau artists. Their main contribution consisted of illustrations for fairy-tales and sagas, combined with a pronounced love for the idyllic, for a romantically conceived family picture, shut away from the world. Carl Larsson may be named as the main exponent of this tendency. A contemporary critic described him as "the man who painted and etched the Swedish family; when painting a child, he understood how to penetrate and depict the most intimate stirrings of the child's heart". Axel Gallén, the illustrator of the Finnish heroic epic, also later painted a cycle of pictures which he called "Building Houses", and which became an epic representation of the family. Related thoughts are suggested in the poetry of Knut Hamsun, and they later experienced a fateful intensification in the nationalist blood-and-earth movements, which were not confined to Germany alone. The ties between the Scandinavian artists and France were much stronger than their relations with England, although there is no doubt that Pre-Raphaelite art provided very considerable inspiration for the large number of cyclic depictions on the subject of the Scandinavian saga. But nearly all the artists spent some time in Paris, met the French Art Nouveau artists at the Académie Julian and took part in exhibitions there. Munch illustrated theatre programmes for the Théâtre de l'Oeuvre, and later he also designed programmes for the works of Ibsen and Strindberg. Jens Ferdinand Willumsen, the Danish artist, even associated himself with the groups of artists who had gathered around Bernard and Gauguin in Pont-Aven and Pouldu.

The art of the Scandinavians in turn had its effect on the German-speaking area, and in particular on those movements which also gave to the subjects contained in the sagas a new meaning coloured by national politics. Fritz Erler was particularly prominent among these artists. Munch gained a footing in Berlin and worked there from 1892 to 1895 in a distinctly combative atmosphere, which commenced with the scandal surrounding the exhibition which he held in 1892 in the rooms of the Association of Berlin Artists. Leistikow, with his Danish park landscapes,

was particularly responsive to Munch's paintings, the result of a close similarity in the manner in which the two artists depicted nature allegorically. However, Munch's art form had a particularly important effect on the later generation of Expressionists, who frequently used his Art Nouveau style as the point of departure for their own conception of art. There was a remarkable discipline in printed graphics. This discipline was more sober than in Munch's works, but the execution of its line was nevertheless powerful, and its influences also spread from Scandinavia to the main body of the Continent. In his "Study of a Nude", executed in 1896 (illustrated on page 117), Larsson may have influenced the early Picasso. However, Olaf Gulbransson, who later chose Bavaria as the place of his adoption, was the artist who was of particular significance in developing an expressiveness which was generated by line and silhouette, was based on the model of illustrative caricature and can best be compared with the works of Toulouse-Lautrec. However, Gulbransson's lack of emotion was in accord with an artistic conception which replaced the Art Nouveau style but only played a peripheral role as far as Expressionism was concerned.

EDVARD MUNCH

Edvard Munch, painter and draughtsman, was born in Loyten, Norway, on 12 December 1863 and died in Ekely/Skoyen on 23 January 1944. He studied at the School of Applied Art in Oslo in 1882/83, and spent a short time in Paris in 1885; his first significant works were executed in 1886. He was in Aasgaarstrand for the first time in 1888, and in 1889 he held his first exhibition in Oslo. In 1889 he made his second trip to Paris, this time on a State scholarship. He attended Bonnat's school of painting and was influenced by Whistler and the Pointillists. In 1890 he travelled to Germany, Italy and France. In 1892 he held an exhibition in Oslo and then in Berlin, where a scandal originated in the art world: Munch's name became well-known. The Symbolists and Strindberg provided him with inspiration. In 1895 he worked on the magazine PAN in Paris. His third visit to Paris, was one which was of decisive importance for his work. He acquainted himself with the new style and established personal contacts with the leading artists practising this style: these were Gauguin, Van Gogh, Toulouse-Lautrec, Bernard, Denis, Séguin and others. He worked on theatre programmes for the "Théâtre de l'Oeuvre". In 1897 he exhibited his "Frieze of Life" in the Salon des Indépendants. In the period from 1898 to 1901 he travelled to Germany, France and Italy. Between 1902 and 1908 he spent some time in Berlin, Hamburg, Weimar and Elgersburg. In 1906 he carried out stage designs for Max Reinhardt. He was in a mental hospital in 1908/09. In 1912 he held an exhibition in the rooms of the "Sonderbund" in Cologne. After 1910 he executed large murals for the university in Oslo and for a chocolate factory in Oslo; the Art Nouveau epoch in his work broke off abruptly when he suffered a nervous breakdown.

SOME REMARKS ON HIS WORKS: "The Scream". A figure on a bridge tormented by his own fears. The silent or loud scream makes the whole of nature vibrate. The arabesque-like Art Nouveau line has almost been deprived of its decorative character and becomes an eloquent psychological pattern. Munch presented two versions of this sheet (Schiefler No 32), one on white paper and one on bluish-red paper. Munch had dealt with this subject previously in an oil painting dated 1893 (Oslo National Gallery) and in a duplicate in oils (Kommunes Kunstsamlinger, Oslo). The landscape background was created as a study in Nice, and is employed again in compositions such as "Despair" and "Feeling of Fear"; the latter also exists as a lithograph dated 1896 (Schiefler No. 61).

"The Death Chamber". Here, the contrast between black and white signifies the absolute demarcation between life and death. Everything that exists in this room is visible as a black silhouette before the white emptiness. Even the dead woman is a white surface with only a shadowy frame around her. Some copies exist which are on grey and on blue paper. They alter the atmospheric content but not the absolute form of the statement (Schiefler No.75). An oil painting with the same title (Oslo National Museum) was created as early as 1895/96 on the occasion of the death of Munch's sister Johanne Sophie. There is also a previous pastel study and a second painted version; both of these are in the Kommunes Kunstamlinger in Oslo.

'Madonna'. This is a depiction of the act of conception. It shows a woman at the moment of total abandon, seen from the perspective of the partner who is leaning over her. The eccentric nature of the experience is dissolved in the vibrations of the swirling, dark-blue background. Symbolic marginal ornaments contain the spermatozoa which are pressing forwards towards the womb; the helpless foetus is seen as a visionary image. Two versions of the lithograph exist: in 1895 (Schiefler No. 33a, b, 2) the black plate for a purely black-and-white plate was created and the three-colour plates were executed in 1902. This print was preceded by a painted version of 1894 (Oslo National Gallery), and a later version followed in 1912/13 (Kunsthalle, Hamburg); neither of the painted versions has a frame surrounding it.

Edvard Munch, The Scream. 1895. Lithograph. (Schiefler No. 32). ▷ 35 × 25.2 cm.

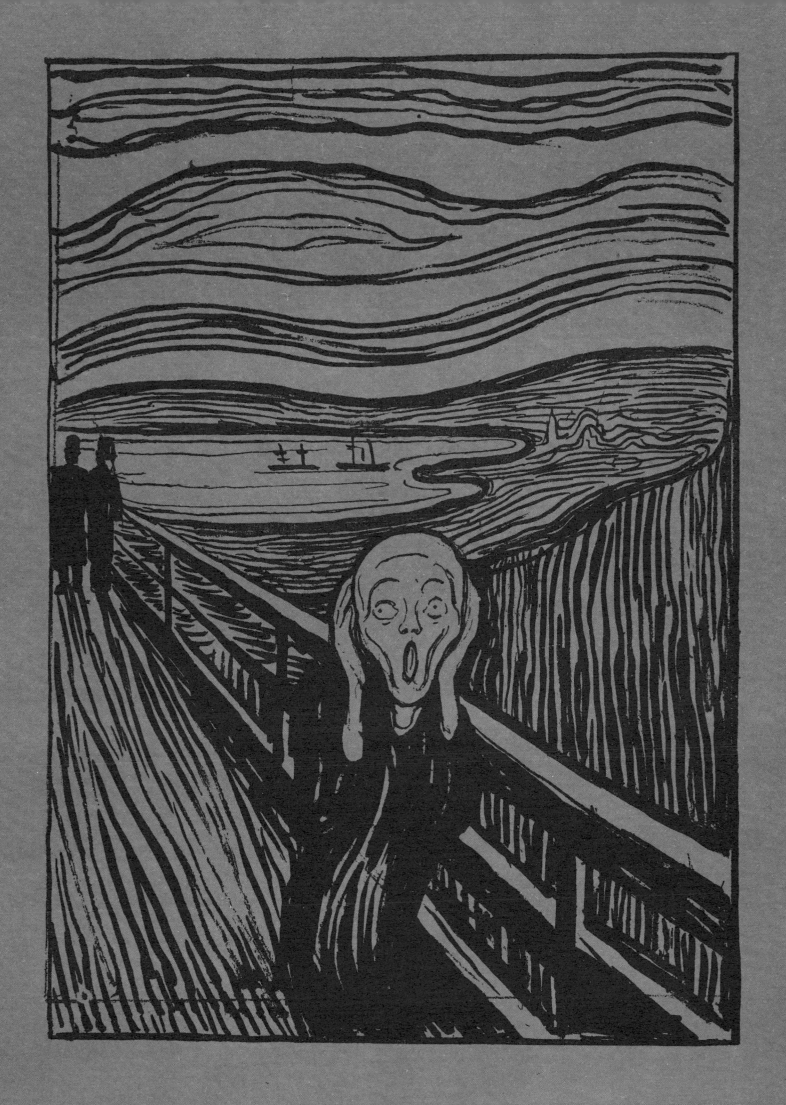

BIBLIOGRAPHY: Benesch, O., "Edvard Munch", 1960. – Esswein, H., "Edvard Munch", 1905 (Modern Illustrators 7), 46 pp., ill. – Gauguin, P., "Grafikeren Edvard Munch". 2 Vols. Trondheim 1946. – id., "Edvard Munch", 1933/1956. – Glaser, C., "Edvard Munch als Graphiker", in KUNST UND KÜNSTLER II, 1913, p. 560 ff. – id., "Edvard Munch". 1917/1922. – Gierloff, Ch., "Edvard Munch selv". 1953. – Hodin, J.P., "Edvard Munch". 1948. – Langaard, J.H., "Edvard Munchs Selvpotretter". 1947. – Linde, M., "Edvard Munch und die Kunst der Zukunft". 1902. – id., "Edvard Munch". 1905. – Moen, A., "Edvard Munch, Age and Milieu". 1956. – id., "Woman and Eros", 1957. – Sarvig, O., "Edvard Munchs Graphik". 1948. – Schiefler, G., "Verzeichnis der Graphischen Werke bis 1906, 1907. – id., "Edvard Munch. Das graphische Werk 1906–1926. 1927. – Stenersen, R., "Edvard Munch", 1946 (German edition 1950). – Svenaeus, G., "Edvard Munch. Das Universum der Melancholie". Lund 1968. – Thiis, J., "Edvard Munch og Hans Samtid". 1933. – Willoch, S., "Edvard Munch, Etchings", 1950. – id., "Edvard Munchs tresnitt (woodcuts)". – Edvard Munch, Mennesket og Kunstneren" (by his friends), Oslo 1946. – Edvard Munchs Brev. Familien (Letters), Oslo 1949. – Catalogues: Exhibition at the Nationalgalerie Oslo 1946, E.M. exhibition Zurich 1922. E.M. exhibition Nationalgalerie Berlin 1927. Exhibtion at The institute of Contemporary Art, Boston (E. Munch by F. Deknatel, Introduction by J.H. Langaard). London 1950 (bibliography by Hannah B. Muller, p. 116). E. Munch exhibition, Munich-Cologne, 1954/1955. E. Munch exhibition, Kunstmuseum Berne 1958. – Schiefler, G., "Edvard Munchs graphische Kunst". Dresden 1923. – Thiis, J., "Edvard Munch". 1934. – Gerlach, H.E., "Edvard Munch. Sein Leben und sein Werk". 1955.

WORKS: Lithographs, etchings and woodcuts, among others the Frieze of Life, self-portraits (for the complete catalogue see Schiefler).

Edvard Munch, The Death Chamber, 1892. Lithograph. (Schiefler No. 75). 40×54 cm.

Edvard Munch, Madonna - Loving Woman - Conception. 1895 to 1902. ▷ Colour lithograph (Schiefler No. 33, a, b, 2). 60.5×44.2 cm.

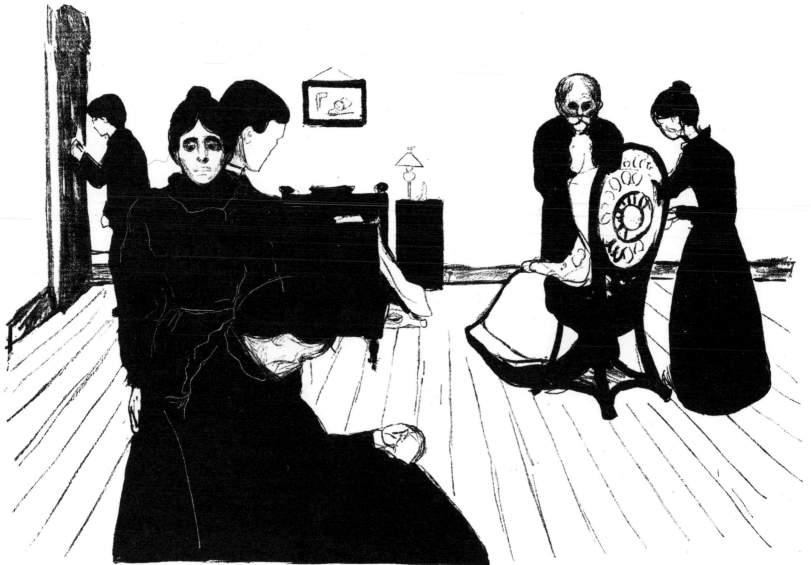

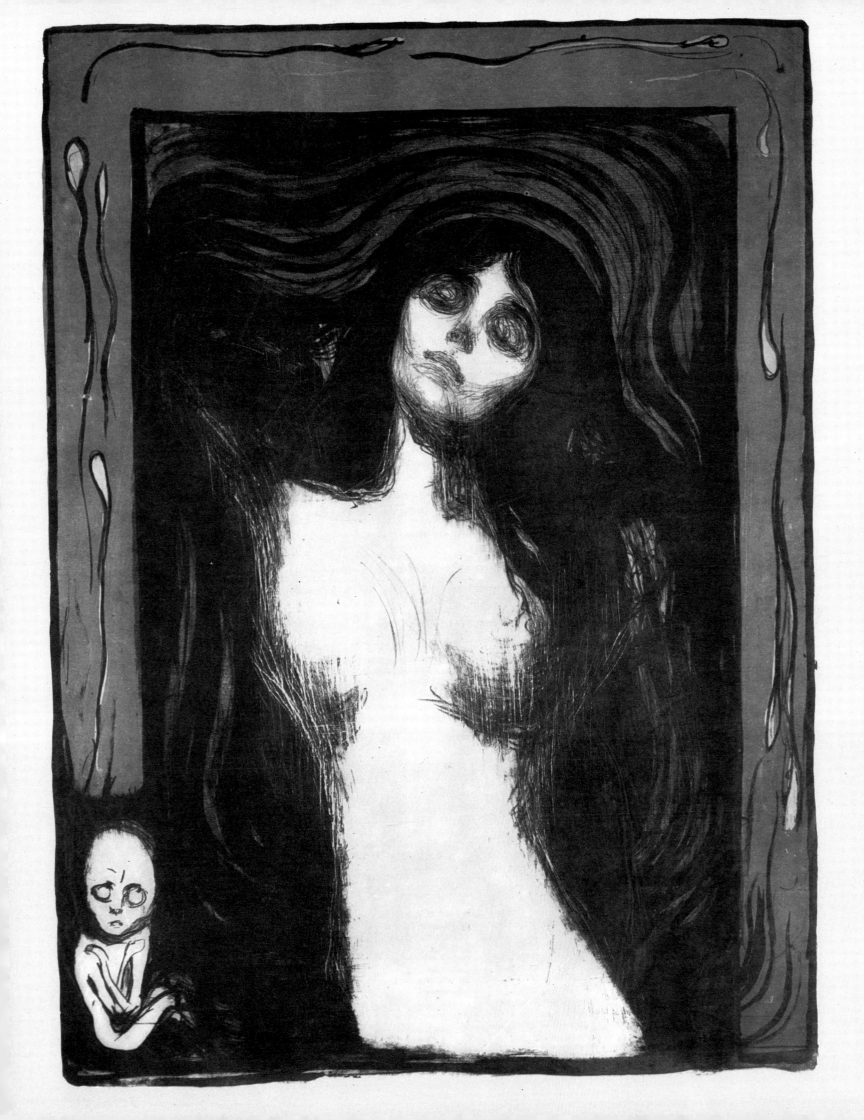

Rolf Stenerson, a friend of Munch's, says of the artist: "The life of Edvard Munch was full of unrest, fear and searching. Unlike his father, he did not find consolation in religious belief. The only thing that helped him was painting.

"Everything that Munch painted was a reflection of his being. Even when he was painting a person posing for him, the picture was essentially a self-portrait. He was opposed to the idea of painting a person's "street face", or what is generally described as a "likeness". A portrait is not intended to be a "Likeness", but first and foremost to be a good picture. "Munch once wrote: 'I am not afraid of photography, as long as it is not possible to take photographs in heaven or in hell. One cannot always be painting women knitting and men reading. I want to depict the people who breathe, feel, love and suffer. The onlooker is intended to become aware of the religious aspects of the picture, so that he will take off his hat as he would in church.'"To Munch, the sun had a divine significance, being the source of light and life. In Munch's view of things,the heavenly bodies and the powers above were living beings; the moon was the child of the earth, and the lava was the curdled blood of the earth. Moonlight aroused fear and the sexual instinct. Dying signified no more than changing to another outward form. Human beings were waves of mind and matter which could dissolve and take on a new form in an eternal transformation. If a butterfly could be created from a caterpillar, why should humans not be able, after their deaths, to live on in a new form which is invisible to us?

"For Munch, human beings were open receptacles which were filled by the waves which flowed into them. Everything had its effect on them: the forest, the trees, the sea, the air and even the stars were alive and exercised their power on human nature. Mankind was nothing but miserable vermin who loved and lived. Human beings were only great in their own imagination. It was dangerous to dig too deep into the earth's crust: 'We call it an earthquake.' If one wearied of subjugating oneself to the dictates of fate, there was only one way out and that was to put an end to one's life.

"The second period of Munch's art comprises the years immediately before and after the tragic lover's shot by which he lost a finger joint. This phase began in 1889 and continued until 1909, when he was released from Dr Jacobsen's clinic. This was his virile period, during which he encountered many women. These experiences formed the substance of his artistry. During this period he was especially captivated by the mystery of love and death. The purely picturesque element, the interplay of colours, the surfaces and the lines were all used mainly as a means of expressing his outlook on life and his moods. He wished to be not merely a painter, but also a poet and thinker. 'I am aware that the large black shadow in "Puberty" is detrimental to the picture when looked at from the purely picturesque point of view. However, I was forced to make this shadow large and monotonous.'

'If I had lost my eyesight, I would have become an intellec-tual. I am a painter; this suits me better than writing or speaking.'

"Munch did not achieve anything decisive as a thinker. His view, approximately stated, was that man did not have a free will but was only a pawn in some higher game. In his search for a visual means of expression for this outlook on life, he experimented with cubes and squares in the period around 1890. In a picture entitled "Encounter", which was included in his "Frieze of Life", he drew the men and women by the shore as being fragments of cubes. Munch also stated: 'Following the dictates of the mating drive, human beings are brought together like grains of sand on a copper plate when the plate is scraped with a violin bow. The earth is female, but the sun, the moon, the air and the sea are male forces which, with each passing day, embrace the earth and make it fertile once again. Human beings, like all living things, are tied to this eternal pairing process.'"

CARL O. LARSSON

Carl O.Larsson, a painter and draughtsman, was born in Stockholm on 28 May 1853 and died in Sundborn near Falun on 22 January 1919. He studied at the Stockholm Academy. He paid visits to Paris, where he absorbed some inspiration from the poster art of Chéret and Mucha. He executed numerous frescos and monumental paintings depicting historical subjects. However, he achieved international recognition through pictures of his own idyllic family life, which he published in the form of book illustrations.

BIBLIOGRAPHY: Alfons, H. and S., "Carl Larsson skildrad av honom själv". Stockholm 1952. – Kruse, J., "Carl Larsson". Stockholm 1906. – Nordensvan, G., "Carl Larsson". 2 Vols. Stockholm 1920/21. – Romdahl, A., "Carl Larsson som estare". Stockholm 1913.

WORKS: Larssons, 1902; At our home in the country, 1907; The house in the sun, 1909. Individual sheets.

Carl Larsson, Study of a Nude, 1896. Etching. 23.6×16.4 cm. ▷

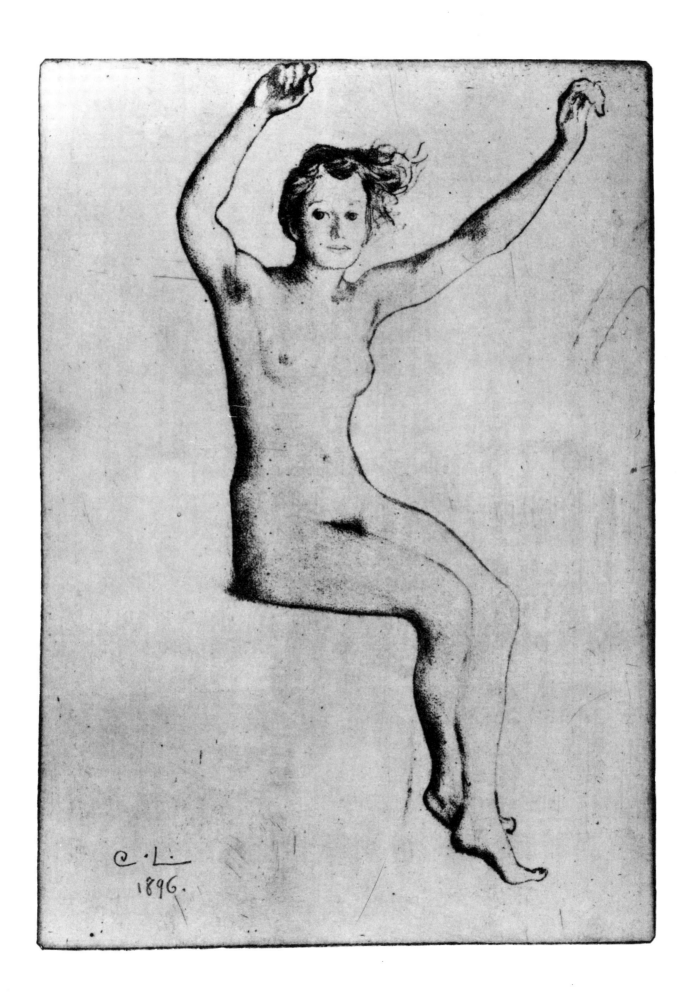

Einar Nerman, Borders for "The Swineherd" by Hans Christian Anderson. Autotype.

Gerhard Munthe, Decorative design, from PAN, I, 1895/96. Collotype. 20.3×26.5 cm.

EINAR NERMAN

Einar Nerman was a Swedish painter, illustrator and commercial artist. He was born in Norrköping on 6 October 1888, and lived in New York. From 1905 to 1908 he studied at the painting school attached to the Art Association in Stockholm. In 1909/10 he studied under Matisse in Paris, and from 1911 he studied under C. Wilhelmson.

WORKS: Illustrations for fairy-tales by H. Ch. Andersen, for books by Selma Lagerlöf and for the journals SÖNDAGSNISSE, THALIA, FIGARO, DIE DAME, PAN, THE TATLER.

GERHARD PETER MUNTHE

Gerhard Peter Munthe, a painter, draughtsman, craftsman, and writer on art, was born in Elverum on 19 July 1847 and died in Oslo on 15 January 1929. He studied in Norway initially and then in Dusseldorf from 1874 onwards, in Munich from 1877 onwards and in Paris from 1883 onwards. Munthe was one of the most significant exponents of Art Nouveau in Norway. Around 1890 he developed a decorative style inspired by ancient Norwegian folk art. He gave an exhibition in Oslo in 1892. In 1893, eleven of his "Aquarelles de Légende" were exhibited at the Salon in Paris. He created numerous designs for ornamental carpets.

BIBLIOGRAPHY: Bakken, H., "Gerhard Munthes dekorative Kunst". Oslo 1946. – id., "Gerhard Munthe". Oslo 1952. – G. Munthe, Minder og Meninger. Kristiania 191. – Thiis, J., "Gerhard Munthe". Trondheim 1903.

Axel Gallén, Illustration to "Kiwi and his Brothers". Autotype. Original size.

AXEL GALLEN

Axel Gallén (Akseli Gallen-Kallela) was a painter and draughtsman. He was born in Pori (Björneborg) on 26 May 1965, and died in Stockholm on 7 March 1931. In 1881 he studied at the art school of the Finnish Society of Arts in Helsinki. He was in Paris from 1884 onwards, and until 1889 he studied at the Académie Julian and in Cormon's studio. He met the Nabis and Bastien-Lepages, and had a high regard for the folk paintings executed by the latter. Puvis de Chavannes and his work also impressed him. After his return to Finland he developed an expansive style which consisted of strong outlines and in which the paint was applied over large surfaces. He became the leader of a romantic national art form whose subjects were the Nordic saga cycles, myths and fairy-tales. He remained close to nature in his pictures. In 1891 he executed a triptych on the subject of the Aino myth. In 1903 he painted frescos decorating the Juselius mausoleum in Björneborg (they were destroyed in 1931). In 1900, he painted the Finnish pavilion for the World Exhibition in Paris. His graphic work combines decorative linear elements with powerful and expressive depictions of events.

BIBLIOGRAPHY: Akseli Gallén-Kallela, Ett bildverk. Introduction by O. Okkonen, Stockholm 1948. – Akseli Gallén-Kallela, Piirustuksia. Teckningar, Drawings. Edited by O. Okkonen, Helsinki 1947. – Akseli Gallén-Kallela, Boken om Gallén Kallela, Helsinki 1924 and 1955 (Finnish), 1932, 1947 and 1948 (Swedish). – Geitel, M., "Finnlands großer Maler Akseli Gallén-Kallela", in DIE KUNST 37, 1918. – Okkonen, O., "Akseli Gallén-Kallela". Helsinki 1949.

WORKS: Mainly illustrations for the Finnish national epic the Kalevala, to the Sampo saga and to The Seven Brothers by Alexis Kiwi (German edition published by Holle, Berlin, no date).

Axel Gallén, The Defence of Sampo. 1895. Woodcut. 22.5×17.6 cm. ▷

GERMANY

In Germany, the art style otherwise generally referred to as Art Nouveau was given the designation Jugendstil (youth style). The evolution of Art Nouveau/Jugendstil in Germany was in accord with the political and social structure peculiar to that country. This art style did not develop centrally in the capital city, but in various other centres with different structural characteristics, in themselves clearly recognizable. Berlin and Munich were focuses for the new cultural currents. In addition, working centres for the new style were formed in the publishing towns of Leipzig and Dresden, in Hamburg, in Worpswede near Bremen, in Darmstadt, Mannheim and Karlsruhe, and in Dachau near Munich. In these towns, the initial development was on such a broad scale, and the effect of the stimuli from abroad combined with the prolific output of the indigenous artists so strong, that the art created in Germany during this period became a focal point for all the developments taking place in Europe. Germany itself became a leading centre for the exchange of ideas in Europe.

Art Nouveau was an art form and a movement of the European youth who were rebelling against the conventions of the older generation, but were not opposing fundamental artistic traditions. These young people provided a platform from which ideas could be exchanged internationally and set against the aims of the nationalist movements which were ominously gathering strength everywhere in the last quarter of the 19th century. However, this pan-European youth movement was too idealistic and aesthetic to be able to interfere with artistic ideas which had been introduced earlier by older generations and which were still being encouraged by those generations. But the advent of the First World War brought an abrupt stop to this widespread cultural activity. The rising importance of economic concepts and political power drove out spiritual creativity and those who had been friends in the academies of art found themselves ranged against one another on the battlefields of Europe.

Those people who, only a short time previously, had established friendships transcending national frontiers did not foresee this total perversion of their ideals, or at least they began by believing that their efforts to achieve pan-European communication had provided a good countermeasure. When reading biographies of German and Austrian artists, one discovers that they nearly all spent some time in Paris, that most of them worked at the Académie Julien, and that they frequented the circle of friends surrounding the Nabis, the REVUE BLANCHE and Vollard. Anyone leafing through German magazines and exhibition catalogues will re-discover many of the non-German friends who had been invited to collaborate with the Germans or to take part in their exhibitions. Walter

Crane's books were translated into German and English typography became the model for books and magazines published in Germany, even though that typography was not imitated but became a starting point for new ideas in this field. Magazines in general provided one of the most important means of exhanging European ideas. This exchange took place on a small scale within Germany itself as well as between European countries in general. Artists would move their residences temporarily to another centre, from Munich to Berlin, from Berlin to Darmstadt, from Dusseldorf to Munich, from Munich to Karlsruhe and so on. An atmosphere reigned in which every idea found an echo and each artist found his chance. The way in which this art style developed into a popular fashion had the result of giving opportunities also to people without artistic talent, because the demand was so great that the good workshops were unable to meet it. This is a characteristic of all artistic developments, but here we are endeavouring to distil the genuine achievements from the rest and to draw attention to those works which are the most worthy of being handed down to posterity.

The artistic life of Berlin was strongly influenced by the nearby court of the Kaiser and by that particular artistic insight which the Kaiser himself was always stressing. Anton von Werner, the Principal of the Berlin Art Academy and the President of the Association of Berlin Artists, officially expounded the Prussian-Hohenzollern concept of art. In 1892, following the model of Brussels, eleven artists joined to form "Die Elf" (The X1) group, to be independent of this aesthetic domination. It actually included some of the later Art Nouveau artists, in particular Walter Leistikow and Ludwig von Hofmann. In November of the same year, there was a scandal in the world of art on the occasion of Munch's exhibition held in the rooms of the "Association of Pictorial Artists": an extraordinary general meeting ruled that the exhibition should be closed down despite the protests of the young artists who then, in the following year, 1893, formed a "Free Association of Artists", from which the Berlin Secession was formed in 1898. In 1895, the poet Otto Julius Bierbaum and the art historian Julius Meier-Graefe founded, in Berlin, a bibliophile magazine entitled PAN, whose title page was designed by Franz Stuck, a painter from Munich. The work both of young men of letters and of artists first appeared in this magazine, and original illustrations which were published in the magazine acquainted the reader with new ideas on artistic form. Peter Behrens, Otto Eckmann, Ludwig von Hofmann, Walter Leistikow, August Endell, Joseph Sattler, Fidus and others were among the artists working permanently on the magazine. The typography was simple and aesthetically pleasing; the type matter was well proportioned and arranged in two columns; the text was accompanied by vignettes and the art pages were bound into the magazine separately as full pages, and were in most cases not conceived as graphic art for books, but as individual works of art. Examples are Leistikow's "Flying Cranes"

Otto Eckmann, Type face design commissioned by the Rudhard type foundry (later the Klingpor type foundry).

Rudhardsche type foundry in Offenbach awarded him the commission for this alphabet with its decorative battens and vignettes. This alphabet then came to be the "classic" Art Nouveau form of writing, and the model for all other experiments in brush-drawn typography. In particular, Peter Behrens and Melchior Lechter were artists who created exemplary written texts.

A magazine similar to PAN, but more modest in form, was the INSEL, which first appeared in Berlin and Leipzig in 1899, published by Schuster und Löffler. The editors were Otto Julius Bierbaum, Alfred Walter Dehmel and Rudolf Alexander Schröder. The art supplements were published in separate portfolios and not bound into the individual magazines. Georg Lemmen, Heinrich Vogeler and Emil Rudolf Weiss were the first to supply material for the magazine issues. In 1902 Anton Kippenberg founded Insel-Verlag, a publishing house specially intended for the publication of this magazine. and the firm has gone down in the annals of German art book publishing. Schuster and Löffler and Insel-Verlag provided exemplars for the new German typography which, starting on the basis of the stimuli received from England, very soon developed some freer type styles of its own. Working in close co-operation with Stefan George, Melchior Lechter created the

Otto Eckmann, Eckmann decorations. (borders for book decoration).

(illustrated on page 129), Hofmann's "Adam and Eve" (illustrated on page 137) and "The Kiss" (illustrated on page 139) by Behrens. But the new typography had its forum here too. For example, Henry van de Velde's essay on "General Remarks on a Synthesis of Art" appeared here and he illustrated it with headbands and other decorative elements which show a particular affinity with the type face. In addition, Otto Eckmann presented one of his first important examples of typographic design for a poem by Hans Bruckner; however, this two-page sheet did not interfere with the typography of the magazine, but was treated as a separate art sheet (see illustration on page 134).

A crucial factor is that Eckmann did not use typesetting for the lettering but wrote the text with a brush, which provided a contrast to the Latin script. With heavy and light lines, and particularly soft curves, he achieved an organically flowing character which harmonized with the content and expression of the text. In addition, the artist filled the margin on the outer side of the page with a flower ornamentation running out to the right at the lower edge of the text sheet. Not only is the modelling of this ornamental plant related to the handwriting in the text, but the motif also corresponds directly to it, both in the manner in which the leaves bend around as they rise upwards, and also in the broken stalk of the blossom.

Eckmann was commissioned to design the title page for the magazine DIE WOCHE, which first appeared in 1899. The "Seven" on this title-page symbolizes the days of the week, and it became a characteristic example of Art Nouveau both for its clarity and its decorative ties with the pictures. This also led to Eckmann developing his own alphabet. The

typographic design for that poet's works, and also provided the book ornamentation. In doing so, Lechter was closely following the ideas of William Morris, particularly in his imitation of the Neo-Gothic tradition, which had a special affinity with George's sacral intentions. To an increasing extent, German typography aimed at emphasizing the text when seen in contrast to the book ornamentation; the text was not intended to be rendered enigmatic by the decorative elements, but to stand out against them in the form of a block.

As against the cultivated aestheticism of the Berlin Art Nouveau, this art form experienced an almost heartily robust type of popularity in Munich. A reservoir for printed art was created here by that almost legendary magazine entitled JUGEND which Georg Hirth, the publisher of MÜNCHNER NEUESTE NACHRICHTEN, first brought out in January 1896, and he gave it the subheading "Illustrated Weekly Munich Magazine for Art and Life". This magazine was certainly not illustrated and designed exclusively by Art Nouveau artists. Despite this, the magazine gave its name to the entire German movement. The probable reason for this was that, being a new type of magazine, it was also vigorous in stressing the new tendencies and driving them into the subconscious of its contemporaries. The main new feature was the coloured title-page which changed every week and, in its poster-like effect, made a more forceful impression than any of the other goods on display in the magazine shops. To a certain extent it was a title-page and a poster in one. While nearly all the other reviews and journals showed the same face year in, year out, so that grey on grey was the general dominant feature in the periodical displays, the influences proceeding from JUGEND magazine could not be overlooked. Once one title had become familiar to the minds of the public, the next and completely different title soon appeared, and in this way the magazine demonstrated that it had a pace of its own with which it reacted to the topical problems of political and cultural life.

An equally surprising factor was the typography of the magazine issues, the frequent alternation of text and illustration, and the apparent lack of unity in the page design which sometimes soberly juxtaposed three columns of text, and sometimes entwined Art Nouveau book ornamentation around the text, or disrupted the existing width of column by inserting an illustration. Not even the type style of the title of the magazine was regularized; the type face of the letters was different on each issue. It was not a magazine for aesthetes, but rather one for those who liked caricatures which shocked, sentimental folk-songs, piquant little stories in words and pictures, and childhood memories of fairy-tale-like bliss. It was also a magazine for collectors of curiosities, particularly where advertisements were concerned. However, it was this very variety that gave the magazine its close connections with actual life and thus also its penetrating effect. The magazine was bound to be simply unendurable to the conventional mind.

Peter Behrens, A title for "Der bunte von Vogel" of 1899. Almanac by O. J. Bierbaum with decorations by Peter Behrens. Publ. Schuster and Löffler, Berlin/Leipzig. Autotype.

The people working on JUGEND included almost all those Art Nouveau artists who lived in Munich or its surroundings and were able to make a name for themselves. In addition, foreigners were also invited to take part, for example Jossot from France and Sturge-Moore and Shannon from England. Among those employed on PAN, Eckmann, Fidus and, of course, Stuck also worked on JUGEND, but not such North German aesthetes as Vogeler, Lechter, Leistikow, Behrens and various others. There is a certain exclusiveness here which, however, thereby reveals all the more clearly the particular character of the different tendencies. Eckmann and Fidus also displayed a more robust style and more popular subject matter when working for this magazine. In the same year, another magazine appeared alongside JUGEND in Munich. This was the politico-satirical weekly magazine SIMPLIZISSIMUS, which was founded by publisher Albert Langen together with Thomas Theodor Heine, the caricaturist. This magazine launched sharp and cynical attacks on the abuses prevailing in social and political life. The artists who created it did not all belong to the new approach, but the penetrating effect achieved by the

magazine was derived from it. Apart from Heine, other artists who were continually creating illustrations for this publication were Eduard Thöny, Rudolf Wilke and Olaf Gulbransson, Bruno Paul and so forth. Heine drew the Simpl dog, the magazine's well-known symbol. There is no doubt that, along with Bruno Paul, Heine was one of the most significant artists of Simpl: they both employed an apt and trenchant manner in the abbreviated, simplified form of the new style.

It was in the artistic atmosphere of Munich that it became especially clear that, although Art Nouveau was particularly fashionable at the turn of the century, it was only one of several art forms prevalent at that time. Seen from the present day, Art Nouveau became crystallized into the movement expressing the style of those times. Other artistic styles existing in Munich were, first, a late Impressionist movement and, second and more important, the expression of a nationally orientated Neo-Romanticism whose followers wished to direct the attention of the public to the artist's native soil. In this Neo-Romanticism, the urbanity of the salon was scorned and, as in France, or even Worpswede, there was a striving for a life-style closely related to nature. In Munich and its surroundings there were two groups with this approach, the so-called Dachau group, whose most important members were Ludwig Dill, Adolf Hölzel and Arthur Langhammer, and the so-called "Scholle" (native soil), whose name says almost all that needs to be known about its programme. It members comprised Fritz Erler, Leo Putz, Reinhold Max Eichler, Adolf Munzer, Max Feldbauer and others. But the Art Nouveau atmosphere which moulded the spirit of the times captured these artists too and gave their works that strange fantastical melancholy or yearning character; they nearly all worked on the JUGEND magazine.

Franz von Stuck, Title page for PAN. Berlin 1895. Autotype. About ▷ 31.8×22.3 cm.

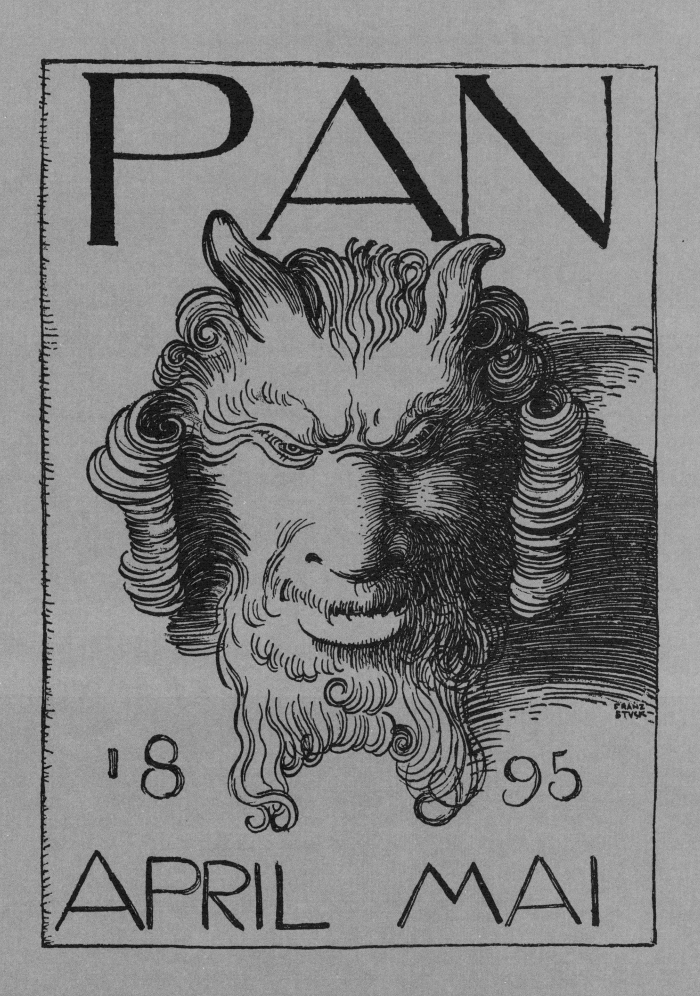

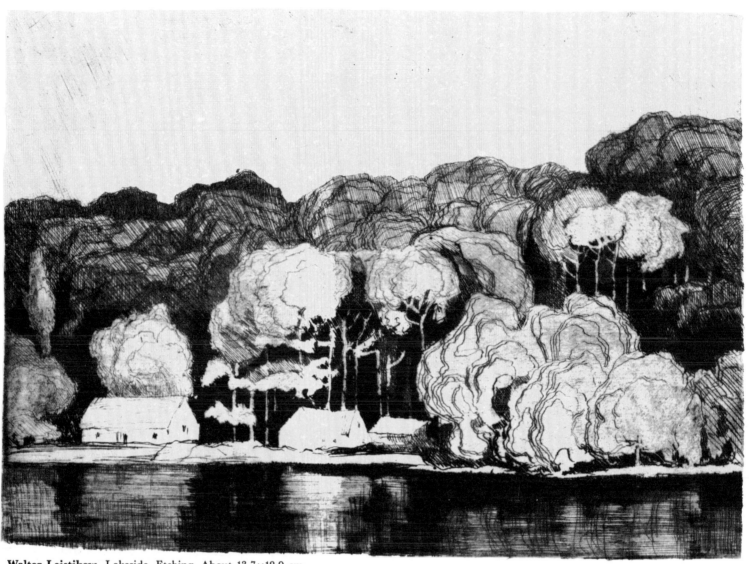

Walter Leistikow, Lakeside. Etching. About 13.7×18.9 cm.

WALTER LEISTIKOW

Walter Leistikow, a painter and draughtsman, was born in Bromberg on 25 October 1865 and died in Schlachtensee near Berlin on 24 July 1908. In 1883 he studied at the Berlin Academy, from which he was dismissed six months later on the grounds that he had no talent. He studied under Eschke from 1883 to 1885 and under H.Gude from 1885 to 1887. From 1880 to 1893 he taught at the art school in Berlin. He was on friendly terms with G.Hauptmann. From 1892 onwards he also worked as a writer. In 1892 he became a founder member of the association of artists called "Die Elf" (The Eleven); he spent a short period in Paris in 1893, and there he acquainted himself with the work of the Nabis, Bernard and Séguin. In 1898, permission was refused to display Leistikow's picture "Grunewaldsee" at the Great Berlin Art Exhibition. In 1898 the Berlin Secession was founded under Leistikow's influence. In 1904 he had a share

in founding the German Association of Artists. Apart from his painted and drawn works, he also produced designs in the field of applied art, mainly wallpapers, but also posters and carpets. Leistikow often took a motif, such as that of the flying cranes, and adapted it for use in all the disciplines of pictorial art - paintings, lithographs, posters and wallpapers. In Leistikow's works, after the initial inclusion of sentimental motifs, the landscape gradually becomes the sole means of expressing the emotional aspects which occupy the artist's attention. The line work is a very significant factor. In his etchings, the artist makes fine differentiations between the lines and intensifies their importance by means of parallelism. On the other hand, in the lithographs which are more in the style of posters, he uses lines for contouring and emphasizes the coloured surfaces. His preferred motifs are water, trees—whose crowns he combines into soft, cohesive shapes—and then heavy, low-flying birds which clarify the contradictory nature of flight.

128

Walter Leistikow, Flying Cranes. 1899. Colour lithograph from PAN.
21.5×27.6 cm.

BIBLIOGRAPHY: Bie, O, "Walter Leistikow", in KUNST UND KÜNSTLER 2, 1904.
– Corinth, L., "Das Leben Walter Leistikows". Berlin 1910. – Elias,
J., "Walter Leistikow", in DIE KUNST FÜR ALLE, 1903/XVIII. – Osborn, M.,
"Walter Leistikow", in DEUTSCHE KUNST UND DEKORATION 1899/1900.

WORKS: Contributions to PAN, etchings and woodcuts with greenwood
motifs, poster and wallpaper designs, calendar pages and others.

HUGO L. BRAUNE

Hugo L. Braune was a painter, lithographer and illustrator. He was born in Frankenhausen am Kyffhäuser on 1 February 1872, and lived in Berlin. He studied at the art school in Weimar, and worked under Th. Hagen and L. v. Kalckreuth. He was an official war artist in World War I. Braune was one of the numerous German painters living around the turn of the century who built up a tradition of destiny in German art, developing a new myth of Teutonism, the interpretation of which later took a disastrous turn. He proved himself to be a convincing story-teller in his distribution of light and shade and in his almost modest style of line drawing. The croaking cranes flying in the upper part of the picture are detached from the picture of the real happenings and they symbolically anticipate the fate of the persons performing actions in the lower section of the picture.

WORKS: Portfolios: Dietrich von Bern; Götterdämmerung; Richard Wagner's dramatic works (2nd. ed. Leipzig 1924). Den größten Deutschen zu Ehren (Berlin 1925).

NATIONAL ART. Up until now, the history of art has deliberately overlooked the delicate subject of the nationalist emphasis in the field of art towards the end of the 19th century. However, something should be said on this subject so that the history of Europe in the 20th century may be better understood. The following quotation from an essay by Richard Muther indicates that the conflicts between a misunderstood nationalism on the one hand, and an artistic sense aiming at mutual European understanding on the other, had become very obvious even as early as the turn of the century.

"Friedrich Schaarschmidt, the librarian of the Dusseldorf Art Academy, has published with Bruckmann in Munich a readable book called "From Art and Life", in which he attacks the alien trends followed by the German painters and, in rousing words, preaches the necessity of "national art". 'Dürer, and many others besides him, have proved that an art such as this existed previously. The ideas that matured in the mind of Cornelius in the days of the wars of liberation prove that this type of art was raising its head at the first ray of sunlight after centuries of almost total abandonment. After this national idea of German unity had been brought to life by the colossal strength of Bismarck, one might have thought that the old servile habit of the admiration of things foreign would now come to an end in the same way in which the calluses of slave labour drop off, or the traces left by chains disappear. However, the old and deep-seated evil appears to be constitutional. During the years of humiliation, there existed an enthusiastic patriotism which made our artists into spiritual pioneers of German thought. A not inconsiderable number of artists have now substituted for this enthusiasm a cosmopolitan insipidness which is supported and praised by a press that is not national. If the German people ever come to realise the significance of their former German art, then, and only then, they will also realise that there is such a native language in art, and then all our artists will joyfully begin singing and speaking in this very own language of theirs, and then every kind of German art will also be national." These are very splendid and fine-sounding words, which, however, suffer from the defect that each sentence contains nonsensical statements.

"All the differences resulting from individual predisposition or local circumstances must recede in the face of that great equality which the spirit of the times imposes upon its sons. In the same way as today's German fashions differ only in small nuances from Paris or London fashions, but have nothing at all in common with the costumes of the Lutheran period, so an artistic style never belongs to a particular nation but only to a particular time. Every new age will find new works. Every new generation makes the discovery that the previous generation was occupied with resolving certain questions and neglected the solution of other and no less important questions. For a time, all efforts are directed towards these new questions, and this is done to an equal extent in all the countries which are connected by the same civilized atmosphere. When the subject is exhausted, the following generation finds a new one. Thus, all European styles since the beginning of Christianity were international. Gothic and Renaissance style, Baroque and Rococo style, Classicism and Romanticism—all these made their way in the world. This gives rise to the impression of a fugue in which the individual nations enter with their own voices, or of a lake into which a stone is thrown from which circular ripples then spread out all round.

"Who will be the precentor? Who will throw the stone into the flood? It will always be the nation which is the first to enter a new cultural phase. This also explains why Germany was never the leader in such matters, but almost always only received the influences provided by Italy or France or by Holland or England.

'The plain honest German became a good European by being receptive towards matters foreign. There has never been a native language in art. And anyone is national who says something of his own."

Hugo L. Braune, Illustration for a Heroic Saga (from an Insel portfolio). Autotype. About original size. ▷

Hugo
L.Braune

Otto Eckmann, Title colophon for the journal DIE WOCHE (published every seven days). 1899. Autotype. Publ. Druck und Verlag v. Aug. Scherl, Berlin. About 11.4×10 cm.

Otto Eckmann, Page from the journal JUGEND, No. 35, p. 587, 1897. ▷ Autotype. 29.6×22.3 cm.

OTTO ECKMANN

Otto Eckmann, a painter, draughtsman and applied art designer, was born in Hamburg on 19 November 1865 and died in Badenweiler on 11 June 1902. He studied at the schools of applied art in Hamburg and Nuremburg, and also at the Academy in Munich. In 1894 he voluntarily auctioned his pictures, and he switched over to graphic art and to artistic handiwork. From 1895 onwards he worked on the two magazines PAN and JUGEND. From 1897 he taught ornamental painting at the School of Applied Art in Berlin. Some of his works in the fields of graphics and applied art were displayed in the Royal Palace of Glass in Munich.

Eckmann is one of the most significant exponents of the floral Art Nouveau, which was given this name because almost all its stylized shapes are derived from the sphere of plants and organic matter. In the artistic forms of handwriting which he developed, even the modelling of the letters gave an impression of nature. The favoured symbolic animal in his sheets, illustrations and carpets is the swan. The pure white of the swan's plumage, the arabesque-like flexibility of its long neck, and the fact that its silhouette naturally lends itself to repetition—all this meant that the swan became a positive symbol of Art Nouveau. The

illustration for Hans Bruckner's poem, with the broken blossom falling back onto the ground, is an typical example of the great extent to which nature, in the works of Eckmann, is used for a symbolic conception of the world. In the portraits of Eckmann's early period, the flowers depicted in the background and on the picture frame are of importance in providing a significant accompaniment to the person being painted.

"When the civilized nations were longing to re-emphasize the decorative element, they were first at a loss what to do. They then received a fortunate stimulus from an unexpected quarter. The ancient cultural world of the Orient opened its gates: the art of the Japanese became known to us. This art bore no relation to the styles of the European past. It was the direct, living expression of a very ancient culture which was thousands of years old and had developed quite independently of the West. Here, the motifs which nature provided for the artist had never been utilized in a direct way, but only as aids with which to decorate life itself. For this purpose, these motifs had to be transformed both in the artistic and in the decorative sense. The whole field of modern applied art drew its most important regenerative strength from this Japanese world of art.

Die rothe Saite
Von Per Hallström

Vor Gott erklang die goldene Welten-
harfe in siegesstolzer Harmonie, und der
Engel glanzgekrönte Häupter und schwe-
bende, weiße Gewänder neigten sich
und wehten im Gesange, wie Binsen
im Wind.

Gott ruhte, die großen tiefen Augen
auf die Saiten der Harfe gerichtet, die
in taktgemäßem Wechsel stiegen und
sanken, ein Meer fluthenden, ebbenden
Lichts und Wohllauts; da fiel sein Blick
auf eine rothe Saite, die stets zitterte,
stumm, ohne einen Ton, ohne ein
Flüstern.

Die Engel sahen sie nicht, sie wurden
in klingender Freude gewiegt und em-
porgehoben, aber Gott verließ seinen
Thron, beugte sich zu der jubelnden
Harfe hinab und löste leicht die rothe
Saite, die über seiner Hand zitterte.

Dann sah er zur Erde hinunter,
die matt in der Tiefe schimmerte, und
sagte: Du rothe Saite, die mit fremdem
Sang zittert, sinke dort hinab und
finde Deine Stimme wieder! Schmiege
Dein reines Metall dicht an rothe,
klopfende Herzen, leihe Deinen Ton der
Sehnsucht, die den warmen Busen sprengt,
klinge in Schönheit, wenn die fluthwelle
der Unendlichkeit ihre Kühle um eine
flatternde Seele breitet!

Juble aus der Kehle der Lerche, gib
schmerzvermischtem Schönheitsdrang und
Schönheitsgenuß Worte und liebkose
mit Deinem weichsten Geflüster das un-
gesehene, von sich selbst nicht geahnte
Gefühl, das im Verstecke eines armen
Sinnes blüht und welkt!

Und er legte die Saite dicht an
seine Brust; sie klang schön und laut,
so laut, daß die Engel emporgehoben
wurden, gleichsam in einem unsichtbaren,
springenden Wasserstrahle badend —
dann ließ er sie fallen, durch den Raum,
zu der matten Erde wie einen funkeln-
den Stern.

Und die Weltenharfe sang, wie
sie die ganze Zeit gesungen, sang ihr
Lied von unendlicher Größe und Schön-
heit, unendlich, ewig, ohne Anfang,
ohne Ende, und die weißen Mäntel
der Engel wehten wie Binsen im Winde.

Aber zuweilen erklang ein anderer
Ton, ein Ton sehnender Schönheit, die
thauig durch Wolken des Kum-
mers bricht, und Gott neigte
sein Haupt hinab und lauschte.

(Aus d. Schwedischen v. Francis Maro.)

Otto Eckmann.

Der Träumer

Ich, Du und die mich schelten,
Sind Blüthen an Einem Baum,
Gott und die rollenden Welten,
Wir alle sind Ein Traum.

Ihr scheltet meine Träume,
Wenn auch mit mildem Wort,
Daß ich das Hier versäume
Um ein erdichtetes Dort.

Wohl bleib' ich fern den Thoren,
Was auch ihr Thun beginnt,
Die da nach Quellen bohren,
Wo keine Quelle rinnt.

Bleib' fern dem Wortgezänke,
Dem Hadern der Partei'n,
Der großen Eselstränke,
Wo Thier und Treiber schrei'n.

Ich suche mir das Wasser,
Dessen meine Seele bedarf,
Den Quell, in den kein Hasser,
Kein Neidling Steine warf.

Und meine Eimer steigen
Hinab, herauf in Ruh,
Die Tiefe wird mein Eigen,
Leben fließt Leben zu.

Und wenn es steigt und fluthet,
Und füllt die Seele ganz,
Und auf der Fülle gluthet
Von Oben her ein Glanz —

Da hebt von selbst zu tönen
Die volle Tiefe an,
Das laß ich mir nicht höhnen,
Meine Seligkeit hängt daran.

Doch wollt ihr umsonst was schmälen,
Da lächle ich nur still,
Mag jeder sein Rößlein wählen
Und reiten wie er will.

Sitz er nur fest im Bügel
Und wisse, wohin es geht:
Nach einem kleinen Hügel,
Darüber Vergessen weht.

Genug, wenn eine Platte,
Mit einem Sprüchlein d'rin
Das Grab mir deckt: Er hatte
Ein Herz und gab es hin.

Gustav Falke.

und was die Welt Dir grau erscheinen ließ
und kalt,
und was die Sehnsucht nach der Heimath in Dir weckte.
——————

— Nun bist Du frei! —
Nun ist versunken alles was Dich drückte,
rings Frieden, heitre, helle Sonne
um Dich die stillen Wasser der Vergessenheit.
Und vor Dir baut die andre Welt sich auf.
Da schaust Du Deine Heimath wieder,
Deine Sehnsucht —
und freie Menschen
frei wie Du;
die sehn Dich nah'n
und eilen Dir entgegen
singend
jauchzend.
Von allen Seiten strömen sie herbei;
„O komm,
o komm zu uns
in Deinen Zaubergarten, wir warten Dein,
wir warten unsrer Königin!" —
Und wie Du lächelst,
wie Du vorwärts schreitest,
entgegen Deinem Glück und Deiner Welt —
Da faßt es Dich
Da hält es Dich zurück
grausam;
„Noch ist's nicht Zeit!"
Und langsam schwindet Deiner Sehnsucht Bild
und weicht —
und sinkt —— ——
——————

Und wieder jener Zug der tiefen Trauer
das wehe Lächeln,
das den Andern Deinen Schmerz
verrieth. —
Wann wird — Du stilles Kind —
wann wird die Heimath Dir die Ruhe schenken —?

HANS BRUCKNER.

"In Germany, the Japanese also had a decisive influence on the dramatic change which took place. Otto Eckmann, to whom we must be grateful for providing us with so many stimuli in the whole field of decorative art, played a leading role here too. As was the case in all his other graphic works, he also followed the incomparable masters of Nippon very closely in his woodcuts. It was from them that he adopted the principle of the free and naturalistic stylized representation of his plants and animals, among which the noble swan played such a privileged role. He also took over from the Japanese the art of easy and pleasing design and the renunciation of perspective in favour of a decorative two-dimensional effect which he put to very ingenious use. In fact, Eckmann even adopted the Japanese way of mixing the delicate colours. He always prepared his colours personally, and did so in an especially refined style." (M.Osborn)

◁ **Otto Eckmann**, Border for the poem "Ḥeimweh" by Hans Bruckner. From PAN, I, 1895/96. 36.5×27.6 cm (page size).

BIBLIOGRAPHY: Eckmann, O., "Vorrede zu meiner Schrift". – Osborn, M., "Prof. Otto Eckmann – Berlin", in DEUTSCHE KUNST UND DEKORATION 1900. – id., "Otto Eckmanns kunstgewerbliche Tätigkeit", in DEUTSCHE KUNST UND DEKORATION 1898. – Velde, H. van de, "Zum Tode Otto Eckmanns", in ZEITSCHRIFT FÜR INNENDEKORATION XIII, 1902.

WORKS: Contributions to PAN and JUGEND. New type faces (Eckmann Type) for Klingspor, Offenbach; Ex Libris plates and posters, calendars, book bindings for Verlag E.A. Seemann. Woodcuts including Schwertlilien (1895), Drei Nachtreiher, Mondschein auf dem Wasser (1897). Borders for poems in the floral Art Nouveau style.

Otto Eckmann, Two Swans. Colour woodcut. 16.7×33.4 cm.

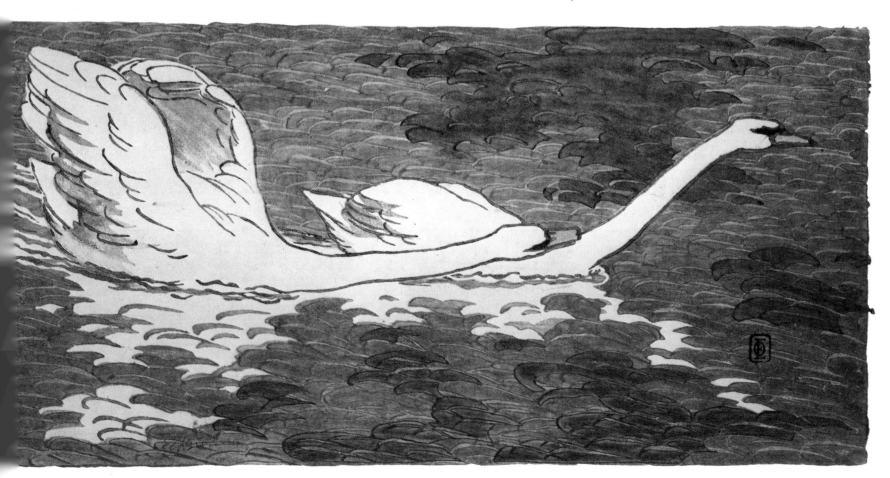

Ludwig von Hofmann, Adam and Eve. Colour lithograph from the journal PAN, 1897. 25.4×19.5 cm. ▷

Ludwig von Hofmann, Vignette from PAN. Autotype. Reduced.

LUDWIG VON HOFMANN

Ludwig von Hofmann, a painter, draughtsman and applied art designer, was born in Darmstadt on 17 August 1891, and died in Pillnitz near Dresden on 23 August 1945. From 1883 to 1889 he studied at the academies in Dresden, Karlsruhe and Munich. He was at the Académie Julian in Paris in 1889/90. He was inspired by Puvis de Chavannes and A. Besnard, and copied the latter's murals. He established relations with Maurice Denis. From 1890 onwards he was a member of the artists' association called "Die Elf" (The Eleven) in Berlin, along with Corinth, Klinger, Leistikow and Liebermann. He stayed in Rome from 1893 to 1900, and from 1900 onwards he was in Darmstadt. In 1903 he was appointed teacher at the art school in Weimar, and in 1916 he obtained a post at the Academy in Dresden. In 1906 he travelled to Greece with G. Hauptmann.

The symbolism of a lost paradise is a favourite motif of this artist. The sheet from PAN reproduced here clearly reveals the academic, traditionalist training whose influence he never denied. Art Nouveau motifs, usually issuing from the frame of the picture, combine themselves with human figures. As a result of this contrast, the motifs create a coded figurative meaning whose symbolic tendencies are nevertheless clearly detectable. In similar fashion to Klinger or Munch, he depicts the puberty problem in his picture of Eve. Eve is the girl who is in a state between unawareness on the one hand and the budding understanding of her physically sensual powers on the other. In her kneeling posture, she has averted her gaze from Adam and is looking out of the picture and into herself, surrounded by the symbols which depict her ideas and are stylized in the Art Nouveau manner. These symbols are the tempting serpent and the blue flowers which are entwining in an upwards direction. All the colours of the nature surrounding her are reflected on her body.

BIBLIOGRAPHY: Brieger-Wasservogel, L., "Ludwig von Hoffmann", in DEUTSCHE MALER. Strasbourg 1903. – Fischel, O., "Ludwig von Hofmann". Leipzig 1903. – Graef, B., "Hodlers und Hofmanns Wandbilder in der Universität Jena". 1910. – Redslob. E., "Ludwig v. Hofmanns Lithographien und Holzschnitte", in DIE KUNST 35, 1917 – id., "Ludwig v. Hofmanns Handzeichnungen". 1917. – Schultze-Naumburg, P., "Ludwig v. Hofmann", in KUNST FÜR ALLE 14. 1899. – id., "Neues von Ludwig v. Hofmann", in DIE KUNST 55. 1927 – Catalogue of the Ludwig v. Hofmann and A. Beyer jubilee exhibition. Darmstadt 1941. – Catalogue of the Ludwig von Hofmann commemorative exhibition. Berlin-Charlottenburg 1962.

WORKS: movement studies after the dances of Ruth St. Denis with commentaries by Hugo v. Hofmannsthal and Th. Däubler, 1906. – Woodcuts for the Hohes Lied, and for the Hirtenlied of G. Hauptmann; contributions to PAN. Also lithographs, designs for posters and book bindings.

Ludwig von Hofmann, Dance. 1910/11. Woodcut. Reduced.

136

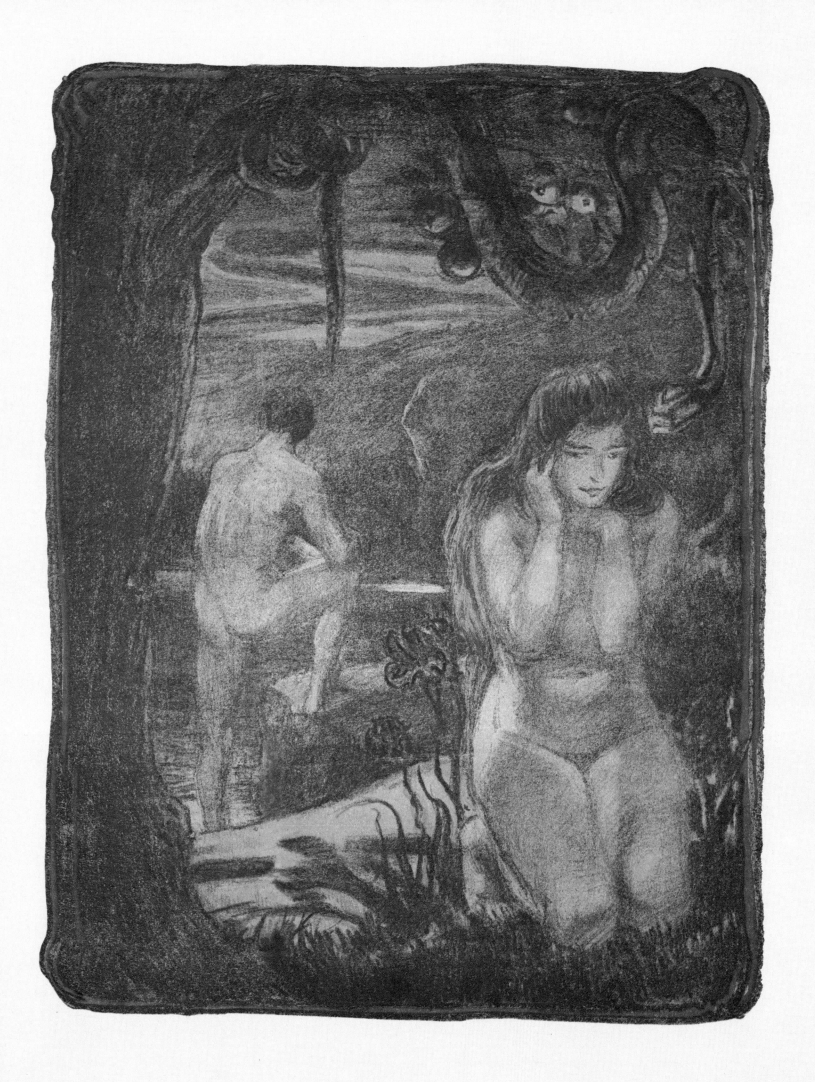

Peter Behrens, Title on binding for "Der bunte Vogel" of 1899. Almanac by O. J. Bierbaum with decorations by Peter Behrens. Publ. Schuster and Löffler, Berlin/Leipzig. 13.9×11.3 cm.

PETER BEHRENS

Peter Behrens was an architect, painter, draughtsman, applied art designer and writer. He was born in Hamburg on 14 April 1868 and died in Berlin on 27 February 1940. From 1886 to 1889 he studied at the art schools in Karlsruhe and Dusseldorf. He was active in Munich from 1890 onwards. He went to Holland to study the luminarists, and was personally acquainted with Israels and Neuhuis. He was in contact with the "Ecole de Petit Boulevard" and was influenced by its monochromatic atmospheric painting. In 1893 he was co-founder of the Secession in Munich. In 1895/6 his painting switched to a two-dimensional Art Nouveau style, and in 1896 he began his series of woodcuts. He travelled to Italy in 1896. In 1897 he gave an exhibition in Zurich, and in the same year he was among the founders of the Associated Workshops for Art in Handicrafts. In 1898 he worked on the magazine PAN. He held an exhibition in Darmstadt in 1899. In 1900 he was appointed a member of the Darmstadt colony of artists. He carried out his first commissions in the fields of architecture and artistic interior decoration, and in 1901 the Behrens house in Darmstadt was built. The Behrens-Fraktur (Behrens Gothic type), the

first type face created by Behrens, appeared in 1902. In 1901/2 he held a course at the art school in Nuremburg, and from 1903 to 1907 he was the Principal of the School of Applied Art in Dusseldorf. From 1905 onwards he obtained some large architectural commissions. He was the art adviser for the company AEG in Berlin from 1907 onwards, and moved to Berlin. He designed a new type face, the Behrens-Kursiv (Behrens Italic). He made another trip to Italy. In 1908 he designed another font, the Behrens-Antiqua (Behrens Roman). In 1909 he designed the AEG turbine factory shop in Berlin, and also the Mannesmann pipe factory in Dusseldorf. Behrens became the co-ordinator of modern industrial buildings and estates, such as the workers' housing estate in Hennigsdorf. In 1914, the Behrens-Mediäval type face (Behrens Old Style) appeared. In 1921 he was appointed to be a member of the Dusseldorf Academy. From 1922 onwards he was Professor of Architecture at the Vienna Academy. He moved to a landed property near Neustrelitz in 1932. In 1936 he was appointed a member of the Prussian Academy of Arts in Berlin, and also took over a master studio for architecture.

In similar fashion to Ludwig von Hofmann, Behrens shows in his "The Kiss" a combination of almost classicist motifs with abstract ribbon shapes which are derived from the hair motif, but are reminiscent of Celtic ornamental wickerwork. A similarity between the art of Behrens and that of Munch is that the lovers' hair unites in a thick entanglement. This would signify that the tangle of hair surrounds the couple with an introverting protection and completely shuts them off from the outside world. These decorative ornaments are derived from the organic world but transport the onlooker into the world of abstraction, and they are also characteristic of Behrens' other works.

BIBLIOGRAPHY: "Peter Behrens", in DEKORATIVE KUNST, special issue, Dusseldorf 1905. – Blei, Fr., "Peter Behrens a German Artist", in THE STUDIO, Vol. XXI, 1901. – Breysig, K., "Das Haus Peter Behrens mit einem Versuch über Kunst und Leben", in a special issue of DEUTSCHE KUNST UND DEKORATION, 1902, year IV, Issue 1. – Breuer, Robert, "Peter Behrens", in DIE WERKKUNST, 9 February 1908, year III, Issue 10. – Casabella, "Peter Behrens" Special issue. Milan 1960 No. 240. – Cremers, P.J., "Peter Behrens". 1928 – Grimme, K.M., "Peter Behrens und seine Wiener akademische Meisterschule", Vienna 1930. – Hoeber, F., "Peter Behrens", Munich 1913 – Moderne Architekten Vol. 1. – Hoeper Fr., "Die Kunst Peter Behrens". around 1909 (Ges. Gebr. Klingspor). – Meier-Graefe, J., "Peter Behrens – Düsseldorf", in DIE KUNST, 1905, p. 381 ff. – Meyer-Shönnbrunn, F. (edited), "Peter Behrens", in "Monographien Deutscher Reklamekünstler im Auftrag de Deutschen Museums für Kunst in Handel und Gewerbe, Hagen i W. Hagen und Dortmund" 1911 ff. – Osborn, M., "Besprechung der in Keller und Reiners Kunstsälen ausgestellten Holzschnitte des Münchner Maler Peter Behrens" – Osthaus, K.E., Peter Behrens, in KUNST UND KÜNSTLER, Dec. 1907, year IV. issue 3. – Ruettenauer, Benno, in KUNST UND HANDWERK, "Peter Behrens". (Über Kunst der Neuzeit VII. Issue, p. 89 ff.) Strasbourg 1902. – Scheffler, K., "Peter Behrens", in DIE ZUKUNFT, 23 Nov. 1907, Year XVI. No. 8. id., in, DEKORATIVE KUNST, October 1901, year I. Issue 5. Special issue, "Das Haus Behrens".

Peter Behrens, The Kiss. 1898. Colour woodcut. 27.2×21.7 cm. ▷

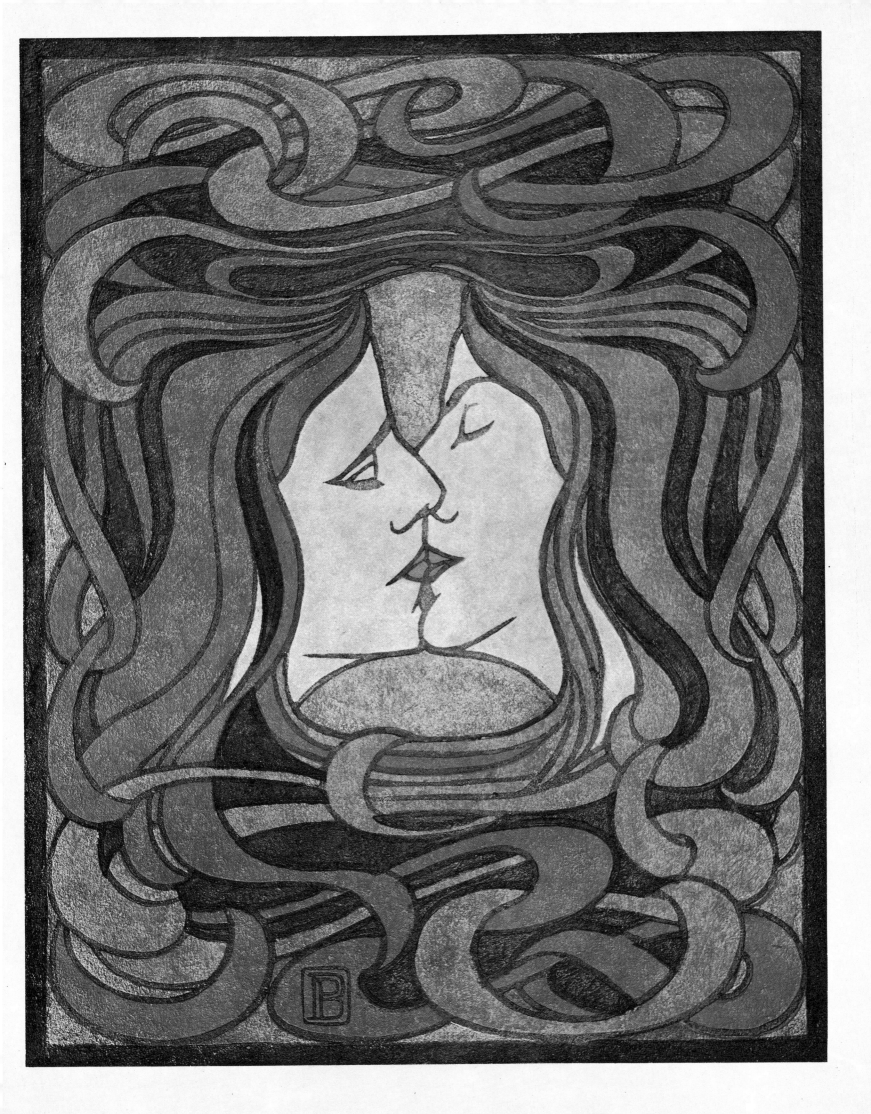

Franz Stassen, Illustration for "Romances and Ballads". Jungbrunnenheft No. 9. Publ. Fischer und Franke, Berlin. About original size.

EXHIBITIONS: Peter Behrens catalogue (1868–1940). Commemorative essay with catalogue on the occasion of the exhibition. Pfalzgalerie Kaiserslautern, Karl-Ernst-Osthaus-Museum Hagen, Kunstverein Darmstadt, Bauzentrum Vienna, Staatliche Hochschule für bildende Künste, Berlin, Dusseldorf, Hochschule für bildende Künste Hamburg, Städt. Galerie und Lenbach-Haus Munich. 1966/67.

WORKS: Contributions to PAN, JUGEND, DEUTSCHE KUNST UND DEKORATION; Illustrations and designs for books, etc. Der bunte Vogel by O.J. Bierbaum, Ein wahrhaft guter Mensch and Die Erziehung zur Ehre by O.E. Hartleben; Till Eulenspiegel. Posters, large format woodcuts, particularly Der Kuß, Sturm, Lotosblüten, Waldbach. His own writings.

FRANZ STASSEN

Franz Stassen, a painter and illustrator, was born in Hanau on 12 February 1869. He attended the school of drawing in Hanau and studied at the Academy in Berlin. His works include cycles of paintings and tapestries, chiefly with motifs from the world of sagas and fairy-tales. His illustrations were also inspired by these motifs.

WORKS: portfolios (published by Fischer und Franke): Tristan und Isolde (for the Wagner opera – 1900), Götter (Theuerdank, 1901), Parsifal 1902,

Fortunat und seine Söhne (Jungbrunnen), Faust II, 1903. Der Ring der Nibelungen: Das Rheingold (24 sheets, 1914), Die Walküre (26 sheets), Siegfried (30 sheets), Götterdämmerung (40 sheets) – published by Verlag Schröter, Berlin.

EMIL RUDOLF WEISS

Emil Rudolf Weiss worked as a painter, draughtsman, applied artist and writer. He was born in Lahr on 12 October 1875 and died in Meersburg a.B. on 7 November 1942. He studied under Kalckreuth and Thoma in Karlsruhe, and also pursued studies in Stuttgart and at the Académie Julian in Paris. From 1903 to 1906 he worked under Karl Ernst Osthaus in Hagen, Westphalia and also for the Folkwang Museum. From 1907 to 1933 he taught at various art institutes in Berlin: these were the Museum of Applied Art and the United State Schools for Free and Applied Art. From 1914 onwards he was married to the sculptress Renée Sintenis. From 1897 he worked in the field of artistic book decoration and developed several type faces.

BIBLIOGRAPHY: Emil Rudolf Weiß commemorative publication, 1925. – Hölscher, E., "Der Schrift- und Buchkünstler Emil Rudolf Weiß, 1941. – Zerbe, W., "Emil Rudolf Weiß, Der Schrift- und Buchkünstler". 1947. – Weiß, E.R., "Das Buch als Gegenstand". Fischer's Jubilee Almanac XXV, 1911.

WORKS: Contributions to PAN, work for INSEL, illustrations to Schönen Madchen von Pao, to Shakespeare's Troilus and Cressida, etc., type faces Weiß-Fraktur, Weiß-Antiqua, Weiß-Gotisch, Rundgotisch.

H. HÖPPENER, known as FIDUS

H. Höppener, a painter and draughtsman, was born in Lübeck on 8 October 1868 and died in Schönblick near Woltersdorf on 23 February 1948. He studied at the Lübeck School of Applied Arts and at the Munich Academy. Until 1889 he studied under Diefenbach in Höllriegelsgereuth in the Isar Valley, and it was Diefenbach who gave him the name "Fidus". From 1889 to 1892 he was back at the Munich Academy again, and then moved to Berlin. He expounded mystical and theosophical ideas, and his work was of varying quality. In his best work he succeeded in achieving a happy combination of human figures depicted in a natural way on the one hand, and abstract stylistic shapes on the other. The frieze representing children has a silhouette-like appearance, as though it had been cut out with scissors.

It stems from his early period, which was not yet encumbered with reformatory ideas and in which the artist observed Diefenbach's children playing in the nude and then portrayed them.

"Wilhelm Diefenbach played a decisive role in Hugo Höppener's artistry. Diefenbach advocated a unity between art and an exemplary life which he led with his pupils in the manner of the early Christians. He renounced all things that were not indispensable, went barefoot in a long flowing garment and sandals, and preached sun-worship and vegetarianism. He was therefore in dispute with the authorities and things were made difficult for this "atheist" even where his children's education was concerned. This strange man had built his workshop in Höllriegelsgereuth, an abandoned quarry in the Isar valley, and lived a hermit-like life there, usually far away from his family and only sometimes accompanied by his pupils. Most of the people who visited him were unable to endure this life full of difficulty and deprivation for very long and therefore they went away again. But Höppener remained, and Diefenbach gave him the honourable monastic name of "Fidus", the faithful one, as a reward for his loyal perseverance. It was under this name that Hugo Höppener first became known. "There is a series of pictures executed by Diefenbach during that period which has recently become very widely known and popular by the name of "Kindermusik" (children's music): they depict figures of small children sitting or hovering in calyxes and playing some instrument. They are reminiscent of the pictures of Ph. Otto Runge. Only a few people know that most of these little pictures were executed by the hand of Fidus in accordance with the designs created by his master who was for long periods often unable to paint, owing to paralysis of his arm. The style of representation, using white on a dark-coloured background, was new and was the work of Diefenbach, whereas the tracing of the human figures was an astonishing

Emil Rudolf Weiß, Illustration for "The Beautiful Maiden of Pao". 1900. Publ. Insel-Verlag, Leipzig. Autotype.

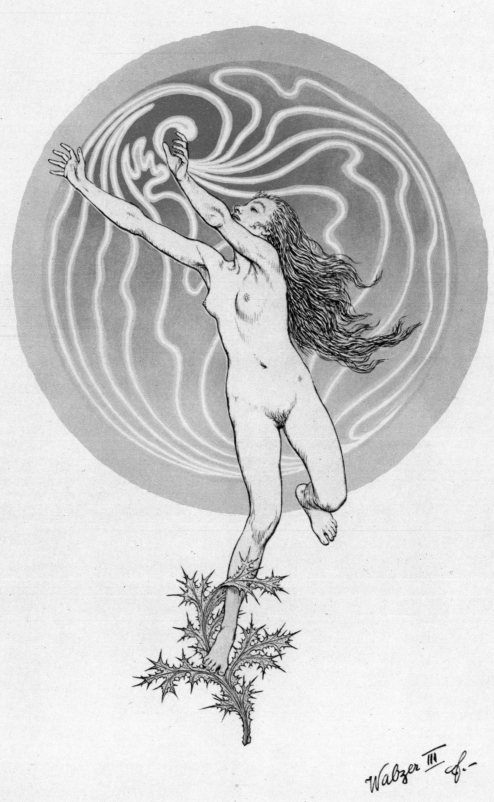

Wabzer III

◁ **Fidus**, Waltz, from the portfolio "Dance" 1894. Colour lithograph. 35.9×24.1 cm.

Fidus, (above and below), Illustrations to K. W. Diefenbach, "Fairytale from life" (Per aspera ad astra). Autotype. Heights 5.1×5.9 cm.

test for the eighteen-year-old Fidus's talent. Apart from the splendid sweep of the lines in the drawing, the significant factor here is that the children's bodies and souls have been captured and reproduced in a manner which had not previously been experienced in that period, when there was a compulsory academic putto style. Not even the early drawings, which were completed by Diefenbach himself and were later published under the name "Divine Youth", were entirely free of this academic style. How did the young artist Fidus arrive at this maturity of representation and this independence? When he first went to visit Diefenbach, he had hardly ever drawn a nude before or even so much as seen a naked body. It was when he visited Diefenbach that Fidus first saw the master's children, Helios, Lucidus and Stella (the names speak for themselves!) growing up in the sunshine without the constraint of clothes. Fidus saw them with a pure artist's eye, so far untainted by an unattractive academic model. Every day he observed their games and their gymnastic exercises, and his wonderful memory for shapes retained all these positions and movements with unerring certainty. There was probably no other painter living at that time who was fortunate enough to be able to paint his studies in this way. And his conviction was an immense help to him." (A.Rentsch)

BIBLIOGRAPHY Spohr, W., "Fidus". 1902. – Rentsch, A., "Fiduswerk". Dresden 1925.

WORKS Contributions to JUGEND, PAN, SPHINX; book decorations, posters, Ex Libris plates. Illustrations to: Tempeltanz der Seele; Dehmel, Aber die Liebe; F. Evers, Hohe Lieder; E. Stucken, Balladen; Übersinnliche Welt; theosophical fairy-tales, etc.; K. Henckell, poems; K. Geucke, Nächte (18979; B. Wille, Offenbarungen des Wacholderbaums. 1901; Lyrische Andachten; Schwingungen; Mein Lied; Das Buch vom Kinde. Lebenszeichen.

E. M. Lilien, Book decoration for "Songs" by Gabriele d'Annunzio. 1904. Publ. Verlag Schuster und Löffler, Berlin. 16.9×12 cm.

E.M.LILIEN

E.M. Lilien, who was a draughtsman and illustrator, was born in Drohobycz, Galicia, on 23 May 1874, and died in 1925. He was the son of a Jewish master turner. Initially taught by a sign-painter, he then studied at the art school in Cracow. He studied under Matejko, a painter of historical pictures, and earned his keep by painting signs. He returned to Drohobycz, where in 1894 he acquired an honorary diploma in a competition held in his native town. He then made an attempt to gain entry to the Academy in Vienna but failed because of his lack of means. In 1896 he moved to Munich. He worked on several socialist publications. He was on friendly terms with Börries von Münchhausen. He founded the Jewish Publishing House

and became its editor, producer and illustrator. In 1902 "The Jewish Almanac" appeared. Lilien travelled to Russia in 1902, and met Maxim Gorky. In 1905 he founded the Bezalel Company in Berlin, with the aim of introducing into Palestine works of art, arts and crafts and domestic products. In 1906 a school of applied art was opened in Jerusalem, and Lilien was to be responsible for its construction. In 1906 he went on his first journey to Palestine, and his second and third journeys to that country took place in the period from 1910 to 1914. He started to draw illustrations for the Bible.

Lilien's work began by relating to the English art of book decoration, but he did not employ the great ornamental extravagencies used in that art. Flexible lines intertwine with one another and bring about a connection between man and his environment. His style soon acquired a less lyrically emotional content, becoming strictly epical, and this development continued until, in his illustrations for the Bible, he achieved an almost iconic language of symbols. Not only did he represent a particular variety of German Art Nouveau, but he must also be appreciated as one of the chief masters of Jewish art in the 20th century.

BIBLIOGRAPHY: Baader, G., "E.M. Lilien", in Jüdischer Volkskalender 1903. – Berger, J., "Die Lilien-Bibel", in DIE WELT No. 46, 1910. – Brieger, L., "E.M. Lilien". 1922. – id., "Neue Deutsche Buchkünstler". XXVVIII E.M. Lilien. Deutscher buch- und Steindrucker. Year No. XVII. – id., "Das radierte Werk von E.M. Lilien". 1911 – Doctor-Bruchsal, M., "E.M. Lilien und sein Werk", ALLG. ZEITUNG DES JUDENTUMS. Issue 6, 1905 – Donath, A., "Der Künstler Lilien", in DIE WAGE, Issue 39, 1901. – Flach, J., "E.M. Lilien". KRAJ" No. 46, 1901 – Gold, A., "E.M. Lilien. Jüdische Künstler". Edited Martin Buber. 1902. –Hirschfelder, M., "E.M. Lilien". OST UND WEST No. 17, 1901 – Münzer, H., "E.M. Lilien". in GENERALANZEIGER. Year I. Issue No. 13, 1902. – Münchhausen, B. v., "E.M. Lilien". 1900 (in Polish). – Reich, L., "E.M. Lilien". 1902 (in Polish). – Regener, A., "E.M. Lilien. Ein Beitrag zur Geschichte der zeichnenden Künste". 1904. – Russ, G., "Ein Illustrator der Bibel". 1911. – Schach, M., "E.M. Lilien", in NEUE NATIONALZEITUNG No. 1, 1908. – Solomon, S.J., "Ephraim Lilien", in THE MAGAZINE OF ART, 1903. – Sukennikow, M., "E.M. Lilien", in WOSCHOD No. 78, 1902 (Russian). – Zweig, St., "E.M. Lilien, sein Werk", 1903. – (detailed bibliography in L. Brieger, E.M. Lilien, 1922).

WORKS: Contributions to JUGEND, LEIPZIGER VOLKSZEITUNG, SÜDDEUTSCHER POSTILLON, etc., Ex Libris plates, vignettes, book bindings and book decoration, illustrations etc. for: J. Wildenrath, Der Zöllner von Klausen (1898); Th. Fontane, Ein literarisches Porträt von Franz Servaes (1899); Börries von Münchhausen, Juda, Gesänge. (1900); M. Gorky, Sbornik (1902); Lieder des Ghetto, poems by M. Rosenfled, (1902); The Theatre, a collection of monographs. Edited by K. Hagemann (1904); poems by Gabriele d'Annunzio, in Nachdichtungen by Else Schenkl (1904); the chess fairy-tale; individual sheets; illustrations for the Books of the Bible.

E. M. Lilien, Illustration for the "The Books of the Bible" Berlin/ ▷ Vienna. 1908. Autotype. Original size.

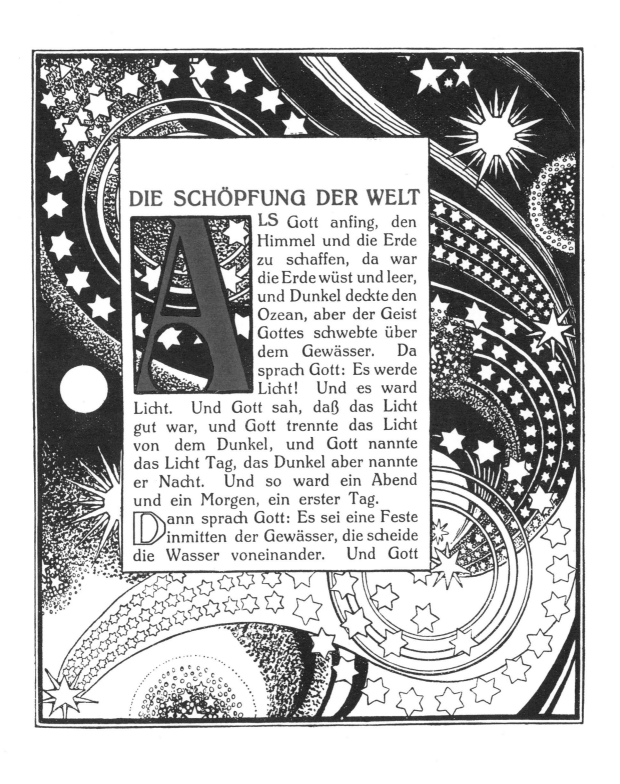

DIE SCHÖPFUNG DER WELT

ALS Gott anfing, den Himmel und die Erde zu schaffen, da war die Erde wüst und leer, und Dunkel deckte den Ozean, aber der Geist Gottes schwebte über dem Gewässer. Da sprach Gott: Es werde Licht! Und es ward Licht. Und Gott sah, daß das Licht gut war, und Gott trennte das Licht von dem Dunkel, und Gott nannte das Licht Tag, das Dunkel aber nannte er Nacht. Und so ward ein Abend und ein Morgen, ein erster Tag. Dann sprach Gott: Es sei eine Feste inmitten der Gewässer, die scheide die Wasser voneinander. Und Gott

MAXIMIN

EIN·GEDENKBUH
HERAUSGEGEBEN
VON
STEFAN·GORGE

BLAETTER·FUER·DIE·KUNST·BERLIN·MDCCCCVII

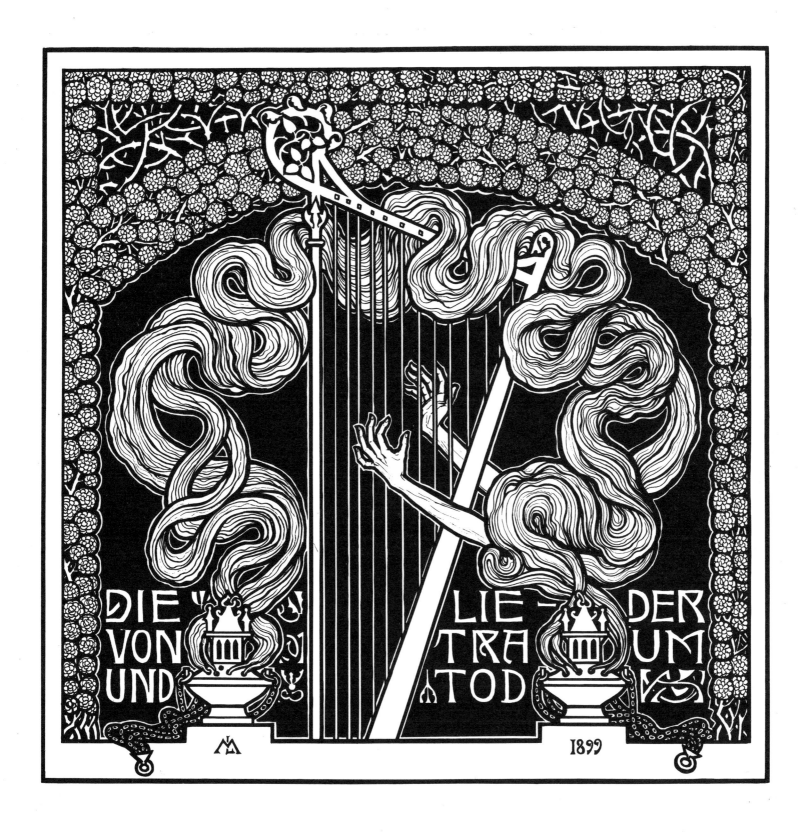

◁ **Melchior Lechter**, Title page for "Maximin, a book of thoughts". Edited by Stefan George 1907 (Design 1897). Printed on imperial Japanese paper in red and black. 39.7×30.1 cm.

Melchior Lechter, Preliminary drawing for the title illustration for "Die Lieder von Traum und Tod" from "Teppich des Lebens" by Stefan George. 1899. Publ. BLATTER FUR DIE KUNST, Berlin 1900. 30.3×30.5 cm.

MELCHIOR LECHTER

Melchior Lechter, a painter and draughtsman, was born in Münster, Westphalia, on 2 October 1865 and died in Raron, Wallis, on 8 October 1937. In 1879 he served an apprenticeship in the Von der Forst glass-painting factory in Münster. He moved to Berlin in 1883 and in 1884 he studied at the Berlin Academy of Arts. In 1895 he began his friendship with Stefan George, who entrusted him with the decoration of his books from 1897 to 1907. In 1896 Lechter gave his first exhibition in the rooms of Gurlitt. From 1898 to 1900 he created the designs and carried out the entire decoration of the Pallenberg Room in the Cologne Museum of Applied Art. In 1900 the Pallenberg Room was awarded the Grand Prix at the Paris World Exhibition. Lechter went to Italy in 1901, and in 1904 he spent some time in Elba and Ischia. He founded the Einhorn Press in 1909. 1910/11 saw him making another trip to Italy. As a painter, Lechter was influenced by the Pre-Raphaelites and as a book illustrater he was influenced by William Morris. He was the artistic leader of the circle of associates surrounding Stefan George, and he mingled the elements of the decorative Art Nouveau with enigmatic symbols taken from George's world of ideas. His works were distinguished by an almost classical economy in the concentration and spacing of the text and illustrations.

Fritz Hellmut Ehmke, Book decorations for "Sonnets from the Portuguese" by Elizabeth Barratt Browning. 1903. Publ. Eugen Diederichs Verlag, Leipzig. Autotype. Each 17×14.9 cm.

BIBLIOGRAPHY: Bänfer, C., "Der Beitrag. M. Lechters zur Buchkunst des Jugendstils", in WESTFALEN 36, 1958, p. 225–280. – Engelsing, R., "Melchior Lechtor, Ausstellung in Berlin", in BÖRSENBLATT FÜR DEN DEUTSCHEN BUCHHANDEL, Year 2, No. 7, 1966, p. 97–99. – Fuchs, G., "Melchior Lechter", in DEUTSCHE KUNST UND DEKORATION I, March 1898, p. 161–192. – Grautoff, O., "Die Entwicklung der modernen Buchkunst in Deutschland". 1901 – Hoffmann, M., "Mein Weg mit Melchior Lechter". 1966. – Landmann, G., "Stefan George und sein Kreis. Eine Bibliographie". 1960. – Raub, W., "Melchior Lechter als Buchkünstler. Darstellung – Werkverzeichnis – Bibliographie". Cologne. 1968. – Rapsilber, M., "Melchior Lechter". in 3rd special issue of BERLINER ARCHITEKTUR-WELT. 1904. – Salzmann, K.H., "Stefan George und die Ausstattung seiner Bücher", in BÖRSENBLATT FÜR DEN DEUTSCHEN BUCHHANDEL, Year 7, Beil, Aus dem Antiquariat 21". – Schreyl, K.H., "Melchior Lechter 1865–1937". Exhibition of the KB Stiftung Preußischer Kulturbesitz. Staatl. Museum Berlin. Dec. 1965–Jan. 1966 – Thormaelen, L., "Erinnerungen an Stefan George". 1962. – Wißmann, J., "Melchior Lechter". 1966. – Wolters, F., "Melchior Lechter". 1911. – Jacobi, K., "Melchior Lechter und der Kreis BLÄTTER FÜR DIE KUNST, in PHILOBIBLON II (1939), p. 201 ff. – Schur, E., "Paraphrasen über das Werk M. Lechters". 1901. – Catalogue of the memorial exhibition on the hundredth anniversary of his birth, Münster (Westf. Kunstverein) 1965.

WORKS: Illustrations to: M. Maeterlinck, Der Schatz der Armen. 1898. – F. Wolters, Herschaft und Dienst (Einhorn-Presse) 1909. – Mallarmé, Herodias. 1905. – Maximin, ein Gedenkbuch, edited by

Friedrich W. Kluekens, Illustrations for "The Book of Esther". ▷ Translated by Martin Luther. Printed by Fr. W. Kluekens and Ch. H. Kluekens in Roman Antiqua. Insel-Verlag Leipzig 1908 (I. Buch der Ernst-Ludwig-Presse). Autotype. 18.8×12.1 cm.

VII

VIII

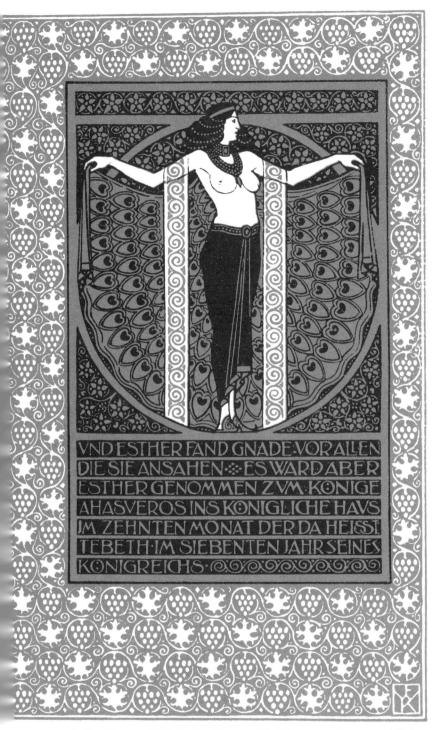

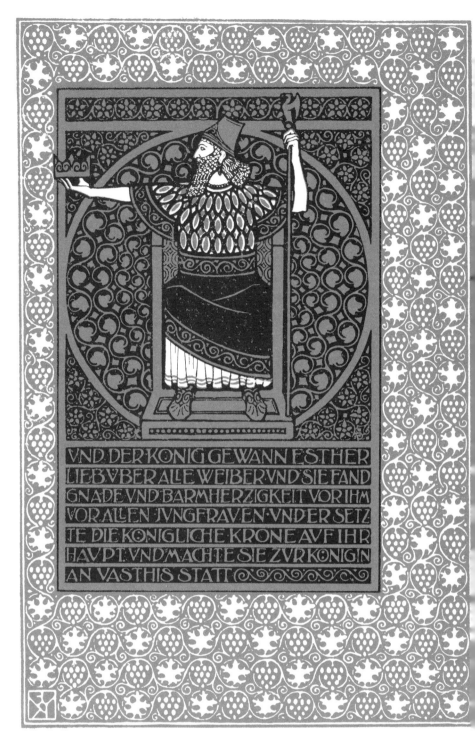

Stefan George. 1907. Stefan George, Die Lieder von Traum und Tod.
– Thomas à Kempis, Die vier Bücher der Nachfolge Christi. – K.
Wolfskehl, Ulais. – Stefan George, Das Jahr der Seele, Der Teppich
des Lebens, Der Siebente Ring; Deutsche Dichtung (edited by St. George
and K. Wolfskehl); Book decoration for: Shakespeare in German;
Tagebuch der Indischen Reise. Did work for BLÄTTER FÜR DIE KUNST.
edited by Stefan George.

FRITZ HELLMUT EHMKE

Fritz Hellmut Ehmke, a draughtsman, applied artist and
architect, was born in Hohensalza on 16 October 1878.
From 1893 to 1897 he studied lithography in Berlin. From
1899 to 1901 he studied under E.Doppler and J. and
L.Manzel at the educational establishment of the German
Museum of Applied Art. In 1900, together with G.Belwe
and F.W.Kleukens, he founded the Steglitz Workshop for
printed art works.

From 1903 to 1913 he taught at the School of Applied Art
in Dusseldorf and then became a professor at the State
School of Applied Art. He invented several type faces which
were named after him. In 1920/21 he was head of the
department of graphics at the trade school in Zurich.

THE WRITINGS OF EHMKE: Drei Jahrzehnte deutscher Buchkunst 1890 bis
1920, Berlin 1922. – Persönliches und Sachliches. Gesammelte Aufsätze.
Berlin 1928. – Schrift, ihre Gestaltung und Entwicklung in neuerer Zeit.
1925. – Die historische Entwicklung der abendländischen

MAX SLEVOGT

Max Slevogt, a painter and draughtsman, was born in Landshut on 8 October 1868 and died in Neukastel, Palatinate, on 20 September 1932. From 1885 he studied at the Munich Academy, where W.Diez was his teacher. In 1889/90 he travelled to Paris and Italy. In 1892 he gave his first exhibition in Munich. He travelled to Holland in 1898, and studied the work of Rembrandt. He was in Frankfurt in 1900. From 1901 onwards he lived alternately in Berlin and on his landed estate in Neukastel, Palatinate. From 1917 onwards he was professor at the Academy in Berlin. His earliest book illustrations were created around 1900 to 1902. In 1913/14 he went to Egypt. In 1914 he was an official war artist at the front in Lorraine.

The style of Slevogt's illustrative works cannot be closely associated with Art Nouveau. His talent for pictorial narration is the sole factor determining the expressive manner of his illustrations. However, late Impressionist elements and, in his later period, Expressionist elements can be found in his work, along with pictorial motifs and stylistic attitudes which were part of Art Nouveau and had an influence on him. After all, the Art Nouveau generation was emphatically a generation of narrators.

◁ **Max Slevogt**, Book jacket for "Pastelle" by Paul Bourget. Autotype. 12.5×10.9 cm.

Johann V. Cissarz, Book decoration for "Unterstrom", poems by Helene Voigt-Diedrichs. 1906. Verlag Eugen Diedrichs, Leipzig. Autotype. About original size.
▽

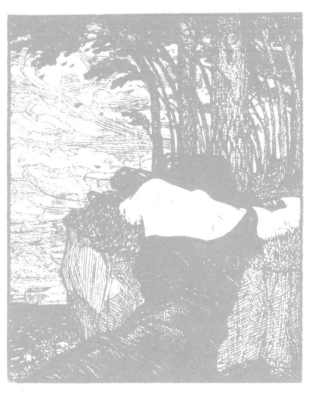

Schriftformen. Ravensburg 1927. – 25 Jahre deutsche Buchkunst, 1890–1914. Leipzig 1915. – Kulturpolitik, Frankfurt 1947.

WORKS: Type faces by Ehmke: Ehmke-Antiqua 1909, Ehmke-Kursiv 1910. Ehmke-Fraktur 1911, Book decorations and designs for bindings for the Steglitz workshop

BIBLIOGRAPHY: Ehmke, F.H., "Klara Ehmke", in Monographien deutscher Reklamekünstler im Auftrag des Deutschen Museums für Kunst im Handel und Gewerbe, Hagen/W. edited by F. Meyer-Schönbrunn. Issue 1/2 Hagen & Dortmund 1911 ff.

FRIEDRICH W. KLEUKENS

Friedrich W.Kleukens worked as a painter, draughtsman and applied artist. He was born in Achim near Bremen on 5 July 1878. Around 1900 he founded the Steglitz workshop together with F.H.Ehmke and G.Belwe. After the workshop was dissolved he worked as a teacher at the Academy of Graphic Art in Leipzig, and in 1906 he was given a post at the Mathildenhöhe artists' colony in Darmstadt. In 1907 he founded the Ernst Ludwig Press in Darmstadt and designed some new type faces which are named after him.

WORKS: Designs for book decorations and applied graphics for the Steglitz workshop and for the Ernst-Ludwig-Press. Posters, illustrations, etc. for the Book of Esther.

BIBLIOGRAPHY: Alten, W. v., "Max Slevogt". 1926. – Guthmann, J., "Die goldene Frucht". 1955. – Rümann, A., "Verzeichnis der Graphik von Max Slevogt in Büchern und Mappenwerken". 1936. – Sievers, J. & E. Waldemann., "Das druckgraphische Werk I 1890–1914, edited by H.-J. Imiela. 1962. – Voll, K., "Max Slevogt". 1912., – Waldmann, E., "Max Slevogt". 1923. – id., "Max Slevogts graphische Kunst". 1924.

WORKS: Illustrations to: Ali Baba, 1903; Schwarze Szenen, 1905; Lithographs for the Iliad, 1907; sheet music title page for "Mephisto" (The Flea Market), 1908; book title page for Peter Baum, Im alten Schloß, 1908; illustrations for Sinbad the Sailor, 1908; Der gestiefelte Kater, 1908; Die Prinzessin auf der Erbse, 1909; Lederstrumpf-Erzählungen, 1908/09; Rennskizzen, 1911; Reineke Fuchs, 1912; Benevenuto Cellini, 1914; individual sheets, etc. Der Überfall (der Riese und die Zwerge), 1893; Hexentanz, 1903; Tänzerin, 1904; Frauenraub im Walde, 1905/06; Penthesilea, 1905/06.

JOHANN VINCENZ CISSARZ

Johann Vincenz Cissarz, a painter, draughtsman, and applied art designer, was born in Danzig on 22 January 1873 and died in Frankfurt am Main on 23 December 1942. He studied at the Dresden Academy. He lived in Darmstadt from 1903 onwards. In 1906 he received a commission to teach book decoration at the Educational and Experimental Workshops in Stuttgart. In 1916 he was awarded a post in Frankfurt am Main as the head of a master class for painting at the School of Applied Arts.

BIBLIOGRAPHY: Pazaurek, G.E., "Johann V. Cissarz". Monograph, in DAS PLAKAT, Year 8. 1917, p. 171 ff.

WORKS: Principally book decoration and illustration, etc. for Diedrichs-Verlag, Leipzig, for the Odyssey. Certificates, posters, book bindings.

HANS BALUSCHEK

Hans Baluschek, a painter and graphic artist, was born in Breslau on 9 May 1870 and died in Berlin on 27 September 1935. From 1889 to 1894 he studied at the Berlin Academy and was active in Berlin. He was a member of the Berlin Secession, the Association of German Artists and the Association of German Illustrators. He used illustration techniques, among the more favoured of which were watercolour, and gouache with oil chalk. These were then used as printer's copy for autotype.

BIBLIOGRAPHY: Wendel, Fr., "Hans Baluschek". Berlin 1923.

WORKS: Book illustrations: fairy-tale books, including Peterchens Mondfahrt; colour lithographs on the subject of a vagabond; Ex Libris plates.

MAX KLINGER

Max Klinger, who worked as a painter, draughtsman and sculptor, was born in Leipzig on 18 February 1857 and died in Groß near Naumburg on 5 July 1920. From 1874 to 1877 he studied under K.Gussow in Karlsruhe, with

Hans Baluschek, Cover for "Von zwei Erlösern" by Hans Land. Verlag der Romanwelt, Berlin (no date). 17.6×11.2.

further studies in Berlin, Brussels and Munich. From 1883 to 1886 he was in Paris, and from 1888 to 1893 he lived in Rome, where he was influenced by Böcklin. From 1893 onwards he worked in Leipzig where he built a house which he planned himself. In 1905 Klinger founded the Villa Romana prize in Florence, an annual scholarship for German artists. It was as early as 1884 that Klinger began to become known as a painter, and he executed fourteen large murals and friezes for the Albers Villa in Berlin-Steglitz. From 1899 to 1902 he worked on the Beethoven monument for the Museum of Fine Arts in Leipzig, and this statue consolidated his reputation. He later created a

Max Klinger, Mother and Child, from the cycle "On Death", I Opus
II. 1889. Etching. 19.6×18.3 cm.

Brahms monument for Hamburg, and in 1912/13 he
designed a Richard Wagner monument for Leipzig, but it
was not actually executed. In 1914 he published an essay
on "Painting and Drawing". Particularly important in his
work are his graphic cycles, which reveal a masterly
command of technique and with which he constructs a
fantastic world that is close to Surrealism. In these works
he occasionally comes even closer to the decorative Art

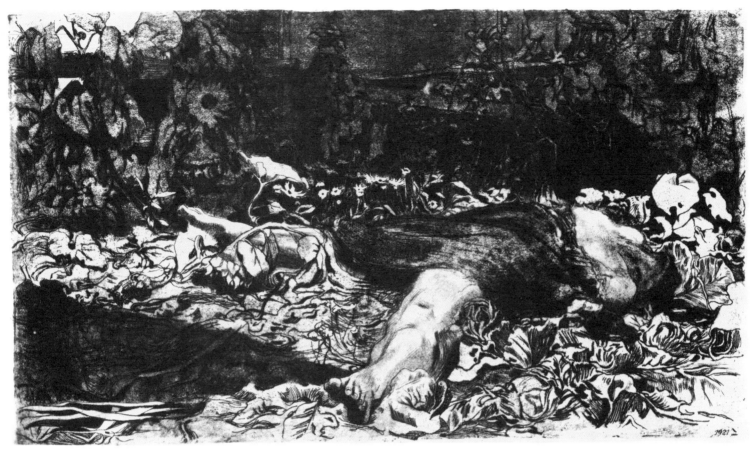

Käthe Kollwitz, Raped, from the cycle "The Farmer's War", Leaf 2, 1903. Etching. 30.2×51.3 cm.

Nouveau than in his painting, and here it should be emphasized that his symbolistically enigmatic pictorial inventions themselves had an effect on Art Nouveau. The Expressionists, particularly E.L.Kirchner, related their work to his motifs. In 1909 his graphic works were scientifically catalogued by H.W.Singer.

BIBLIOGRAPHY: Avenarius, F., "Max Klinger". 1917. – Biermann, Chr. W., "Max Klinger in seinem graphischen Werk". Diss. Berlin 1938. – Heyne, H., "Max Klinger, Gedanken und Bilder aus der Werstatt des werdenden Meisters". Leipzig 1925. – Kühn, P., "Max Klinger". Leipzig 1907. – Plietzsch, E., "Max Klinger". 1943. – Schmid, M., "Max Klinger". Bielefeld 1899 (edited by J. Vogel 1926). – Servaes, "Max Klinger". Leipzig 1902. – Singer, H.W., "Max Klingers Radierungen, Stiche und Steindrucke". Berlin 1909. – id., "Max Klinger, Meister der Zeichnung". Leipzig 1912. – id., "Klingers Briefe aus den Jahren 1874-1918". Leipzig. 1924. – Vogel, J., "Max Klinger und Leipzig". 1923.

WORKS: Cycles of graphic works: Intermezzi 1880, Rettungen ovid'scher Opfer, 1879, Eva und die Zukunft 1880, Amor und Psyche, Fund eines Handschuhs 1881, Ein Leben 1883, Eine Liebe 1887, Vom Tode I/II 1889/1898 ff. Brahmsphantasie, 1894 including printed sheet music to songs by Brahms and subsequent Prometheus cycle.

KÄTHE KOLLWITZ

Käthe Kollwitz, a graphic artist and sculptor, was born in Königsberg on 8 July 1867 and died in Moritzburg, Saxony, on 22 April 1945. From 1885 to 1889 she studied at the Girls' Art School in Berlin where her teacher was Stauffer-Bern, and also at the Girls' Art School in Munich, where her instructor was Herterich. From 1891 to 1944 she lived in Berlin, the wife of a doctor to the poor. In 1893 she watched the première of G.Hauptmann's drama "Die Weber" (The Weavers) at the Freie Bühne in Berlin and was thereby inspired to create the series of drawings entitled "A Weavers' Uprising". In 1893 some of her works were displayed at the "Free Art Exhibition" and it was proposed that she should be awarded the Golden Medal, but Wilhelm II declined to confer it on her. In 1904 she was in Paris, studied at the Académie Julian and met Rodin. In 1907 she was awarded the Villa Romana prize. In 1917 she gave an exhibition at the rooms of Paul Cassirer. From 1919 onwards she was a member of the Prussian Art Academy. In 1927 she took part in the celebrations in Moscow commemorating the tenth anniversary of the Union of Soviet Socialist Republics. In 1932 she held exhibitions in Moscow, Leningrad and Kharkov. She withdrew from the Prussian Art Academy in 1933. In 1936 she was banned

153

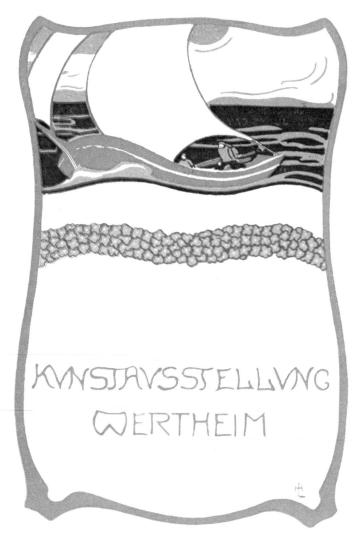

Hans Looschen, Catalogue cover for the Wertheim Art Exhibition. 12.9×5.7 cm.

from holding exhibitions, and in 1943 her studio and numerous original works were destroyed. Being a doctor's wife, she had a particular insight into the poverty of the masses, and this led her to include elements of social criticism and political opinion in her work. Although Käthe Kollwitz belonged to the Art Nouveau generation, the extent to which she shared in its concerns was very limited. Her works are not involved with stylization, atmosphere or enigmas, but rather with rousing drama and tension. Nevertheless, the sensations generated by the Art Nouveau movement sometimes also appear in her work, as for example in the sheet reproduced here, in which nature envelops the corpse and the earth symbolically takes it back to its bosom.

BIBLIOGRAPHY: Bonus, A., "Das Käthe-Kollwitz-Werk". Dresden 1925. – Heilbronn, A., "Käthe Kollwitz". 1949. – Klipstein, A., "Das graphische Oeuvre von Käthe Kollwitz". Berne 1953. – Sievers, J., "Die Radierungen und Steindrucke von Käthe Kollwitz von 1890-1912". 1913. – Singer, H.W., "Käthe Kollwitz". – Wagner, A., "Die Radierungen, Holzschnitte und Lithographien. 1912 bis 1927". 1927.

EARLY WORKS: Etchings: der Werberaufstand (6 sheets) 1895–98; Carmagnole, 1901; Totes Kind 1903; Bauernkrieg (7 sheets) 1903–08; self-portraits.

HANS LOOSCHEN

Hans Looschen, a painter and draughtsman, was born in Berlin on 23 June 1859 and died in that city on 12 February 1923. He studied at the Berlin Academy. His work included book illustration, still-lifes, symbolic compositions and portraits.

WORKS: Illustrations to: Eichendorff, Aus dem Leben eines Taugenichts; Chamisso, Peter Schlemihl, Märchen und Sagen. Posters, dust-jackets, calendars.

ERNST LUDWIG KIRCHNER

Ernst Ludwig Kirchner, who worked as a painter and graphic artist, was born in Aschaffenburg on 6 May 1880 and committed suicide in Frauenkirch near Davos on 15 June 1938. From 1901 to 1905 he studied architecture in Dresden. In 1903/04 he interrupted his studies and went to Munich, where he spent two semesters at the art school of W.Debschitz and H.Obrist. He continued his studies in Dresden and made the acquaintance of E.Heckel. In 1905 he took his diploma examination in Dresden and turned to painting. In 1905, together with Fritz Bleyl, E.Heckel and Schmidt-Rottluff, he founded the association of artists calling itself "Die Brücke" (The Bridge). In 1906 Kirchner drew up the programme for "Die Brücke", which he made into a woodcut. In 1911 he moved to Berlin and lived there until 1916. In 1917 he moved to Davos.

Kirchner was an Expressionist and, like nearly all Expressionists, he developed his ideas on the basis of innovations introduced by Art Nouveau: distortion of the figures, and consistent chiaroscuro composition without intermediate shades. In our example, the influence of

Ernst Ludwig Kirchner, Woodcut. c. 1906.

Tuil Nolde 06.

Emil Nolde, Tempest. 1906. Woodcut, hand coloured. (from the Portfolio: 10 woodcuts, 1906, Leaf 7). Schiefler No. 12/II. Japan. 15.5×19.0 cm.

French Art Nouveau, particularly of Toulouse-Lautrec and Vallotton, may be observed. In his early period, Kirchner had an leaning towards symbolic motifs, and this led to an intense involvement with such heterogeneous forces as Munch and Klinger.

BIBLIOGRAPHY: Dubs-Heynig, A., "E.L. Kirchners Graphik. 1961. – Grohmann, W., "Kirchners Zeichnungen". 1925. – id., "Das Werk Ernst Ludwig Kirchners. 1926. – id., "Ernst Ludwig Kirchner. 1958. – Schiefler, G., "Die Graphik Ernst Ludwig Kirchners" 2 Vols. 1926–31. – Catalogue of the Kirchner exhibition, Kunsthaus Zurich 1952 (with detailed bibliographical references).

EMILE NOLDE

Emile Nolde was a pseudonym for E.Hansen. This artist was a painter and draughtsman. He was born in Nolde (Tondern) on 7 August 1867, and died in Seebüll, Northern Schleswig, on 13 April 1956. From 1885 to 1889 he studied at the Woodcarving School in Flensburg. He taught at the School of Arts and Crafts in St. Gallen. From 1899 onwards he studied painting in Munich (under A.Hözel in Dachau), Paris and Copenhagen. From 1905 to 1907 he had connections with the artists' association "Die Brücke". In

Markus Behmer, Yuesléon. From VER SACRUM 1903. Woodcut. 15×15 cm.

1913/14 he made a tour to Siberia, Japan and the Pacific. After 1918 he lived alternately in Berlin and Seebüll. After 1933 Nolde was declared to be decadent and he was forbidden to paint.

Nolde belonged to the same age group as the Art Nouveau artists, and in his early woodcuts and engravings he showed a strong link with French Art Nouveau: this in itself showed him to be an observer of his environment, the essence of which he captured in his pictures. The road from Art Nouveau to Expressionism can be seen with particular clarity in the storm-troubled, flaming figures of the work reproduced here. This is one of a series of woodcuts depicting fairy-tales, and in 1906 Nolde published the series in a portfolio comprising the Schiefler numbers 6–15. The sheets in it were published as black-and-white prints; there were none in colour. The sheet which we are reproducing

here is probably unique, being hand-coloured. Individual hand-coloured prints also exist for some of the other sheets in this series.

BIBLIOGRAPHY: Fehr, H., "Emil Nolde. Ein Buch der Freundschaft". 1957. – Gosebruch, M., "Nolde. Aquarelle und Zeichnungen". 1957. – Haftmann, W., "Emil Nolde". 1960. – id., "Radierungen von Emil Nolde".1948. – Sauerlandt, M., "Emil Nolde". 1922. – Schiefler, G., "Das graphische Werk Emil Noldes bis 1910". 1911. – id., "Das graphische Werk Emil Noldes 1910–1925". 1927. – Emil Nolde. Aquarelle. Concluding remarks G. Busch, Munich 1957. – Commemorative publication on the opening of the exhibition in the Seebüll rooms. Edited by J. von Lepel. 1957. – Emil Nolde. Holzschnitte. Introduction by F. Bayl (Buchheim-Bücher) 1957. – 1958/59 Yearbook of the Stiftung Seebüll Ada and Emil Nolde. Flensburg 1958 (with bibliography). – Catalogue of the Emil Nolde exhibition, Kunsthaus Zurich, 1958.

WRITINGS OF E. NOLDE: Das eigene Leben. 1931–1949. – Jahre der Kämpfe. 1934. – Letters (edited by M. Sauerlandt) 1927.

EARLY WORKS: Woodcuts: Prinzess und Bettler (1906), Mädchenphantasie (1906), Der große Vogel (1906), General und Diner (1906), Mausefallenmann (1906), Sturm (1906), König und Narr (1906), Verzweiflung (1906), Gefangene (1906). (compiled in portfolio: 10 woodcuts 1906).

MARKUS BEHMER

Markus Behmer, a painter and draughtsman, was born in Weimar on 1 October 1879 and died in Berlin on 12 September 1958. He was self-taught. In more recent literature on art, Behmer's work has not yet been re-discovered, although it is to him that we owe the most attractive Art Nouveau work to have been created in Germany. However, his style frequently avoided the dictates of fashion. His early works show influences derived from Beardsley, but also display ties with the strictly classicist Art Nouveau, as expounded in Germany by Behrens and Stuck. Later on, his drawings became more subtle and refined, portraying abstruse, but at the same time fascinating, motifs which consist of fabulous beasts and beings entangled in strange erotic bonds. He continued applying the principles of Art Nouveau until his death.

BIBLIOGRAPHY: F.W., "Ex Libris und Radierungen von Marcus Behmer in DEKORATIVE KUNST 1910/XIII. Exhibition, Kunstamt Berlin-Charlottenburg 1954. – Klingspor-Museum-Offenbach 1958.

WORKS: book decorations, Ex Libris plates, drawings for the Munich Associated Studios and for INSEL, VER SACRUM, SIMPLIZISSIMUS, illustrations to: Goethe, Westöstlicher Divan; Grimms fairy-tales; Balzac, La Fille aux Yeux d'or; Grimmelshausen, Der erste Bärenhäuter (INSEL-Book No. 340); Ph. O. Runge, Von dem Fischer un syner Fru (1914, INSEL-Book No. 315); E. Hardt, Plays; Enno Littmann, Von morgenländischen Floh; Voltaire, Zaîre; H. Graf Kessler, Petronius; Oscar Wilde, Salome (1903) and La Sainte Courtisane (1921); dem Unbekannten treu (unpublished series of woodcuts) and others.

HEINRICH VOGELER

Heinrich Vogeler, a painter, draughtsman and designer of applied art, was born in Bremen on 12 December 1872 and died in Kazakhstan, USSR, on 14 June 1942. In 1890 he began studying at the Academy in Dusseldorf. He travelled to Holland and Italy in 1891. In 1893 he completed his studies in Dusseldorf. In 1894 he made a trip to Paris. He travelled to Worpswede where he was taught by Mackensen and Hans am Ende. In 1895 he purchased the Barkenhoff landed estate in Worpswede. In 1896 he made the acquaintance of R.A.Schröder and A.W.Heymel. His works were displayed at the exhibition held in the Palace of Glass in Munich. In 1897 he became acquainted with some pictures by Munch in Dresden. In 1898 he travelled to Florence and met Rilke for the first time. He was

awarded commissions to illustrate books. In 1899 he published a small volume of poems entitled "Dir"; Rilke was living at the Barkenhoff estate. He married Martha Schröder in 1901. He travelled to Amsterdam, Paris and Bruges, and in 1903 he went to Italy. In 1905 he worked at applied art in Bremen; he enlarged the Barkenhoff estate. He travelled to Ceylon in 1906. In 1907 he went to Lodz and became acquainted with the works of Maxim Gorky. In 1908, together with his brother Franz, he founded the Worpswede workshops for country house furniture. He travelled to England. In 1909 he visited G.Hauptmann. In 1913 he separated from his family. He saw Rilke for the last time in Munich in 1914, when he volunteered to join the army. After the war he turned to Communism. The Barkenhoff country estate was transformed into a socialist commune, and he gave training courses for workers. In 1922/23 he executed a cycle of frescos at Barkenhoff depicting the class struggle in Germany. He travelled to Carelia in 1924. In 1932 he gave some lectures in Moscow

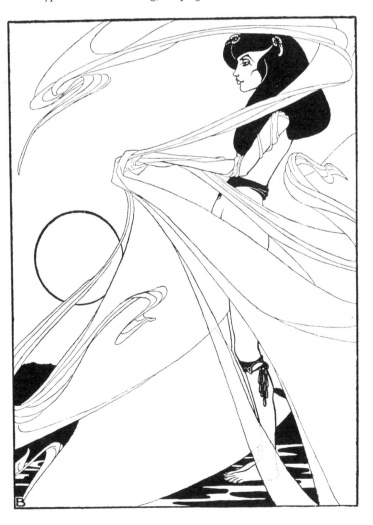

Markus Behmer, Illustration to "Salome" by Oscar Wilde. 1906, Autotype. Publ. Insel-Verlag, Leipzig. 11×8 cm.

on the subject of art education; the Soviet government commissioned him to create some large-sized propaganda pictures. Vogeler lived in Russia from 1932 onwards. In 1941 he held an exhibition in Moscow. In 1953 his entire works were transferred to the National Gallery in East Berlin. Vogeler follows the English art of book decoration in the sheets reproduced here. He fills not only the shapes in the frames, but also the pictures themselves, with an almost pious fairy-tale atmosphere which was peculiar to him and which supercedes the purely narrative context of the fairy-tale.

Rainer Maria Rilke wrote the following on the subject of Vogeler:"No one else had the skill of Heinrich Vogeler in

Heinrich Vogeler, Illustration for "The Fisher and His Soul", a fairy-tale by Oscar Wilde. Publ. Insel-Verlag, Leipzig (4th edition 1914). Autotype. 16.6×10.4 cm.

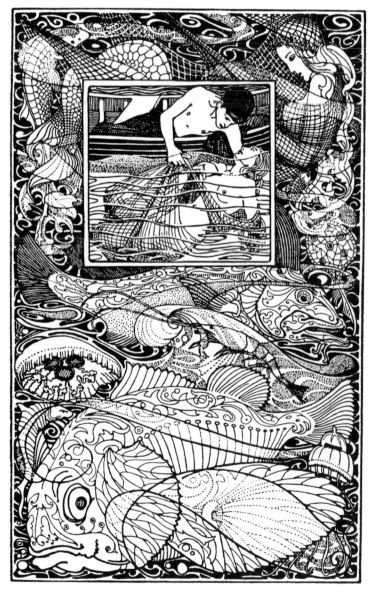

creating that art which presents the whole of springtime and all the fullness and superabundance of the days and nights, and which does so in a flower, in the twig of a tree, in a birch or in a girl who feels yearning. He has not learned of springtime in the expanse of the wide land where he lives; he has learned of it in a confined garden about which he knows everything, his garden, his silent, flowering and growing reality in which everything is placed and guided by his own hand, and in which nothing takes place where he might not be needed. He is the cultivator of this garden in the same way as one is the friend of a woman: he quietly falls in with the garden's wishes, which he himself has aroused, and they carry him further by means of his fulfilling them. What he entrusts to the garden in autumn comes to him again in spring, and what he puts into the springtime does not remain as it is but grows, grows into summer, and has a life of its own and also its own death in the deadly days of autumn. Thus he lives his life into the garden, and there it seems to be distributed into a hundred things and to continue growing in a thousand ways. He writes his feelings and moods into this garden as in a book.

"An additional feature of this strange development of Heinrich Vogeler is that it has given him a very special ability in book ornamentation. His intentions have been aimed in this direction for a long time, but it is only now—his linear style having attained this consummation—that he will be able to arrive at any very happy achievement in this area. Some title pages in INSEL, the decoration of a small volume of Bierbaum's poems, and the wonderful ornamentation with which he wreathed the drama "The Emperor and the Witch" by Hugo von Hofmannsthal—all these confirm that his linear art, which makes such a quiet and compact impression but is inwardly so rich, is suited, as is no other, to accompanying the path of noble letters like a song."

BIBLIOGRAPHY: Brieger-Wasservogel, L., "Heinrich Vogeler", in DEUTSCHE MALER. Strasbourg 1903. – Gallwitz, S.D., "Dreißig Jahre Worpswede". 1922. – Liebau, H., "Heinrich Vogeler". Diss. Berlin 1958. – Rilke, R.M., "Heinrich Vogeler", in DEUTSCHE KUNST UND DEKORATION 10. – Sponsel J.L., "Heinrich Vogeler", in DEUTSCHE KUNST UND DEKORATION 4, 1899. – Wefels, H., "Heinrich Vogeler und der Jugendstil", Diss. Göttingen 1959. – Exhibition catalogue of the Deutsche Akademie der Künste in Berlin 1954. Exhibition catalogue of the Westfälischer Kunstverein Münster and Bötterstraße GmbH. Bremen 1962/63.

THE WRITINGS OF VOGELER: Dir, (poems 1899); Expressionismus der Liebe, 1918; Reminiscences.

WORKS: Illustrated books: H. Vogeler, Dir, 1899. – Hugo Salus, Ehefrühling. 1900. – Irene Frobes-Mosse, Mezzavoce. 1901. – Irene Frobes-mosse, Peregrinas. no date – R. Schaukal, Pierrot und Colombine, 1902. – H. v. Hofmannsthal, Der Kaiser und die Hexe, 1902. – G. Hauptmann, Der arme Heinrich, 1902. – Ch. Günther,

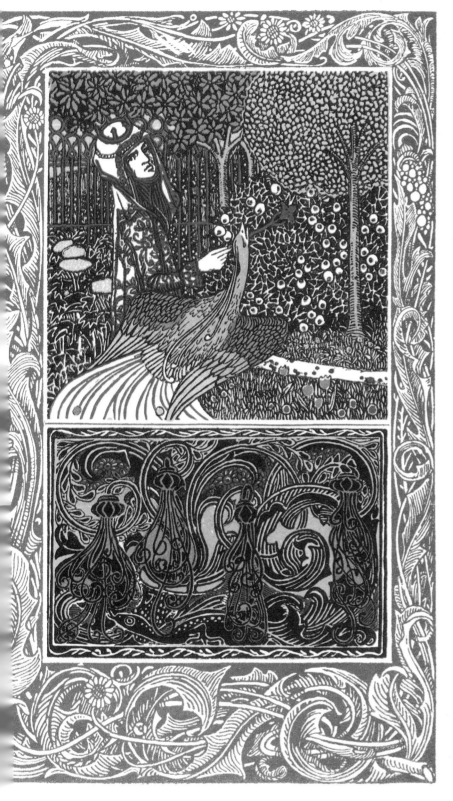

Heinrich Vogeler, Title illustration and title page for "Der Kaiser und die Hexe" by Hugo von Hofmannsthal. 1900. Autotype. Insel-Verlag, Leipzig. 20.2 × 25.3 cm.

Strophen, 1902. – R. Huch, Vita somnium breve, 1903. – J.H. Fehrs, Ute Elenbeck, 1903. – Worpswede pocket calendar, no date. (1903); Jens Peter Jacobsen, collected works, 1903. – I. Turgenev, prose poems, 1903. – E. v. Wildenbruch, Kindertränen, 1903. – Vogeler Zierrat no date. – G. Falke, Das Büchlein Immergrün, 1905. – Cl. v. Brentano, Frühlingskranz, 1907. – O.J. Bierbaum, Mein ABC, 1908. – Oscar Wilde, Stories and fairy-tales, 1910. – Grimm, Kinder- und Hausmärchen no date – design for the Melusine fairy-tale, initials,

vignettes, decorative borders, wallpaper designs, endpapers, book decoration, Ex Libris plates; worked for INSEL Leipzig; individual sheets (etchings): Die sieben Raben, Verkündigung, Schlangenbraut, Minnetraum, Die Lärche, Hexe mit Wappen, Hexe mit Eule, Froschkönig, Tod und Alte, Frühling, Die Nymphe, Frühlingsabend, Nacht, Im Frühling, Dornröschen, Die sieben Schwäne, An den Frühling (10 sheets and a covering sheet), Walther von der Vogelweide, Wintermärchen, Frühlingsmärchen, etc.

159

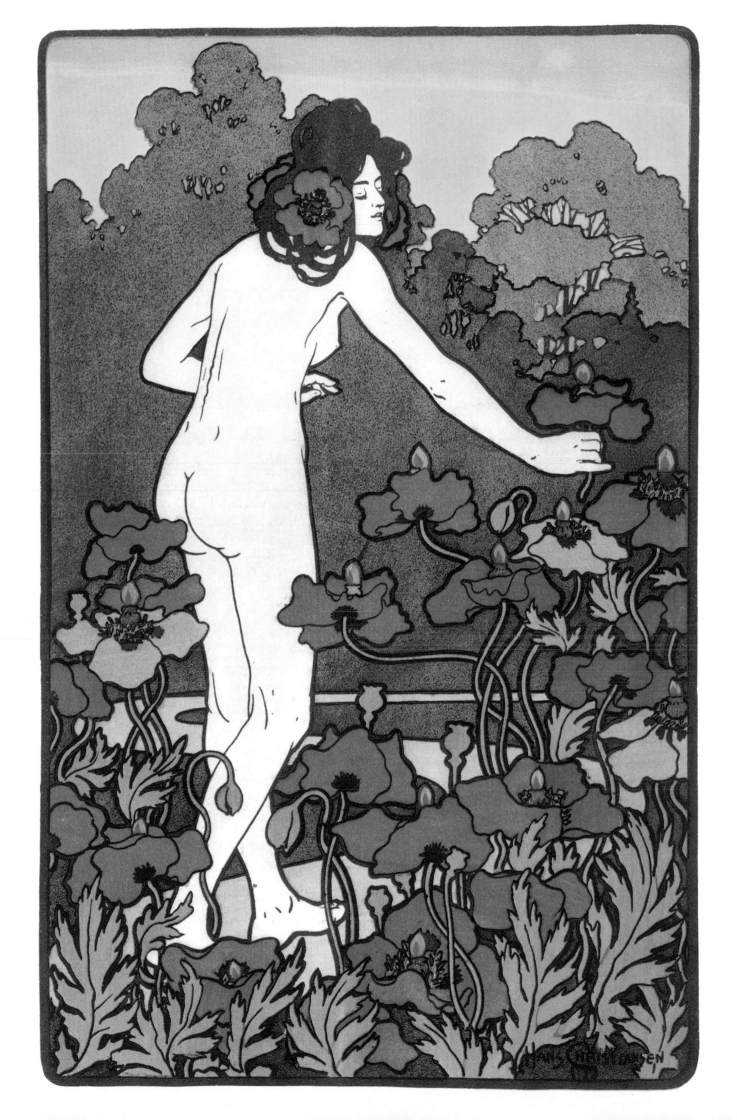

Heißer Frühling

Wie nun der Tag in fel'ger Klarheit steht
Bei diefes Himmels wundervoller Bläue! —
O hüt' Dein Herz! In folchem Frühling geht
Auf irren Wegen felbst die Treue.

Leicht fchaukelt fich der Sehnfucht flinkes Boot,
Und immer füßer lockt und lacht die Ferne,
Sie lockt im Morgen- und im Abendroth,
Im kühlen Wunderreich der Sterne.

Geheime Mächte ziehn und irren Dich,
Wie eine Flamme loht die Luft der Erde,
Heiß wird Dein Herz und drängt und wendet fich
Vom stillen Glück am eignen Herde.

Viel taufend Rofen blühn ja fern im Grund,
Sie warten nur, fich Dir zum Kranz zu flechten,
Auch fpricht im Schlaf manch rother Mädchenmund,
Der ungeküßt in diefen Sehnfuchtsnächten.

Es glänzt die Nacht und überm Tage steht
Verklärt des Himmels wundervolle Bläue —
O hüt' Dein Herz! In folchem Frühling geht
Auf irren Wegen felbst die Treue!

Carl Busse

H. Christiansen (Darmstadt)

◁ **Hans Christiansen**, L'Heure du berger, from
L'ESTAMPE MODERNE. Colour woodcut. 34.6 × 22.1 cm.

Hans Christiansen, Decoration for the journal
JUGEND, No. 30, 1900. Autotype. 24 × 118 cm.

HANS CHRISTIANSEN

Hans Christiansen, a painter, draughtsman and designer of applied art, was born in Flensburg on 6 March 1866 and died in Wiesbaden in 1945. In 1887/8 he studied at the Munich School of Applied Art. After this he worked initially as a decorative painter in Hamburg. He travelled to Italy in 1889. In 1895 he was in France, first in Anvers and then in Paris, where he attended the Académie Julian. From 1899 onwards he lived in the Mathildenhöhe artists' colony in Darmstadt. In 1902 he returned to Paris. Christiansen was one of the most important artists of the German Art Nouveau. His literary and philosophical writings were published in 1915.

The dominant features in Christiansen's graphic works are the line and the silhouette-like bordering of the surfaces; these characteristics are often reminiscent of Emil Bernard's "cloisonnism" and of designs for painted glass windows.

BIBLIOGRAPHY: Christiansen, "Neue Flachornamente. Altona no date.

WORKS: Worked for JUGEND. book decorations, poster and wallpaper designs, individual sheets, lithographs.

Paul Bürck, Games in the Wood. About 1900. Woodcut. Slightly reduced.

PAUL BÜRCK

Paul Bürck was a painter, draughtsman and designer of applied art. He was born in Elberfeld in 1878, and studied at the Munich School of Applied Art. In 1899 he held an exhibition in the book trade museum in Leipzig. He was appointed to work in Darmstadt. In 1902 he taught at the School of Applied Art and Handiwork in Magdeburg. After this he spent several years in Rome. From 1908 onwards he was in Munich.

WORKS: Designs for book decorations, Two series of etchings: Totentanz; Italienisches Volksleben.

JULIUS DIEZ

Julius Diez, a painter, draughtsman and handicrafts designer, was born in Nuremburg on 18 September 1870, and died in Munich on 13 March 1957. He was a nephew of Wilhelm Diez, the painter. From 1888 to 1892 he studied at the Munich School of Applied Art, and also under Hackl and Seitz at the Munich Academy. From 1896 onwards he was active in the circle of artists working for the magazine JUGEND. From 1907 he held a teaching post at the Munich School of Applied Art, and from 1925 onwards he was a Professor at the Academy and the second President of the Secession.

BIBLIOGRAPHY: Von Ostini, F., "Julius Diez". no place or date.

WORKS: Contributions to JUGEND. Two series of graphic works: Traumhafte Reise (1929); Jedermann (1932).

FRANZ VON STUCK

Franz von Stuck, a painter, draughtsman, sculptor and architect, was born in Tettenweiss, Lower Bavaria, on 23 February 1863, and died in Munich on 30 August 1928. He was a miller's son. From 1882 to 1884 he studied at the Munich School of Applied Art, and from 1885 he was at the Academy, studying under Lindenschmitt; he was influenced by W. Diez and Böcklin. In 1889 his works were displayed at the Munich Annual Exhibition; he was awarded the gold medal of the First Annual Exhibition held at the Munich Palace of Glass. He was among the founders of the Munich Secession in 1893. From 1895 onwards he was a professor at the Munich Academy, where he succeeded Lindenschmitt. In the late 1890's he built himself a studio and a residential house: this was the Villa Stuck in Munich. He rose from being the poor son of a miller, who had to earn his money by doing odd drawing jobs,

Julius Diez, Cover for the journal JUGEND 1899. Embossed on linen. ▷
29.3 × 23.3 cm.

JVGEND

·G·HIRTH'S·VERLAG·
·MVENCHEN·

·1899·

·I·

Franz von Stuck, Sensuality. 1894. Etching. About original size.

Franz von Stuck. Title page for the ▷ journal JUGEND, No. 28, 1897. Height 25.6 cm.

to becoming known as the "Painter Prince" of Munich, which became a fact through the bestowal of the ennobling prefix in 1906. In 1929 a memorial exhibition was held in his honour in the Munich Palace of Glass. On 9 March 1968, the Villa Stuck in Munich was re-opened as an Art Nouveau museum.

Stuck represented the academic school in the Art Nouveau movement, and his motifs were emphatically symbolic. The factor allying him to the Art Nouveau movement was the atmosphere of the times rationalizing tendencies of Art Nouveau. However, when a commission such as for the title-page of the magazine JUGEND (reproduced here) inspired it, he was also able to revel with uninhibited ecstasy in swirling arabesques.

When Wilhelm Hausenstein wrote an obituary notice on

Franz von Stuck, he was conditioned by the prevailing mood of prejudice against Art Nouveau and was thus biased against it, which makes his words all the more significant as a testimony to this artist's persuasive power.

"The land in which Stuck was born is old Limes country. The Counter-Reformation bloodily confirmed its Roman origins. And what did this painter look like? He had the head of one of those legionaries who, more than a millenium and a half ago, not only kept the land south of the Danube within bounds, but also fertilized it with Roman blood. If this man Stuck is the gladiator of his painting, and if his paintings are circus displays, then his blood must have remembered its source! His Roman villa up yonder in Bogenhausen, behind the golden angel belonging to the column of peace, was legitimate; it was the house of a

descendant from some unknown southern ancestors. This aspect may seem strange to some, particularly in the north; but its reality is of the simplest.

"This is the reason: Stuck's inclination towards the antique was more than an inclination; it was compulsion derived through his ancestry, and was not a stylistic mood; the antique element in Stuck's art is as good in itself as is his whole liquid and magnificently tuned talent! However, by accepting the validity of the innate yearning towards the antique, the onlooker has not yet accepted the awareness which - as seen in the picture - exists in this artist's yearning and in his entire talent.

"Or do we here place a limitation on the negation stated above? We do so to some extent when we are speaking for the youth of our own generation, the generation born around 1880. When we reached manliness, 'the sin' of Stuck crossed the erring ways pursued by our searching eyes and— whatever else this sin might be—it travelled into our veins and into our hearts. We are now nearly fifty years old; we are now smiling; but do we know how much that picture, possessing only some meaningless content for the confused enthusiasm of young people on the threshold of manhood, may still fatally haunt us in our innermost life at night? May there not be some unearthly connection between us and this dead man? Stuck has been with us more than once in some development, by no means the least beneficial, even though it may have had nothing to do with art.

"And was it possible to encounter him, this man himself, and to remain unmoved? He was handsome in the Roman way, and as his short black hair became white, his face grey and wrinkled, his hot eye cool and his ear dull, even then we could not look at him without emotion.

"We realized also that he was a good teacher. He was stimulating only in the material aspects of training and handicraft, but he was tolerant of any individual manifestation of talent. His best pupils flourished in opposition to him, a situation which he endured with dignity. Their leader was Weisgerber, of the Palatinate, who was more liberal, and who went to Paris where he found the guidance denied him in the new Munich.

"It is true that we were affected only in our minds, but how wonderful are the senses of a fourteen-year-old! They embrace the entire poetry of existence, from the high point of ecstasy to tragedy, and both rolled into one. It is also true that this painter's hold on us, the young ones, was that of the alluring lack of scruple of a barbarian, for that he was, a colonized barbarian, a northerner colonized by the Romans: but how beautiful indeed is the unscrupulousness of young robbers...This retrospective on Stuck the artist concerns not only the man himself with his pictures and bronzes; Stuck represents also a moment of our own gloriously uncritical youth. In truth, like a decadent Roman, he inflicted on us the insidious poison of a downfall which he helped to represent, one that Fate itself may well have prescribed."

166

BIBLIOGRAPHY: Bie, O., "Franz Stuck", in KUNST FÜR ALLE 1903/XIX. – Bierbaum, O.J., "Franz von Stuck". Munich 1893., Bielefeld 1924. – Heilemann, A., "Franz von Stuck", in KUNST DEM VOLK, Vienna, April 1943. – Heilmeyer, A., "Franz von Stuck, Monograph", in DAS PLAKAT, Year 10 1919, p. 37 ff. – Nicodemie, G., "Franz von Stuck". 1936. – Ostini, F. v., "Franz von Stuck", in DIE KUNST 9, 1904. – id., "Das Gesamtwerk Franz von Stucks". 1909. – Catalogue for the re-opening of the Stuck villa in Munich 1968, with contributions by J.A. Schmoll, known as Eisenwerth, Helga D. Hofmann and others.

WORKS: Worked on the magazines ALLOTRIA, FLIEGENDE BLÄTTER and JUGEND; title page of PAN; allegories and emblems; cards and vignettes; Die zwölf Monate (published by Gerlach und Schenk, Vienna); individual sheets, etchings.

LEO PUTZ

Leo Putz, a painter and draughtsman, was born in Meran on 18 June 1869, and died there on 21 July 1940. From 1886 to 1889 he studied under R.Poetzelsberger in Munich, and then under Hackl at the Munich Academy. He was taught by Bouguereau and B.Constant in Paris in 1891/92, and from 1893 to 1895 he was the pupil of Höcker in Munich. In 1899 he was a founder member of the artists' association "Die Scholle" (The Native Soil) in Munich. He was a member of the Berlin, Viennese and Munich Secessions. He lived in Rio de Janeiro from 1928 to 1933. He worked on the magazine JUGEND.

BIBLIOGRAPHY: Michel, W., "Leo Putz", Leipzig 1908. Leo Putz und die Scholle. Exhibition catalogue of the Galleria del Levante. Munich 1968.

LUDWIG VON ZUMBUSCH

Ludwig von Zumbusch, a painter and draughtsman, was born in Munich on 17 July 1861 and died there on 28 February 1927. He studied at the Viennese and Munich Academies, and also in Paris. He was a member of the Munich Secession. He worked on the magazine JUGEND.

PAUL HAUSTEIN

Paul Haustein, a painter and draughtsman, was born in Chemnitz on 17 May 1880. In 1896 he studied at the Dresden School of Applied Art, and in 1897 at the Munich School of Applied Art. In 1897 he was a founder member of the United Workshops for Artistic Handiwork in Munich. In 1898 he studied under Jos. Herterich at the Munich Academy. From 1899 onwards he worked on the magazine JUGEND. In 1903 he was given a post at the Artists' Colony in Darmstadt. From 1905 onwards he taught at the Stuttgart School of Applied Art; he was a specialist instructor in the art of metalworking at the "Educational and Experimental Workshops".

Ludwig von Zumbusch, Title page for the journal JUGEND, No. 40, 1897. ▷ 27 × 20.7 cm.

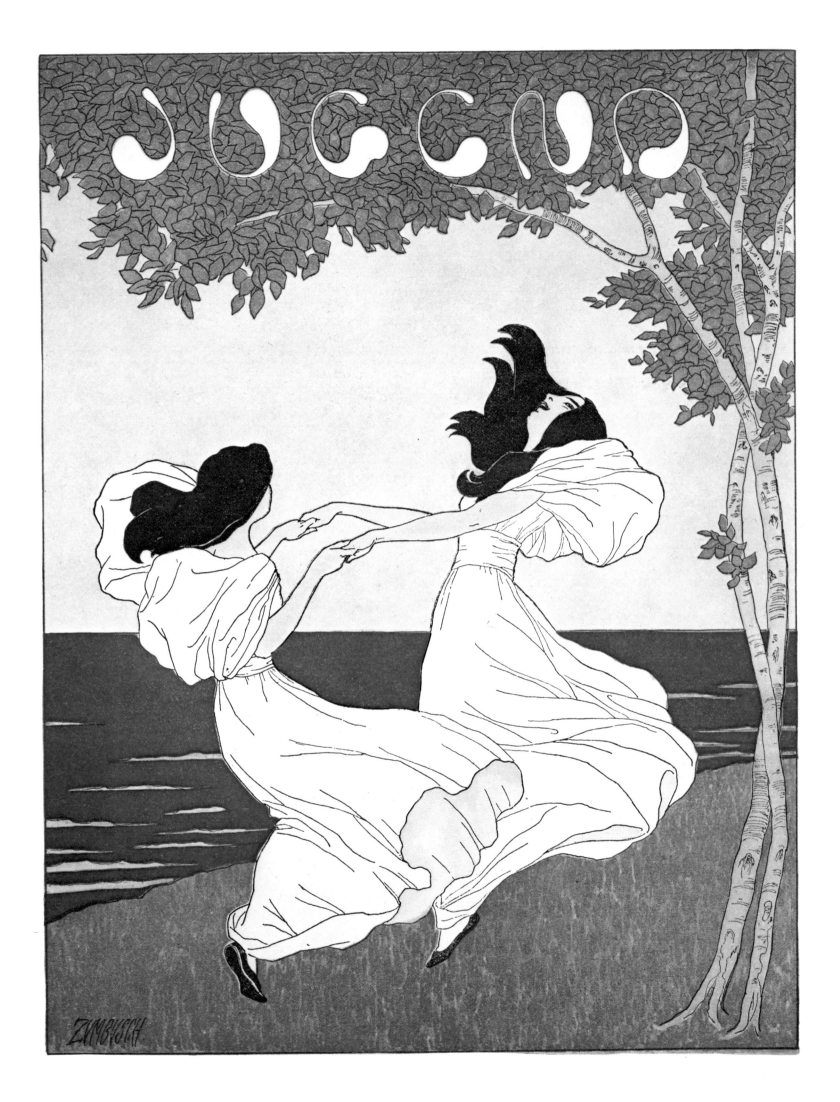

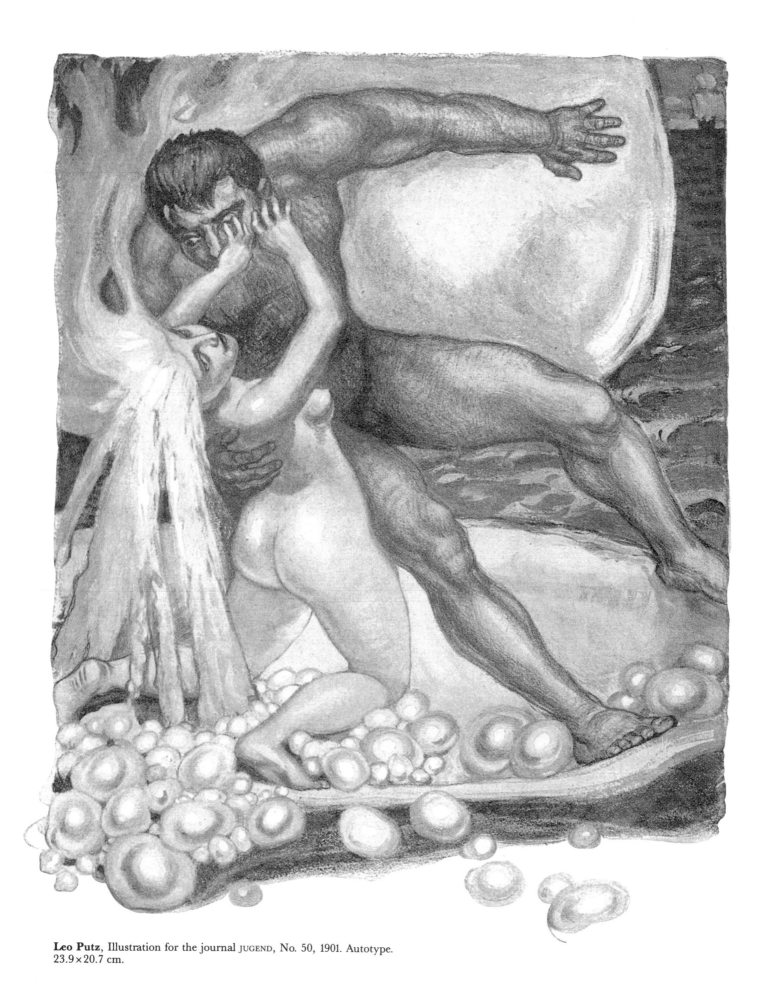

Leo Putz, Illustration for the journal JUGEND, No. 50, 1901. Autotype.
23.9×20.7 cm.

In der Sonne

Die Sonne wärmt ihr goldbraunrothes Haar:
das leuchtet nun so tief — das sprüht so reich —
der Prunk der Feste flammt um ihre Schläfen!

Man darf ihr nicht verrathen, wie so hoch,
wie sie so herrlich thront vor meinen Sinnen —
sonst küsst sie meine Hände mir nicht mehr,
und lacht nicht mehr so wie die Kinder lachen,
und macht wohl fremde Seelen unterthan . . .
das will die Sonne nicht.

Venedig, Oktober 1902 Otto Erich Hartleben

Neues Leben

Zur Mittagsstund', da zwischen Dornenzweigen
Die Rose ihre schwülsten Düfte hauchte,
Da fühltest Du, wie mit geheimem Schweigen
Mein Blick in Deinem selig untertauchte.

Und Deines Auges flimmerblaue Wellen
Erzitterten wie unter Ruderschlägen,
Und auf den sonnensprüh'nden Wasserfällen,
Da tanzte Deine Seele mir entgegen.

Und wie ich mich in ihrem Glanze sonnte,
Verstummte jählings jeder Wunsch und Wille.
Ich fühlte, dass ich wieder lieben konnte,
An meines Herzens klarer Sabbathstille.

Seit jener Stund', da zwischen Dornenzweigen
Sich unsre mittagstrunk'nen Seelen küssten,
Da wissen wir, dass wir einander eigen,
Ob wir auch ewig auseinandermüssten.

Edgar Steiger

Paul Haustein, Decoration for the journal JUGEND, No. 10, 1903.
Autotype. 26 × 21 cm.

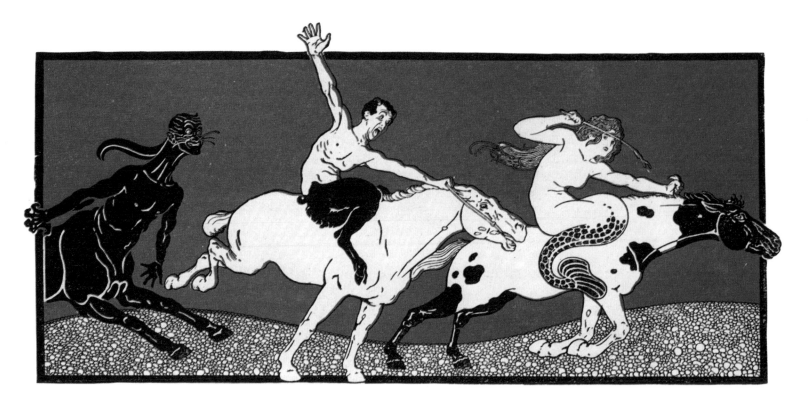

Franz Christophe, The Blacks are Coming. Illustration for the journal JUGEND, No. 45, 1897. Autotype. 8.5×18.3 cm.

Fritz Erler, To Frighten. Illustration for the journal JUGEND, No. 52, 101. ▷ Autotype. 25.1×15.8 cm.

FRANZ CHRISTOPHE

Franz Christophe, a draughtsman, was born in Vienna on 23 September 1875. He was self-taught. Initially he worked in Munich and later in Berlin. He worked on several magazines.

BIBLIOGRAPHY: Franz Christophe monograph in DAS PLAKAT. Year 9. 1918, p. 232 ff.

WORKS: Worked on JUGEND, SIMPLIZISSIMUS, NARRENSCHIFF and DIE LUSTIGEN BLÄTTER. Illustrations for H. Bang, Exzentrische Novellen. – Franz Blei, Blühende Gesten des Orients; Die Puderquaste. Posters.

FRITZ ERLER

Fritz Erler, a painter, draughtsman, and theatre and applied art designer, was born in Frankenstein, Silesia, on 15 December 1868 and died in Munich on 11 July 1940. From 1886 to 1890 he studied under Albrecht Bräuer at the Royal Art School in Breslau. From 1892 to 1894 he was at the Académie Julian in Paris, and spent a short period in Brittany. He received inspiration from the Nabis and from Albert Besnard. In his work, Erler devoted himself to subjects derived from sagas and fairy-tales. Working in the applied arts, he created numerous designs for vases, glass windows and textiles. In 1896 he was a co-founder of JUGEND magazine in Munich. In 1899 he was a founder of the artists' association "Die Scholle" in Munich. In 1898 he decorated the music room and conservatory in a private

house in Breslau. In 1908 he creaated designs for the theatre sets for "Faust" and "Hamlet" in the artists' theatre in Munich. In 1912 he created frescos in the banqueting room of Hanover's town hall, while in 1913 he executed some frescos in the boardroom of the counter-insurance company in Munich. Erler was an honorary member of the Academies in Munich and Milan.

"In the summer of 1895, when he had just arrived in the Bavarian capital, Erler—as has been said before—established relations with the publishing house of the magazine JUGEND and created that magazine's first title-page, which became its distinctive symbol. He portrayed a youthful ice-skater making a jubilant, rushing advance, brandishing a firebrand and a sprig of mistletoe: this magazine issue appeared around the Christmas period. It was vastly different from everything else that had been regarded as title-page style, and this page by Erler was as fresh, striking and youthfully vivid as a magazine called JUGEND (youth) could possibly desire—it was a work programme for the magazine and for the artist." (F.v.Ostini)

BIBLIOGRAPHY: von Belepsch, H.E., "F.E.", in DEUTSCHE KUNST UND DEKORATION I, pages 93–124. – Biermann, G., "Fritz Erler und das Theater", in LEIPZIGER ILLUSTRIERTE ZEITUNG 3489, issue dated 12.5.1910. – Mayr, K., "F.E.", in DIE GRAPHISCHEN KÜNSTE 1901, pages 113 ff. – Ostini, F. v., "Fritz Erler. Leipzig 1921.

WORKS: Worked on the journal JUGEND, posters etc. for the Cococello Club Munich. Illustrations to M. Schilling, Ingwelde.

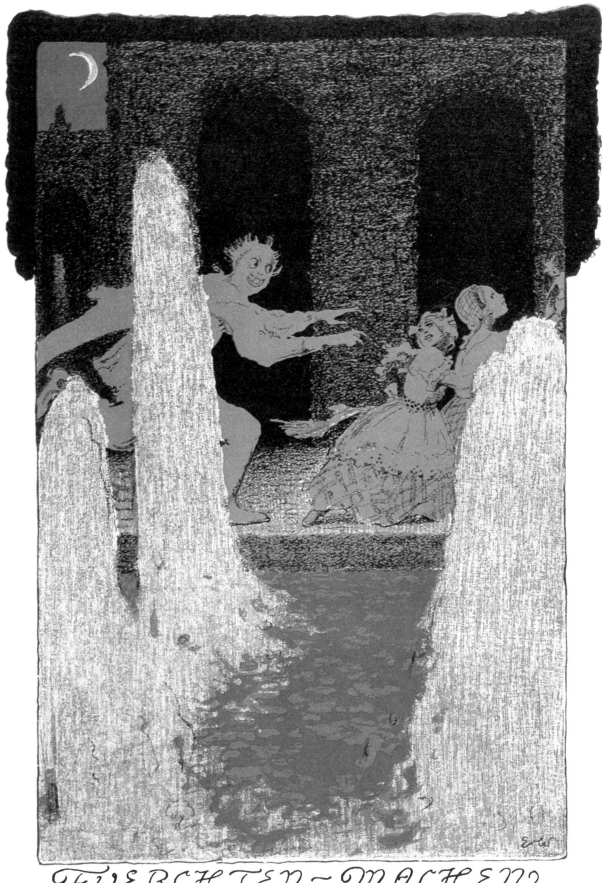

FÜRCHTEN-MACHEN

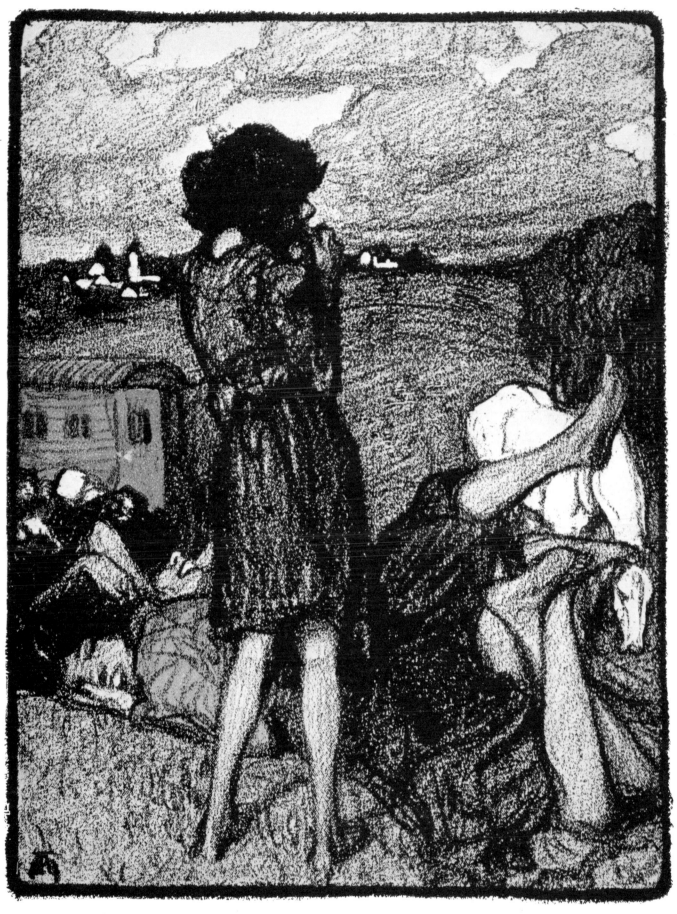

„Als die Mutter mich geboren, In dem Gras bin ich gelegen, *Adolf Münzer (Paris)*
Hat sich Keiner um mich geschoren; Und getauft hat mich der Regen."
 (Alter Zigeunervers)

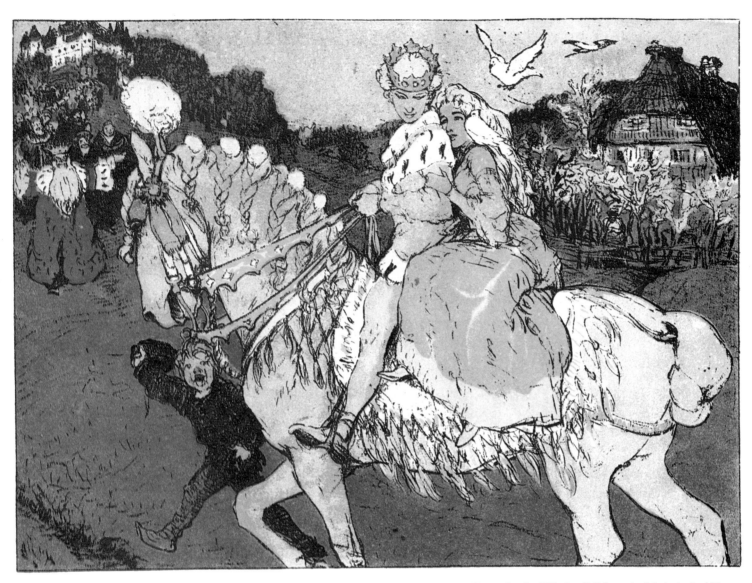

Adolf Münzer, Illustration for the journal JUGEND (to an old spring verse), No. 38, 1900. Autotype. 25.1×19.3 cm.

Adolf Münzer, Illustration for "Cinderella" from the Scholz Artists' Picture Books (Das deutsche Bilderbuch) No. 3. Verlag Jos. Scholz, Mainz (no date). Drawing dated: 1903. Autotype. 21.3×27.2 cm.

ADOLF MÜNZER

Adolf Münzer, a painter and draughtsman, was born in Pleß, Upper Silesia, on 5 December 1870, and died in Holzhausen on Lake Ammersee in 1952. He studied under C.Raupp, O.Seitz and P.Höcker. In 1900 and 1902 he was in Paris. From 1903 to 1909 he lived in Munich where he was a member of the "Die Scholle" association of artists. In 1909 he was appointed the head of a painting class at the Dusseldorf Academy. His style was one of popular narrative and fairy-tale.

BIBLIOGRAPHY: Worked on JUGEND. Fairy-tale illustrations for Verlag Scholz in Mainz.

ANGELO JANK

Angelo Jank, a painter and draughtsman, was born in Munich on 30 October 1868, and died there on 9 October 1940. He studied at the Munich Academy from 1891 to 1896. From 1895 onwards he was a member of the "Die Scholle" association of artists. In 1898 his works were displayed in public for the first time at the exhibition of the Munich Secession. From 1899 to 1907 he was a teacher at the Ladies' Academy of the Munich Association of Lady Artists. He also taught at the Munich Academy from 1907 onwards. He worked on JUGEND magazine.

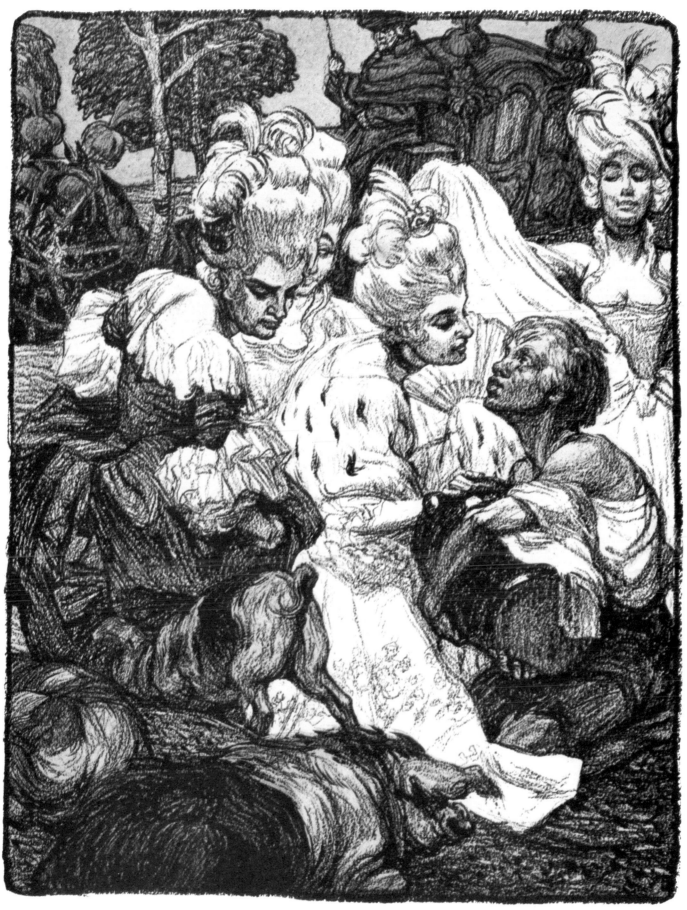

Angelo Jank (München)

Angelo Jank, The Swineherd. Illustration for the journal JUGEND,
No. 52, 1900. Autotype. 25.2×19.3 cm.

Walter Georgi, The Shepherd Thomas. Illustration for the journal ▷
JUGEND, No. 43, 1900. Autotype. 25.4×18.8 cm.

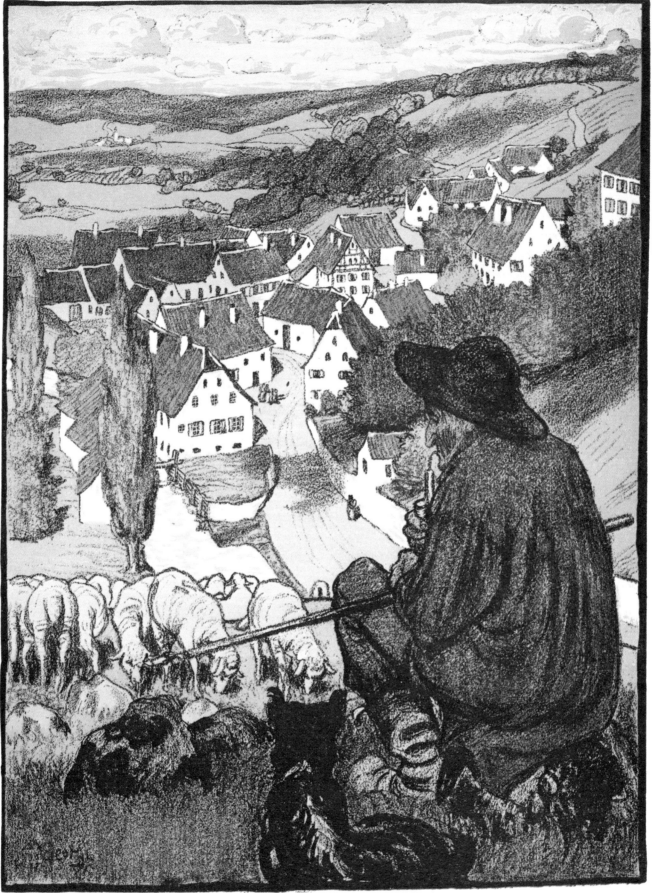

Der Schäfer Thomas

Walther Georgi (München)

Der Alte lebt noch immer, er raucht und prophezeit:
Es kommt ein schlimmer Winter und eine böse Zeit.

Besonders mit den Kohlen wird's haben eine Noth,
Und Viele holt bis Frühjahr der Teufel und der Tod.

WALTER GEORGI

Walter Georgi worked as a painter and illustrator. He was born in Leipzig on 10 April 1871, and died in Karlsruhe in June 1924. From 1890 to 1893 he studied at the Academies of Leipzig, Dresden and Munich. In 1899 he was a founder member of the "Die Scholle" association of artists in Munich. In 1900 his "Autumn Day" cycle, consisting of five large murals, was displayed at the Paris World Exhibition. In 1909 he painted the fresco for the cupola of the St. Blasien Cathedral in the Black Forest. He held a professorship at the Academy in Karlsruhe from 1908 onwards. He worked on JUGEND.

BERNHARD PANKOK

Bernhard Pankok, a painter, draughtsman, sculptor, designer of applied art, and an architect, was born in Münster, Westphalia, on 16 May 1872 and died in Stuttgart on 5 April 1943. He studied at the Dusseldorf and Berlin Academies. From 1892 to 1902 he lived in Munich. In 1897 he took part in the Seventh International Art Exhibition at the Palace of Glass in Munich. He was one of the founders of the "United Workshops for Art and Handiwork" in Munich. In 1899 a room decoration by him was displayed at the Exhibition of the Munich Secession. In 1900, a decoration carried out by him for a larger room was put on show at the World Exhibition in Paris. From 1902 onwards he was active in Stuttgart. From 1903 he was the head of the "Educational and Experimental Workshops" in Stuttgart. Pankok created the decorations for the Lake Constance steamer "Friedrichshafen" and for the Zeppelin airships (1910-19).

BIBLIOGRAPHY: "Panok, Bernhard", in DEUTSCHE KUNST UND DEKORATION, Darmstadt 1903, Vol. 1, p. 51 and 1902, 1, p, 449

WORKS: Worked for JUGEND, entire decoration of the German catalogue for the 1900 Paris World Exhibition, book decoration.

LIMITS OF APPLIED ART: In the art of book decoration, especially where work on the bindings, endpapers and title-page drawings is concerned, an especially important part is played by such ideas for designs as serve only the purposes of applied art, even if their high artistic level sets standards of its own, as is the case with the examples by Pankok and Strathmann which we are showing here. However, there was at that time a deeply rooted wish for ornamentation. This wish was not limited to occasions when it was useful to have decorations from the field of applied art; rather it was the case that this need frequently caused the systems of decoration—by no means the least being that of book art—to be transferred also to objects where the justification for this decoration was no longer in accord with the intention for it. At the beginning of the 20th century,

Werner Sombart characterized this situation as follows in his essay on the limits of applied art:
"If the situation of applied art in civilized countries today is correctly observed and if the conditions of its development are examined precisely, I believe that the conclusion which must of necessity be drawn is that very good provision has been made for the future of applied art. There is scarcely any danger that the coming generations might not have enough applied art. The number of artists specializing in applied art will certainly not diminish; peoples' increasing prosperity will ensure this. However, this prosperity also creates a constantly widening circle of purchasers of beautiful and higher quality consumer goods. There is a strong trend towards sensuality today, which means that people will become more and more inclined to beautify their lives by all kinds of ornamentation.
"It seems to me that there is another and much greater danger, of which I intend to speak in conclusion, which is that there may be too much applied art.
"By this I mean too much applied art in the subjective sense in which I interpret that phrase. Too much applied art as a spiritual mood, as a frame of mind. Too much of a demand that our environment be given a beautiful shape. All trade productions, and finally all living, too exclusively oriented towards aesthetic values. Simply, in the interests of a full and deep culture: too much. This is because I am afraid that an overgrowth of aesthetic values will destroy other important values; because I am afraid that the hierarchy of values will be shaken, that high things will be debased and low things placed on high. Because I am afraid that all values will be levelled down, and that this levelling-down will lead to a detrimental effect resulting from a materialistic and level culture showing no elevations or depressions, a sensual and intellectual everyday culture which shows neither the mysteries of dawn and dusk nor the majesty of the night. I now intend to state in detail what I mean.
"The first thing against which we should guard ourselves is that we should not indiscriminately apply an aesthetic aspect to all the objects we use. First of all, that would be tactless and tasteless—very tactless and tasteless. Anyone who wants artistic taste to be preserved everywhere is climbing the peak of tastelessness. Anyone who wishes to take the thousand important things which we require in order to satisfy our needs, and who wishes to immerse those things in beauty, is offending against the spirit and dignity of beauty itself. If it is frivolous to wish to die in a beautiful state, it is stale and trite to carry out in a beautiful state such acts as cleaning one's teeth, wiping one's pen and performing other necessities. We should not wish to have moustache-trainers and spittoons closely following the designs of great artists, because we should thereby be

Bernhard Pankok, Endpapers for the catalogue to the Paris World ▷ Exhibition 1900. Coloured lithograph. About original size.

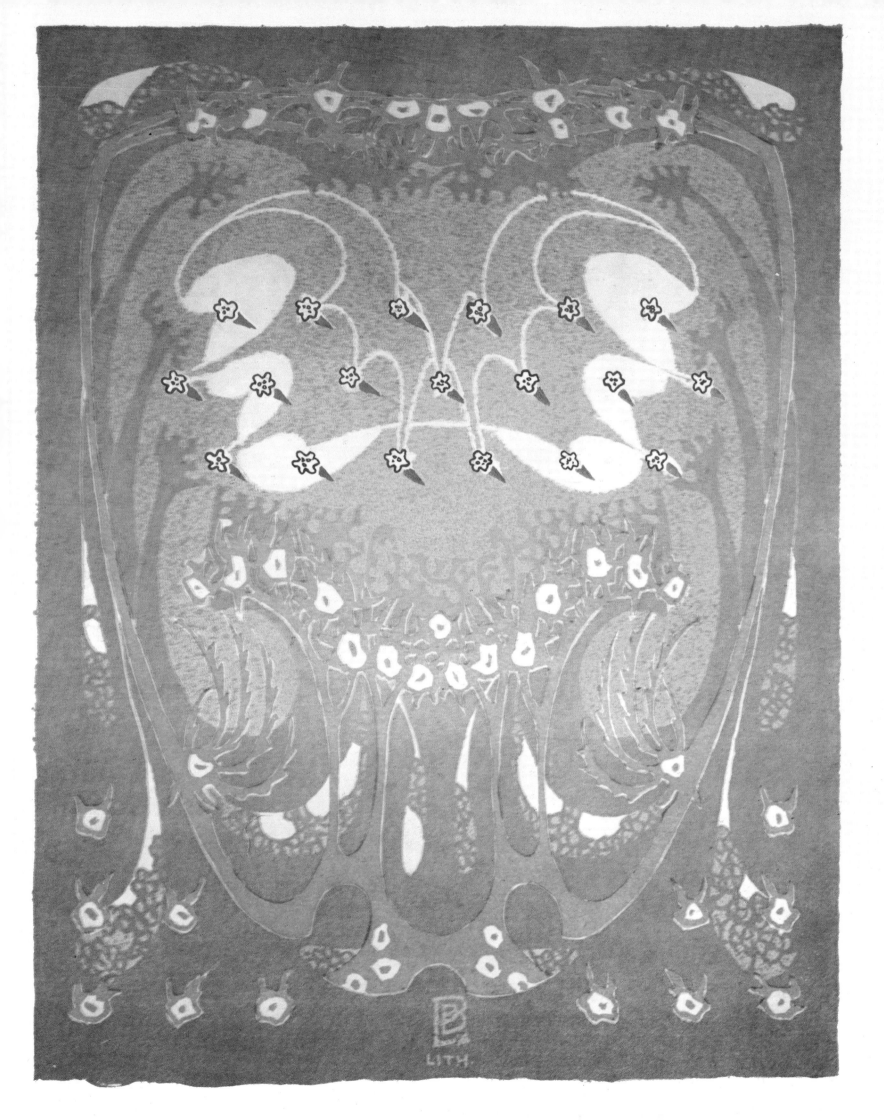

LITH.

lending importance or sacredness to the futilities or seamy sides of human life.

"However, too much sensual beauty can also flatten our spirit. Today we have nearly reached the stage where we do not ask about the content of a book, provided that it is printed with fine characters on good paper and provided that the jacket, book ornamentation and endpapers—all of which must always be "created by an artist"—arouse our aesthetic satisfaction. We penetrated more deeply into the content of the work when we were still able to devour, with cheeks aglow, those torn paperback copies of the classics. And when we see a Shakespeare play in Berlin, almost the only matter which basically interests us is the effect of an actor's green velvet costume against the red background, and we are only slightly interested in the lines spoken by that actor.

"I also believe that too much beautiful sensuality dulls our spirit. Modern reproduction technology has increasingly accustomed us to looking only at pictures and to examining our knowledge on the basis of what we see there. It is a sorry product of our times if we start imparting to our children the blessings of applied art and if we want to surround them with nothing but aesthetically unobjectionable things. 'Art in the life of the child'—dreadful phrase! For the child itself has enough imagination to generate for itself a world of pictures and shapes and to give all glory and splendour even to the most meagre object. The child should above all be uncivil and unaesthetic in order that he may frolic about to his heart's content, and he should grow up as a little barbarian and not as an aesthete. The more 'beautiful' objects I place in front of his nose, the more I dull the creative force of his imagination.

"And if our entire thinking and aspiration is only aimed at rendering beautiful and tasteful that world of dead things in which we live: do we not thereby become impoverished? Do we not become stunted by closing our minds and our hearts to the thousand other worlds which press upon us? This continues until we finally become the pitiable slave of our own surroundings: we become our own valets and our own castle wardens.

"The harmony of the overall personality should be the most important factor in aesthetic considerations, but it can, in the manner sketched above, be destroyed by a one-sided emphasis on the purely artistic aspect. What then finally develops is not a full and lively personality, but rather the caricature of the aesthete.

"The remarks which I am making here will not cause me to be suspected of wishing to begin a struggle against beautiful life forms. Instead, I believe that the tasteful fashioning of our surroundings is a necessary postulate of all culture, and I hope that such tastefulness will become more and more a matter of course. For it is precisely by such means that a large number of the dangers just referred to would be eliminated, even though we would be able to possess those objects which we regard as worthy of being beautiful, and we could possess them without much reflection and without thereby being too greatly distracted. "I only intended to warn of the dangers of a one-sided development towards a purely 'artistic' culture, which has now become a slogan. In the same way that we do not wish to see every necessity made into an object of aesthetic consideration, we also do not wish to do this to the entire content of life. There is a sphere of our existence which is beneath artistic evaluation, and there is also a sphere above that evaluation. If we intended to orientate our entire culture towards purely aesthetic principles, our lives would become cold and deserted and empty; our souls would dry up and our minds would be desolate. We must give to artistic endeavours the place which is due to them in the overall context of our affirmation of life, and the final goal of that affirmation is probably really the moulding of harmonious personalities, that is to say personalities which, in their entire reality, are good, efficient, distinguished and spiritually high-ranking. In this method of observation, there are also 'limits of applied art'."

CARL STRAHTMANN

Carl Strahtmann, a painter and graphic artist, was born in Dusseldorf on 11 September 1866 and died in Munich in 1939. From 1882 to 1886 he studied under Crola and Lauenstein at the Academy in Dusseldorf, and from 1886 to 1889 under L.v.Kalkreuth at the art school in Weimar. He lived in Munich from the early 1890's onwards; around 1900 he shared a studio with A.Niemeyer.

BIBLIOGRAPHY: Corinth, L., "Carl Strahtmann", in KUNST UND KÜNSTLER I, 1903.

WORKS: Worked on FLIEGENDEN BLÄTTER, and JUGEND.

Carl Strahtmann, Cover for a songbook, "Totentanz - Vor meiner ▷ Kammertür - Schlummerlied - Vor der Schlacht". Colour lithograph. About original size.

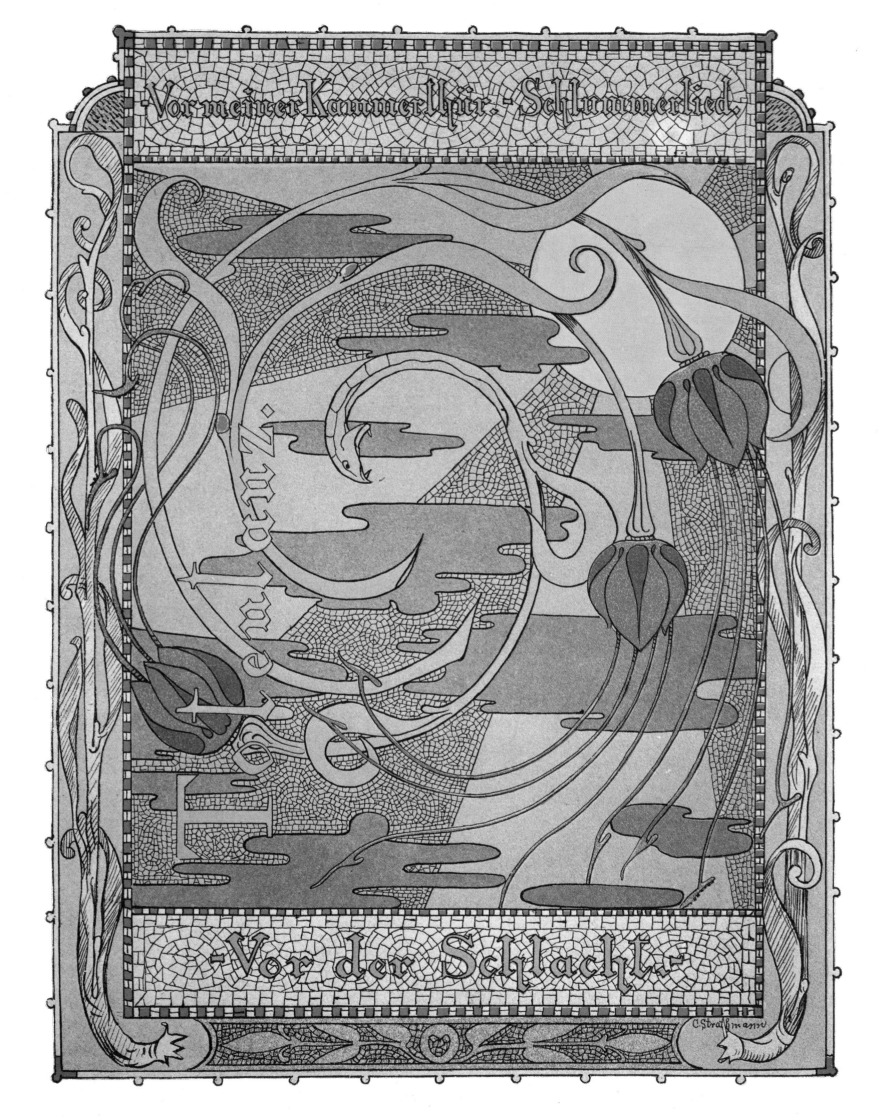

Vor meiner Kammer Thür. · Schlummerlied.

Vor der Schlacht

C. Strathmann

THOMAS THEODOR HEINE

Thomas Theodor Heine, who worked as a painter, draughtsman and writer, was born in Leipzig on 28 February 1867 and died in Stockholm on 26 January 1948. He studied under Janssen at the Dusseldorf Academy. From 1889 onwards he worked as an illustrator in Munich. In 1896, together with L.Thomas and A.Langen, he founded SIMPLIZISSIMUS, a political-satirical magazine, and he continued working on its issues together with Gulbransson and E.Thöny until it was banned in 1933. In 1898 he was interned at the Königsstein in Dresden for lèse-majesté. In 1909 he held a collective exhibition in Munich. He emigrated to Prague in 1933, and worked on the newspaper TAGBLATT which appeared there. He spent periods in Brünn and in Oslo, where he worked on the Göteborg newspaper for trading and navigation. In 1942 he emigrated to Stockholm and worked on the SÖNDAGS-NISSE-STRIX. He published his memoirs entitled "I am waiting for miracles" in Stockholm in 1945.

BIBLIOGRAPHY: Corinth, L., "Th. Th. Heine und Münchens Kunstleben am Ende des vorigen Jahrhunderts", in KUNST UND KÜNSTLER 4, 1906. – Hölscher, E., "Th. Th. Heine", in DAS BUCHGEWERBE 3, Issue 4, 1948. – Popp, J., "Th. Th. Heine", monograph in DAS PLAKAT, Year 8. 1917, p. 265 ff. – Wolff, G.J., "Th. Th. Heines Gemälde", in DIE KUNST 23, 1916. – id., "Gobelinentwürfe von Th. Th. Heine", in DIE KUNST 38. 1918.

WORKS: Contributed to JUGEND, FLIEGENDEN BLÄTTER, SIMPLIZISSIMUS, illustrations to Thomas Mann, Wälsungenblut; Ludwig Thoma, Die bösen Buben; Oscar Wilde, Salome. Die Lebensmüden (four individual pictures), F. Hebbel. Judith. – designs for book bindings and posters, including Die elf Scharfrichter, Gloria (pen and ink), for the "Zust" car marque. Portfolios (Verlag Langen, Munich): Bilder aus dem Familienleben; Torheiten.

Thomas Th. Heine, Cover for BÜHNE UND BRETTL. (third year, No. 4). ▷ Autotype. Original size.

Thomas Th. Heine, Illustrations for "Judith" by Friedrich Hebbel. Publ. Hans von Weber-Verlag, Munich 1908. Autotype. About original size.

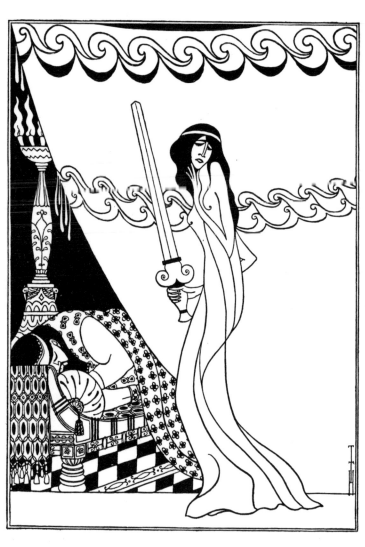

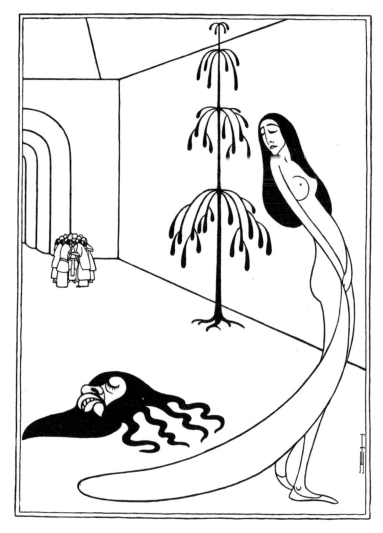

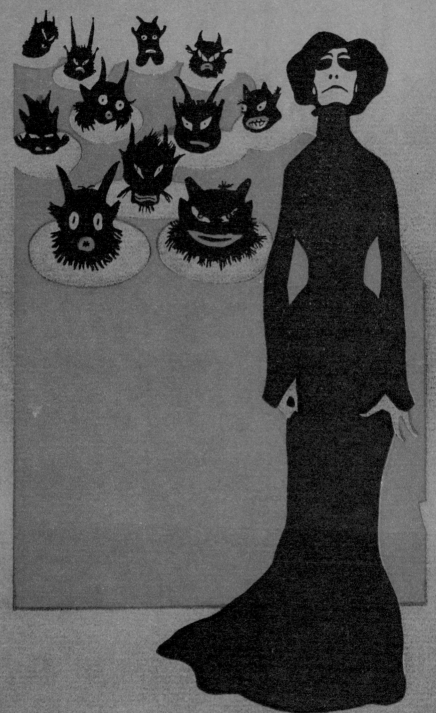

Auflage 12000.

III. Jahrg.
No. 4.

Bühne und Brettl

Preis
20 Pfg.

Elf Scharfrichter-Nummer

BRUNO PAUL

Bruno Paul, a painter, draughtsman, designer of applied art and an architect, was born in Seifhennersdorf, Lausitz, on 19 January 1874. From 1886 to 1894 he studied at the Dresden School of Applied Art, and from 1894 onwards he studied at the Academy in Munich. He worked on some magazines in Munich during his studies. In 1897 he was the co-founder and head of the "United Workshops for Art and Handicraft" in Munich. From 1907 onwards he was head of the teaching establishment of the Museum of Applied Art in Berlin, and from 1924 he was Principal of the "United State Schools for Free and Applied Art" in Berlin. In 1933 he resigned his post and moved to Dusseldorf. Paul worked mainly as an architect and interior decorator, and furniture design was among his chief interests; he developed the first stylized furniture as early as 1906.

BIBLIOGRAPHY: Hessberg, R., "Bruno Paul", monograph in DAS PLAKAT, Year 10. 1919, p. 33 ff. – Popp, J., "Bruno Paul". 1916.

WORKS: Worked on SIMPLIZISSIMUS and JUGEND, "Steckbriefe" by M. Möbius, poster designs, etc.

Bruno Paul, Illustration for "Steckbriefe" by M. Möbius. Frank Wedekind. Verlag Schuster und Löffler, Berlin. 1900. Autotype. About original size.

Thomas Th. Heine, Vignette from "Judith" by Friedric Hebbel.

JOSEF SATTLER

Josef Sattler, a painter and draughtsman, was born in Schrobenhausen, Upper Bavaria, on 26 July 1867 and died in Munich on 12 May 1931. From 1886 to 1891 he studied in Munich. Among his teachers was Gysis. He worked as a teacher in Strasburg from 1891 onwards. From 1895 to 1904 he lived in Berlin. He then returned to Strasburg. From 1910 onwards he was resident in Munich.

WORKS: Worked on SIMPLIZISSIMUS and PAN, illustrations, etc., to: H. Boos, Geschichte der rheinischen Städtekultur 4 Vols. 1897–1901; Die Nibelungen 1898–1903; Die Quelle – ein fliegender Bilderbogen (1892); Elsässische Bilderbogen (3 series, 1893–1896); Bilder aus der Zeit der Bauernkriege (1893); Ein moderner Totentanz (1894); Die Widertäufer (1895); Bilder vom internationalen Kunstkrieg (1896); G. Spetz, Légendes d'Alsace (1905 & 1910); Grimmelshausen, Simplicius Simplicissimus (1913). Also illustrations to Gottfried Keller, Theodor Storm, Will Vesper. – Ten pictures from the Life of Martin Luther (1929).

Josef Sattler, Illustration for "The Nibelung" - Hagen sinks the Nibelung ▷ Treasure in the Rhine. Edited by K. Lachmann, from the Hohenems-Münchner manuscript A. Printed on parchment for the World Exhibition in Paris, 1900, by the Reichsdruckerei Berlin, 1898 - 1904. About half size.

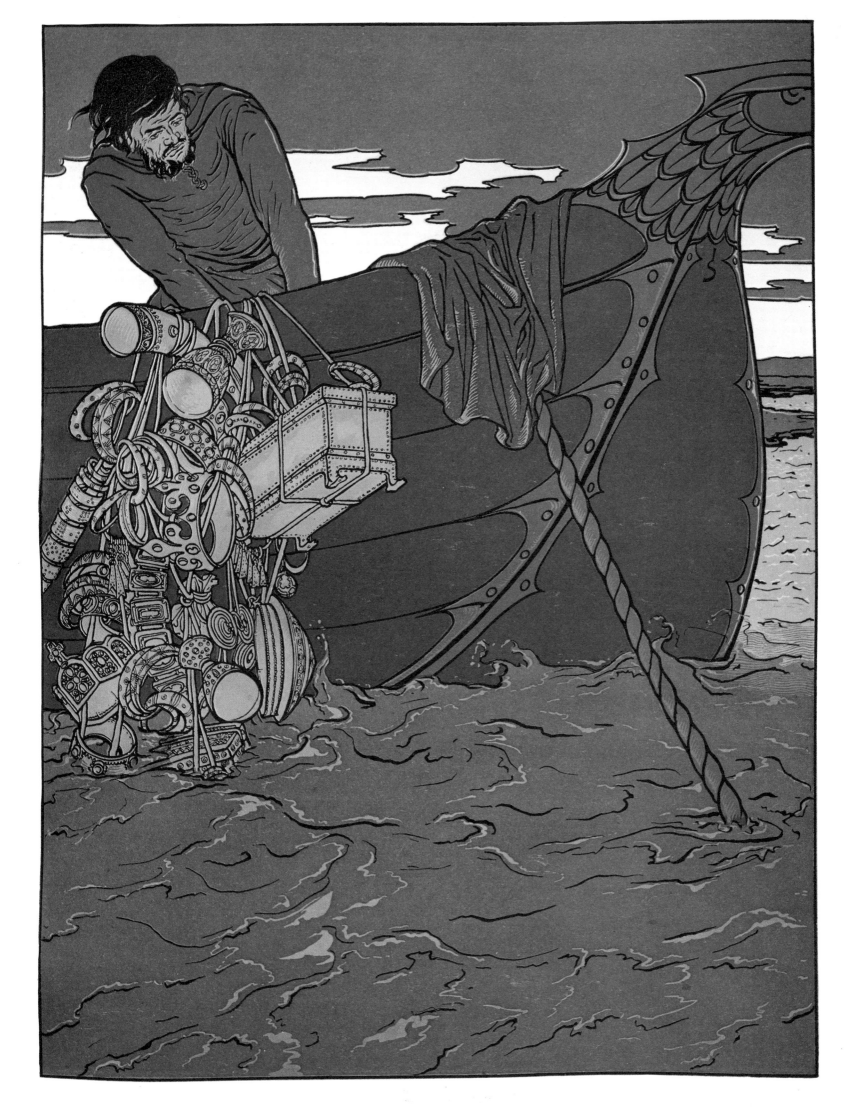

HANS VOLKERT

Hans Volkert, who worked as a painter and illustrator, was born in Erlangen on 7 August 1878, and studied at the Munich Academy.

WORKS: Cycles: Frühlingsblühen (6 lithographs); Die sieben Leuchten der Tugend (7 etchings); illustrations to Eichendorff, Rükert, Lenau, Goethe, Novalis; A Roessler, Es gibt solche Menschen; a sketch book. Ex Libris plates and applied graphics.

Hans Volkert, Decoration for "Es gibt solche Menschen, ein ▷ Skizzenbuch" by Arthur Rössler. Publ. Aug. Schrimpp, Munich, 1901. Autotype. About original size.

Hans Volkert, Illustration for "Goldene Kinderzeit". Munich 1905. Autotype. 15.1×8.6 cm.

FRITZ ENDELL

Fritz Endell, a painter and draughtsman, was born in Stettin on 12 November 1873 and died in Bayrischzell on 8 February 1955.

Originally he studied theology. It was in Munich, under the influence of his brother, the architect August Endell, that he turned to the profession of artist instead. Around 1900 he was in Paris, entered the Académie Julian and studied under Colarossi. He specialized in wood-engraving and received technical instruction from Quesnel. He was influenced by Vallotton, Lepère and Colin. He moved to Stuttgart in 1902. He worked under Max Weber and was a master pupil of Kalckreuth and Hölzel. In 1914-20 he lived in America and taught drawing at the Duncan School. He occupied himself with antique vase painting and with mirror-engravings, and also with the art of the North American Indians.

WORKS: Woodcuts: Die Welle (1900–1902), Phantastische Erfindung, Das Ende (1900–1902), Der Raub (1900–1902), Paradise Lost (1902–1906), border designs, including portfolios: Kleines Buch für kleine Leute (1913), Old Tavern Signe (1916, Boston).

Fritz Endell, The Wave. 1900-1902. Colour woodcut on Japan paper. ▷ 26.0×11.7 cm.

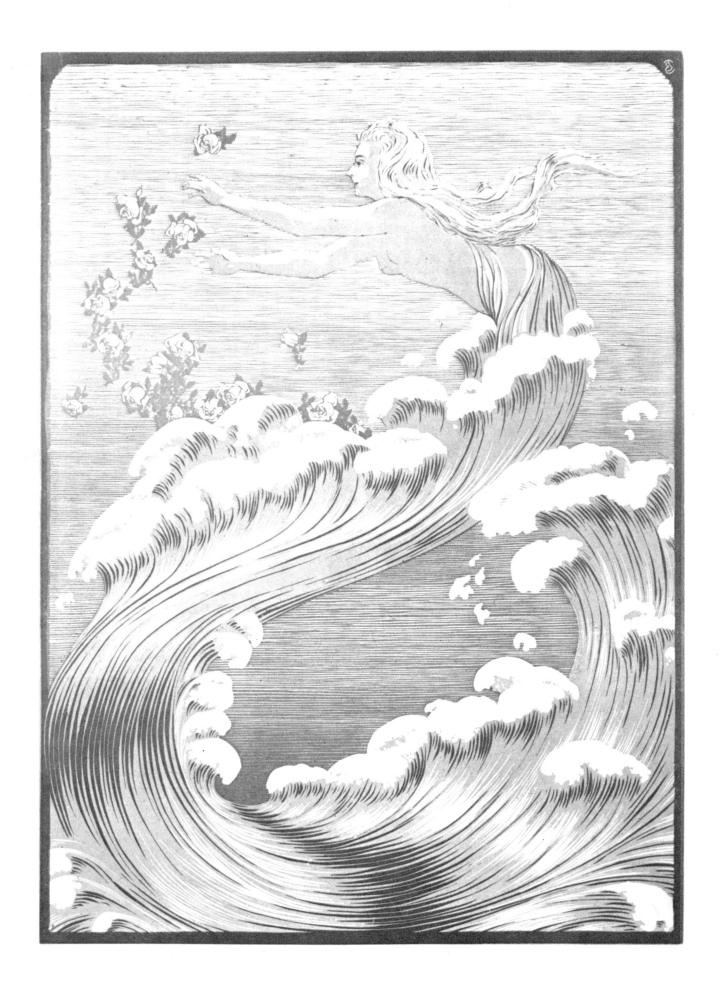

EMIL PREETORIUS

Emil Preetorius, a draughtsman, theatre designer and writer, was born in Mainz on 21 June 1883. He completed his studies of natural sciences, history of art, and law, by passing his examination to become a qualified junior lawyer, and graduated as a doctor of law (Dr.Jur.) As an artist he was essentially self-taught, but he also attended the Munich School of Applied Art for a short time. In 1909, together with Paul Renner, he founded the Munich School for Illustration and Book Design. He was among the founders of the association of Munich poster artists called "Die Sechs" (The Six). From 1910 onwards he worked as a teacher at the Munich Workshops and the Munich Academy. From 1926 onwards he was the head of a class for illustration and of a class for the art of theatre design, both at the Munich Academy. From 1928 onwards he was Professor at the College of Pictorial Art in Munich. In 1932 he was in charge of the stage sets for the Bayreuth Festival. From 1948 onwards he was a member of the Bavarian Senate. In 1953 he became President of the Bavarian Academy of Fine Arts. He collected Asian art works. An honorary doctorate was conferred on him by the philosophical faculty of the University of Mainz.

WRITINGS of E. Preetorius: Vom Wesen ostasiatischer Malerei, 1937; Vom Bühnenbild bei Richard Wagner, 1938; Gedanken zur Kunst 1947; Reden und Aufsätze 1953; Sprache der Kunst 1955; etc.

BIBLIOGRAPHY: "Preetorius, Emil", in MONOGRAPHIEN DEUTSCHER REKLAMEKÜNSTLER by order of the Deutsches Museum für Kunst im Handel und Gewerbe, Hagen/W., edited by F. Meyer-Schönbrunn. Hagen & Dortmund 1911 ff. – Hoelscher, E., "Emil Preetorius, Das Gesamtwerk". 1953, Year 9. Wolf, Emil, "Preetorius", in DEKORATIVE KUNST 1913/XVI.

WORKS: Contributed to SIMPLIZISSIMUS and JUGEND; book bindings; illustrations, etc. to Tartarin of Tarascon by A. Daudet; Eichendorff, Aus dem Leben eines Taugenichts (1914); Jean Paul, Schulmeisterlein Wuz (1915); book decorations, posters.

LUDWIG HOHLWEIN

Ludwig Hohlwein was an architect, applied artist and draughtsman. He was born in Wiesbaden on 27 July 1874 and died in Berchtesgaden on 15 September 1949. He studied at the Technical College in Munich; he was an assistant teacher at the Dresden Academy. He made study trips to Paris and London. He worked in Munich. From 1906 onwards he created mainly poster designs. Hohlwein was one of the most significant poster artists of his time and had a considerable influence on poster art in Germany.

BIBLIOGRAPHY: Sachs, H., "Ludwig Hohlwein". Monograph in DAS PLAKAT, Year 4. 1913. p. 103 ff.

WORKS: Posters, including some for the Tochtermann perfumery, Brussels World Exhibition 1910, DEUTSCHE KUNST UND DEKORATION, Zoological Garden, Munich, artistic covers for Gebrüder Rosenthal AG, Munich.

Emil Preetorius, Cover for "Physiologie des Alltagslebens" by Honoré de Balzac. Georg-Müller Verlag. 17.5×9.5 cm.

Ludwig Hohlwein, Poster for the Parfumerie Tochtermann, Munich. ▷ Lithograph, much reduced.

ALBERT WEISGERBER

Albert Weisgerber, a painter, draughtsman and designer of applied art, was born in St Ingbert, Saar, on 21 April 1878, and was killed in the war at Fromelles, Ypres, on 10 May 1915. In 1891 he began his apprenticeship as a decorator in Kaiserslautern. In 1894 he entered the workshop of a decorative painter in Frankfurt, and after that he attended the Munich School of Applied Art. From 1897 to 1901 he attended the Munich Academy, and his teachers were G. von Hackl and then Franz von Stuck. From 1897 to 1912 he was active as an illustrator, and in 1902 he travelled to Venice. He went to Paris in 1905/6. In 1907 he married and became the successor to Angelo Jank as a teacher of drawing at the Ladies' Academy in Munich. In 1909 he travelled to Florence and made the acquaintance of Purrmann, Matisse and Levy. He made a trip to Italy in 1911; he held his first collective exhibition at the rooms of Brakl in Munich; in 1912 he gave an exhibition at the rooms of Cassirer in Berlin. In 1913 he was a founder member and the first President of the New Secession in Munich. The first exhibition of the new Secession took place in 1914, and Beckmann, Heckl, Kokoschka, Lehmbruck, Pechstein and others were also among those participating. Weisgerber was not young enough to be a member of the Art Nouveau generation, but Art Nouveau determined the style and atmosphere of his early works.

BIBLIOGRAPHY: Bornsheim, R., "Der Maler Albert Weisgerber", in RHEINFRONT, 23. 7. 1938. – Braune, H., "Albert Weisgerber", preface to the catalogue of the commemorative exhibition of the Munich Secession, 1916, p. 13 ff. – Christoffel, U., "Albert Weisgerber". St. Ingbert, 1950. – Etrel, K.F., "Das war verfemte Kunst, Albert Weisgerber", AUSSAAT, Year 2. 1947. – id., "Weisgerber und Purrmann", in KURPFALZ, 1955. – Gerke, F., "Sebastian und Jeremias, Zur Problematik des religiösen Werkes von Albert Weisgerber", catalogue of the Weisgerber exhibition in the Kunstgeschichtlichen Institute Mainz, 1961, p. 59 ff. – Glaser, C., "Weisgerber-Gedächtnisausstellung in Berlin", in KUNSTCHRONIK, Year 27, 1916. – Graf, H., "Albert Weisgerber", in PFÄLZISCHES MUSEUM

◁ **Albert Weisgerber**, The Peacock Dance, design for the journal JUGEND. Gouache. 1902. 33.6×27.9 cm. Slg. Kohl-Weigand. St. Ingbert.

Albert Weisgerber, Picnic in the Woods, from the journal JUGEND, 1904. Woodcut.

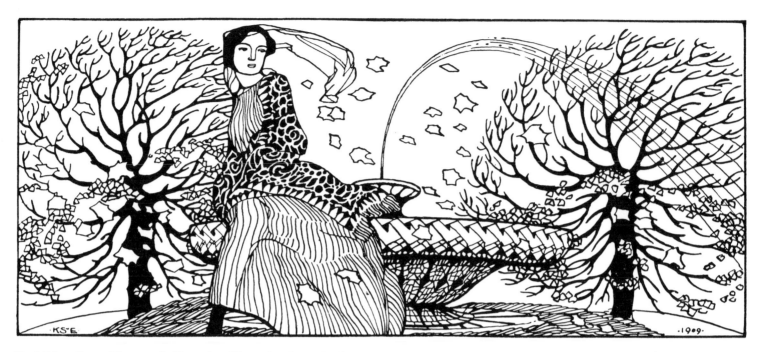

Karl Schmoll von Eisenwerth, November. Illustration for a calendar. 1903. Autotype. 6.9×16.1 cm.

Ferdinand Staeger, Youth, from the cycle "Way of Life". Etching. ▷ 30.5×22 cm.

40, 1923, p. 134. – Hausenstein, W., " Albert Weisgerber", in ZEIT IM BILD, II, Year 39, p. 2641 ff. – id., "Albert Weisgerber", in KUNST FÜR ALLE, 1916, Issue 7/8. – id., "Albert Weisgerber, Ein Gedenkbuch", 1918 – id., "Albert Weisgerber", preface to the commemorative exhibition in the Moderne Galerie Thannhauser, Munich 1925. – Heuss, Theodor, "Albert Weisgerber", in EINE WOCHENSCHRIFT, Issue 21, 1915. – Hausen, E., "Albert Weisgerber als Plakatmaler", in PFÄLZER ZEITUNG, 31. 5. 1926. – Lankheit, K., "Albert Weisgerber", in RUPERTO CAROLA, Vol. 19, June 1956. – Michel, W., "Albert Weisgerber", in DEUTSCHE KUNST UND DEKORATION, 29, 1911/12. – Riezler, W., "Albert Weisgerber", in DEUTSCHE KUNST UND DEKORATION, 36, 1915, and 38, 1916. – Uhde-Bernays, H., "Albert Weisgerber", in KUNST UND KÜNSTLER, Year 13. 1915. – Weber, W., "Von der Skizze zum Werk", catalogue of the Weisgerber exhibition, Homburg 1955. – id., "Albert Weisgerber – Seine Bedeutung in der deutschen Kunstgeschichte", in Kulturelle Monatshefte der Stadt Frankenthal, December 1956. – id., "Karikaturen von Albert Weisgerber", in SAARBRÜCKER ZEITUNG, 20. 5. 1953. – id., "Albert Weisgerber, Zeichnungen". 1958. – id., "Albert Weisgerber", preface to the commemorative exhibition in the Graphisches Kabinett and in the Saarland Museum on his 80th birthday, 1958. – id., "Albert Weisgerber, introduction to the catalogue of the memorial exhibition, Pfalzgalerie Kaiserlautern, 1959. – id., "Albert Weisgerbers Mitarbeit und der Zeitschrift JUGEND", catalogue of the Weisgerber exhibition in the Kunstgeschichtlichen Instsitute Mainz, 1961 – Wolff, G.J., "Albert Weisgerber", in KUNST FÜR ALLE, 1915. – Ziegler, M., "Erinnerungen an Weisgerber", in KULTURGEMEINDE February 1955. – Catalogue of the commemorative exhibition in Heidelberg Castle 1962 (G. Poensgen, Th. Heuss, W. Weber).

WORKS: Contributions to JUGEND: Der Berggeist, Literaturgrößen, etc. Etchings and posters: Nuremburg trade and art exhibition, poster for the dancer Sent Mathesa, for Hedi Königs, Der Bunte Vogel, etc.

KARL SCHMOLL VON EISENWERTH

Karl Schmoll von Eisenwerth, who was a painter, draughtsman and designer of applied art, was born in Vienna on 18 May 1879 and died in Stuttgart in 1947. In 1894 his family moved to Darmstadt. He passed his final school examination, and received his first artistic stimuli from Richard Hoelscher, the painter, and then in the circle of the artists' colony which was being formed in Darmstadt. From 1898 onwards he studied under P.Höcker and L.Herterich at the Munich Academy, and received stimuli from the works of Franz von Stuck. In 1902 he went to Italy together with Paul Klee and Hermann Haller. He spent some time in Paris in 1903. In 1904, at the large-scale Dresden Art Exhibition, he was awarded the Golden Medal for Graphic Art. From 1905 to 1907 he was head of the graphic art department at the "Educational and Experimental Workshops for Free and Applied Art" in Munich. In 1907 he was appointed Professor at the Technical College in Stuttgart, where he worked until 1944. In 1912 he was awarded the Golden Austrian State Medal. He was Principal of the Technical College in Stuttgart in its centenary jubilee years from 1927 to 1929. He was a member of the Innviertler Artists' Guild. He published several essays and speeches. He received a number of patents for some improved techniques in graphic art in the fields of colour lithography and aluminium etching (algraphy), and also worked as a designer of applied art.

The calendar sheet which we are reproducing here not only shows the linearity based on Art Nouveau, but at the same time also displays the brittle line modelling which is influenced by Expressionism.

WORKS: Worked on VER SACRUM, etchings, woodcuts, a cycle on Dauthendey's seasons (incomplete), illustrations for several calendars, Ex Libris plates, advertising material for the Jacobi cognac firm, drawings for the newspaper of the 10th Army in Lithuania (1916–1918), posters for art festivals in Munich and Stuttgart and for war loans.

FERDINAND STAEGER

Ferdinand Staeger, a painter and draughtsman, was born in Trebitsch, Czechoslovakia, and lived in Waldkraiburg, Bavaria. From 1898 onwards he studied under Prof. J. Schickaneder at the Prague School of Applied Art. After his studies he spent some time in Vienna and then returned to Prague. From 1908 onwards he was in Munich where he worked on the magazine JUGEND. From 1943 to 1957 he was in the Alpine foreland of Upper Bavaria, and from 1957 he had a flat in Waldkraiburg. Staeger's works comprise some 150 paintings, numerous graphic works,

Olaf Gulbransson, Cover for "Herz ist Trumpf" by Korfiz Holm. Munich 1917. Autotype. About original size.

and portraits of G. Hauptmann, Hugo Eckener, Peter Dörfler and others. At the last Paris World Exhibition he won a gold medal for a lace mat entitled "The Marriage of Figaro". Staeger contributed to the combination of Art Nouveau elements on the one hand and emotional Symbolistic motifs on the other, and it was in this "outmoded" type of artistry that he found his personal style.

BIBLIOGRAPHY: Leisching, J., "F. Staeger". 1913. – Muschler, R.C., "F. Staeger". 1922 and 1924; A new monograph on Staeger's works is being prepared.

WORKS: Contributed to JUGEND. Illustrations (mainly etchings) for Stifter, Eichendorff, Mörike, etc. "Ein Lebens weg" cycle and many individual sheets.

OLAF GULBRANSSON

Olaf Gulbranssson, a painter and illustrator, was born in Oslo on 26 May 1873 and died in Schererhof, Tegernsee, in 1958. From 1885 to 1892 he attended the School of Arts and Handicrafts in Oslo. In 1900 he studied under Colarossi in Paris. He returned to Oslo in 1901 and produced an album of caricatures. From 1902 onwards he was a member of the permanent staff of the SIMPLIZISSIMUS magazine in Munich. Gulbransson became a member of the Academy of Arts in Berlin in 1916. From 1924 onwards he was an honorary member and professor at the Academy in Munich. From 1929 he was an ordinary professor of drawing and painting at the Academy in Munich. It was as a result of caricature-like exaggerations that Gulbransson proceeded beyond the comical and arrived at more penetrating characterizations. The basis of his technique is his pen drawing with its suggestive inclusion of the empty surface area of the picture.

WORKS: Illustrations etc. for SIMPLIZISSIMUS, to Ludwig Thoma's Aunt Frieda. Album with caricature portraits of famous Norwegians, 1905; famous contemporaries, 1911; From My Drawer, 1934; Once Upon A Time.

ALASTAIR

(Alastair is a pseudonym for Baron Vogt.) Alastair worked as a draughtsman and musician. He began working as an illustrator in 1908. He was self-taught. He received commissions from American and European publishers. He transferred his dry-point work on to valuable fabrics, using methods which he devised himself. In 1925 he held a collective exhibition at the Weyhe Gallery, New York. Throughout his lifetime, Alastair kept himself and the details of his life hidden from the public eye; the result was that—through his work for foreign publishers—he was sometimes described as a Frenchman, and sometimes as an Englishman. In Alastair's illustrations, the influence of

Olaf Gulbransson, Eleonore Duse as Hedda Gabler. 1901. Autotype. 34 × 22.8 cm. (passepartout - a cut).

We yearn for detachment, for the possibility of an illumination which we ourselves create. It is in this way that we overcome space, and also overcome the hard reality of natural forms; we transform things according to our free and beautiful pleasure, and the artificiality of the arbitrary area which we are entering enables us to reflect upon ourselves and treat ourselves ironically in this abnormality, in this higher form of nature." (H.Slonimsky)

BIBLIOGRAPHY: Ross, R., "Forty three Drawings by Alastair". 1914. – Slonimsky, H., "Alastair", in DEKORATIVE KUNST 1911/XIV. THE ART NEWS, No. 4, 31. 10. 1925, p. 3. – THE BURLINGTON MAGAZINE 24 (1913/14), p. 353 f.

WORKS : They include illustrations to: Walter Pater, Sebastian von Storck (1927); Abbé Prévost, Manon Lescaut; Oscar Wilde, The Sphinx. Portfolio works: Forty three Drawings.

Alastair, Illustration to "Carmen" by Prosper Mérimée - Before the Bullfight. Verlag Rascher & Co. Zurich (no date). Autotype. About original size.

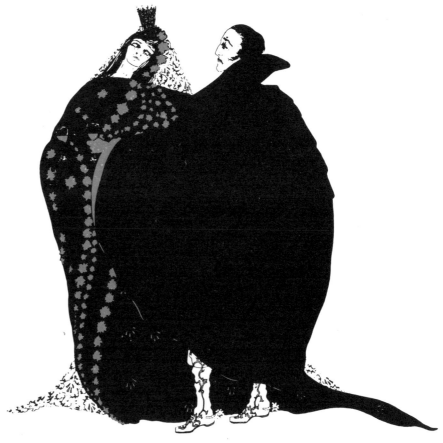

Beardsley gave rise to enigmatic demonizations, particularly in the erotic picture subjects.

"Thus these two elements, surface and line, are the factors with which Alastair builds up his world. By operating purposefully with these two elements, Alastair succeeds in conveying and rendering plausible an atmosphere consisting of a strange mood. This general atmosphere is given the name 'stylization'. The tendency towards stylization is latently present in the essence of all the graphic arts (drawing, fresco, vase-painting, tapestry, etc.); however, it is to men such as Beardsley and Alastair that we owe the clear elaboration and tonal realization of this tendency. This stylization is a deviation from what is natural, but it is a perfectly intentional deviation and wishes to be recognized as such: here lies its deeper element of irony. The knowledge that for once one is free of the obtrusive shackles of what is too real and too close is a knowledge that is highly appealing and provides high aesthetic joy.

193

Franz Marc, Ex Libris. Original size.

FRANZ MARC

Franz Marc, a painter and draughtsman, was born in Munich on 8 February 1880 and died at Verdun on 4 March 1916. He studied at the Academy in Munich, travelled to Italy in 1902, and spent time in Paris in 1903 and 1907. In 1910 he made friends with Macke and Kandinsky. In 1911, together with Kandinsky, he founded the artists' association called "Blauer Reiter" (Blue Rider). In 1912 he became acquainted with Cubism. Around 1914 he created abstract compositions.

The preconditions for Marc's pictorial ideas which are derived from Art Nouveau can clearly be seen in the animal pictures and figurative compositions of his early works, where the creatures and the landscape are combined in arabesque-like outlines. Among his graphic works, it is particularly the early work "Ex Libris" that displays this relationship.

BIBLIOGRAPHY: Buchheim, L.-G., "Der blaue Reiter". 1950. – Lankheit, K., "Franz Marc". 1950. – id., "Franz Marc im Urteil seiner Zeit". 1960. – Schardt, A., "Franz Marc". 1936.

WRITINGS OF F. MARC: In, Der blaue Reiter, 1912, 1914. – letters, papers and aophorisms, 2 Vols. 1920. – Briefe aus dem Felde. 1940, reprinted 1948.

PAUL KLEE

Paul Klee, a painter, draughtsman and writer, was born in Münchenbuchsee near Berne on 18 December 1879 and died in Muralto near Locarno on 29 June 1940. He initially vacillated between talent and inclination where music and painting were concerned. From 1898 onwards he was in Munich, where he studied initially under H. Knirr and then under Franz von Stuck. In 1901 he travelled to Italy with Haller the sculptor. From 1903 to 1906 he was in Berne and executed his first independent works. He moved to Munich in 1906, and met Kandinsky. He was a member of the "Neue Künstlervereinigung" (New Artists' Association) and of the "Blauer Reiter" (Blue Rider), and worked on the magazine DER STURM. In 1906 and 1912 he made trips to Paris where he met Picasso, Delaunay and Apollinaire; he acquainted himself with the works of Cézanne and the Fauves. In 1914 he travelled to Tunisia with Macke and in 1915 he went on a trip to Switzerland. He did his military service from 1916 to 1918. In 1920 he was appointed teacher at the Bauhaus School of Design in Weimar. He was given a teaching post at the Dusseldorf Academy in 1931. In 1933 he was dismissed from the teaching profession, and returned to Berne.

In his early etchings, Klee depicted with irony the sensibility of the Art Nouveau world of motifs and the Art Nouveau addiction to arabesques, and he did so with a bitterness which resulted from personal experience and from clashes between his sensitive intelligence on the one hand and the conventional phenomena of the times on the other. The following extract from Klee's diaries deals with this subject matter:

"When I was still an unbridled rogue, I knew some saucy songs. I still remember one line: 'He came down and she was delivered'. The others have been blown away by the wind. Now I am making an effort and am behaving decently.

"I can still vaguely remember some designs for pictures. One of them was called 'Disgust', and in it a woman was depicted pouring a liquid out of a can. Another picture was called 'Disgrace'. It showed a loving couple at the break of day; he was still sleeping peacefully and she was making a frightened gesture in the direction of the window where the new day was dawning. Then there was a drawing where people were casting dice to win a woman. It was possible to venture upon such banalities if one could find the one and only correct form in which to depict them.

"July 1903. Together with Louis Moilliet, I am executing some studies from nature after depicting a boy in the nude. These studies are intended to preserve me from any inappropriateness in my drawings. On the other hand, I must avoid the danger of being unable to venture on any drawing possibility because I was afraid of the natural perspective.

"The first sketch has been successful, at least from the technical point of view. Woman and animal. The copies of the first version of this subject no longer exist, except possibly somewhere in some provincial drawer. The second version is still in existence.

"The animal in the man is pursuing the woman who is not entirely insensitive towards it. The woman has some connections with animal?? the use of a differing heaviness of stroke. I first etched the contours of the trees. Then I modelled the tree and the contours of the body, and then

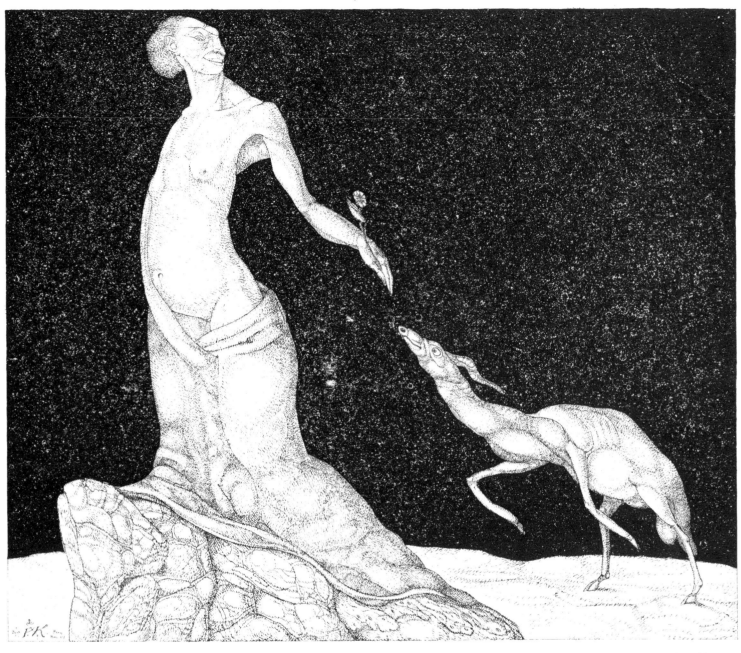

Paul Klee, Woman and Beast. 1904. Etching. 17.1×20.1 cm.

came the modelling of the body and of the pair of birds. "The poetic content is basically equally applicable to both woman and animal. The animals (the pair of birds) are natural and there are two of them. By being a virgin, the woman wishes to be something special, but without looking very happy in so doing. Criticism of bourgeois society."

BIBLIOGRAPHY: Der frühe Klee – Zeichnungen, Aquarelle, Druckgraphik, Ölbilder, Hinterglasbilder. Exhibition in the Staatl. Kunsthalle Baden-Baden 1964. Catalogue with preface by D. Mahlow and introduction by L. Zahn, as well as previously unpublished letters by the artist. ñ Grohmann, W., "Paul Klee". 1954. – Hofstätter, H.H., "Symbolismus und Jugendstil im Frühwerk von Paul Klee" in KUNST IN HESSEN UND AM MITTELRHEIN, issue 5, 1966.

WRITINGS OF KLEE: Amongst others, Paul Klee, diaries 1898–1918. Edited with an introduction by Felix Klee, Cologne 1957.

EARLY WORKS: Etchings: Two men meeting, each supposing the other to be in a higher position, 1903; A man sinking down before the crown, 1904; Comedians I/II, 1904; Threatening head, 1905; Female gracefulness, 1904; A woman sowing weeds, 1903; Woman and animal, 1904; Virgin in the tree, 1903.

FERDINAND HODLER

BIBLIOGRAPHY: Bender, E. and Müller, W.W.Y., "Die Kunst Ferdinand Hodlers". 2 Vols., 1923/1941. ñ Burger, F., "Cézanne und Hodler". Munich 1917. – Hugelshofer, W., "Ferdinand Hodler". 1952. – Loosli, C.A., "Ferdinand Hodler", 16 portfolios and 1 volume of text 1918–1921. – id., "Ferdinand Hodlers Leben, Werk und Nachlaß". 4 Vols. 1921–1924. – id., "Aus der Werkstatt Fedinand Hodlers". 1938. – Mühlestein, H., and Schmidt, G., "Ferdinand Hodler". 1942. – Überwasser, W., "Hodler, Köpfe und Gestalten". 1947.

Ferdinand Hodler, a Swiss painter and draughtsman, was born in Berne on 14 March 1853 and died in Geneva on 20 May 1918. He studied initially under his stepfather, a decorative painter, and then under F.Sommer in Thun. In 1871 he entered the Ecole des Beaux-Arts in Geneva as a pupil of B.Menn. Geneva was Hodler's place of residence from then on, and he did not leave that city except for brief educational trips. In 1875 he went to Basle and was very impressed by Holbein's works. In 1878/9 he was in Madrid and came into contact with the works of Velasquez. From 1885 onwards he was on friendly terms with L.Duchosal, a Symbolist poet. In 1887 he had an unsuccessful exhibition in Berne. In 1890 Hodler worked on "Night", a work in which he turned to Symbolism and two-dimensionality. The picture caused a scandal in Geneva and Hodler became well known. He was in Paris in 1891 and joined the Société Nationale des Artistes Français. He made contact with the Nabis who introduced him to the Rosicrucians. In the phase of his activities around 1890/91 he became acquainted with Art Nouveau, and also with the works of de Chavanne and the Pre-Raphaelites. From 1900 onwards he was a member of the Berlin Secession and an honorary member of the Viennese Secession. In 1904 he went to Vienna at the invitation of Gustav Klimt, and took part in the exhibition held at the Viennese Secession. In 1905 he held an exhibition at the Viennese Secession together with Klimt, Klinger and Von Hofmann. He became President of the Swiss Painters, Sculptors and Architects in 1908. In 1910 he took part once again in the exhibition of the Berlin Secession. In 1913 he became Officier de la Légion d'Honneur. In 1914 Hodler moved into a flat in Geneva which J.Hoffman decorated for him. He was excluded from all German art associations in 1914. In 1917 he was the head of a 'Cours supérieur de dessin' at the Geneva art school.

Although line is of great importance in Hodler's works, particularly in the outlines of human figures, he was not prominent as a draughtsman and evidently did not work as an illustrator at all. The full force of his expressiveness went into his paintings. Hodler's few poster designs for the Secession, and the only poster which the present author knows to have been executed by him, are on the same level as his paintings. The surroundings are always given a more abstract character than the stylized pantomime figure which rests or acts in those surroundings. Any movement or relaxation does not come from the figure itself, but is the result of Hodler's idea of a cosmos which determines the nature of a object from outside it. By the repetition of parallel shapes, Hodler is visibly lending support to his idea of a superhuman order of things.

ERNST KREIDOLF

Ernst Kreidolf, a Swiss painter and draughtsman, was born in Tägerwilen, Thurgau, on 9 February 1863, and died in 1956. He served an apprenticeship in lithography in Constance. He studied under Hackl and Löffz in Munich. (He paid for his studies by drawing the heads of criminals for the Munich file on wanted persons.) He lived in the Bavarian mountains from 1889 to 1895. Kreidolf became known chiefly as an illustrator of books of fairy-tales. There are a large number of fairy-tales which he not only illustrated, but also actually wrote himself; they contain personified flowers and animals, especially insects. In 1896 he made lithographs of his first fairy-tales to personify flowers. From 1917 onwards he was permanently in Berne. Kreidolf is one of the most imaginative illustrators of children's books in the first half of the 20th century. The illustrations of Walter Crane provided him with stimuli, and the dream-like logic of the metamorphosis of nature played a significant role in his works. In pictures that had more of an atmospheric than a narrative character, he created a combination between a lyrical element and an eerily mysterious factor.

"It is self-evident that a precise study of the subject makes it compulsory to draw it; the fine pen can copy flawlessly such things that the broad brush full of paint can reproduce only to a very limited degree: examples are a grasshopper's leg, a dandelion seed or the veined wing of a bee. Drawing leads to much more intensive observation than does painting, because painting, as a result of the rapid effect of the colour, pleases the artist too quickly in those cases where it does not delight him. When the nature study of all objects, whether large or small, is as precise and conscientious as this, evey shape—whether it is anatomical or mimical or phrenological—must imprint itself so deeply on the artist's mind that it will certainly be at his disposal for each special case arising. This is especially true of Kreidolf. It may be said that it is no more possible to find the slightest inclination towards caricature in any of the

Ferdinand Hodler, Secession poster for the XIX Exhibition of the ▷ Vereinigung Bildender Künstler Österreichs. Vienna 1904. Lithograph. 95×62.5 cm.

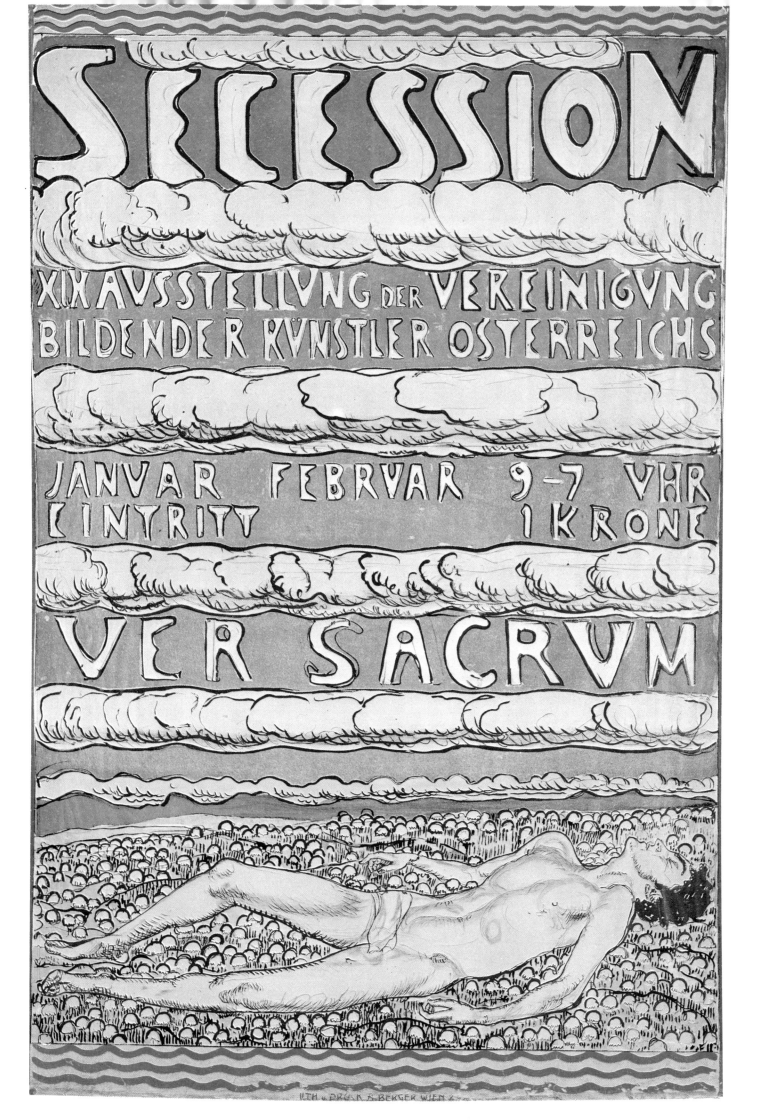

beings he depicted than it is possible to discover that anything about them has been wrongly drawn (it should be noted that this refers to wrong drawing resulting from a lack of knowledge of the shape). This fact may contribute towards a tendency to refrain from criticizing, in his drawings, that level-headednesss which is generally referred to as a characteristic of the Swiss people. In contrast to this, however, we have absolute reliability in the representation of every shape: the gait and gestures of his children, their clothes, even the cut of their clothes; the movements of his dancers, of his fighters, of his riders, of his animals and of his insects; the mimicry employed by his peasants and by his personified flowers—all these display such certainty and such truth that no critical doubt should arise. In Kreidolf's drawings, we should accept everything as we find it, just as the artist accepted it from nature.

"After the critics and artists had given favourable recognition to Kreidolf's 'Blumenmärchen' (his fairy-tales which personified flowers), his books for children appeared one after another over a period of a few years, being published by H. & F.Schaffstein in Cologne. In these books we have the whole of Kreidolf's best kind of artistic work

Ernst Kreidolf, The Garden Dream, from "Neue Blumenmärchen". Verlag Hermann & Friedrich Schaffstein, Cologne. 1923. Autotype. About 21.5 × 29.3 cm.

Ernst Kreidolf, Endpapers for "Die schlafenden Bäume". Verlag Hermann & Friedrich Schaffstein, Cologne. Autotype.

before us, because he was here able to work entirely on his own initiative and without being influenced by any colleague. The verses composed by the artist himself are simple, appealing and not too difficult for the mind of a child; the personification of the flowers is also done happily and unaffectedly. It is immediately clear to a child that a 'margaret' (marguerite) can be regarded as a nursemaid, that willow catkins can be looked upon as young white kittens or that whitehorn and blackthorn can be thought of as fighting knights armed with lances. Some very admirable features are the characterization and the simple and pertinent mimicry of the individual flower beings: at the same time, each one of the lines is so simple and certain that one cannot but be astonished at what has been achieved with them."(H.E.Kromer)

BIBLIOGRAPHY: Fraenger, W., "Ernst Kreidolf". 1917. — Huggler, M., "Das Werk von Ernst Kreidolf". 1933. — Kehrli, I.O., "Aus der Werkstatt Ernst Kreidolfs". 1943 reprinted 1953. — "Lebenserinnerungen", edited by J.O. Kehrli, 1957. — Kromer, H.E., "Ernst Kreidholf', in DEKORATIVE KUNST 1907 XI. — Wartenweiler, F., "Ernst Kreidolf. Bewegte Jahre. verklarte Wirklichkeit. Besinnung". 1963.

EXHIBITION: Ernst Kreidholf centenary exhibition, Rotapfel-Galerie, Zurich.

WORKS: Illustrations for: Die Wiesenzwerge, Alpenblumenmarchen, Ein Wintermarchen, Das Hundefest, Der Traumgarten, Grashupfer, Gnomen und Elfen, Kinderzeit, Himmelsreichwiese, Versunkene Garten, Biblical pictures, Traumgestalten, Die Schlafenden Baume, Fitzebutze, etc. — new editions of his works published by Rotapfel-Verlag, Zurich.

HERMANN ABEKING

Hermann Abeking, a book illustrator and poster artist, was born in Berlin on 26 August 1882. No further biographical details are known. Proceeding under the influence of the art of Beardsley and Toorop, he used Art Nouveau art forms to express his own dry ironic humour.

BIBLIOGRAPHY: DEUTSCHE KUNST UND DEKORATION 19 (1906/07) p. 509 with ill. – Velhagen und Klasings MONATSHEFTE 49/II (1934/35) p. 670, ill. p. 672.

Hermann Abeking, Illustration for "Hugdietrichs Brautfahrt von Rideamus". Harmonie-Verlagsgesellschaft für Literatur und Kunst. Berlin (no date) 16.4×32.5 cm.

Antonio Rizzi, Title page for the annual NOVISSIMA, Casa Editrice Baldini Castoldi, Milan 1902. 12.7 × 25.5 cm.

ITALY

Italy did not make a very considerable contribution to Art Nouveau in Europe. Only in the succeeding period, with Futurism, which was similar in emotional content to German Expressionism and French Fauve art, although different in its basic concepts, did Italy begin to play an active role in modern European art. The point of departure of the young Italian Art Nouveau generation must not on that account be underestimated; foremost in importance here are the paintings of Boccioni. Italy's silence at the turn of the century is somewhat surprising in view of its nineteenth century tradition of painting, which had developed certain features of the naturalistic style which appeared to pre-figure Art Nouveau. The chief names appearing at that time are those of Federigo Zandomeneghi, Telemaco Signorini, and Giovanni Fattori who flourished during the second half of the century. In their work we find the typical, but in them precocious, simplification of outline,

the characteristic silhouette painting, and the juxtaposition of almost unmodulated areas of colour, connecting the abandonment of naturalistic perspective with a highly decorative manner of filling the picture surface. The achievements of these painters have been much neglected by historians of European art.

Italy's role in Art Nouveau painting and printing was more one of absorption and revitalization than of true creativity. In the field of literature, Gabriele d'Annunzio exercised a strong influence on a movement which may be described as literary Art Nouveau, and his works were embellished by artists following the style of foreign book illustrators. A. de Carolis shows predominantly British traits, even including Pre-Raphaelite tendencies, whilst other artists adapted, some French styles, some the geographically nearer manner of Austria, and in particular the Art Nouveau of Vienna with its playful symbolic motifs. The calendar by the anonymous L.E. reproduced here shows features of the East Austrian style. A survey of poster art

Brunellei, Illustration for the annual NOVISSIMA, Casa Editrice Baldini Castoldi, Milan.1902. 14.1×27.4 cm.

also yields only a few names, among them Mataloni, Bistolfi, Cambellotti, and Laskoff. The unknown artist of the posters for the MELE department store in Naples created highly effective publicity material, which was nevertheless in its glossy salon finish and its profusion of imitative and poorly unified motifs very much the work of its day. Even the collection reproduced here, though frequently original, is not highly important in terms of its contribution to European art. If one includes the Symbolist landscape painter Giovanni Segantini, who was born in the Southern Tyrol and died a naturalized Swiss, among Italian painters, an inclusion justified by his influence on the subsequent generation of Italian painters, he is then the only creative Italian painter in this style. However, no important prints of his have survived, he produced no individual graphic work, and illustrated no books. In thus commenting on the passivity of the Italian Art Nouveau painters and graphic artists one must not neglect the achievements of Italian

architecture and interior design, which brought Italy to the attention of the rest of European Art Nouveau, notably in the 1904 Turin exhibition which provided the most comprehensive and updated exposition of Art Nouveau. Italo Cremona has this to say on this subject: 'When one considers the cultural position of Italy in those years alongside the economic factors which conditioned them, it becomes apparent that certain innovations developed slowly of necessity. First and foremost, the Symbolist and decadent stimuli which had spread from literature into painting and the decorative arts in France, Britain, and Belgium were absent. The Romantic movement in Italy was very different from that in other countries of Europe. Its revolutionary element was weak, and quite innocent of that so necessary 'sense of irony and fun, of the soul pervading nature, and of the mystical vein which illuminates the close relationship between romanticism and decadence'. (Walter Binni, "La poetica del decadentismo", Florence 1961).

ANTONIO RIZZI

Antonio Rizzi, a painter and graphic artist, was born in Cremona on 18 January 1861 and died in Florence in 1941. He was Professor at the Academy in Perugia. He worked as a painter in the historical, genre, portraiture, and decorative fields, producing also graphics and illustrations. He was an occasional contributor to JUGEND. The illustration reproduced here reveals a strong affinity with the academic Art Nouveau of Munich (Stuck).

BRUNELLEI

Biographical details are not available. Like Ricci, he is close to the illustrated work of the Munich Art Nouveau; his use of motifs suggests contact with Arnold Böcklin.

ALBERTO MICHELI

Alberto Micheli was born in February 1870. He studied at the Florence Academy. No further biographical details are available.

L.E.

The artist behind these initials is unknown. However, the calendar is among the finest of its type produced in Italy. The client was the Ditta Nebiolo and Co. of Turin machine factory, but there is no watermark. The chief stylistic influence is the poster art of Mucha; the work's importance lies in the unusually free use of colour, which succeeds in avoiding the tendency to schematism.

ADOLPHUS DE CAROLIS

Adolphus de Carolis was a painter and illustrator. He was born in Montefiore dell'Aso (Ascoli) on 18 January 1874, and died in Rome on 7 February 1928. He studied in Bologna, Rome, and Florence. He belonged to the 'In Arte Libertas' movement and taught at the Rome Academy. De Carolis worked chiefly in the field of graphics, and was one of the revitalizers of the Italian woodcut. His illustrations are very close to the English style of William Morris prints.

Antonio Rizzi, Illustration for the annual NOVISSIMA, Casa Editrice Baldini Castoldi, Milan 1902. 12.5×26.6 cm.

INCIPIT CRIMEN AMORIS

no cor si dimanda uno cor si dimanda

Adolph de Karolis, Illustration for "Francesca da Rimini" by Gabriele
D'Annunzio. Publ. Gebr. Jos. Treves, Milan 1902. 16.7×14.2 cm.

BIBLIOGRAPHY: Maraini, A., "A de Carolis silografo", in DEDALO 2, 1921,
p. 332–351. – d'Annunzio, "Lettere inedite di Gabriele d'Annunzio
al pittore Adolfo de Carolis", in ABRUZZO 2, 1964, p. 309 to 326. –
Bonarelli, G., "Xilografie di Adolfo de Carolis", in RASSEGNA
MARCHIGIANA I (1922/23), 470–476. – Carnevali, F., "Adolfo de Carolis
(illustratore)", in RASSEGNA MARCHIGIANA 12 (1934) 377–393. – Orano,
P., "A. de Carolis". Rome 1939.

WORKS: Illustrations to: G. Pascoli, Poemi Latini; Aeschylus, Tragedies;
d'Annunzio, Francesca da Rimini, La Figlia di Joris, Fiaccola sotto il
moglia, Elegie Romani, Fedra, Laudi, Notturna; individual woodcuts:
The night, Landscape, The mothers, The Danaids, The harvest, Eve
and others.

THE FEMININE MODEL: Small as was Italy's contribution to Art Nouveau painting and graphics, the model of the feminine which so influenced the aesthetic of the fin-de-siècle and whose many facets were reflected in Art Nouveau, was embodied in an Italian woman. This was the actress Eleonora Duse, who toured all Europe in her guest appearances. Her performance comes to life in Hugo von Hofmannsthal's description.

"Duse does not act herself, she acts the poet's figure. And where the poet flags and lets her down, she plays his puppet as a living being, with a spirit which it never had, with every last expressive meaning which he had never found in it, with the same creative powers and intuitive psychological gifts. "With a pursing of the lips, a movement of the shoulder, or a change of tone, she portrays her reaching of a decision, the swift passing of a chain of thought, the entire mental and bodily process by which a word comes to be. One reads unspoken words on her lips, unexpressed thoughts flash across her brow. She has the courage to let the important

Adolph de Karolis, Illustration for "Francesca da Rimini" by Gabriele D'Annunzio. Publ. Gebr. Treves, Milan 1902. 11.6×9.5 cm.

to V.
na ul-
a.

tenuto per la falda della sopravvesta a un ferro della cateratta. Francesca, a quella vista inattesa, getta un grido acutissimo, mentre lo Sciancato si fa sopra all'adultero e lo afferra per i capelli forzandolo a risalire.

GIANCIOTTO.

Sei preso nella trappola,

ah traditore! Bene ti s'acciuffa

per queste chiome!

La donna gli s'avventa al viso minacciosa.

FRANCESCA.

Lascialo!

Lascialo! Me, me prendi! Eccomi!

Il marito lascia la presa. Paolo balza dall'altra parte della cateratta e snuda il pugnale. Lo Sciancato indietreggia, sguaina lo stocco e gli si avventa addosso con impeto terribile. Francesca in un baleno si getta tra mezzo ai due; ma, come il marito tutto si grava sopra il colpo e non può ritenerlo, ella ha il petto trapassato dal ferro, barcolla, gira su sé stessa volgendosi a Paolo che lascia cadere il pugnale e la riceve tra le braccia.

FRANCESCA, morente.

Ah Paolo!

Lo Sciancato per un attimo s'arresta. Vede la donna stretta al cuore dell'amante che con le sue labbra le suggella le labbra spiranti. Folle di do-

lore e di furore, vibra al fianco del fratello un altro colpo mortale. I due corpi allacciati vacillano accennando di cadere; non danno un gemito; senza sciogliersi, piombano sul pavimento. Lo Sciancato si curva in silenzio, piega con pena un de' ginocchi; su l'altro spezza lo stocco sanguinoso.

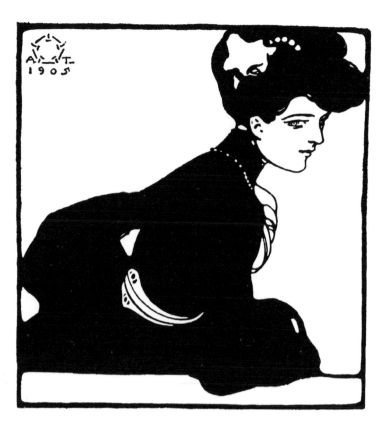

Terzi, Vignette for the annual NOVISSIMA.

drop casually, and to emphasize trifles, just as happens in life. As in nature she underlines banalities and lets revelations drop. She is capable of speaking words in such a way that we feel she forgets the thought at that very moment. The inexpressible is actualized. Many of her characteristics cannot be understood directly by the conscious mind, but make their effect only on the darker imagination, generating moods which exert on us the power of suggestion. Even the most attentive of today's audiences are not capable of watching such continuous weighty characterization. She acts Sardou and Dumas as if they were Ibsen. How would she play Ibsen himself?

"She plays the individual, and yet we sense the type. She acts that merriness which is not happiness, she plays with clear laughter the empty darkness which lies behind laughter. She portrays the wish not to think of something, combined with a recognition of the necessity to think of it. She acts the squirrel and the lark, with a nervous wildness which unsettles as if by a physical touch; as she falls from the feverish rhythm of the tarantella, her back rigid in deathly terror, she pales, her lower jaw drops, and her tortured eyes scream dumbly. During the pauses when others are acting, it is impossible to tear one's eyes away from her, as she portrays the dawning of consciousness, the shattering of inner illusions, the painful fruition of

necessity. This lasts right up to the last scene of the third act, up to the great clash; one does not have the impression that her decision must now have been taken because the poet requires it, but rather one knows that it is made because one has seen it being made, with an inner necessity which none could doubt.

"Then, purified by sorrow, she stands facing the man. Her voice, once childish and fluttering, is clear and cold and hard; her full lips and soft shoulders have become arrogant and stiff, and she is enveloped in an icy, pitiless hauteur. In between are flashing glimpses of blazing hate and revenge which turn in a moment to ice; then, as her children collapse, the shadow of a tear flows amid the silvery tinkle of her contemptuous, majestic words.

"Words have no meaning for her, whether beautiful or ugly. Her body is no more than the changing projection of her changing moods. Faces glide across her face: a flirting young girl with mocking eyes and lips; a pale woman with the care-laden eyes of sorrow; a gaunt bacchante with hot, deepset eyes and dry lips framing her open mouth, her neck muscles wild and swollen; and a cold and beautiful statue with deep peace on her shining brow.

"Each time she has a different step: the elastic, even step of the grande dame, the tripping swaying step of young Nora, the voluptuous, smooth, drawn-out step of the poor sentimental flirt. Each of her limbs speaks a different language at each moment: the fine, pale fingers of Fedora are transformed next day into the smooth wheedling fingers of the Dame aux Camélias, and on the next again into the wriggling, playful fingers of the wife in the Dolls' House. Each occasion brings forth a new way of crying: the warm, good tears into which great nervous tension dissolves, in which real tears flow freely down her cheeks; a scornful sobbing; and the heart-rending silent weeping of helplessness ... She has power over her pallor and her blushes, and over what we call the unconscious bodily movements."

L.E. (anonymous), Calendar page for the year 1900. Turin 1899. Com- ▷
missioned by the Nebiolo & Co. machine factory, Turin. Lithograph.
55×41.5 cm.

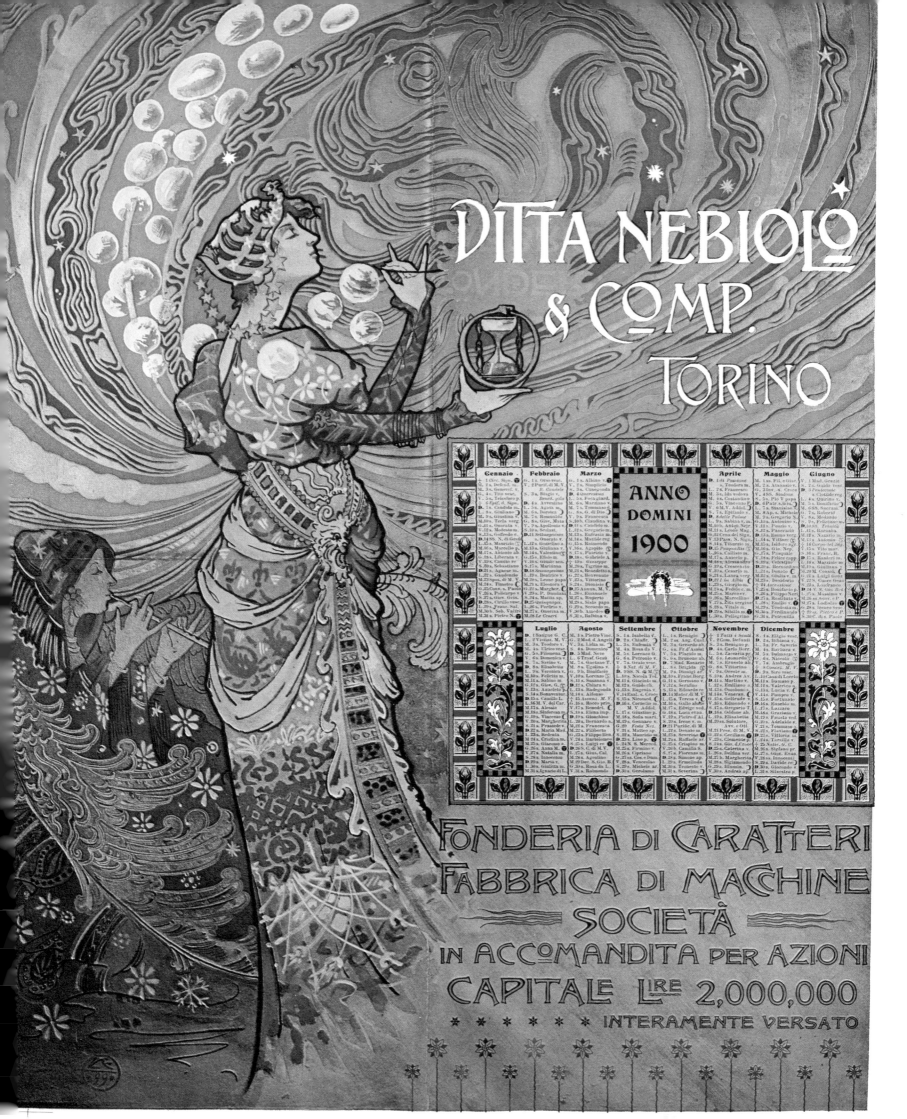

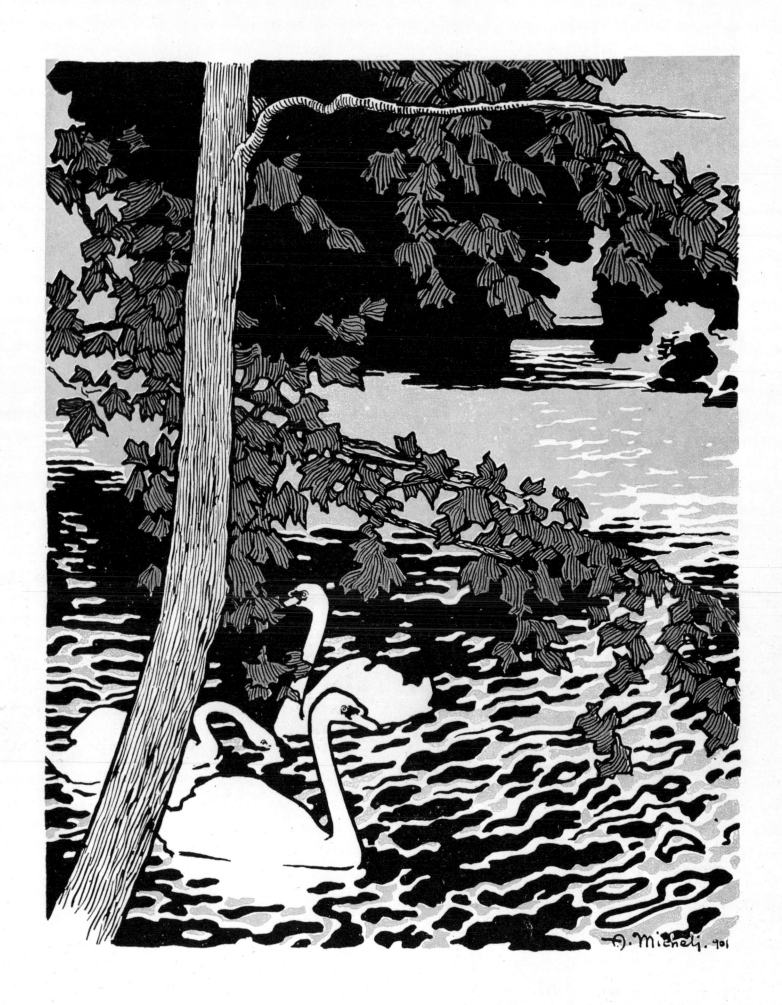

AUSTRIA

The Austrian artists who developed Art Nouveau were drawn to Vienna: here, historicist art and naturalism had met to create a climate in which new ideas could flourish, while retaining a strong sense of the city's past. Vienna's intellectual life was enriched by Freud's new science of psychoanalysis, which was deeply bound up with the needs and concerns of men of the time; and indeed the very fact that psychoanalysis began in Vienna is indicative of the city's intellectual feeling—in some ways acute and frank, in others clothing repressed desires in symbols. Following Freud, Viennese society made it a kind of game to track down and interpret these symbols, and to re-examine established symbolic meanings: everyone could delight in making their own interpretations, and in rediscovering their own desires in symbolic form. From this source every Viennese Art Nouveau painting drew life, as did the stories of Arthur Schnitzler and Hugo von Hofmannsthal, the poems of Rainer Maria Rilke, and the early music of Gustav Mahler, Arnold Schönberg and Richard Strauss.

In 1897 the Vienna Secession was founded. The aim of the Union of Austrian Artists was to gather together all the creative talent in the country, to make contact with foreign artists, and to set up a true art in opposition to the pseudo-art of the Viennese academic salon. Their official organ was the periodical VER SACRUM ("Sacred Spring"), also founded in 1897. The magazine's literary adviser, Hermann Bahr, set out their general aims in the first number: "Our Secession is not the struggle of new artists against old, but the revolt of artists against pedlars who pretend to be artists and have a financial interest in preventing any art from coming into being...business or art, is the question which our Secession asks...the struggle is not about aesthetics but about attitudes."

Art Nouveau graphic artists in Vienna grouped themselves around VER SACRUM. In character it was a literary publication with original graphic decorations and illustrations specifically "drawn for V.S.". In most of these decorations and illustrations, line forms the expressive graphic element—line subtly handled, and made yet more refined by the use of delicate colour printing enriched with gold. The illustrations are also characterized by symbolism, drawn predominantly from erotic fantasy as interpreted by Freud. One of the favourite motifs was the fish, which Freud identified as a sexual symbol: Klimt depicts ornate fish and sensuous naked girls gliding through flowing water. Symbolism also reigned in the pictorial calendars which came out with every magazine. Klimt's illustration for

◁ **Alberto Micheli**, Illustration for NOVISSIMA, Casa Editrice Baldini Castoldi, Milan 1902. 19.5×15.5 cm.

January 1901 is dominated by the figure of Saturn or Chronos with an hourglass; in front of him the New Year appears in the form of a young girl stretching upwards, while the Old Year stands on the right, veiled and resentful - but both are linked by a serpent biting its tail, representing the eternal cycle of time.

The affinity between word and image is especially explicit in the illustrations to poems, of which VER SACRUM included many fine examples. Among those reproduced here are illustrations to works by Von Saar, Arno Holz and Rilke. In every case the metaphors used in the text are transformed into visual motifs which twine decoratively around the type area.

VER SACRUM became the focus for a somewhat precious aestheticism: members of the Secession added the letters "O.M." to their names, signifying "Ordentliches Mitglied" ('Member of the Order'), as if they were members of a religious fraternity, and gradually adopted a special form of signature made by placing their initials or name in a square or rectangle.

Some of the most important publishing achievements of Viennese Art Nouveau are the children's books and fairy-tales produced by the firm of Gerlach und Schenk. These were small square volumes with clear and legible type and illustrations on every page. Their strong colours and the elegant and decorative treatment of the coloured areas evoke a distinctive fairy-tale mood: it would be hard to imagine a better image of the Pied Piper of Hamelin, shown as a rat-catcher with red trousers and long flute, or a more moving Parsifal, in blue jerkin, before a dark wood full of sinister toadstools. The fairy-tales are told in the text, but in addition the picture creates a world of visual fantasy which imprints itself upon the reader like some archetypal symbol.

After the foundation of the Secession, Austrian poster art achieved a level of excellence comparable with that of other countries. Posters for exhibitions, plays and, in particular, books developed into works of art. In keeping with Viennese aestheticism, there are relatively few designs for industrial products. The layout of the posters resembles the style of VER SACRUM, in that the artists strove for a clear layout of text and illustration, and for easily legible lettering. As with the poem-pictures in VER SACRUM, this was usually achieved by keeping the text in a single block, or by using strips of text excitingly interrelated with the decorative elements, themselves inspired by the theme of the poster. The sublimation of script into ornament displayed in the VER SACRUM calendar reproduced here is exceptional in Viennese Art Nouveau. More extreme styles of art lettering were seldom used for anything but initials or titles framed by decorative borders. Even a type face such as Eckmann was considered too illegible for Vienna.

VER SACRUM soon ran up against criticism from a nationalist element within the Viennese movement, which felt that with its international orientation the magazine ran the risk of being overwhelmed by foreign influences. The

Josef M. Auchentaller, Vignette for VER SACRUM, No. 4, 1901. Original size.

practical expression of this criticism came in the form of a secession from the Secession, a group of young painters who left in 1901 to found the "Wiener Hagenbund". Looking back, there seems in fact to have been little danger that the VER SACRUM group would have been submerged by outsiders: on the contrary, only artists who were felt to be in some sort of communion with the Austrian spirit received invitations to contribute—among them the corresponding members from France, Aman-Jean, Bartholomé, Carrière, Grasset and Rodin; from Britain, Crane and Whistler; from Belgium, Khnopff and Van de Velde; from Germany, Klinger, Stuck, Uhde and others; from Switzerland, Holder and Segantini; from Russia, Somov; and from Finland, Gallén-Kalela. A much stronger element within the Hagenbund was its espousal of the nationalist Germanic revival, an ideology which was to have disastrous results in Germany and Austria. Already in 1898 this interest in the northern past could be discerned on the title page of No. 4 of VER SACRUM, where a Viking long ship glides swiftly towards the observer.

In 1903 the Union of Austrian Painters suffered another crisis, which led to yet another split. Klimt, Wagner, Orlik, Roller, Moll, Hoffmann, Moser and others (the "Klimt group") left the Union, which then declined considerably in importance. In the meantime, however, a new influence had entered Austrian Art Nouveau with the foundation in 1903 by Hoffmann, Moser and Czeschka of the "Wiener Werkstätte" ("Viennese Workshop"), which provided a forum not only for industrial art but also for graphic design. Czeschka refined the Art Nouveau concept of the "total work of art" into something simpler and more functional. In 1907 the Wiener Werkstätte decorated "The Fledermaus", a fashionable Viennese cabaret theatre in Kölner Strasse, with Hoffmann's designs. The programmes designed by the Werkstätte marked a new high point in Austrian late Art Nouveau, as did the postcards by Egon Schiele and Oskar Kokoschka produced there, and the latter's book, "Die träumenden Knaben" ("The Dreaming Youths"), published in 1908. Along with Schiele and Kokoschka, Czeschka, Berthold Löffler, Moritz Jung, Fritz Zeymer and others were responsible for the last flowering of Art Nouveau in Vienna, at a time when the rest of Europe had long since adopted more vital styles. Until its dissolution in 1932, the Wiener Werkstätte, like the Werkbund and the Bauhaus in Germany, represented a design style which was both heavily indebted to tradition and also open to modern methods of industrial production.

Gustav Klimt, Title page for VER SACRUM, No. 5/6, 1898. 29.1×28.4 cm. ▷ (whole page).

210

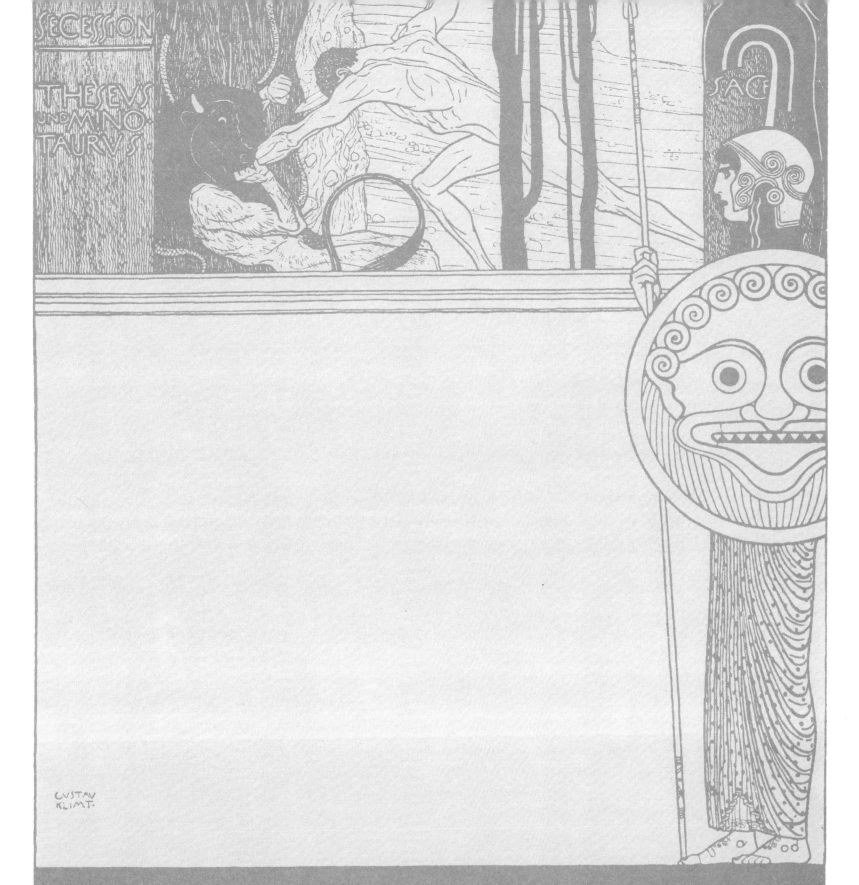

SECESSION

THESEVS
VND MINO
TAVRVS

SACR

GVSTAV
KLIMT.

VER SACRVM
ORGAN DER
VEREINIGVNG
BILDENDER
KVENSTLER
OSTERREICHS

JÄHRL·12·HEFTE
IM A·DONN·6 FL·10 M

Gustav Klimt, Fish Blood, drawn for VER SACRUM, 1898, 18.6×18.6 cm. ▷

Gustav Klimt, Salve Saturne, Calendar page for January, from VER SACRUM, No. 1, 1901. Drawn for V.S. 17.8×19.2 cm.
▽

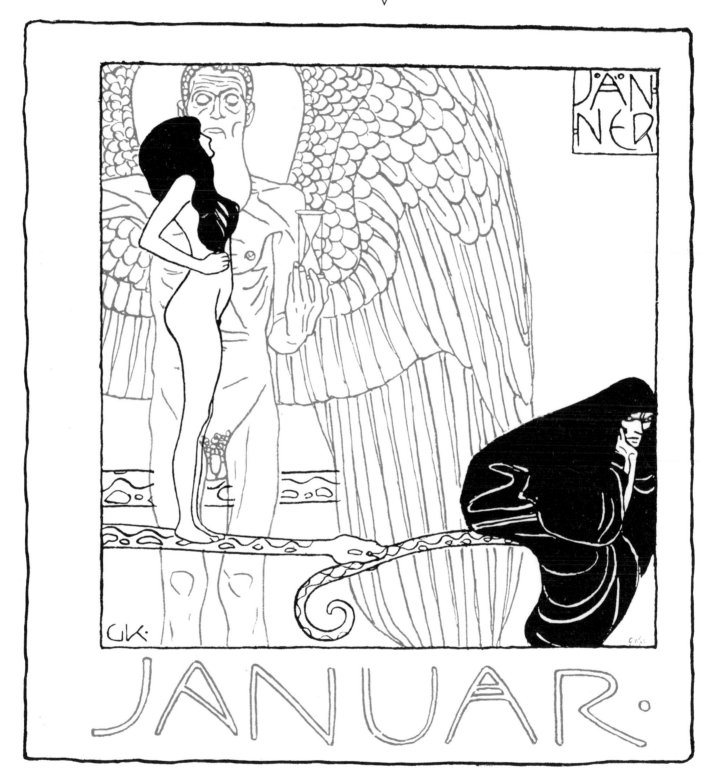

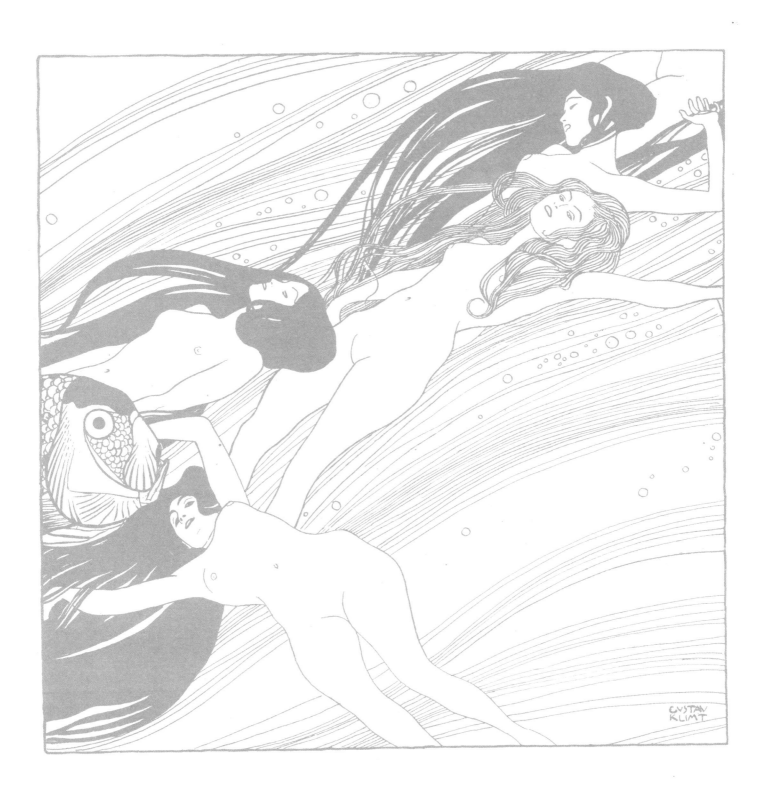

GUSTAV KLIMT

Gustav Klimt was a painter and graphic artist. Born 14 July 1862 in Baumgarten, Vienna, and died 6 February 1918 in Vienna. 1876–83, a scholarship at the State School of Applied Art in Vienna. 1882–92, in co-operation with his brother Ernst Klimt and his fellow-pupil Franz Matsch, produced murals and ceiling paintings in the theatres of Reichenberg (1882), Fiume (1883), Karlsbad (1886), the Hermesvilla in Lainz, Vienna (1885), the Vienna Burgtheater (1886–90), and elsewhere, as well as in the Kunsthistorisches Museum in Vienna (1890–91). His historical works reveal the clear influence of the painter Hans Markart. 1888, awarded the Gold "Verdienstkreuz" (cross of merit); 1890, the Kaiserpreis (worth 400 guldens) for his painting, "Auditorium of the old Burgtheater, Vienna". 1891, member of the Künstlerhaus association. 1892, death of his brother Ernst. 1897, left the Künstlerhaus association to found the Vienna Secession along with Rudolf von Alt, Josef Hoffmann and others; the periodical VER SACRUM founded. President of the Secession and director of exhibitions up to 1905. 1898, honorary member of the International Committee of Art in London. 1900-03, frescos for the hall of Vienna University (representing the Faculties of Philosophy, Medicine and Jurisprudence); these works caused a scandal and were rejected. VER SACRUM was discontinued at the end of 1903. In 1904 Klimt took part in exhibitions in Germany, including Dresden and the Munich Secession. 1905, took part in the 2nd Exhibition of the League of German Artists in Berlin; together with his friends in the "Klimt group", left the Vienna Secession. 1910, participated in the 9th Venice Biennale with great success. 1910/11, wall mosaics for the Palais Stoclet in Brussels (architect Josef Hoffmann). 1917, made Honorary Member of the Vienna and Munich Academies of Fine Art. Nomination to a professorial chair withdrawn at Archduke Franz Ferdinand's objection. His most important pupils were Egon Schiele and Oskar Kokoschka.

In the field of graphics, Klimt worked almost exclusively in autotype, choosing subjects similar to those in his paintings, symbolic allegories inspired by ancient myths and associative images as suggested by Freudian psychology. His line is so sensitive that the essence of his work is lost in the technical process of converting it to woodcut or etching.

"What does Klimt depict? Almost always a concern with women. He never tires of capturing in delicate strokes the flowing line of a thigh, the melodious rhythm of a hip, or the rounded softness of a shoulder. His young women appear in ever new, ever repeated variations, pressing their breasts, crouching on the floor, their legs drawn up. In truth his sensuality was boundless. The voluptuous greed with which he transforms his sensual experience into artistic expression is quite astonishing. Sar Péladan's remarks are absolutely true of these works: 'animated drawing, line imbued with soul, felt form—you give body to our dreams'."

"Of course the type of beauty which he liked is not universally appealing. Perhaps blond Teutonic beauty was not sufficiently distinctive for him, or perhaps he avoided it because Teutonic plumpness did not accord with the slender shapes of modern applied art—in short, he preferred a boyish type, a kind of Old Testament taste which not all find sympathetic. None, however, can deny that he portrayed what he found attractive with exquisite refinement." (R. Muther).

BIBLIOGRAPHY: Altenberg, P., Speech on 12. 9. 1917. appendix in "Das Werk Gustav Klimts (1914)–1918. – Bahr, H., "Rede über Klimt". 1903. – Dobai, H., "Das Frühwerk Gustav Klimts". Diss Vienna 1959. – Eisler, M., "Gustav Klimt". 1920. – Hatle, I., "Gustav Klimt, ein Wiener Maler des Jugendstils". Diss. Graz 1955. – Fleischmann, B., "Gustav Klimt – eine Nachlese". 1946 – Haberfeld, H., "Gustav Klimt", in DIE KUNST 25, 1912. – Novotny, F., J. Dobai, Gustav Klimt. 1967. – Pirchan, E., "Gustav Klimt. Ein Künstler aus Wien". 1942. – id., "Gustav Klimt". 1956. – Salten, F., "Gustav Klimt. Gelegentliche Anmerkungen". 1903. – Strobl, A., "Gustav Klimt. Zeichnungen und Gemälde. 1962. – Tietze, H., "Gustav Klimts Persönlichkeit", in DIE BILDENDEN KÜNSTE, Vienna 1919. – Weixelgärtner, A., "Gustav Klimt", in DIE GRAPHISCHEN KÜNSTE, 35, Vienna 1912 –. Zahn, L., "Gustav Klimt und Egon Schiele", in DAS KUNSTWERK Year II, Issue 9, 1958. – Zuckerkandl, "Die Klimt-Affäre", in ZEITKUNST, Vienna 12. 4. 1905. – Catalogue of the "Gustav Klimt – Egon Schiele" exhibition in the Albertina collection of graphic works, Vienna 1968. – Detailed bibliography in F. Novotny, H. Dobai, Gustav Klimt. Salzburg 1967.

WORKS: Allegorien und Embleme edited by Martin Gerlach. Explanatory text by Dr. A. Ilg. Verlag Gerlach und Schenk, Vienna 1883 ff. (in batches); Allegorien, new series, edited by Martin Gerlach, Gerlach und Schenk, Vienna, no date (published in batches from spring 1896); illustrations for VER SACRUM; Dialogues of the Heterae by Lucian, German by Franz Blei, with fifteen illustrations by Gustav Klimt. 1907 (fifteen drawings in collotype); Paul Verlaine, Femmes, Avec Six Dessins de Gustav Klimt. The Dandy, no place or date; Das Werk Gustav Klimts. (1914) to 1918. (60 publisher's marks signed by Klimt designating the pictures). Poster for the International Exhibition of Music and Theatre (1892).

Josef M. Auchentaller, Calendar page for February, from VER SACRUM, ▷ No. 1, 1901. Drawn for V.S. 18.6×18.1 cm.

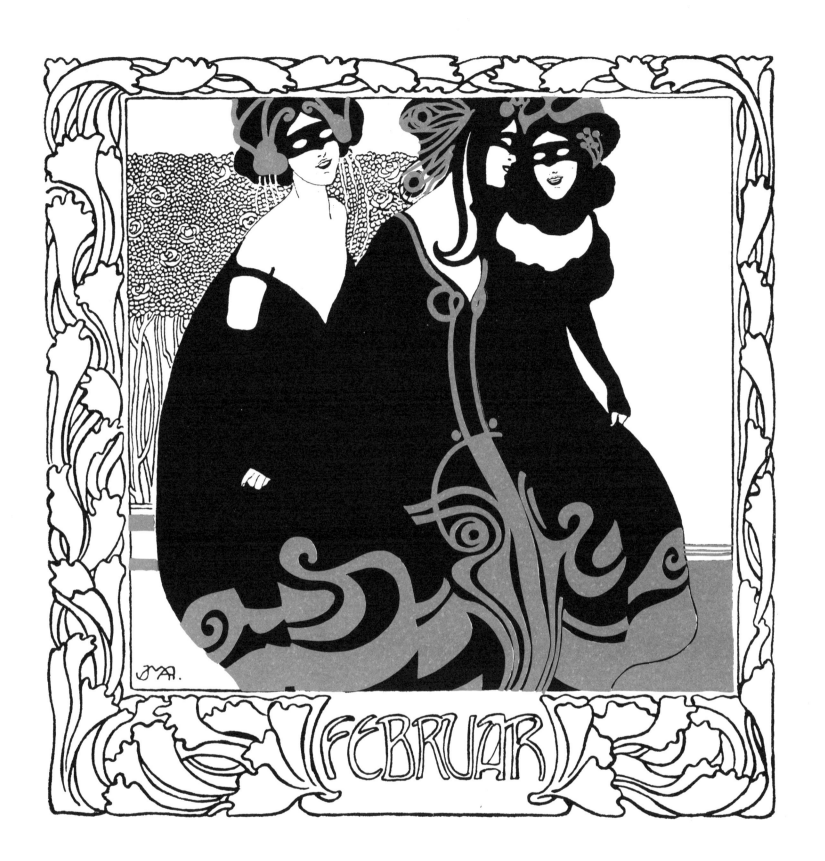

Für V. S. gez. v.
Jos. Auchen-
taller.

VER SACRUM.

Wieder draussen im weiten All
Wird es Frühling.
Mit dem blassen Gold
Der Primeln schmückt sich die Flur;
Der Weissdorn leuchtet,
Es leuchtet die rosige Pfirsichblüte —
Und im ergrünenden Wald
Singt die Drossel.

Aber in stillen,
Geheimnisvoll umzirkten Zaubergärten
Blüht die Kunst.
Dort, in ewigem Sonnenlicht,
Schattenlos überwipfelt,
Hauchen den schweren Duft,
Leuchten in durchsichtiger Irispracht
Weitkelchige Liliaceen und Tulipanen.
Falter, breitflüglig,
Stahlblau und flammenroth,
Umschweben sie,
Und auf des Rasens Smaragd,
Lastenden Silbergefieders,
Schreiten weisse Pfauen. —

J. Auchentaller

Für V. S. gez. v. Jos. Auchentaller.

Traumhaft,
In zarter, schimmernder Gliederhoheit,
Die Häupter umkränzt mit Blumensternen,
Wandelt ein Menschenpaar.
Sanft aneinander geschmiegt,
Wandelt es auf verschlungener Pfade Windungen
Höher, immer höher hinan —
Bis zum achat'nen Säulenhalbrund,
Das in den Azur des Himmels ragt.
Rubine blitzen, Saphire und Opale
An den gold'nen Capitälen
Und an den goldenen Sockeln.
Auf hundertstufiger,
Weit ausgebuchteter Onyxterrasse
Thront die Sphinx.
Mit marmor'ner Brust,
Doch den geschmeidigen Löwenleib
In jeder Faser glutdurchzittert,
Thront sie,
Grossäugig ins Unendliche blickend,
Über dem Räthselabgrund der Schönheit.

FERDINAND v. SAAR.

Josef M. Auchentaller, Decoration for a poem by Franz von Saar. Double page spread from VER SACRUM, No. 7, 1898. 20.2×20.2 cm.

JOSEF MARIA AUCHENTALLER

Painter and graphic artist. Born 2 August 1865 in Vienna. Died 31 December 1949 in Grado. Studied under Franz Rumpler at the Vienna Academy of Fine Arts. 1893-95, Professor in Munich. From 1898, member of the Vienna Secession. 1901, moved to Grado.

WORKS: Contributed to VER SACRUM; book decoration.

FERDINAND ANDRI

Painter and graphic artist. Born 10 March 1871 in Waidhofen, Ybbs. Died 19 May 1956 in Vienna. Studied under J. Berger and Lichtenfels at the Vienna Academy. 1892, studied at the Karlsruhe Academy. 1899-1909, member of the Vienna Secession, President 1905.

BIBLIOGRAPHY: Bassaraba, A., "Der Maler Ferdinand Andri". 1941. – Lutz, F.A., "Oeuvre'katalog Prof. Ferdinand Andri". 1941.

WORKS: Contributed to VER SACRUM, posters, book decoration.

ALFRED ROLLER

Painter, graphic and applied artist. Born 2 October 1864 in Brno. Died 22 June 1935 in Vienna. Studied at the Vienna Academy. 1899, teacher at the Vienna School of Applied Art; Art Director with responsibility for sets and costumes at the Vienna Staatstheater, where he designed the first productions of Richard Strauss's operas. Worked in Berlin for Max Reinhardt. Member of the Vienna Secession; left in 1905 with the Klimt group.

WORKS: Contributed to VER SACRUM, book decoration.

KOLOMAN MOSER

Painter, graphic and applied artist. Born 30 March 1868 in Vienna, died there 18 October 1918. 1886-92, studied at the Academy. 1892-95, at the Vienna School of Applied Art. 1897, founder member of the Vienna Secession. 1905, left with the Klimt group. 1899, teacher, from 1900 professor, at the Vienna School of Applied Art. 1903, co-founder of the Wiener Werkstätte with Josef Hoffmann.

BIBLIOGRAPHY: Zuckerkandl, B., "Koloman Moser", in DEKORATIVE KUNST, VIII, Munich 1904.

WORKS: Contributed to VER SACRUM and worked in the Wiener Werkstätte, posters, book decoration.

FRIEDRICH KÖNIG

Painter, graphic artist, craft designer. Born 20 December 1857. Died 11 March 1941 in Vienna. Studied at the School of Applied Art at the Austrian Museum in Vienna, as well as at the Academies in Vienna and Munich. Founder member of the Vienna Secession.

WORKS: Contributed to VER SACRUM, wood engravings for book illustration.

ADOLF BÖHM

Painter and graphic artist. Born 25 February 1861 in Vienna. Died 20 February 1907 in Klosterneuberg. Founder member of the Vienna Secession. From 1900, teacher in the Art School for Ladies and Girls in Vienna.

WORKS: Contributed to VER SACRUM, book decoration.

Josef M. Auchentaller, Decoration from VER SACRUM, No. 7, 1898. Drawn for V.S. About original size.

Ferdinand Andri, Colour lithograph for the poster of the Tenth Exhibition of the Vienna Secession. From VER SACRUM, No. 9, 1901. 16×19.5 cm.

MATERIAL ON VER SACRUM:

WHY ARE WE PRODUCING A PERIODICAL?

"For years the struggle has been raging merrily over the battlefields of Europe, from London to Munich and from Paris to Petersburg. In Vienna alone, sunk in placid contemplation and genteel silence, we have felt scarcely a breath of turbulence. The spring storm that has blown its liberating gusts through art everywhere, bringing a deep refreshment of the spirit, rending the intellectual calm with a cloudburst of reviving rain, illuminating with its lightning and proclaiming its message in its thunder, bringing everywhere life, movement, hope, energy and exuberance— this storm has failed to reach Vienna alone; only here remained at peace.

"Yet it was not the peace of death. Here too there was a deep yearning, a presentiment of things to come. Artists

Ferdinand Andri, Double page spread from VER SACRUM, for the VER SACRUM calendar 1903. (left) days of the week; (right) the calendar. Woodcut. 21.6 × 21 cm (with a border).

and writers who dared to venture beyond the city limits came back with news of something different, something fresh, something of today coming to life here and now. Soon, like a whisper from mouth to mouth, the rumour spread: something does exist after all beyond the Kahlenberg—perhaps even Modern Art!

"This is not the place to tell the story again—how the dull pressure that weighed down our spirits led finally to a decisive step within the ranks of the artists. However, the publication of this periodical requires explanation, and this we shall attempt to provide, insofar as one can put an artistic endeavour into words.

"The shameful fact that Austria has not a single widely read art journal focusing on her own art has made it impossible until now for artists to win recognition for their own aims. The appearance of this periodical will remedy that. Austria will be able to claim her own place in art vis-à-vis other countries, and this will put an end to the step-motherly attitude that has been virtually universal until now. This periodical speaks for the Union of Austrian Artists; it is a call to the Austrian people's artistic sense, for the stimulation and support of Austrian art, for the extension of artistic life and the strengthening of artistic independence.

"We declare war on empty reputations, rigid Byzantinism, and every manifestation of lack of taste. We count on the support of all those who hold art to be a high cultural calling and recognize it as one of the great educational forces of civilization.

"We do not, however, intend to produce long-winded generalizations. Not even in this first issue. Precise points will be made when they are relevant. We have had enough speeches and resolutions. Now is the time for action.

"In the first place, we demand powers of destruction and demolition. No one can build on shaky foundations, any more than he can put new wine into old bottles. Every harvest has to start with the preparation and ploughing of the ground, followed by the beneficent sun, hard toil, and the forces of creation and preservation. All constructive activity has to begin by clearing away obstructions. But it is nonsense to assert that modern art is bent on destruction for its own sake, that it is eliminating colour and form, that it has no respect for the past and preaches the overthrow of everything that is established. Art does not preach. It creates. It constructs in accordance with its own being, it does not throw down. Every true artist honours and reveres the great masters of the past for that very reason; he loves them with child-like awe and bows before them in sincere admiration.

"Only a fool derides the past. But every movement in the history of mankind has had its fools, and they are with us today, like jesters dancing round the king's coach. When knights rode to tournaments there were always men to bear their armour and squires to rattle their lances. But when they entered the lists, the noise ceased and the real work began. No one looked at the squires and armour-bearers.

"Every age has its own feelings, however. Our aim in publishing this periodical, our main concern, is to awaken the artistic feelings of our age, to stimulate them and broaden them. To all who are aspiring to the same goals, even if by different paths, we extend our hand in friendship and alliance.

"We are calling for an art that is not subservient to foreign

Koloman Moser, Woglinde, calendar page for July, from VER SACRUM, ▷ No. 1, 1901. Drawn for V.S. 17.1×19 cm.

222

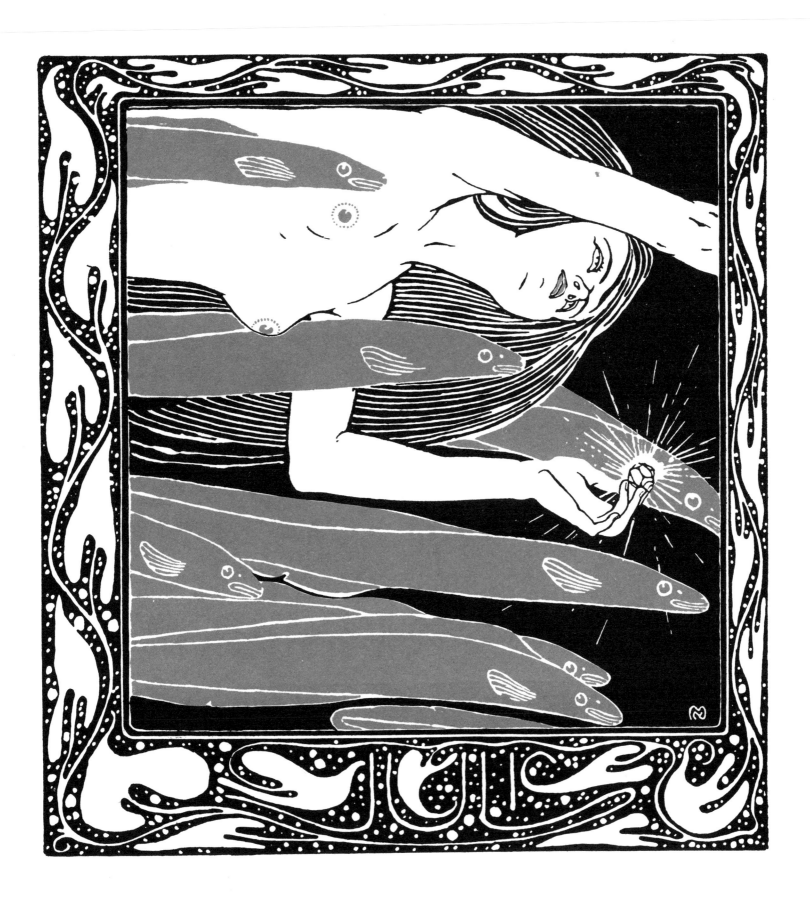

Sieben Billionen Jahre vor meiner Geburt
war ich eine Schwertlilie.

Unter meinen schimmernden Wurzeln
drehte sich ein andrer Stern.

Auf seinem dunklen Wasser
schwamm
meine blaue Riesenblüte.

Koloman Moser, Illustration for a poem by Arno Holz, from VER
SACRUM, 1898. Drawn for V. S. 20.2×18.8 cm.

Koloman Moser, Boisterous Weather, calendar page for April, for the 1903 VER SACRUM calendar. Woodcut. 21×21.6 cm.

influences, but which is equally without fear or hatred of those influences. Foreign art can stimulate us, can make us aware of ourselves; we wish to understand it and admire it as it deserves, but not to copy it. We want to attract foreign art to Vienna, to make everyone appreciate art—not just artists, connoisseurs and collectors, but the people at large, to awake in every human breast the dormant longing for beauty and freedom of thought and feeling.

"So we turn to you all, without distinction of wealth and social position. We acknowledge no distinction between 'high art' and 'low art', or between art for the rich and art for the poor. Art is common property.

"We shall not fall into the old habit of Austrian artists, of complaining about the public's lack of interest in art, yet doing nothing to bring about any change. We reiterate again and again, in language as passionate as we can make it. that art is more than an agreeable external pleasure, a sort of perfume that you can dab on to the surface of existence: it is the expression of the whole life of an intelligent nation, as indispensable as speech or codes of conduct. What we are asking for is just a few crumbs from the table of your sumptuous—yet so impoverished—lives. If you give us these crumbs just once, if you only stretch out your little finger to us, we shall fill those brief moments with a joy and splendour that will be a revelation, showing up the whole dreary monotony of your present lives. Then we shall want not just your finger but your hands, your hearts, yourselves!

"Some of you may say: 'But why do I need artists? I don't like paintings!'. Well, if you don't like paintings, we can show you how to adorn your walls with beautiful wallpapers. Or perhaps you like drinking wine out of fine glasses: come to us and we will show you a vessel whose shape is worthy of the wine you put into it. Or are you looking for some rich jewel or some unusual fabric to adorn your wife or your beloved? Tell us, try us just once, and we shall show you how to enter a new world and to discover that you already know and already possess things whose beauty you did not suspect, whose pleasures you have never sampled! Artists are not people who work in a misty, visionary haze: they stand in the midst of life, surrounded by its heights and depths, glories and horrors; they know it intimately; they are part of its raging turmoil. We want to teach you to stand firm with us, like a tower of bronze, to know, to understand, to become adept and wise, to be lords of the spirit! That is our mission.

"Each of you can work in your own field and win over your friends, not just for personal advantage, but for the sake of the same great and glorious goal for which thousands are longing. There are so many of you who, deep down, are already on our side, far more than you suspect. All of you who belong to the hordes who labour wearily and hopelessly in the varied struggles of life (the rich and envied as much as the poor)—you all thirst for a refreshing draught from this fountain of youth, this source of eternal beauty and truth. You are all our brothers in the great crusade.

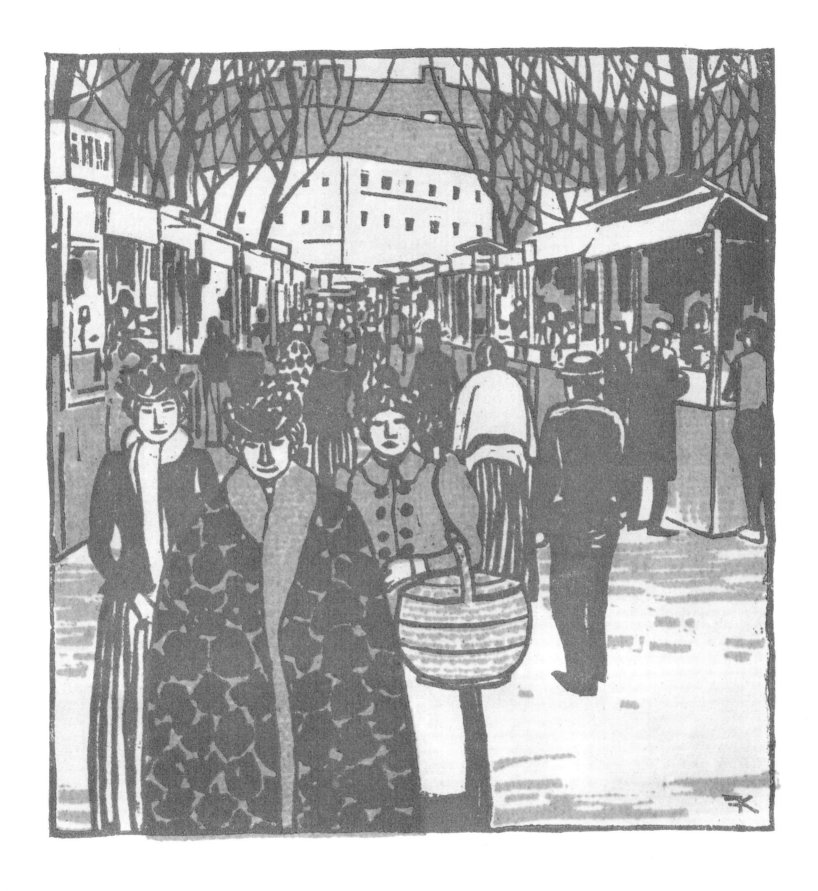

◁ **Friedrich König**, Ornamental border from VER SACRUM. 1903. Wood-cut. 5×14.8 cm.

Friedrich König, Row of Stalls in the Vienna Naschmarkt, for VER SACRUM, 1903. Woodcut. 15.7×9.6 cm.

Leopold Stolba, Woodcut from VER SACRUM, 1903. 15.2×14.6 cm.

Our role is to go before. You must follow. You must build on our loyalty, for we have consecrated ourselves to the 'Sacred Spring' with all our strength, all our future, all our being!."

SECESSION. "I shall never forget one particular scene. It was five years ago, at a time when I had been lamenting the pitiable state of our art in the 'Deutsche Zeitung'. There were plenty who secretly agreed with me but did not have the confidence to speak openly in public. Then one day there was a knock at my door. I opened it and saw before me an army officer, a captain, whom I did not know. He was in an agitated state. He spoke vehemently, sternly, almost threateningly, with brusque gestures. As soon as I let him in he began bombarding me with words. Only at this point did I realize who he was—Theodor von Hörmann, the brave captain who has since been snatched from us. He sat down beside me and I was able to watch him closely. Shouting hoarsely in a deep, baleful voice and waving his large hands emotionally, he abused the League with great scorn. Yet he had fine, attractive eyes and dark, lined features that gave him a tired and sad expression not at all in keeping with his wild, bellicose manner. He stood up and paced about the room, getting more and more excited. He told me how much he was having to endure, how the people in the Künstlerhaus hated him, how nothing was too low or too mean for them if only they saw a chance of wounding or insulting him. It was painful to see his distress. Finally I asked: 'But what have you done to them that makes them hate you so much?' He laughed scornfully—'Done? What have I done to them? Ha ha! I want to be an artist. Yes, I am impudent enough to have that ambition! That they can never forgive! For that they let all their dogs loose on me!' I shall never forget the scene. I can still hear his tragic voice and see his fury. He stood there like a prophet calling down vengeance. Even then I sensed that death was at his elbow. He had drawn too much hatred upon himself. He was doomed. The malice of his enemies was killing him.

"It was then that I discovered the sorry plight of our young artists in Vienna, and that their 'Secession' would have to be something very different from that in Munich or Paris.

"The intention of the Secession in Munich and Paris was to set a 'new' art against the 'old'. The whole affair was thus a struggle within art circles for a better form. For a number of young men tradition was not enough, and they were searching for something different, something individual. They wanted to look at the world through their own eyes and express it through their own feelings. This the older artists did not like: they did not tolerate any new techniques, and they grew ill-tempered. Nevertheless, the matter remained a struggle within art itself. In the last analysis each of the opposing parties had the same aims, to serve beauty, and it was only over the means of achieving this that they could not reach agreement. Both parties were calling for art, but each in their own words and language. Artists stood up against artists: it was a fight between

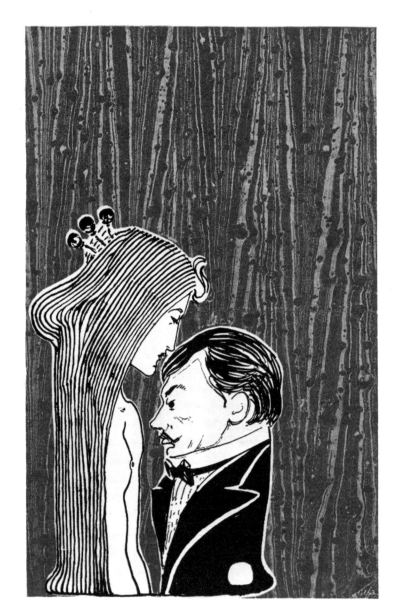

Friedrich König/Koloman Moser, Moser-Muse, from VER SACRUM, No. 3, 1901. Drawn for V.S. 15.7×9.6 cm.

schools, doctrines, temperaments, or whatever name you care to give it. With us, however, this was not the case. "No, with us it was quite different. There was no struggle for and against tradition here, for we have none. It was not a question of a struggle between the old art, of which we had none, and a new art. The fight was not over some development or change in art, but over art itself, over the right to artistic creativity. That was the nub. Our Secession is not the struggle of new artists against old, but the revolt of artists against pedlars who pretend to be artists and have a financial interest in preventing any art from coming into being. The Union is not reproaching the League for being 'old' or challenging them to 'become modern!'. No, it simply says, 'You are manufacturers, we want to be painters!' This is the struggle: business or art, is the question which our Secession asks. Should Viennese painters be condemned to remain small businessmen, or may they attempt to become painters? Those who adhere to the old Viennese notion that paintings are goods just like trousers and stockings made to the buyer's order should remain in the League. Anyone who wishes to lend form to the secrets of his soul in paint or pencil is already a member of the Union. The struggle is not about aesthetics, but about attitudes: whether we will be ruled by business, or whether we will at last be permitted to live according to artistic convictions. This is the right for which the Union is fighting on the painters' behalf, the right to be allowed to be artists. "Our Secession is thus a union of agitation. Therefore it must model itself on those agitators who have had some measure of success amongst us. If it examines them, it will find that it can learn three maxims from them. The first is this: Anyone trying to achieve something in Vienna by agitation must not be afraid of ridicule. All those people who have eventually triumphed here and all the causes which have prevailed here first endured years of ridicule. The second maxim is this: You must know how to make yourself hated. The Viennese respect only those whom they actually detest. It is only by hate that one wins power here. The third is this: One must never let oneself be appeased. When someone asks for something the Viennese are accustomed to offer half. If one seems to be satisfied with that, they will shortly take it back. But if one is awkward and refuses to moderate one's demands, they find it uncomfortable and they give more than they were asked for. The slogan must be all or nothing.

"Viennese painters must show whether they understand how to become agitators; that is the meaning of our Secession. If they do, then they cannot go wrong. Then a glorious time will come, a time of peace and pure art, when agitators will be needed no more. This is our great aim." (Hermann Bahr)

FROM THE CONSTITUTION OF THE UNION OF AUSTRIAN ARTISTS:
"The purpose of the Union of Austrian Artists is the promotion of purely artistic interests, and principally the improvement of artistic awareness in Austria. This it will seek to achieve by bringing together Austrian artists living both at home and abroad, by striving to make lively contact with outstanding foreign artists, by establishing exhibitions in Austria which will be free of the touch of the market-place, by showing Austrian art to advantage in foreign

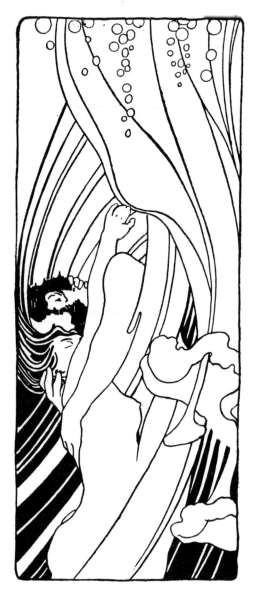

◁ **Alfred Roller**, Illustration for a poem by Ernst Schur, from VER SACRUM, No. 20, 1900. Drawn for V.S. 15×6 cm.

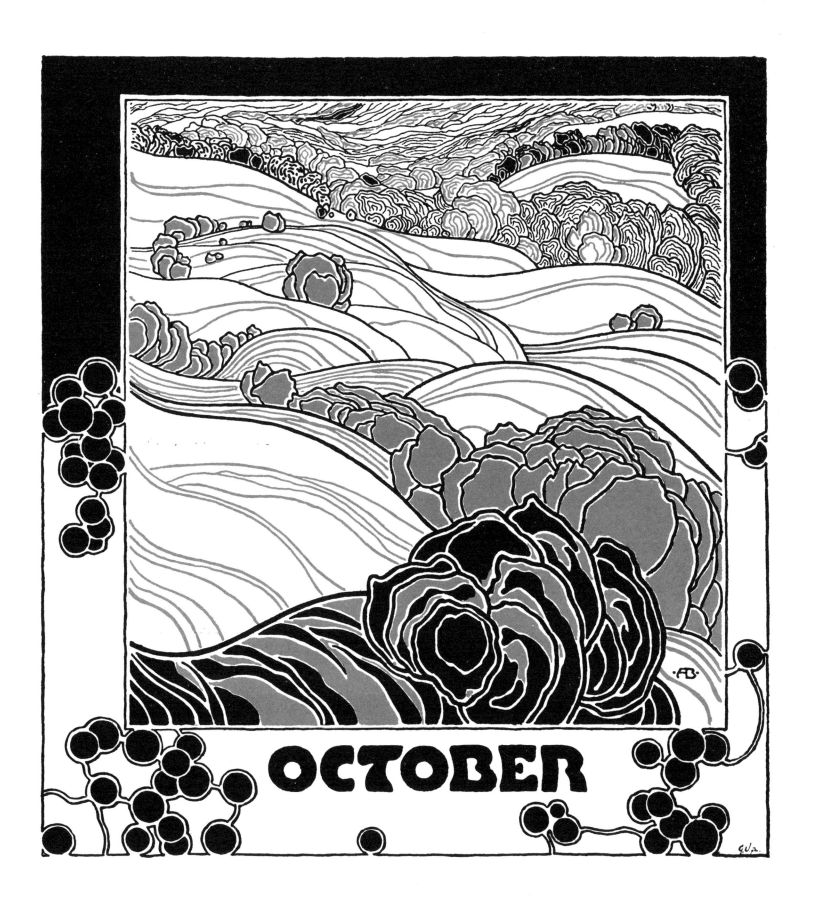

Adolf Böhm, Autumn Glow, Calendar page for October, from VER SACRUM, No. 1, 1901. Drawn for V.S. 19.2×17.8 cm.

Alfred Roller.

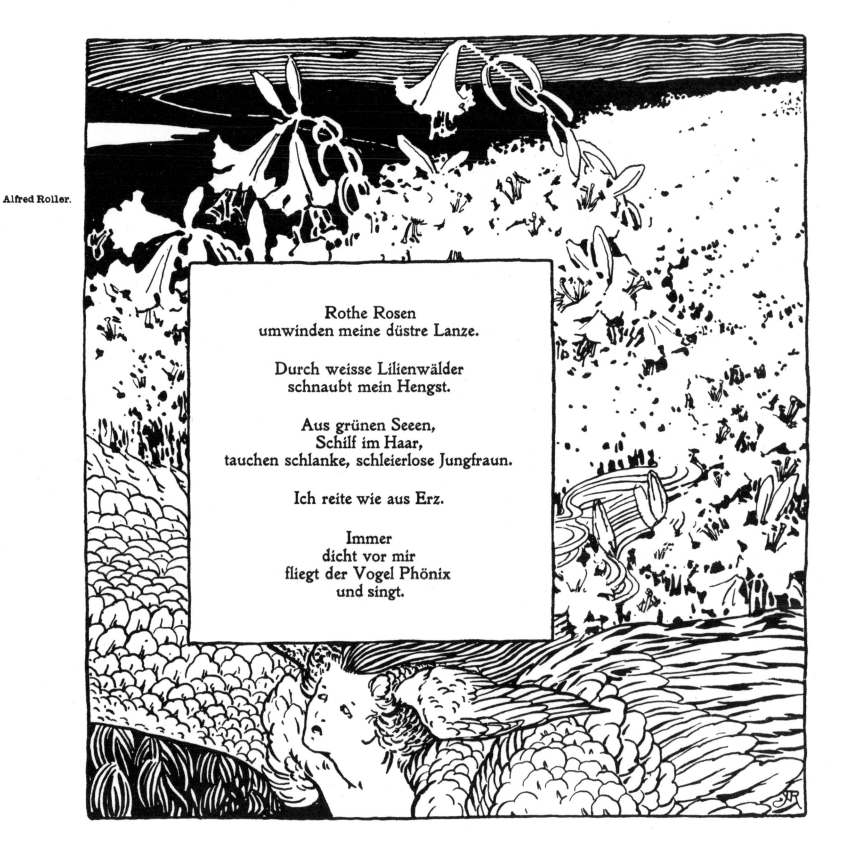

Rothe Rosen
umwinden meine düstre Lanze.

Durch weisse Lilienwälder
schnaubt mein Hengst.

Aus grünen Seeen,
Schilf im Haar,
tauchen schlanke, schleierlose Jungfraun.

Ich reite wie aus Erz.

Immer
dicht vor mir
fliegt der Vogel Phönix
und singt.

Alfred Roller, Illustration for a poem by Arno Holz, from VER SACRUM,
1898. Drawn for V.S. 20.3×19 cm.

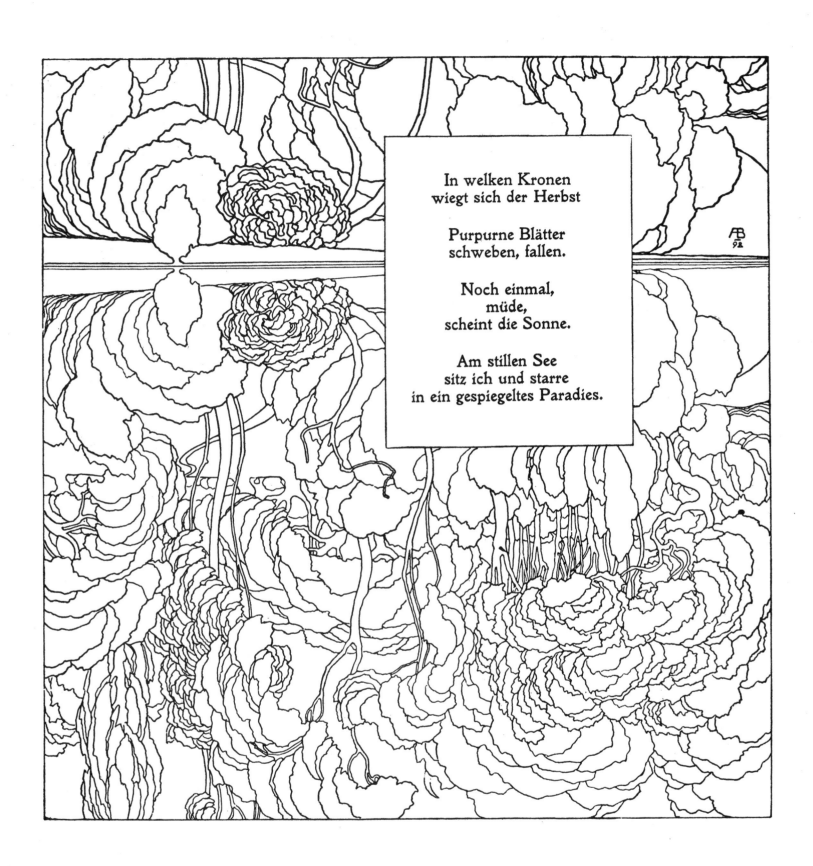

In welken Kronen
wiegt sich der Herbst

Purpurne Blätter
schweben, fallen.

Noch einmal,
müde,
scheint die Sonne.

Am stillen See
sitz ich und starre
in ein gespiegeltes Paradies.

Alfred Böhm, Illustration for a poem by Arno Holz, from VER SACRUM,
1898. Drawn for V.S. 20.2×18.7 cm.

exhibitions, and by attracting the most important foreign works here to stimulate native creativity and to enlighten the Austrian public on the general progress of developments in art.

"The permanent home of the Union is Vienna.

"The Union consists of founders and members. The members are divided into full and corresponding members; only practising artists may become members, and only Austrian artists full members. Foreign artists who have performed a special service to art may become corresponding members.

"Members will be appointed.

"Members will exhibit in Vienna only in public exhibitions arranged by the Union; they shall not exhibit at any public exhibition arranged by any similar body. There is no restriction on arranging or exhibiting at private exhibitions.

"Members who have not taken part in the artistic activities of the Union for three consecutive years shall lose their active and passive right to vote until they have again begun to participate.

"In accordance with its basic guiding principles, the Union intends to use the profits from the exhibitions which it arranges (keeping back a third for its reserve fund) to buy art works shown in these exhibitions and to present them to one of the public galleries in Vienna.

"With regard to the organization of exhibitions, the following important basic regulations are laid down:

"All the full members present in Vienna shall act as the selection jury, together with any corresponding members staying in Vienna throughout the entire sitting of the jury.

"The sole criterion to be adopted by the jurors in accepting or rejecting a work submitted will be its artistic merit, so that works of every kind which fulfil this condition are to be accepted, even those in which the artist has made use of techniques of applied art as a means of expression. At exhibitions in Vienna only works not previously shown there will be accepted. Architects may exhibit their own drawings, and may include reproductions and models if these serve to clarify their autograph work; office work is excluded. All mass-produced articles are also excluded."

LEOPOLD STOLBA

Painter and graphic artist. Born 11 November 1863 in Vienna, died there 17 November 1929. 1879–81 studied at the Vienna Academy. From 1900 member of the Vienna Secession. Well-known as a graphic artist; during his lifetime his paste-papers and sized-papers were famous. Worked on VER SACRUM and produced etchings, woodcuts, and monotypes.

NORA EXNER

(married name Von Zumbusch). Graphic and applied artist. Born 3 February 1879 in Vienna, died there 18 February 1915. Studied in Vienna under A. Roller and in Munich under L. Kalckreuth. Studied sculpture in Rome and at the Vienna School of Applied Art under Franz Metzner and Franz Barwig. 1909–10 active in the Wiener Keramik.

WORKS: Contributed to VER SACRUM.

Rudolf Jettmar, Vignette from VER SACRUM.

Nora Exner, Fish, from VER SACRUM, 1903. Coloured woodcut. 18.4 × 16.3 cm ▷

Rudolf Jettmar, Illustrations for poems by Richard Schaukal, from VER SACRUM, No. 23, 1900. Drawn for V.S. 14.9×14.5 cm.

RUDOLF JETTMAR

Painter and graphic artist. Born 10 September 1869 in Zawodzie (Tarnow, Galicia), died 21 September 1939 in Vienna. 1886 studied at the Vienna Academy, 1892 in Karlsruhe under K. Ritter. 1893 travelled in Switzerland and Italy. 1894 worked as a designer in Leipzig and Dresden. 1896 received a grant to study in Rome. From 1898 member of the Vienna Secession. From 1910 teacher at the Vienna Academy. In 1929, given a master-class. Jettmar stood in opposition to Klimt, and his contribution to Art Nouveau was distinctive. With Klinger, for whom he felt a particular affinity,he produced large graphic cycles expressing the problems of the artist. His use of line is less economical than Klimt's: he creates a thick web of dark surfaces from which landscape and figures emerge, illuminated by strong light, often from concealed sources.

BIBLIOGRAPHY: Weixelgärtner, A., "Rudolf Jettmar, in DIE KUNST 27, 1913.

WORKS: Contributed to VER SACRUM, book decoration, individual sheets, cycles, etc., poems by Byron.

Rudolf Jettmar, Colour woodcut from VER SACRUM, 1903. 10.9×14.5 cm.

JOSEF HOFFMANN

Graphic artist and architect. Born 15 December 1870 in Prinitz, Iglau (Moravia), died 7 May 1956 in Vienna. Studied architecture at the Vienna Academy under Otto Wagner. Went to Italy after winning the Rome Prize. 1898 founder member of the Vienna Secession. From 1899 professor of architecture at the Vienna School of Applied Art. 1903 co-founder of the Wiener Werkstätte with Moser and Czeschka; artistic director of the Werkstätte until 1931. 1905 left the Vienna Secession with the Klimt group and organized the Kunstschau. 1912 founder and director of the Österreichischer Werkbund. 1920 took over direction of the Viennese group in the Deutscher Werkbund. Took part in planning and organizing international exhibitions (Buenos Aires 1909, Rome 1911, Leipzig 1913, Paris 1925, etc). 1905–11 designs for the Palais Stoclet in Brussels. Honorary member of the Berlin Academy, honorary doctor of the Technical High School in Dresden.

Josef Hoffmann, Ex Libris, from VER SACRUM, 1903. Drawn for V.S. 15×5.7 cm.

Hoffmann showed himself primarily an architect, even in book decoration. His ornamentation is based on strict regularity and the repetition of motifs, seen for instance in fretwork and inlay in his furniture. The individual motifs are interchangeable, allowing his furniture also to be divided into different groups, something which had not until then been apparent in Art Nouveau interior design. The new trend towards standardization and mass production is apparent even in his use of ornament. The elongated female figures of his Ex Libris design point to one of the strongest sources of influence on Austrian artists of the Secession: Scotland.

BIBLIOGRAPHY: Kleiner, L., "Jos. Hoffmann". 1927. – Rochwanski, L.W., "Josef Hoffmann, eine Studie, geschrieben zu seinem 80. Geburtstag". 1950. – Veronesi, G., "Jos. Hoffmann". 1956. – Weiser, A., "Jos. Hoffmann". 1930. – Zuckerkandl, B., "Jos. Hoffmann", in DEKORATIVE KUNST, VII, Munich. 1903. – "Jos. Hoffmann, Einfache Möbel", in DAS INTERIEUR, II, Vienna 1901.

WORKS: Contributed to VER SACRUM, and worked for the Wiener Werkstätte; book decoration.

MAX KURZWEIL

Painter and graphic artist. Born 13 October 1867 in Bisenz (Moravia), died 10 May 1916 in Vienna. 1879 moved with his family to Vienna. 1886–92 studied at the Vienna Academy. From 1891 travelled to Cracow, East Galicia, Brittany and Paris, where he attended the Académie Julian for a short time. His painting "Autumn" was exhibited at the Salon of the Society of French Artists. Visited Concarneau in Brittany, where he met his future wife. 1894 returned to Vienna. 1896 elected member of the League of Fine Artists of Vienna. 1897–1905 founder member of the Vienna Secession. 1905 left the Secession with the Klimt group. 1909–15 teacher at the Art School for Ladies and Girls in Vienna as a disciple of Rudolf Jettmar. 1915 called up, 1916 appointed war artist. Committed suicide.

BIBLIOGRAPHY: Wawra, C.J., "252. Kunstauktion, Versteigerung des künstlerischen Nachlasses des Malers Max Kurzweil", Vienna 1918. – Galerie Miethke, Max Kurzweil and Carl Moll joint exhibition, Vienna 1911. – Max Kurzweil 1867–1916, 58 Wechselausstellung, Österreichische Galerie Vienna, 1965/66.

WORKS: Contributed to VER SACRUM. Woodcuts, lithographs, posters.

Josef Hoffmann, Two designs for house entrances, drawn for VER ▷ SACRUM. Original size in V.S.

DIE ARCHITEKTONISCHEN SKIZZEN DIESES HEFTES.

Dem Tempo des modernen Lebens entspricht es, dass uns Variationen eines einmal gefundenen künstlerischen Gedankens nicht mehr befriedigen, dass wir vielmehr einen wahren Heisshunger und eine unglaubliche Verdauungsfähigkeit in Bezug auf neue Ideen entwickeln. Die aus früheren Kunstperioden stammenden oder solchen anhängenden Architekten traten neuen Aufgaben, wenigstens in Bezug auf die Formensprache, zunächst mit compilatorischen Absichten gegenüber; die modern empfindenden dagegen trachten einem neuen Problem zunächst mit ihrem künstlerischen Empfinden nahe zu kommen und aus dieser primären baulichen Empfindung wächst dann die Erfindung der angemessenen Form heraus. Lange schon sind wir gewöhnt, die Skizzen der Maler und Bildhauer mit ernstem Interesse zu betrachten. Warum sollen wir dasselbe nicht auch den flüchtigen Niederschreibungen allererster, allerpersönlichster Gedanken der Baukünstler entgegenbringen? Als solche Notierungen allererster baulicher Gedanken aber wollen die architektonischen Skizzen dieses Heftes betrachtet werden. Der Weg von ihnen bis zum fertigen Bauplane ist ein weiter, aber nicht weiter als der von der Skizze des Malers, des Bildhauers, zum fertigen Gemälde, zur Statue. V. S.

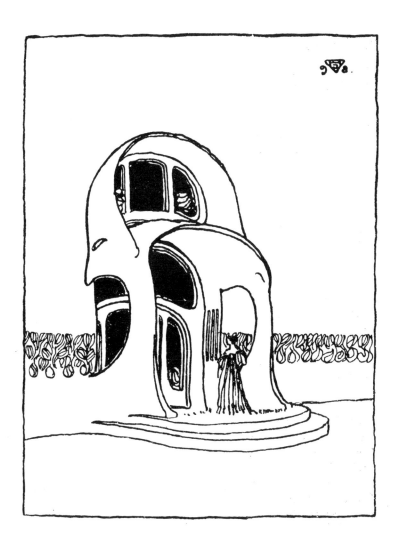

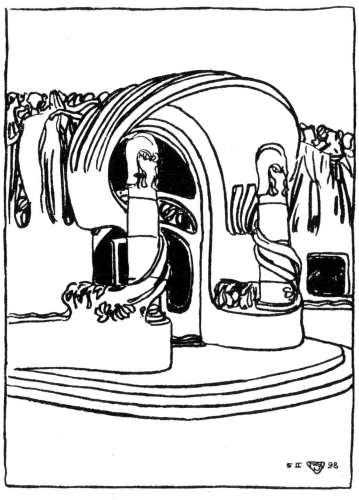

Ein Händeineinanderlegen,
Ein langer Kuss auf kühlen Mund,
Und dann: auf schimmerweissen Wegen
Durchwandern wir den Wiesengrund.

Durch leisen, weissen Blütenregen
Schickt uns der Tag den ersten Kuss —
Mir ist: Wir wandeln Gott entgegen,
Der durchs Gebreite kommen muss.

RAINER MARIA RILKE.

Josef Hoffmann, Border for a poem by Rainer Maria Rilke, from VER SACRUM. Original size.

Max Kurzweil, The Cushion (Martha Kurzweil seated on a divan). ▷ About 1903. Colour woodcut. 28.6 × 25.9 cm.

Emil Orlik, Pilgrims to Fuji. 1900. Colour woodcut. 23.9×42 cm.

EMIL ORLIK

Painter, graphic and applied artist. Born 21 July 1870 in Prague, died 8 August 1932 in Berlin. 1891–93 studied at the Munich Academy under Lindenschmitt and J.L. Raub. 1897 journeyed to Holland and Paris, 1898 to England. 1900–01 travelled to Japan, studied Japanese woodcut techniques and was inspired by them to produce colour woodcuts. 1903/04 in Vienna, where he joined Klimt and his circle, becoming a member of the Vienna Secession. 1905 left with the Klimt group; appointed professor at the Educational Institute of the Museum of Applied Art in Berlin. Met Max Reinhardt, designed scenery and costumes for his productions. 1911 travelled in Egypt, China, Japan, and Russia.

Orlik's work was sometimes so close to Japanese coloured woodcuts as to be virtually indistinguishable from them.

The differences lie in the large surface areas of his motifs and in his simpler compositions, which recall the way in which the French artist Emile Bernard had adapted Japanese art in the 1880's. In book decoration, especially in his illustrations to Lafcadio Hearn, Orlik developed the principle of repetition and variation of motifs, an idea which had rarely been so emphatically treated since the earliest European printed books (cf. Schedel's "Weltchronik", 1493).

Emil Orlik, Endpapers for "Kwaidan" by Lafcadio Hearn. Publ. ▷
Literarische Anstalt Rütten und Loening, Frankfurt am Main. 1908.
20.3×28 cm.

BIBLIOGRAPHY: Loubier, H., "Emil Orlik", monograph in DAS PLAKAT, Year 7, 1916, p. 159 ff. – Osborn, M., "Emil Orlik", in ZEITSCHRIFT FÜR BILDENDE KUNST, new series 21, 1910. – Singer, H.W., "Emil Orlik – Wien", in DEUTSCHE KUNST UND DEKORATION 15, 1904 to 1909. – id., "Emil Orlik", in Meister der Zeichnung 7, 1914. – Wolff, H., "Emil Orlik", in DIE KUNST 35, 1917.

WORKS: "Aus Japan", 25 coloured etchings and lithographs. 1904; portfolio of caricatures, book bindings, book decoration, including the books of Lafcadio Hearn: Lotos, Kokoro (with foreword by Hugo von Hofmannsthal), Jzumo, Kyushu, Kwaidan, Buddha. End papers, posters; picture sheet for the Wiener Werkstätte.

Hugo von Hofmannsthal:
"I was called to the telephone and told that Lafcadio Hearn was dead. He died in Tokyo, yesterday, or last night, or early this morning. News travels quickly by wire, so that by tonight one or two people in Germany will know; further west a couple of hundred people, further west still a couple of thousand will have heard that their friend is dead, their friend to whom they owed so much and whom they never saw. I too had never seen him and shall never see him, and his stiff hands will never now hold the letter which I so often wanted to write to him.
"And Japan has lost her adopted son.
"His ears understood their speech. His books contain hundreds of children's words, words spoken by grand-mothers to their grandchildren, delicate words thin as the twittering of birds spoken by women in love, women in agony, which would have flown away through the paper walls of those tiny rooms had it not been for him, words of wise old men, of devout monarchs, of the clever men of our day, matching those of the cleverest and most cultivated Europeans, and differing in no wise in tone from the tone of those who bear the burden of the full harvest of our wisdom."

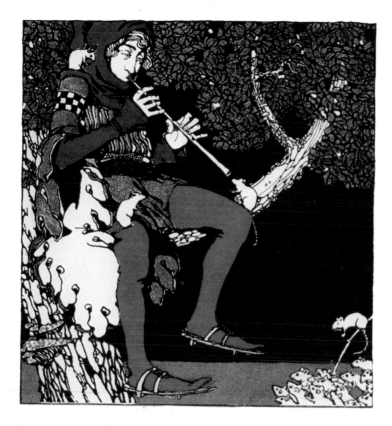

Ignatius Taschner, Illustration for The Pied Piper of Hamelin, from "Grimm's Tales". Publ. Gerlachs Jugendbücher, Vienna/Leipzig (1901). About original size.

BERTHOLD LÖFFLER

Painter, graphic and applied artist. Born 28 September 1874 in Lower Rosenthal (Bohemia), died 23 March 1960 in Vienna. Studied at the School of Applied Art in the Austrian Museum in Vienna under Kolo Moser and J. von Matsch. 1903 frescos for the dome of the Brigitte-Kapelle, 1912 frescos for the Austrian Museum in Vienna, 1914 frescos in the Salzburg Volkskeller. 1902 founded with M. Powolny the Wiener Keramik workshop, which became the Gmundener Keramik in 1912. From 1907 worked in the Wiener Werkstätte. 1909 appointed professor at the Vienna School of Applied Art.

WORKS: Illustrations for a young people's edition of "Des Knaben Wunderhorn", contributions for the publishing house Gerlachs Jugendbücher Vienna-Leipzig; Andersen's fairy-tales; designs for Austrian postage stamps and bank notes. Worked in the Wiener Werkstätte.

IGNATIUS TASCHNER

German architect, painter, graphic artist and craftsman. Born 9 April 1874 in Lohr am Main, died 25 November 1913 in Mitterndorf, Dachau. 1889–95 studied at the

Munich Academy under Syrius Eberle and Jakob Bade. Active in Munich. 1903–05 professor at the Academy of Art in Breslau. From 1905 member of the Berlin Secession in Berlin. Taschner is included here because of his illustrations for the Viennese publishing house Gerlach, for which he did his finest drawings.

WORKS: Book decorations and illustrations for: L. Thoma, Der Heilige Hies (Langen-Munich); Grimms fairy-tales (Gerlachs Jugendbücher); Musäus, Nymphe des Brunnens (Gerlachs Jugendbücher) etc.

CARL CZESCHKA

Painter and graphic artist. Born 22 October 1878 in Vienna, died 30 July 1960 in Hamburg. Studied at the Vienna Academy under C. Griepenkerl. 1902–08 teacher at the Vienna School of Applied Art. Member of the Klimt group and co-founder of the Wiener Werkstätte. From 1908 professor at the School of Applied Art in Hamburg. Czeschka's illustrations are among the finest works published by Gerlach. They are characterized by a sparing

Berthold Löffler, Illustration for "Des Knaben Wunderhorn". Publ. Gerlachs Jugendbücher, Vienna/Leipzig. 1902. About original size.

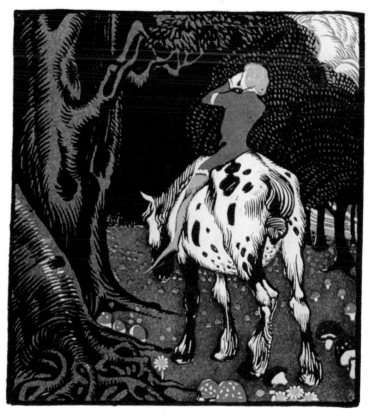

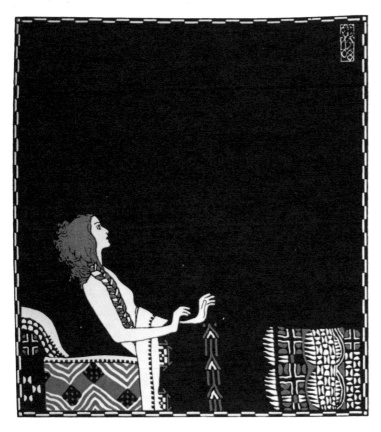

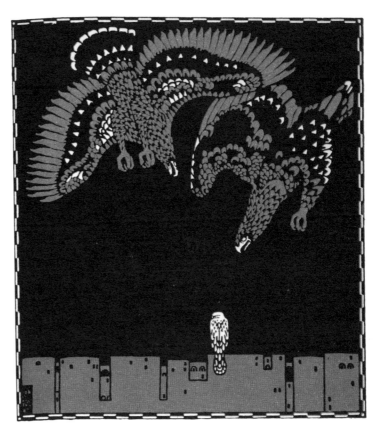

Carl Czeschka, Double page spread from "The Nibelung". Publ. Gerlachs Jugendbücher, Vienna/Leipzig 1909. About original size.

use of colour with gold, and by the juxtaposition of large and significant empty areas with small mosaic-like forms. The illustration shows a doublespread without text, a device often adopted by the artist to show two different aspects of a scene. Here we see Krimhilde waking in terror from her dream, and on the right the dream itself, with the solitary falcon on the wall on which two eagles swoop from the night sky.

WORKS: Worked for the Wiener Werkstätte, book decoration and illustration for Verlag Gerlach, Vienna.

OTTO TAUSCHEK

Painter and graphic artist. Born 9 June 1881 in Vienna. Studied at the Vienna Academy under Unger and in Munich under Hugo von Habermann. Lived in Munich.

WORKS: Book decoration and illustration, including those for children's and household fairy-tales after Grimm's fairy-tales. Contributed to Gerlach's Jugendbücher.

FRANZ WACIK

Painter and graphic artist. Born 9 September 1883 in Vienna, died there 15 September 1938. Studied first at the Strehblow School of Painting, then at the Vienna School of Applied Art under Roller and 1902–08 at the Vienna Academy under C. Griepenkerl, Rumpler, and Löffler. From 1906 worked on the periodical MUSKETE. Member of the Secession from 1910.

BIBLIOGRAPHY: Ankwicz, H. v., "Franz Wacik", in Thieme-Becker, Vol. 35 (1942), p. 6–8 (very detailed).

WORKS: Contributed to the weekly magazine DIE MUSKETE (Vienna), creating 577 coloured illustrations in all. Book illustrations for: Andersen, Brothers Grimm, E.T.A. Hoffmann, Clemens Brentano, Till Eulenspiegel, H. v. Hofmannsthal. Illustrations for children's books for Verlag Gerlach, Vienna-Leipzig, Verlag für Jugend und Volk, etc. Several series of water-colours of fairy-tale illustrations and historical sequences (not printed); some of these are in the Museum des 19. Jahrhunderts in Vienna.

MORITZ JUNG

Painter and graphic artist. Born 22 October 1885 in Nikolsburg, Moravia, killed 11 March 1915 in Galicia. 1901–08 studied at the Vienna School of Applied Art under Roller, Czeschka and Löffler.

WORKS: Worked in the Wiener Werkstätte, theatre programmes for the Viennese cabaret "Fledermaus", applied graphics. The reproduced sheet appeared only in black and white in the above theatre programme.

JOSEF VON DIVÉKY

Painter and graphic artist. Born 1887 in Farmos, died September 1951 in Ödenburg. Studied at the Vienna School of Applied Art under R. Larisch and B. Löffler. Active in Zurich and Brussels, and from 1941 in Hungary.

WORKS: Worked in the Wiener Werkstätte; book decoration and illustration.

OSKAR KOKOSCHKA

Painter and graphic artist. Born 1 March 1886 in Pöchlarn, died 22 Fevruary 1980 in Villeneuve. From 1904 studied at the Vienna School of Applied Art, being influenced at first by Klimt. 1907 worked for the Wiener Werkstätte, which printed his first book "Die träumenden Knaben" ("The Dreaming Youths"). 1908 first participation in the Kunstschau exhibition; his play, "Murderer, Hope of Women", was first performed in Vienna. 1909 left the School of Art and travelled in Switzerland. 1910 stayed in Berlin where he worked on STURM. 1911 returned to Vienna, evening classes at the School of Applied Art. Friendly with Alma Mahler, travelled with her to Venice in 1912. 1914 separated from her, volunteered for the army. 1915 seriously wounded in Galicia, returned to Vienna. 1916 war reporter on the Isonzo front. 1917 stayed in Dresden, premières of three plays. 1919 appointed professor at the Dresden Academy. 1924 resigned this post; visited Vienna, travelled in Italy, France, and Spain. 1926 visited London. From 1924 to 1927 his main residence was in Paris, until 1931 in Auteuil. Travelled in North Africa, Egypt, and the Far East. 1924–31, 21 exhibitions of Kokoschka's work. 1931 moved to Vienna, 1934 to Prague. Wrote autobiographical works and material on children's education. 1938 fled to London with his wife, almost penniless. 1939–45 lived as a refugee in Britain. 1943 president of the Free German League of Culture. 1947 adopted British nationality. From 1945 his works were once again exhibited in Europe. 1949 vist to the USA, with guest lectures in Boston. 1951 awarded the Stephan Lochner Medal by the city of Cologne, 1952 the Lichtwark prize by the city of Hamburg. 1952–62 at the "Schule des Sehens" ("School of Vision") at the Salzburg Academy Summer Seminars. 1953 settled at Villeneuve on the Lake of Geneva. 1955 sets and costumes for "The Magic Flute" at the Salzburg Festival. 1956 loaded with honours on his seventieth birthday. Travelled to Greece, Italy, and Morocco. 1966 his eightieth birthday marked by honours and exhibitions.

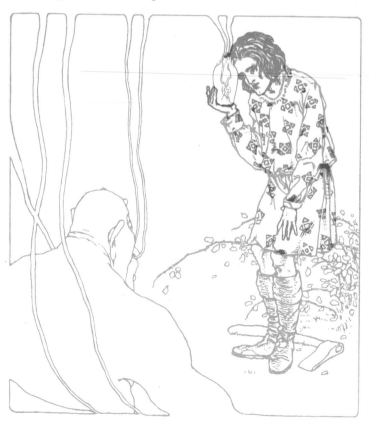

Otto Tauschek, Illustration to Children's and Domestic Fairy-Tales based on "Grimm's Tales". Publ. Gerlachs Jugendbücher, Vienna/Leipzig. 1901. About original size.

BIBLIOGRAPHY: Bultmann, B., "Oskar Kokoschka". 1959. – Heilmaier, H., "Kokoschka". 1930. – Hoffmann, E., "Kokoschka. Life and Work". 1949. – Hodin, J.P., "Bekenntnis zu Kokoschka". 1963. – Goldscheider, L., "Kokoschka". 1963. – Rathenau, E., "Kokoschka, Handzeichnungen". 1935. – id., "Der Zeichner Kokoschka". 1961. – Stephan, P., "Oskar Kokoschka. Dramen und Bilder". 1913. – Westheim, P., "Oskar Kokoscka". 1925. – Wingler, H.M. "Oskar Kokoschka. Ein Lebensbild in zeitgenössischen Dokumenten". 1956. – Oskar Kokoschka, Schriften 1907–1955, Munich 1956. Exhibition catalogue, "Das gesammelte Werk, Städt". Kunsthalle Mannheim 1931. – Tate Gallery, the Arts Council, London 1962. – Aquarelle und Zeichnungen, Graphische Sammlung Staatsgalerie Stuttgart 1966. – Kunsthaus Zurich 1966. – Das Portrait, Badischer Kunstverein Karlsruhe 1966.

WORKS: Contributions for the Wiener Werkstätte; worked on STURM: "Die träumenden Knaben" (A sample illustration from this work is reproduced here and it reveals the Viennese Art Nouveau's view of Expressionism, a view which here still shows close connections with tradition.).

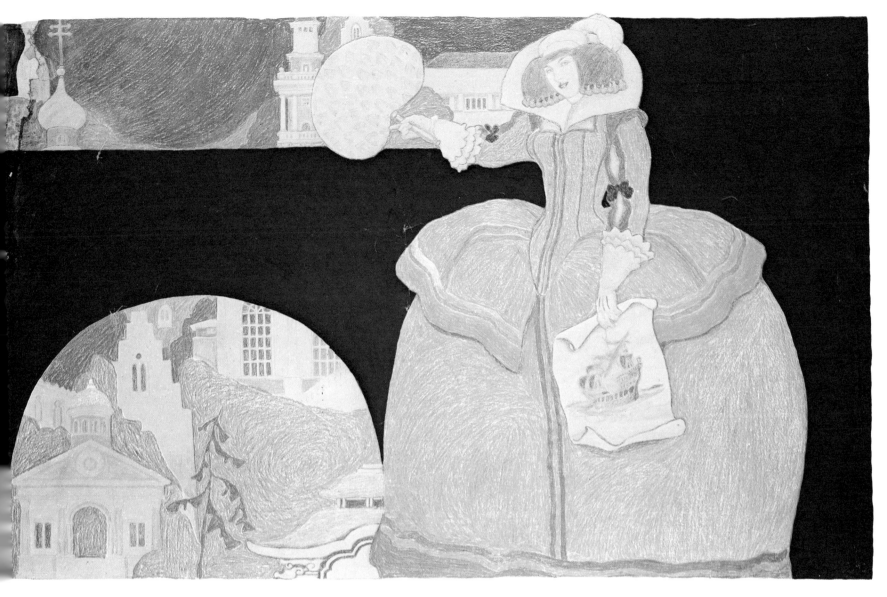

Franz Christophe, Design for a poster for the World Exhibition in Brussels. 1910. Oil, pastel and gouache. 74 × 100 cm.

PROGRAMME OF THE WIENER WERKSTÄTTE (1905) The tremendous disaster in the field of applied arts caused by poor quality mass-production and the mindless imitation of old styles is sweeping through the entire world like a tornado. We have lost contact with the culture of our ancestors, and are blown hither and thither by countless desires and circumstances. Handiwork has largely been replaced by machinery, the craftsman by the businessman. It would be folly to attempt to swim against this current. This is why we have founded our workshops. They are to be a place of peace on our native soil amidst the grateful din of handicraft, a place of welcome to those who confess their faith in Ruskin and Morris. We appeal to all who value culture in this sense, and hope that our friends will not be discouraged from supporting our aims by the mistakes we shall inevitably make.

We wish to forge a strong bond between the public, designers, and craftsmen in order to produce handsome and simple household goods. Our aim is first of all for utility; our strength must lie in good proportions and good use of materials. Where appropriate we shall use ornament, but we shall not feel compelled to decorate. We use many

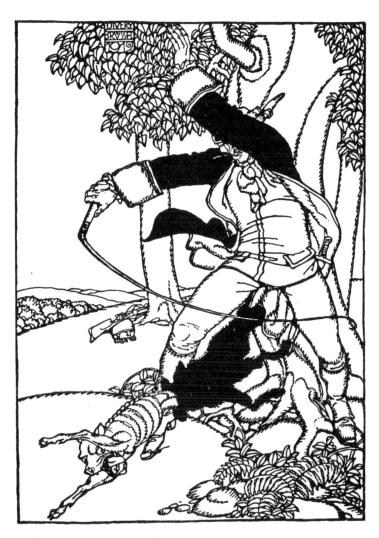

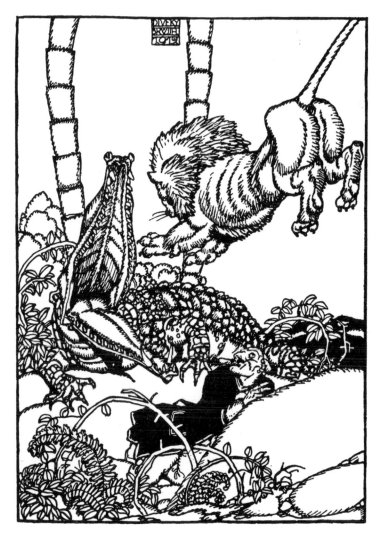

Josef von Divéky, Illustrations for ''Des Freiherrn von Münchausen Reisen und Abenteuer''. Publ. Morawe & Scheffelt, Berlin. No date.

semi-precious stones, especially in metalwork: their beautiful colours and endless variety are a fine substitute for the cost of precious stones. Silver we like for its silvery sheen, gold for its glitter; copper to us is as valuable as the noble metals in its artistic possibilities. We declare that an ornament of silver can be as valuable in itself as a similar one of gold and gemstones. The value of a work of art and its conception must be recognized anew and assessed anew. A craftsman's work should be measured by the same standard as that of painters and architects.

We cannot and will not compete with cheap goods. The same is particularly true of the craftsman's labour: we consider it our first duty to restore pleasure in creation and a truly human life to him. All this we shall achieve only step by step.

Our leather workers and bookbinders, like all our other craftsmen, will have good materials and their work will be technically perfect. It need hardly be said that we shall employ ornament only where the nature of the material does not prevent it. We shall use all types of leather inlay, blind blocking, hand gilding, leatherthonging, and sizing.

The fine book has entirely disappeared. Hollow spines, spiral binding, unattractively trimmed and poorly sewn pages, and bad leather cannot be eradicated. All we have now is the so-called first edition, factory-produced, with a richly decorated jacket. Machines work busily on, filling our bookcases with faultily printed works; their achievement is cheapness. Surely any cultured man should blush at this range of materials, for easy production reduces responsibility, whilst variety leads to superficiality. How many books are truly our own? Should not these be printed on the best paper, bound in the best bindings of fine leather?

Have we forgotten that the love with which a book is printed, produced, and bound creates a totally new relationship between us and it, and that associating with beautiful objects makes us finer? A book should be a work of art and its value should be measured in these terms.

In our cabinet-making workshops we require only the most solid and perfect craftsmanship. Sadly, the modern age has become so accustomed to cut-price goods that even partly well-made furniture seems beyond our means. We should remember that we are unfortunately compelled to furnish a house of substantial size for the same sum that it costs to build, say, a wagon-lit. We must recognize that it is impossible to do this properly. A century ago hundreds of thousands would be paid for a cabinet in a castle, but today we are inclined to reproach the modern age with a lack of elegance and poverty just where it might have the most unexpected effect given the necessary controls. Only the nouveaux riches can be satisfied with stylish imitations and replicas. Today's middle-class citizen, like the worker, must take pride and recognize his own worth; he should not vie with other classes whose cultural tasks have been accomplished and who can justly look back on a splendid

Moritz Jung, Illustration for the second theatre programme for the ''Fledermaus'' cabaret, Vienna 1907. Lithograph. Verlag der Wiener Werkstätte.

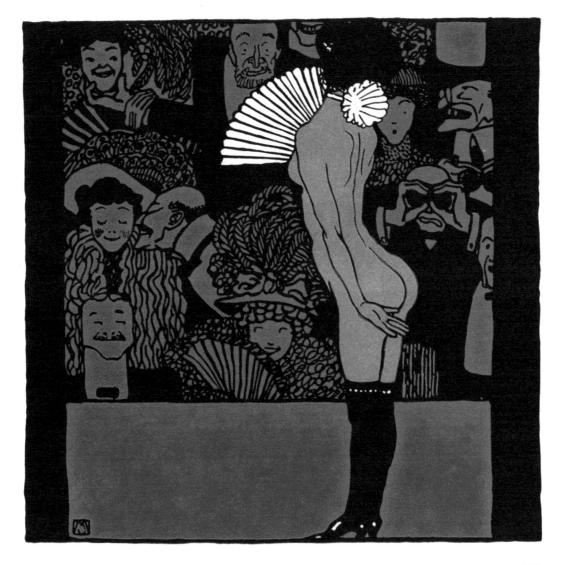

Oskar Kokoschka, Illustration from "Die träumenden Knaben" (8 colour lithographs for one of his own poems), 1908. Colour lithograph. Verlag der Wiener Werkstätte.

past of artistic achievement. For many years our middle classes have failed to fulfil their artistic duties. It cannot possibly suffice to buy paintings, however beautiful. So long as our cities, our houses, our rooms, our cupboards, our equipment, our clothes and our jewellery, so long as our speech and our feelings do not embody the simpler, plainer, and more attractive spirit of our age, we shall be eternally far behind our ancestors, and no lie can hide our weakness from us. We must be permitted to remark that we too are conscious that under certain circumstances we can create a tolerable mass-produced article with the help of machines, but this must without fail bear the stamp of its provenance. We do not consider it to be our task to enter this field at present. What we are seeking is what the Japanese have always done. Who would try to produce any piece of Japanese applied art on a machine? We shall attempt to do what lies within our capabilities, but we can only take a step forward if we have the co-operation of all our friends. We do not have the right to indulge in fantasies. We stand with both feet firmly on the ground, and we need tasks.

Franz Wacik, Illustration for "Münchhausen". Publ. Gerlachs Jugend-bücher, Vienna/Leipzig 1906. Slightly reduced.

EASTERN EUROPE

HUNGARY, CZECHOSLAVAKIA, POLAND AND RUSSIA

The Eastern European countries have been grouped here for practical rather than historical reasons. Politically, of course, before the First World War much of this area formed part of the Austro-Hungarian Empire—indeed, the names of a number of the artists mentioned in the chapter on Austrian Art Nouveau betray an Eastern European origin. Practically, however, they present similar problems for the Western art historian, for on the whole we have only a scanty knowledge of the documents and have access chiefly to artists who worked in Western Europe, in Germany or more importantly in Paris. The situation is, however, constantly improving, with new research being done and information shared through international exhibitions and publications. We are indebted to our Polish contributor, W. Jaworska, for valuable information on Polish and Russian Art Nouveau artists.

In Hungary, the state most closely allied politically to Austria, we not surprisingly find that the closest artistic connections were with Vienna, and many illustrators worked entirely in the Viennese idiom. A notable exception is Joszef Rippl-Ronai, probably the most gifted Hungarian artist of this period, who developed his talent in Paris, where he was part of the circle of the Nabis. In 1889 he visited Pont-Aven, and he used what he assimilated there in a number of works, including the lithograph reproduced on p. 261: the influence of Emile Bernard's "Breton Women in the Meadow" is plain, though Rippl-Ronai's picture is more rhythmic and dynamic in composition. (The same artistic influences can be detected in Munch's "Dance in the Summer Night" in Oslo.)

From Czechoslovakia the most important Art Nouveau artist was Alfons Mucha, who is known above all for his posters. At the age of twenty seven he went to Paris, where he was soon forced to work for a living, and swiftly became famous as a commercial artist and a set designer for Sarah Bernhardt. In all his work, however fashionable, there remains something of the charm peculiar to Vienna—charm not of the Art Nouveau period but of the previous era, dominated by the opulent, sensual paintings of Hans Makart. This idiosyncratic blend of historicism and Art Nouveau gives Mucha's work its distinctive fascination, but it also provoked a strong hostile reaction on the part of the younger generation against the art of the turn of the century.

Mucha's fellow-countryman, František Kupka, lived in Paris from 1895 onwards. He took no part in the Art Nouveau movement, but there is a reminder of Viennese Art Nouveau in the formal relationships in his first fully abstract pictures and drawings after 1911. Strongly influenced by Art Nouveau, though he belongs properly to the following period, was Jan Preisler, who designed the posters for an exhibition in Prague of works by the colony of artists living at Worpswede in Germany. Reminiscences of their lyrical view of nature, and of the paintings by Puvis de Chavannes (who was a corresponding member of VER SACRUM and had exhibited in Vienna) appear in Preisler's work in a more dynamic and vivacious form, which suggests the Café du Dome group. In a striking way, he plays a series of variations on each pictorial motif.

The centre of Polish Art Nouveau was Cracow, home of the Sztuka Art Club, who in the years up to 1908 exhibited three times in Vienna as guests of the Secession. The most important names here are Wyspianski, Mehoffer, Karpinski, Slewinski, Wojtkiewicz and, in the first decade of the new century, Makowski. They too took ideas from Paris, above all from Puvis de Chavannes, Toulouse-Lautrec and especially Maurice Denis, and transformed them into the idiom of their homeland. After 1900 Polish artists turned to Expressionism, and after that not to abstraction but back to realism.

Russian Art Nouveau was concentrated in two centres, each with a distinctive style: St. Petersburg and Moscow. The Petersburg group was conservative and neo-romantic, taking great delight in constructing an anti-realist world in opposition to the socially committed realism of painters like Repin. Benois, Somov, Bakst and Bilibin travelled through Germany to France, and became known and loved there as well as in Russia—Somov for his elegant historicizing illustrations, Bakst for his posters, costumes and sets for the Russian Ballet tour of Europe, and Bilibin for his fairy-tale illustrations in which the unreal, often surreal, world of the traditional Russian woodcut picture-book lived on. Support for the Petersburg attitude was expressed in reviews and articles in the journal MIR ISKUSSTVA ("The World of Art").

Moscow took an attitude which was much more realistic and more capable of development. As early as the mid-19th century it was clear that Moscow would stand at the opposite end of the spectrum from St. Petersburg, although its general cultural level was nothing like as high. It speaks for the realism of the Moscow spirit that there had already been an exhibition of posters there in 1897, which had early demonstrated the value and impact of poster art. The most influential painter for the subsequent development of European art came from Moscow: Wassily Kandinsky, whose work derived from Russian folk picture-books, like

Bilibin's, but was from the beginning stronger and more dynamic. He used kaleidoscopic blossoming particles of colour which the observer himself must organize into a picture, and similarly in his monochrome work the fairy- and folk-tale illustrations take shape from a host of white flecks against a black ground.

The circle in which Kandinsky's art developed, that of the very fine painters Konstantin Juon and Philip Maliavin, is as yet little known in the West. It was in the Art Nouveau period that Russian pictorial art began to make an impact in Europe. It reached its peak after the October Revolution, but then swiftly declined—just as the Bauhaus and De Stijl, European movements in which Russian ideas were fruitfully developed, came to an early and obscure end. The study of the period from the late 19th century to the mid-1930's clearly illustrates the need and benefits for Europe of cultural exchange between nations.

ALFONS MARIA MUCHA

Alfons Maria Mucha was a Czech painter, graphic artist and craftsman. Born 24 July 1860 in Ivancice (Eibenschütz, Moravia), died 14 July 1939 in Prague. 1877 moved to Vienna, where he worked as a scene painter. After the Ringtheater fire in 1881 he worked for Graf Khuen-Belessi, who made his study at the Munich Academy possible. After 1887 in Paris, studying at the Académie Julian and at the Académie Colarossi. From 1889, after the death of his patron, made his living as an illustrator. His first poster for Sarah Bernhardt (1894) brought him fame in Paris as a master of Art Nouveau. This poster marked his first breakthrough to a new style— indeed it was called "Style Mucha" at the time in Paris. 1900 exhibited several works at the Exposition Universelle. 1904 travelled to America, where he designed stage sets in New York and taught drawing and composition at the Art Institute in Chicago. Shortly before the First World War he returned to Prague. Apart from various lithographs, the Prague years produced principally "L'Epopée Slave" ("The Slav Epic"), a series of 20 monumental pictures. Mucha was buried in the pantheon of Czech artists, the old castle of Vysehrad.

Mucha and his muse, Sarah Bernhardt, for whose publicity he was almost exclusively responsible, gave Art Nouveau a distinctive new flavour. The elegant women's faces, wreathed ornamentally in hair and trails of flowers, or set against a background of fragmented colour, remind one of Viennese Art Nouveau—which Mucha may well have influenced, for many Austrian artists must have seen his posters in Paris. In the JOB poster reproduced here there is an extreme contrast between the linear decoration and the melting tones of the face, and the different golds laid over one another in the hair are scarcely reproducible by modern printing methods. The same fine feeling for rich decorative contrasts is evident in the scattering of silver stars on the violet evening sky behind the figure of the lady with the camellias. From a cycle of pictures representing the seasons, where equally fashionable female figures stretch in the grass or let birds feed from their hands, comes the picture of Winter illustrated here, in which the artist strikes a suddenly intimate, almost melancholy chord, and evokes a mysterious, fairy-tale atmosphere that one would hardly have expected from him.

Jiri Mucha said of his father: "It was a paradox characteristic of my father's life that again and again that aspect of his art which was most conditioned by fashion brought him most fame. He himself, however, was not aware of this, and in none of his lectures or writings on art does he give the slightest hint as to how he arrived at the style he then had. Probably he himself did not know, and if he ever concerned himself with this particular problem he ascribed it all to Destiny. For him his work was simply art, and his personal gift to draw and paint. Drawing and composition were his particular strength. His virtuosity in drawing was such that his compositions were the most harmonious possible.

"The sudden change in his style that occurred around Christmas 1894 remains puzzling to this day, since we know how indifferent he was to external influences—an attitude that eventually brought down upon him the wrath of an entire generation of artists. Even in Paris he was much more interested in science and politics than in the debates concerning new art forms. When I asked him what he thought of Gauguin and Van Gogh, he said that they were rowdies who spent their nights in dissipation. He was certainly not blind to his surroundings, but his own way was the most important to him. His art was of necessity personal, and nothing was so repugnant to him as merely imitating the masters.

"After the immense success of the posters for Sarah Bernhardt, which became collectors' items as soon as they appeared, the Champenois Press began the production of what they called 'decorative panels'. These were basically posters too, but without advertising text. They were printed on durable paper or on silk, and people had them framed like pictures or used them to decorate screens. Very soon ready-made folding screens were being produced with these prints, and a number of shops were specializing exclusively in a range of work by Mucha. The decorative panels all had the long narrow format that was so characteristic of his theatre posters. Unfortunately they were not all equally well produced, depending on how much proof correction my father carried out himself. The press was often in so much haste that there was no time for correction. In such cases a glance at the original is enough to show how much delicacy of line and colour were lost in the lithograph. In this context I would like to explain my father's technique,

Alfons Maria Mucha, Poster for JOB (cigarette paper), 1899. Colour ▷ lithograph. 53 × 40 cm.

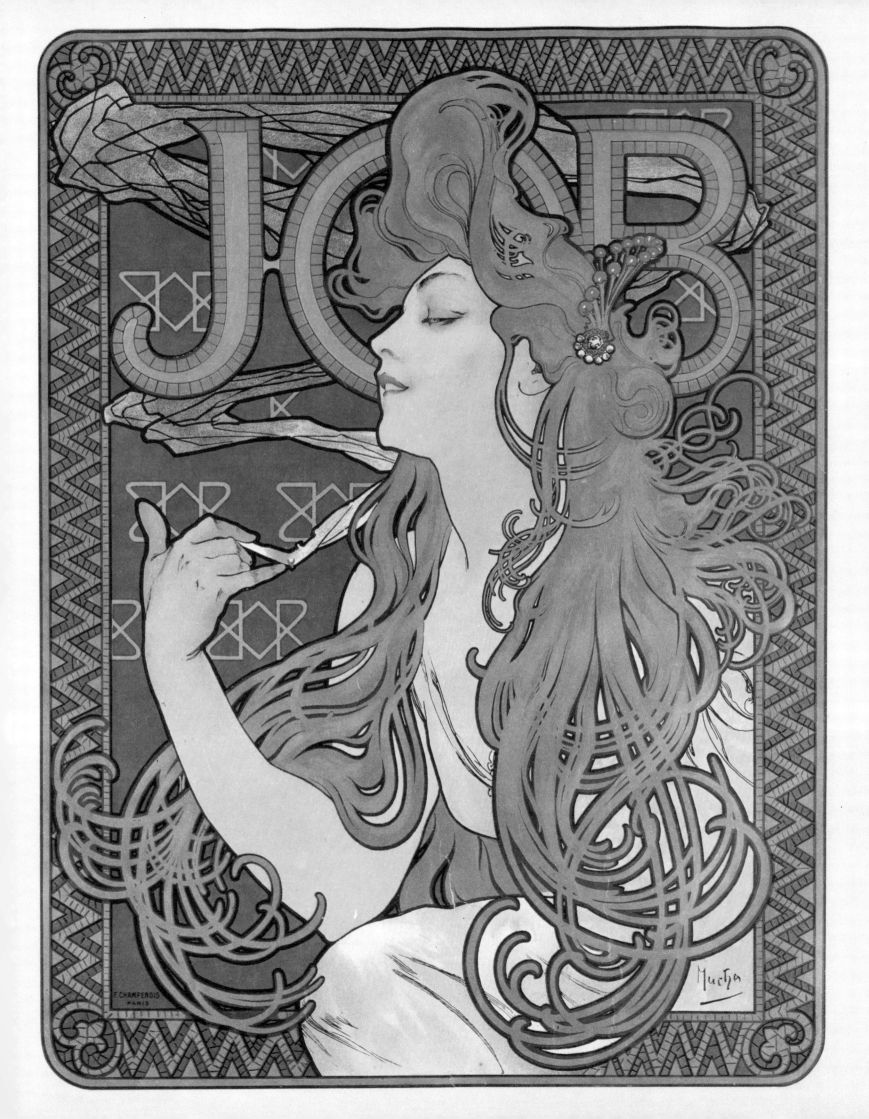

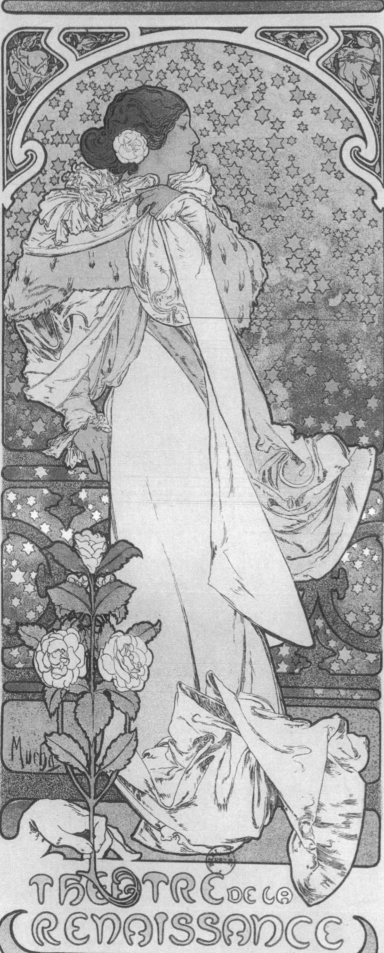

about which there has been needless controversy. My father first drew the design in coloured pencil, pastel, or occasionally watercolour. Several variants exist of many of the designs, since in his thoroughness he continued experimenting until he was entirely satisfied. Then he drew the panel full size on tracing paper and transferred the drawing from this on to the stone. The press produced several monochrome proofs, and not until then did he start using colour. He did this in order to avoid having to draw everything again from the beginning whenever some colour variation displeased him. The final colour original was thus a tinted monochrome print. After this stage came the colour proofs, the corrections and the printing on silk. This system of tracing drawings was used by Mucha again later, in the painting of large format pictures."

BIBLIOGRAPHY: Mucha, J., "Meister des Jugendstils". 1965. – "Alphonse Mucha et son Oeuvre" (Ouvrage collectif) Paris 1897, (Société anonyme LA PLUME 1897, in- 80, 94 p. ill). Reade, B., "Art Nouveau and Alphonse Mucha". London 1963 (Victoria and Albert Museum "Large Picture Book" No. 18). – Alphonse Mucha exhibition catalogue Galleria del Levante, Munich 1967.

WORKS: Posters for Sarah Bernhardt, JOB cigarettes, the SALON DES CENT, Chocolat Masson, RUINART Champagne, the 1900 World Exhibition; colour lithographs including: The Four Seasons, Twelve Months and individual sheets; book illustration: Documents décoratifs, Figures décoratifs, Ilsée, Le Pater, Au son de cloches de Noel et Pâques; book jackets and titles for journals (COCORICO, The West End Review); menus, calendars, work for the NEW YORK DAILY NEWS and others.

Alfons Maria Mucha, Poster for Sarah Bernhardt as "La Dame aux Camélias", (Théâtre de la Renaissance). Colour lithograph. 32.9 × 11.2 cm.

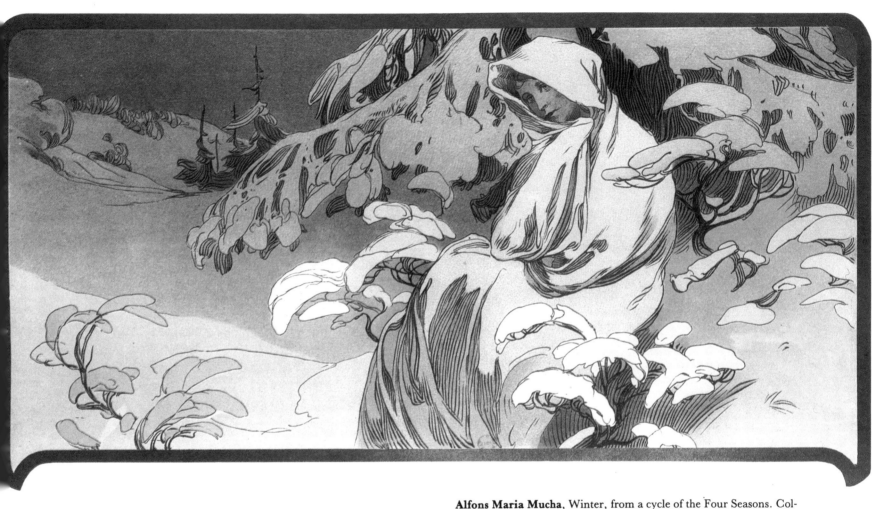

Alfons Maria Mucha, Winter, from a cycle of the Four Seasons. Colour lithograph. Later printed in a reduced format as a postcard.

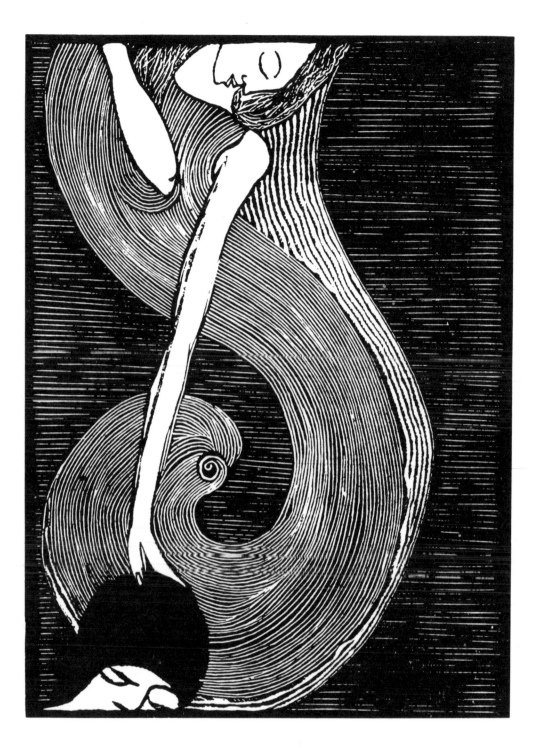

Josef Váchal, The Little Elf's Pilgrimage.
1911. Woodcut. 18 × 13 cm.

JIRI KODALIK: ART NOUVEAU IN CZECHOSLOVAKIA:

Czech painting of the 1890's faithfully reflects all the trends and pre-occupations of the time. It is therefore a complex subject, and deserves the attention that has been given to it by art historians, even though they seem to confine themselves to a few of the major artists. About the less well-known painters we are still relatively ignorant. They are, nevertheless, equally significant in that they also form part of the intellectual climate of their age.

At the end of the 19th century a new generation of artists arose who brought renewed life to Czech painting. In their creative fertility they can be compared to the poets of the same era, and indeed painting and poetry were unusually closely linked. Both sought to realize the same ideas and purposes, and both used similar devices of form, rhythm and nuances of colour. Almost every trend in Czech literature can be paralleled in painting.

The previous decades had seen a very slow, sometimes a positively sluggish, development. Now the pace quickened. The artists of the so-called "National Theatre Generation" were those who enjoyed the greatest public acclaim. Many of them were aware of the new style that was emerging; some of them even understood it; but their concept of a monumental type of art capable of expressing ideas valid for all time and all people was no longer appropriate in an era when class conflict was becoming ever fiercer.

We have already noted how the new movement drew together several tendencies chacteristic of the period. The first such tendency was that towards realism, or rather naturalism. Artists of this persuasion made a valiant attempt to proclaim the new era in their own terms, but they lost impetus and failed. Their achievements were superficial, centring on important public events. The second tendency was that towards Impressionism. Reality was the starting point for these artists too. They tried to convey not just the transient appearance of things but the concentrated essence of nature and her manifestations. They turned mostly to landscape, attempting to solve particular problems of light and colour. The third tendency was towards Symbolism, the importance of which has long been

František Bílek, The Prophet. About 1910.
Woodcut. 6.2 × 9.8 cm.

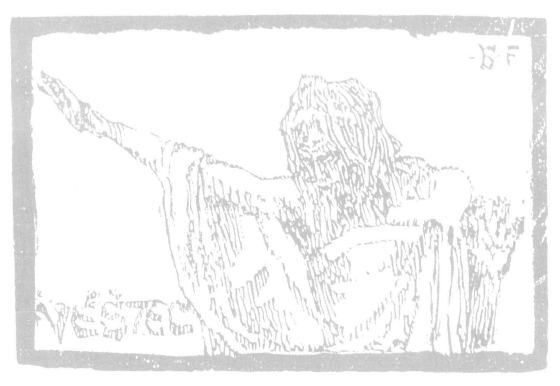

František Kobliha, Loneliness. Woodcut 29 × 23 cm.

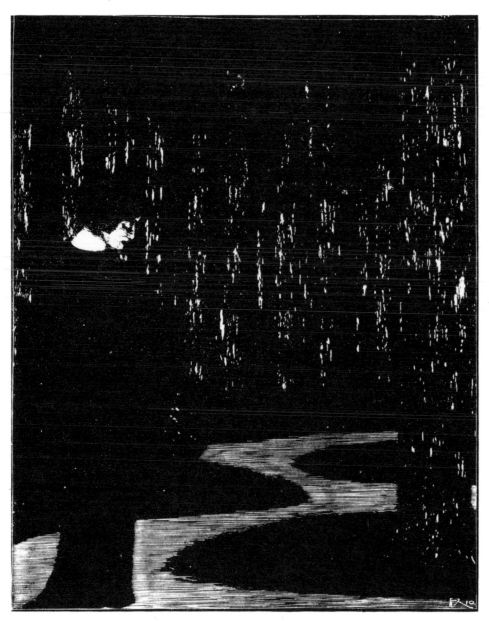

underestimated. The Symbolists tried to combine reality and ideals through the pictorial expression of desires and dreams. It was a very personal style, emphasizing the individual element within the formal scheme. The fourth tendency was towards the decorative; themes originally derived from realism were translated into pure rhythm, line, surface and colour. This school has long been underrated by art historians, often ignored altogether. It has been regarded as an artistic dead end, decoration being seen as a legitimate aim only in the the crafts, not the arts. But the relation between craft and art has not been fully understood. We now see that this decorative tendency was one of the roots of Art Nouveau, influencing the course of late 19th- and early 20th-century art far more than used to be admitted.

To give an adequate idea of Czech painting in the 1890s, it is not enough to single out a particular movement which is then christened 'dominant' - as Impressionism was. Nor should we simply divide art movements into two opposing schools called "realist" and "idealist". The truth is more complicated. A complete image of the period has to include a whole multitude of thoughts, forms and aspirations. It is therefore pointless to try to trace exact sequences or precise relationships. On the contrary, one must see everything happening simultaneously, overlapping and interdependent. Art Nouveau is not a separate, distinct phenomenon. It is something that can combine and live with other styles—Impressionism, Symbolism, even realism. It permeates the age, it subjects itself to the spirit of the time and loses itself in it.

FRANTIŠEK BÍLEK

Czech sculptor and graphic artist. Born 6 November 1872 in Chynové near Tabor, and died there 13 October 1941.

FRANTIŠEK KOBLIHA

Czech painter and graphic artist. Born 17 November 1877 in Prague, died 12 December 1962.

JOSEF VÁCHAL

Czech painter and graphic artist. Born 23 September 1884 in Milavci.

Most Czech Art Nouveau artists visited Paris, and their style shows the impact of the Nabis, though German-language art journals were also influential. Kobliha's woodcut reproduced here recalls the Nabis in the ornamental serpentine band of the road, the monumental, seemingly limbless figure, and the contrast between the densely structured patterning of the background and the light clear area of the face. If Kobliha derives from a naturalistic tendency within French Art Nouveau, Bílek and Váchal stem from the contrary idealistic, anti-naturalistic vein. Bílek was a sculptor, and his chiselled-looking woodcut, "The Prophet", recalls the Belgian sculptor Georges Minne in the pathos of the gesture and the furrowed detail of the surface. It also suggests the influence of Rodin, with whom Bílek worked. Váchal, with his linear rhythm, his dissolution of shapes and space in a series of curving parallel lines, and his stylization of faces and limbs, is the equal of the Dutch artist Toorop. The impulse towards abstract art is manifest in the way he shifts the more identifiable elements—the faces—to the edge of the picture, and fills the centre with an arabesque crossed by an unnaturally extended arm.

Two other Czech artists of note in the Art Nouveau period were Frantisek Kupka and Jan Preisler (see p.251). Kupka (Opocno 1871 — Paris 1957) drew satirical cartoons, somewhat in the manner of those in the Munich journal SIMPLIZISSIMUS, for a weekly paper in which anti-capitalist, anti-clerical and anti-semitic ideas were expressed in line with avant-garde social criticism of the time. After 1910 Kupka turned to abstraction, combining ideas from French Orphism with elements from Viennese Art Nouveau to produce kaleidoscopic colour effects almost as brilliant as fireworks. As late as the 1920's his pen-and-ink drawings in pure line without tone, which look like designs for etchings, have an Art Nouveau flavour in their parallel streaks of light and dark curving across the surface in arabesques. His illustrations, too, recall Viennese Art Nouveau, especially the illustrative work of the Wiener Werkstätte. Jan Preisler (Popovice near Beroun 1872 — Prague 1918) worked in a manner not unlike that of Kobliha.

JOSZEF RIPPL-RONAI

Joszef Rippl-Ronai was a Hungarian painter and graphic artist. Born 24 May 1861 in Kaposvar, died there 25 November 1927. 1884 began studying art in Munich under J. Herterich. 1887-89 studied in Paris under Munkascy, with the aid of a State grant. 1889 visited Pont-Aven in Brittany. In Paris, became friends with the Scottish painter James Pitcairn Knowles and shared an apartment with him in Neuilly. Met Maillol. About 1890 he came into contact with paintings by Gauguin and Van Gogh, who replaced Whistler as an influence in his work. About 1893 he became acquainted with the Nabis, who had noticed his picture, 'Grandmother'. Took part in the exhibition at Le Barc de Bouteville. Friendship with Thadée Natanson of the REVUE BLANCHE. 1899 stayed for some time with Maillol at Banyuls-sur-Mer. 1900 large exhibition in Budapest of works produced in France. 1901 travelled in Holland and Russia. 1902 returned to his birthplace in Hungary, where he worked almost exclusively as a painter, and became the most important representative of the modern French-influenced school. "Villagers", which is closely modelled on Emile Bernard's "Breton Women in a Meadow", clearly shows his connection with the early phase of French Art Nouveau. The impression of a country scene is here similarly rendered by the reduction of figures to characterful outlines, the use of flat areas of solid colour, and the tilting up of perspective to a high horizon line. The composition grows out of the random grouping of people.

"During the long years in Neuilly Rippl-Ronai managed not only to become personally acquainted with the circle of the Nabis but also to meet other artists whose names were already known or who were already respected by their colleagues. He had a particularly deep admiration for the art of Puvis de Chavannes. Clearly he prized above all the strong and well-organized structure of that artist's composition, which he emphasized in complete contrast to the Impressionists. This is extremely interesting in that Rippl-Ronai at the time referred to himself as an Impressionist painter, although his black period made him remote from the principles of Impressionism. The basis of composition was for him decorative unity, to achieve which he arranged his forms as far as possible without destroying the decorative rhythm, in flat areas or masses. Such a method relies on concentration and omission, and the artist made bold use of his right to omit. He simply left out those shapes which he was unable to associate formally with all the others. A deep chasm divides this method of composing from the optical theory and atmospheric word-picture of the Impressionists, but the main goal of the Post-Impressionists, a clear organization of spatial relationships, also left him cold. It was evidently the calm and simplicity of Puvis de Chavannes' art which attracted him.

"Following the fashion of the time, he also illustrated books for collectors. This came about in a very curious way.

Pitcairn Knowles had the idea of making monochrome lithographs in an archaic style to illustrate an imaginary book that he called 'Les Tombeaux'. At the same time his Hungarian colleague made four lithographs to which he gave the title 'Les Vierges'. Bearing these drawings, they sought out Bing, who had brilliant social connections. Bing commissioned the Belgian novelist Georges Rodenbach, author of the once popular novel 'Bruges la Morte', to write a text to accompany the existing pictures. The books appeared at Christmas 1895, with a text full of Symbolist rapture. In his illustrations Rippl-Ronai then favoured decorative linear rhythms, doubtless under the powerful influence of Maurice Denis.

"All his life Rippl-Ronai was an enthusiastic draughtsman, with a vivid and receptive interest in the appearance of the world about him. Even pastel did not seem a rapid enough medium to capture fleeting impressions. However, his development as a draughtsman had its roots elsewhere. After his detailed and formal academic studies in Munich, Rippl-Ronai swung to the other extreme, to a style built up of decorative contour lines, and his drawings of this later period are companion pieces to 'Les Vierges'. He himself attributed this style to Japanese influence. It is well known that the fruitful influence of Far Eastern art may already be discerned in Rococo architecture, sculpture and painting, and the Impressionists owe as much as do their opposites, the Post-Impressionists, to this exotic and capriciously beautiful art with its highly developed graphic techniques. Rippl-Ronai was a frequent visitor to the Musée Guimet, where he admired not the colourful woodcuts of the famous masters Hokusai, Sharaku and Utamaro, but rather the works of those artists closer to the Chinese tradition and hence more delicate, less concerned with externals. He succeeded in acquiring several ink drawings by Sesshu, and was enraptured by the sophisticated way in which they rendered only what was essential and left out everything else. Nevertheless, the characteristic style of his Neuilly period drawings derives not from the Far East but rather from the distinctive decorative manner of his friends the Nabis. Of all his group it was he who drew most assiduously and with most pleasure." (I.Genthon)

BIBLIOGRAPHY: Rippl-Ronai, Jozsef, "Joszef emlékezésci". Budapest 1911. – Kallai, E., "Neue Malerei in Ungarn". (Die junge Kunst in Europa. II). 1925. – Genthon, I., "Rippl-Ronai. Der ungarische 'Nabi'". 1958. – Petrovics, E., "Rippl-Ronai". Budapest no date – Pewny, D., "Rippl-Ronai Jozsef". 1940. – Wertheimer, K., "Lettres d'Aristide Maillol à Jozsef Rippl-Ronai". (MÜVÉSZETTÖRTÉNETI ÉRTESITÖ) (Art History Gazette) 1953, p. 110–118 (French and Hungarian).

WORKS: Contributed to the REVUE BLANCHE; colour lithographs (individual sheets).

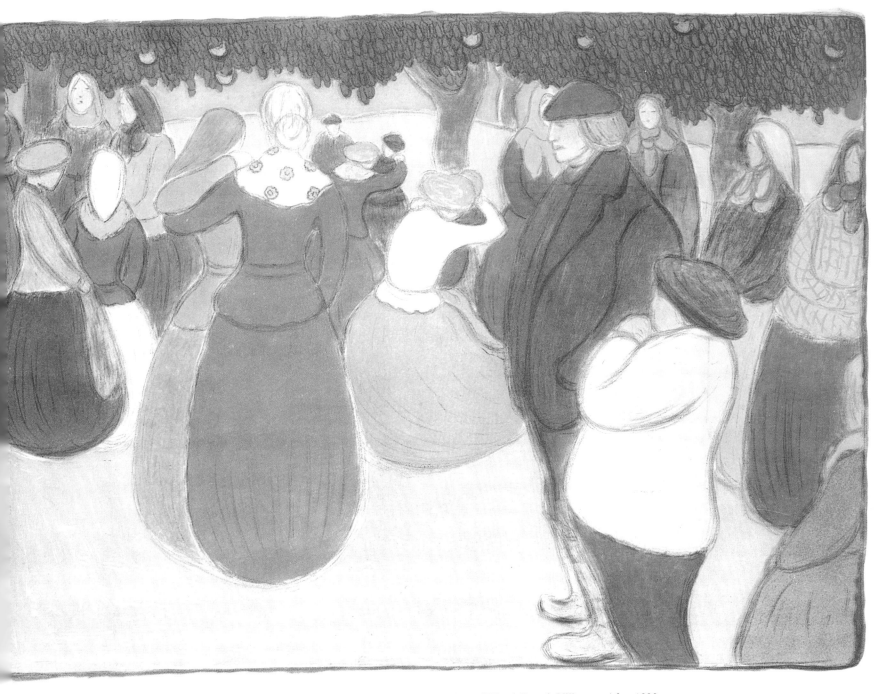

Joszef Rippl-Ronai, Villagers. After 1890.
Colour lithograph. About 47 × 64.

WYSTAWA DRUKARSKA W KRAKOWIE MDCCCCIV

Jan Bukowski, Catalogue cover for the exhibition of printing in Cracow 1904. 20 × 15.2 cm.

Jan Bukowski, Title-page for "Dialogue about ▷ Art" by Oscar Wilde. 1906. 16.8 × 11 cm.

JAN BUKOWSKI

Jan Bukowski was a Polish painter, graphic artist and craftsman. Born 1873 in Barszczowice, died 1943 in Nowy Targ. From 1893 at the Crakow Academy under Luszczkiewicz, Axentowicz and Wyczólkowski. 1900 studied graphic art in Munich. Made study trips to Germany, Italy and France. 1901 joined the Sztuka Club in Crakow and was co-founder of the POLSKA SZTUKA STOSOWANA. 1904-15 director of the Crakow University Press. From 1912 professor at the Cracow School of Arts and Crafts.

At first Bukowski painted landscapes, portraits and genre scenes, but gradually he turned to decorative mural paintings (for instance in churches, using stylized flower motifs in Cracow) and book illustration. In the latter field, where he stands as a successor to Wyspianski, he was a convinced exponent of a traditional style with carpet-like ornamentation and baroque framing. Together with Wyspianski's, his prolific output had a great influence on the development of Polish commercial art.

262

OSKAR WILDE

DYALOGI·O·SZTUCE

JAN BUKOWSKI

STYCZEŃ

1	N.	MIECZYSŁAWA KR.	17	W.	ANTONIEGO OPATA
2	P.	MAKAREGO I MART.	18	Ś.	PRYSKI PANNY
3	W.	DANIELA I GENOW.	19	C.	FERDYNANDA, HEN.
4	Ś.	EUGENIUSZA BISK.	20	P.	FABIANA P. I SEBAST.
5	C.	TELESFORA B. M.	21	S.	AGNIESZKI P. MĘCZ.
6	P.	TRZECH KRÓLI			
7	S.	JULIANA I LUCYANA	22	N.	WINCENTEGO
			23	P.	RAJMUNDA W.
8	N.	SEWERYNA OPATA	24	W.	TYMOTEUSZA B. M.
9	P.	MARCYANY PANNY	25	Ś.	NAWR. ŚW. PAWŁA
10	W.	AGATONA I WILH.	26	C.	POLIKARPA B. M.
11	Ś.	HYGINA P. M. I HON.	27	P.	JANA CHRYZOSTOMA
12	C.	ARKADYUSZA I TAC.	28	S.	WALEREGO I JUL.
13	P.	GOTFRYDA I LEONC.			
14	S.	HILAREGO I FELIKS.	29	N.	FRANCISZKA SALEZ.
			30	P.	MARTYNY I HIACYNT.
15	N.	IM. JEZUS. PAWŁA	31	W.	PIOTRA NOLASCO
16	P.	MARCELLA P. M.			

J. B.

Jan Bukowski, Calendar page for January 1905 from the
catalogue of the Cracow exhibition of printing, 1904. 21 × 15.3
cm.

CZERWIEC

1	C.	WNIEBOWST. P. JEZ.	16	P.	BENONA B. W. JUST.
2	P.	MARCELINA EUGEN.	17	S.	ADOLFA B., JOLANTY
3	S.	ERAZMA B. M. I KLOT.	18	N.	TRÓJCY PRZENAJŚW.
4	N.	FRANCISZKA W.	19	P.	JULIANY FALKONER
5	P.	BONIFAC., FAUST.	20	W.	SYLWEREGO P. M.
6	W.	NORBERTA I PAUL.	21	Ś.	ALOJZEGO GONZAGI
7	Ś.	ROBERTA OP. W.	22	C.	BOŻE CIAŁO, PAUL.
8	C.	MEDARDA I WILH.	23	P.	N. M. P. NIEUST. POM.
9	P.	FELICYANA M. I PEL.	24	S.	NAR. Ś. JANA CHRZC.
10	S.	MAŁGORZ. SZK. MAX.	25	N.	WILHELMA OPATA
11	N.	ZESŁ. DUCHA ŚW.	26	P.	JANA I PAWŁA BR.
12	P.	ESCHILA B. M., JANA	27	W.	WŁADYSŁAWA KR.
13	W.	ANTON. Z PADW. W.	28	Ś.	LEONA P. I IREN.
14	Ś.	BAZYLEGO W.	29	C.	PIOTRA I PAWŁA AP.
15	C.	WITA, MODESTA MM.	30	P.	SERCA JEZ., LUCYNY

Jozef Mehoffer, Calendar page for June 1905, from the catalogue of the Cracow exhibition of printing, 1904. 20.3 × 15.4 cm.

Stanislaw Wyspianski, Illustration for "Poems" by Lucjan Rydel. Warsaw 1901.

BIBLIOGRAPHY: Munnynck, P.M., "Les vitraux de Mehoffer". Freiburg 1934. – Peretiatkowicz and Sobieski, WSPOLCZESNA KULTURA POLSKA, Poznan 1932, p. 159. – Franqueville d'Abancourt, H. de., "Grafika ksiazkowa Jozefa Mehoffera na tle pradow wspolczesnych". Cracow 1929. – Catalogue of the Jozef Mehoffer, National Museum, Cracow. Cracow 1964 (Introduction by H. Blum). – Berthier, J., "Les vitraux de Mehoffer à Fribourg". Lausanne 1918.

STANISLAW WYSPIANSKI

Stanislaw Wyspianski was a Polish painter, graphic artist, poet and playwright. Born 1869 in Cracow, died there 1907. 1887–91 studied at the Cracow Academy under Matejko, and made study trips to France, Italy and Germany. 1891-94 in Paris, at the Académie Colarossi. From 1895 permanently in Cracow, where he taught at the Academy of Art. A versatile genius, he was equally famous as an artist and as a dramatist. He designed sets for his own plays, and ornaments and illustrations not only for his own and his friends' books, but also for the journal ZYCIE ("Life"), which he edited with Stanislaw Przybyszewski. He was also of crucial importance for the beginnings of commercial art in Poland. Wyspianski sought new possibilities for graphic art, and his books, decorated with beautiful asymmetrical plant motifs, had a revolutionary effect on traditional Polish graphic art at the turn of the century.

BIBLIOGRAPHY: Wystawa typograficzna J.B. Cracow. 1947. – Smolik, P., "J.B. prace graficzne". Lodz 1930. – Grajewski, L., "Bibliografia ilustracji". Lvov 1933. – Klemensiewicza, Z., "Bibliografia Exlibrisu polskiego". Wroclaw 1952. – Warchalowski, J., "Polska Sztuka dekoracyjna", Warsaw 1928. – Olszewicz, B., "Lista strat kultury polskiej". Warsaw 1947.

WORKS: W. Orkan, Nad urwiskiem, Cracow, 1889; Kalendarz krakowski Jozefa Czecha, Cracow 1902; W. Panekowa, Kaj ten smrek siwy?, Cracow 1904; Friedrich Nietzsche, Dziela Werke, Warsaw 1905; A. Dygasinski, Lebensfreuden, Munich, 1905; K. Glinski, Krolewsky piesn, 1906; Oscar Wilde: Dialogi o sztuce, 1906; Bogurodzica, old Polish songs, Cracow 1910; Upanisazady, translation by F. Michalski, Cracow 1912; K. Chledosski, Rzym Ludzie Odrodzenia, Cracow 1909, and others.

JOZEF MEHOFFER

Jozef Mehoffer was a Polish painter, designer of stained glass, graphic artist and writer on art. Born 19 March 1869 in Ropczyce, died 8 July 1946 in Cracow. Studied under Mateyko at the Cracow School of Art. 1889–90 in Vienna, then till 1896 in Paris, at the Académie Colarossi. After 1897 in Cracow, where from 1900 he was professor at the Academy. Co-founder of the Sztuka Club.

Stanislaw Debicki, Initial for "Legends" by A. Niemojewski. 1901.

BIBLIOGRAPHY: S. W. Dziela malarskie (296 ill.), Text by S. Przybyszewski, T.Z. Skarszewski, S. Swierz. Bydgoszcz 1925. – Potocki, A., "S.W." Lvov 1902. – Kolaczkowski, St., "S.W." Poznan 1922. – Smilik, P., "Zdobnictwo ksiazki w tworczosci W.", Lodz 1928. – Szydlowski, "T.S.W." (monograph), Warsaw 1933. – Koczorowski, St. P., "S.W. odnowiciel piekna ksiazki polskiej 'Miesiecznik graficzny'", 1938, No. 4–6. – Skierkowska, E., "W. artysta ksiazki", Wroclaw 1950.

WORKS: Illustrations to own text: Klatwa, 1904 (3 editions); Kazimier Wielki 1900; Wesele, 1903 (3 editions); Akropolis, 1904; Legenda Cracow 1897; Achilleis, Cracow 1903; Noc listopadowa, 1904; Homer, Iliada, Cracow 1903; The Tragical Historie of Hamlet, Cracow 1905; Lucjan Rydel, Poezje (2 editions) Cracow 1901, Rocznik Krakowski, Cracow 1900 and others.

Stanislaw Wyspianski, Illustration for "The Iliad" by Homer. Cracow 1903 (Homer's Iliad has 11 illustrations by Wyspianski). 28.5 × 22 cm (book size).

ΟΜΗΡΟΥ
ΙΛΙΑΣ·
ΛΟΙΜΟΣ·ΜΗΝΙΣ

Μῆνιν ἄειδε θεὰ Πηληϊάδεω Ἀχιλῆος
οὐλομένην, ἣ μυρί᾽ Ἀχαιοῖς ἄλγε᾽ ἔθηκεν,
πολλὰς δ᾽ ἰφθίμους ψυχὰς Ἄϊδι προΐαψεν
ἡρώων, αὐτοὺς δὲ ἑλώρια τεῦχε κύνεσσιν
5 οἰωνοῖσί τε πᾶσι, Διὸς δ᾽ ἐτελείετο βουλή,
ἐξ οὗ δὴ τὰ πρῶτα διαστήτην ἐρίσαντε
Ἀτρεΐδης τε ἄναξ ἀνδρῶν καὶ δῖος Ἀχιλλεύς.
 Τίς τ᾽ ἄρ σφωε θεῶν ἔριδι ξυνέηκε μάχεσθαι;
Λητοῦς καὶ Διὸς υἱός· ὁ γὰρ βασιλῆϊ χολωθεὶς
10 νοῦσον ἀνὰ στρατὸν ὦρσε κακήν, ὀλέκοντο δὲ λαοί,
οὕνεκα τὸν Χρύσην ἠτίμασεν ἀρητῆρα
Ἀτρεΐδης· ὁ γὰρ ἦλθε θοὰς ἐπὶ νῆας Ἀχαιῶν
λυσόμενός τε θύγατρα φέρων τ᾽ ἀπερείσι᾽ ἄποινα,
στέμματ᾽ ἔχων ἐν χερσὶν ἑκηβόλου Ἀπόλλωνος
15 χρυσέῳ ἀνὰ σκήπτρῳ, καὶ λίσσετο πάντας Ἀχαιούς,
Ἀτρεΐδα δὲ μάλιστα δύω κοσμήτορε λαῶν

Achilla gniew — i klęski zeń spadłe na Greków
Śpiewaj, bogini, bogow śpiewaczko i wiekow:
Gniew śpiewaj, który w ciemne piekło zaprowadził
Tyle dusz i przed czasem tylu męży zgładził,
Na polach trupem całe położył zastępy,
Psy zwołał, i na ciała rzucił czarne sępy,
Przed losem i przed bożym upokorzył tronem,
Naprzod Achilla z czarnym skłóciwszy Memnonem.

Powiedz, w jakiej nieszczęsnej godzinie poczęta
Tylu nieszczęść przyczyna, ta kłotnia nieświęta?
Za jaką się swojego kapłana urazę
Mścił Apollo, okropną zwaliwszy zarazę
Na Greczyna obozy, tak że niesłychany
Był mor, i z trupow całe urosły kurhany?
A to wszystko, aby krol krzywdzący kapłany
Ujrzał się sam — w cierpiącym ludu ukarany.

8

9

Witold Wojtkiewicz, Initial for "Trzecia Godzina" by Jaworski, from the journal NASZ KRAJ. Lemberg 1908.

Mileva Stoisavljevic, The Grey Princess, from VER SACRUM, 1903. ▷
Woodcut. 18.5 × 12.5 cm.

WITOLD WOJTKIEWICZ

Witold Wojtkiewicz was a Polish painter and draughtsman. Born 1879 in Warsaw, died 1909 in Crakow. Studied at the Warsaw School of Drawing and the Cracow Academy. Painted fantastical compositions, illustrations for fairy-tales and pictures for children. Wojtkiewicz is one of the most outstanding Polish Symbolists and may also be considered a precursor of Surrealism.

BIBLIOGRAPHY: Exposition Witold Wojtkiewicz, Paris 1907 (preface by André Gide). – Nowakowna, Z., "Witold Wojtkiewicz", in SZTUKA I KRYTYKA, R. VII, 1956, No. 3–4, p. 104–138. – Juszczak, W., "Wojtkiewicz i nowa sztuka", Warsaw 1965.

STANISLAW DEBICKI

Stanislaw Debicki was a Polish landscape and genre painter and illustrator. Born 1866, died 1924. Studied in Munich, Paris, Lvov and Cracow. From 1909 a teacher and from 1911 professor at the Cracow Academy. A member of the Viennese Secession and the Sztuka Club; responsible for the decoration of the foyer of the Lvov Municipal Theatre. An outstanding graphic arist and illustrator, Debicki brought new life to the illustrative and printing arts in Poland. He was associated particularly with the Lemberg publisher Altenberg, for whom he designed countless vignettes, book jackets and illustrations.

WORKS: Oscar Wilde, Salome. 1905. – L. Rydel, Bajka o Kasi i krolewiczu, 1905. – A. Niemojewski, Legendy. 1901. – J. Kasprowicz, "Bajki, basnie i klechdy". 1902. – Contributions to the journal "Chimera", Warsaw, 1901–1907, and others.

BIBLIOGRAPHY: SZTUKI PIEKNE 1924, No. 2, p. 21–27. – Katalog Grafika St. Debickiego i Rud. Meckickiego, Lvov 1928. – Remerowa, Z.K., "O grafice Stanislawa Debickiegi, Lvob 1929. – Polski Slownik Biograficzny 5/1939/46.

Stanislaw Debicki, Cover for the journal CHIMERA, Warsaw 1901.
22 × 18 cm.

Edward Okun, Vignette for "Salve Regina" by Jan Kasprowicz, from the journal CHIMERA, 1901. 3.5 × 9.5 cm.

EDWARD OKUN

Edward Okun was a Polish painter, graphic artist and illustrator. Born 1872, and died 1945 at Skiernewice. Studied in Warsaw under Gerson, in Crakow under Jablonski and Mateyko, and in Munich and Paris. From 1921 lived permanently in Poland. 1925–30 professor at the Warsaw School of Art. From 1898 he exhibited in the TZSP in Warsaw, showing portraits and landscapes as well as graphic works.

BIBLIOGRAPHY: Czy wiesz kto to jest? 1938. – Olszewicz, B., "Lista strat kultury polskiej", Warsaw, 1947. – Grajewski, L., "Bibliografia ilustracji", Lvov 1933.

B. Zuckerkandl on Young Poland: "Everything had been taken away from them: the right to a fatherland, the freedom to decide for themselves, national unity. They had been cut to pieces, vivisected. They were required to assume three divergent cultures, submit themselves to three different processes of civilization and feel, conceptualize, shape their souls here to an Austrian pattern, there to a German and there to a Russian mould. But what resulted was merely a façade of political expediency, corresponding to a single momentary stage of political development. The mysterious primal strength of the race, which controls the workings of the soul's smothered fire with eternal laws like brilliant stars, preserved the ideal of a culture sprung from national soil, from the mothering earth and the fathering country. With a strong, even, rhythmical heartbeat, Polish culture and Polish art built up a united fatherland, sharing in all the yearning of the time, assimilating all the achievements of the latest movements.

"Cracow, the ancient city clustered round the citadel of the Wavel, was the centre of the Polish intellectual revival, and the little association of artists, the Sztuka, was the point where all cultural forces gathered and from which all cultural values emanated. Many of its members taught and worked in Cracow, but not all: here and there, scattered in Russian or German lands, artists managed to keep in close contact, encouraging and challenging one another, each working with firm resolution for the unity of Polish culture.

"The influence of the Sztuka in all this, and particularly in the revival of a national art, was very far-reaching. Behind it lay the outstanding genius of one man, Stanislaw Wyspianski. Here was a painter-poet whose personality seemed to have an uncanny ability to arouse and shape the ambitions of others. Impulses from him ran through all the visual and literary arts. He saw the relationship between life and art, seeking to make life itself into a work of art. As a painter his predominant quality was one of profound melancholy and perceptive imagination. As a poet, despite his talents, he failed to find a means of expressing the

Edward Okun, Cover for the journal CHIMERA, Warsaw 1902. 22 × 18 ▷ cm.

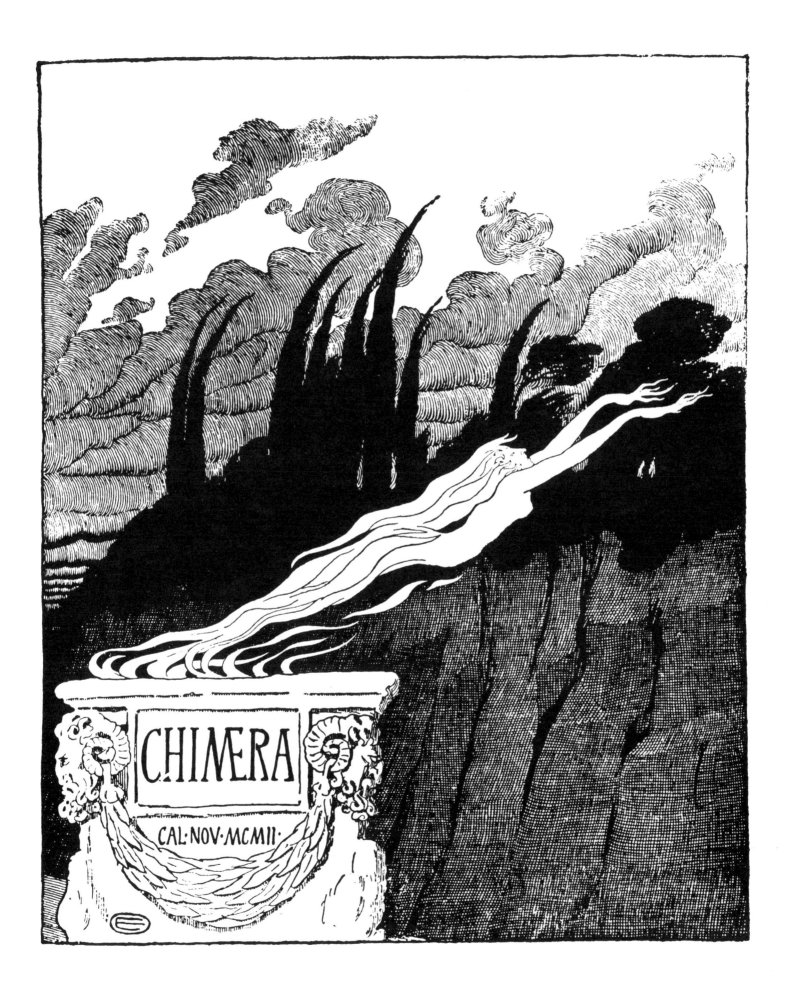

struggle for national identity and the ideals that the Sztuka stood for. Here it was perhaps Mickiewicz who best summed up the feeling in a single phrase: 'in the common people there dwells an inexhaustible strength'. The Sztuka took this literally: their programme for a national renaissance was based directly on the people—farmers, workers, simple folk close to the earth. By educating the people, they thought, the national ideal could be realized and with it the enrichment of all mankind. Sometimes this theory was put into practice in the most literal way. The poet Rydel and the painter Tetmayer actually married peasant women.

"Polish artists of this time had the rare advantage of a leading journal entirely and unreservedly dedicated to their cause—CZAS, published in Cracow. Paradoxically, from the political angle, this belonged to the other side: its editor was a member of the Polish National Conservative Party. But it nevertheless strongly supported the ideal of ennobling the people through cultural and ethical values. Here artists and journalists were at one."

Wassily Kandinsky, Woodcut from ''Xylographies'', 1907.

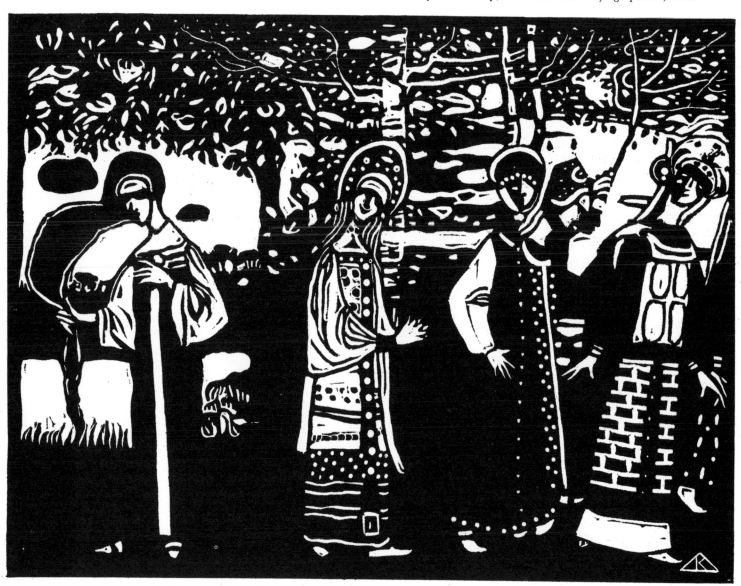

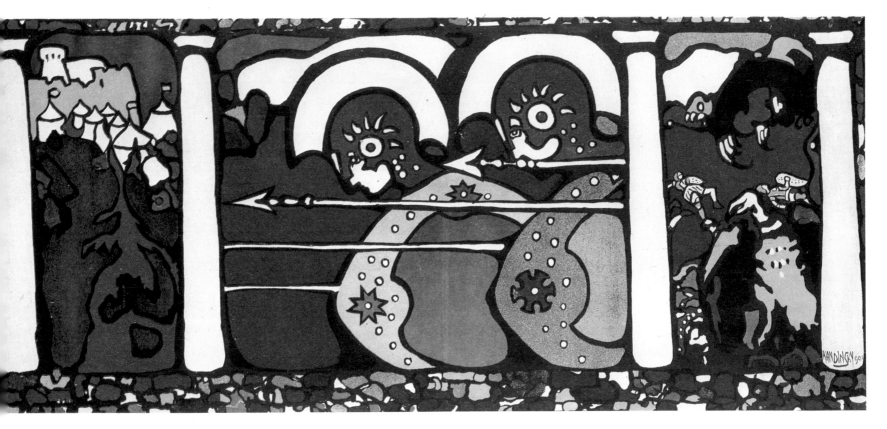

Wassily Kandinsky, Poster for the 1st Phalanx Exhibition, Munich. 1901. Colour lithograph. 48.2 × 65 cm.

WASSILY KANDINSKY

Russian painter and graphic artist. Born 4 December 1866 in Moscow, died 15 December 1944 in Paris. At first studied law and economics in Moscow: in 1896 he was a tutor in jurisprudence at Dorpat and made several investigative journeys into central Russia. Abandoned his academic career for art and moved to Munich. 1897/98 studied at the School of Arts and Crafts, then until 1900 in the studio of Franz von Stuck. 1901 co-founder of the Phalanx group. His first works in Munich were created under the influence of Art Nouveau and used motifs from Russian folklore. 1903–08 travelled to Paris, North Africa and Italy. 1909 co-founder of the Neue Künstlervereinigung (New Artists' Association) in Munich. 1910 painted his first abstract picture. 1911 founder member of the Blauer Reiter (Blue Rider). 1914 emigrated to Switzerland, and returned to Russia via Scandinavia. 1918 appointed professor at the Moscow Academy of Art. 1921 returned to Germany, where from 1922 to 1933 he was professor at the Bauhaus in Weimar and Dessau. 1933 emigrated to Paris.

WRITINGS OF W. KANDINSKY: Über das Geistige in der Kunst. 1912–1925 – Autobiography. 1913 – Punkt und Linie zur Fläche. 1926–1928 – Regard sur le passé. 1946 – Klänge. Prose poems with black and white and colour woodcuts printed from the wood. 1913 – Essays über Kunst und Künstler. Edited by Max Bill. 1955.

BIBLIOGRAPHY: Arland, M., "Kandinsky. 1947. – Bertram, H., "Kandinsky". 1947. – Bill, M., "Wassily Kandinsky". 1950. – Brion, M., "Wassily Kandinsky". 1960 – Buchheim, L.-G., "Der blaue Reiter und die "Neue Künstlervereinigung München". 1959. – Eichner, L., "Kandinsky und Gabriele Münter". 1957. – Etienne, Ch., "Kandinsky". 1950. – Grohmann, W., "Wassily Kandinsky". 1924. – id., "Wassily Kandinsky". 1930. – id., "Farben und Klänge – Zweite Folge (Gemälde)". 1956. – id., "Wassily Kandinsky. Leben und Werk". (containing a catalogue of his paintings and a detailed bibliography). 1958. – Rebay, H. v. (edited), "In Memory of Wassily Kandinsky". 1945. – Solier, R. de, "Kandinsky". 1946. – Vordemberge-Gildwart, "Kandinsky". 1944. – Zehder, H., "Wassily Kandinsky". – Wassily Kandinsky. Twelve original sheets of graphic work. 1922. – Special issue of the journal Sélection. Wassily Kandinsky. (containing a catalogue of his graphic works from 1903 to 1932 and a catalogue of his drawings from 1910 to 1932. 1933).

EARLY WORKS: Portfolio of xylographs, 1907; poster for the first Phalanx exhibition, Munich 1901; individual sheets including Singer and Pianist (coloured woodcut) 1903; Moonrise (coloured woodcut) 1904.

273

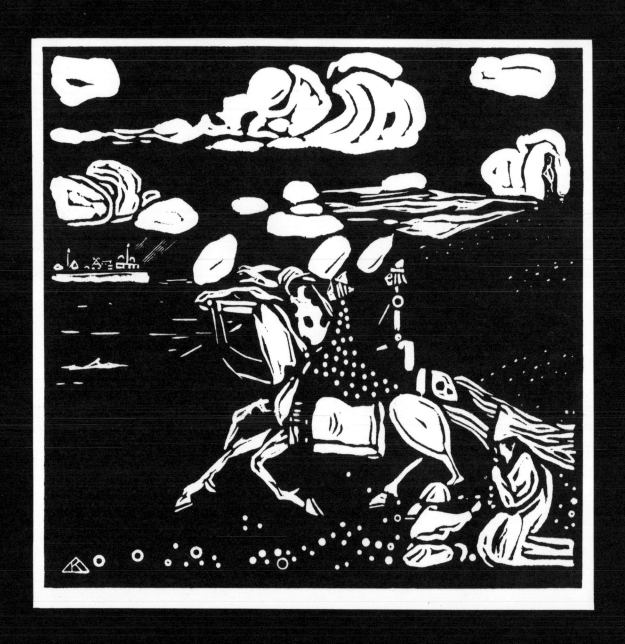

274

Wassily Kandinsky, Woodcuts from ''Xylographies'', 1907. Original size.

Юнга юрта

Alexander N. Benois, Illustration for the "Russian Alphabet in Pictures" by Asbuk W. Kartinach, from the "Ju" edition.

Alexander N. Benois, Illustration to a story by Henri de Regnier (La maison magnifique?) 1909.

ALEXANDER NIKOLAYEVICH BENOIS

Alexander Nikolayevich Benois was a Russian painter, draughtsman and writer on art. Born 1870 in St Petersburg, died 1960 in Paris. Initially studied law at St Petersburg University, but gave it up to devote himself fully to art, which he studied in Paris from 1897 to 1899. He soon became famous for watercolours, chiefly of scenes in the time of Catherine the Great and Louis XIV. A member of the Mir Iskusstva (World of Art) artists' society, he drew for the journal of the same name, and for APOLLON and SOLOIOJE RUND. Benois was also a designer for Diaghilev's Russian Ballet, and a spirited critic and illustrator.

WORKS: Amongst others, N. Kutiyepov, Okhota (The Hunt) 1902, together with other artists; Azbuk v kartinakh (Russian alphabet in pictures) 1904; Tsarskoye Selo, St. Petersburg 1910; A. Pushkin, Medny vsadnik (The Copper Horseman), St. Petersburg 1923; A. Pushkin, The Queen of Spades, with the first full page decorative compositions in Russian book illustration.

BIBLIOGRAPHY: A.N. Benois, in, "Russkaya shkola zhywopisi (History of Russian Painting) St. Petersburg 1904. – Ernst Sergey, "Alexander Benois, St. Petersburg 1921. – Zokolova, N., "Mir Iskusstwa", Moscow-Leningrad 1934. – Obolyaninov, H., "Zametki o russkikh illyustrirovannykh izdaniyach, Moscow 1916. – Sidorov, A.A., "Istoriya oformleniya russkoy knigi, Moscow-Leningrad 1946.

LEON NIKOLAYEVICH ROSENBERG, known as BAKST

Leon Nikolayevich Rosenberg was a Russian painter, draughtsman and theatrical designer. Born 1866 in St Petersburg, died 1924 in Paris. A student at the St Petersburg Academy and also educated in Paris; active in Moscow and Paris. He first became known as a painter: he showed a self-portrait in pastel in 1899 at the Munich Secession Exhibition, and "La Sultane rose" in 1911 at the Paris Salon d'Automne. His strength, however, lay in his decorative graphic work. He was a co-founder of MIR ISKUSSTVA, and a contributor to their journal as well as to APOLLON. In Paris he played an important role as designer and painter of sets and costumes for Diaghilev's Russian Ballet. His style is a highly interesting blend of Russian folk art with elements of modern French art, including Fauvism.

Bakst, from whom Diaghilev had commissioned the sets and costumes, was asked to attend the ballet rehearsals in order to give his opinion of Nijinsky's new 'creation'. At last, after several agonizing months, "L'Après-midi d'un Faune" was ready. Diaghilev was radiant with pride at the

Leon N. Bakst, Title page for the journal APOLLON, No. 11, St. Petersburg 1910. 16.5 × 13 cm.

thought that Nijinsky would for the first time be billed as choreographer in the programme. But an obstacle suddenly presented itself, as unexpected as it was ridiculous. The permission of Mallarmé's heirs was required. His daughter was dead, leaving only his son-in-law, Doctor Bonniot, a medical man, full of prejudice and bourgeois scruples, who held that what Nijinsky did with the nymph's veil was the height of immorality. In short, he banned the performance. Diaghilev, in a raging fury, called together a kind of honorary jury, and commissioned them to pronounce on the 'propriety' of the ballet. Rodin, then at the peak of his fame, declard that to speak of immorality in connection with this piece was utterly senseless; he himself gave it an enthusiastic reception.

Eventually the peformance took place in a very tense atmosphere. Part of the audience had already firmly decided to be disgusted—not so much by the unusual choreography as by Nijinsky's closing gesture in which he appeared to mate with the veil.

The next day an article appeared in LE FIGARO, signed Calmette, which fired the first salvo. "I am convinced", he wrote, "that none of our readers who were present in the Châtelet last night would blame me for raising an indignant protest against this improbable exhibition. It had been represented to us as a profound work of noble art and poetic concept. Anyone who uses the words art and poetry about this ballet can only be joking...We have seen nothing but a lascivious faun, whose erotic animal movements are emphasized in a completely shameless manner. That is all there is to say..."

LE TEMPS did not lag behind LE FIGARO, and soon the press was split into two camps, who also indulged in mutual vilification. It was Rodin, however, who aroused the widest sympathetic response with his article in LE MATIN: "Nijinsky has to the highest degree the advantages of physical perfection and harmonious proportions. In 'L'Après-midi d'un Faune' he reaches the very frontier of the miraculous, creating solely by means of carriage and gesture, without using jumps or leaps, a being almost entirely unselfconscious and close to nature. There is a perfect union between his art of mimicry and his physical control. He possesses the flawless beauty of antique frescos and statues. He is the ideal model for whom painters and sculptors have always been seeking. I wish that every artist passionately committed to his art could see this ideal embodiment of ancient Greek beauty."

Diaghilev carried this article with him wherever he went. It was one of the great joys of his life.

WORKS: Contributions to MIR ISKUSSTWA and APOLLON; N. Gogol, The Nose – Svetloff, Anna Pavlova – Le ballet contemporain.

BIBLIOGRAPHY: Levinson, A., "L'Oeuvre de Bakst pour le Belleau Bois dormant", in L'AMOUR DE L'ART, 1923, p. 211–216, – Levinson, A., "The Story of Leon Bakst's Life". New York and London 1923. – id., "L.B.", Berlin 1925. – Einstein, C., "Leon Bakst", Berlin 1927. – Alexandre, A., "L'ART DECORATIF de Léon Bakst", Paris 1913. – Zokolova, N., "Mir Iskusstwa", Moscow-Leningrad, 1934. – Obolyaninov, H., "Zametki o russkikh illyustrirovannykh izdaniyakh", Moscow 1916. – Sidoroff, A.A. (editor), "Russkoye knigopechataniye (Russian book printing) 1564–1917, Moscow 1964.

Constantin Somov, Vignette from "Das Lesebuch der Marquise" by Franz Blei. 4.85 × 12.2 cm.

Leon N. Bakst, Cover for the programme for ▷ Debussy's ballet "L'Après-midi d'un Faune". 1912. Colour lithograph.

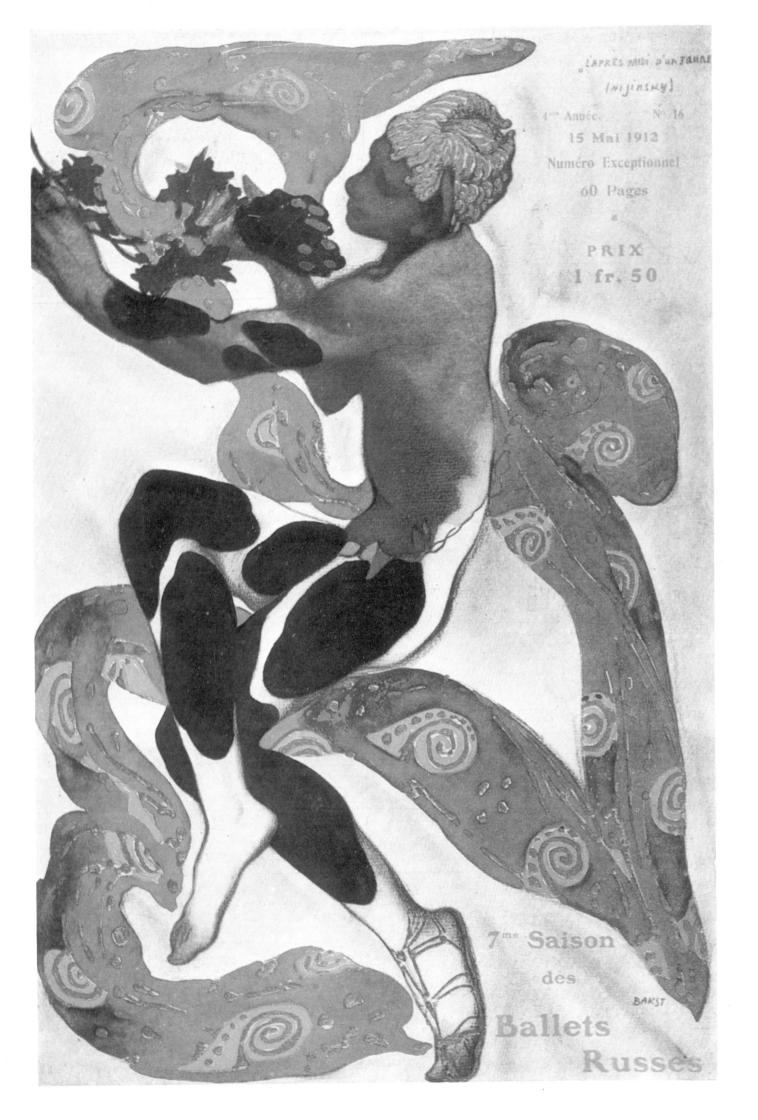

"L'APRÈS MIDI D'UN FAUNE
(NIJINSKY)

4ᵐᵉ Année. Nᵒ 16
15 Mai 1912
Numéro Exceptionnel
60 Pages

PRIX
1 fr. 50

7ᵐᵉ Saison
des
Ballets
Russes

BAKST

Constantin Somov, Illustration for "Das Lesebuch der Marquise". Verlag Hans v. Weber. Munich 1908.

CONSTANTIN ANDREYEVICH SOMOV

Constantin Andreyevich Somov was a Russian painter, book illustrator and commercial artist. Born 1869, died 1939. 1888–92 studied at the St. Petersburg Academy under Repin, then in Paris. A member of the Mir Iskusstva group; specialized in scenes inspired by Rococo and Neo-Classical Russia; and worked for the journals MIR ISKUSSTVA, ZOLOTOYE RUNO and TOISON D'OR.

YEVGENY YEVGENEVICH LANCERAY

Yevgeny Yevgenevich Lanceray was a Russian painter, graphic artist and theatrical designer. Born 1875, died 1964. 1895–99 studied in St.Petersburg and Paris. From 1911 artistic director of the State Stone-cutting Works. 1913 became an academician. 1917-34 lived and worked in Georgia. Lanceray was one of the most gifted graphic artists of the Mir Iskusstva circle, and a pioneer in book illustration and theatre design. He drew and painted scenes from the Russia of Peter the Great and Catherine the Great. Later he became famous for his monumental murals, including the ceiling of the Kazan Station in Moscow and work for the Moscow underground railway. He was also known as a writer on art.

Yevgeny E. Lanceray, Dining Room. Illustration for the journal MIR ISKUSSTWA, 1903.

Yevgeny E. Lanceray, Vignette for a poem by Tchernbina de Gabriac, in the journal APOLLON, St. Petersburg 1910. 17 × 13 cm.

WORKS: Illustrations to: Spaziergang der Marquise. 1909; Tagebuch der Marquise, Berlin 1921 and others.

WORKS: Illustrations for, amongst others MIR ISKUSSTWA, APOLLON, ZOLOTOYE RUNO and for Leo Tolstoy, Khadkhi-Murat, 1916.

BIBLIOGRAPHY: Babentchikoff, "Eugène Lanceray, 'Le Journal de Moscou'" 1936 (in French). – Bebenchikov, M.W., "E.E. Lanceray", Moscow 1949. – Lobanov, B.M., "Knizhnaya grafika E.E. Lanceray", Moscow-Leningrad 1908. – Lobanov, B.M., "E.E. Lanceray", Moscow 1952. – Polonsky, M. (editor), "Mastera sovremennoy gravyury i grafiki", Moscow-Leningrad 1928. – Kravchenko, K., "E.E. Lanceray", Moscow-Leningrad 1946. – Kurbatov, B., "Gruppa khudozhnikov 'Mira Iskusstwa'", Kiev 1912. – Sidorov, A.A., "Istoriya oformleniya russkoy knigi", Moscow-Leningrad 1946.

IVAN YAKOVLEVICH BILIBIN

Ivan Yakovlevich Bilibin was a Russian painter and graphic artist. Born 1876, died 1942. 1895–98 studied in St. Petersburg under Repin and others, and travelled to Italy and Switzerland to study. After 1918 lived in France. 1936 returned to the Soviet Union, to work as an artist and teacher. Died during the siege of Leningrad.

Bilibin was a member of Mir Iskusstva and was eventually known as an illustrator of Russian folk-tales and of the Byliny tales of Russian national heroes. His flat, decorative, richly coloured style was influenced by folk art, old Russian miniatures and ornaments. He also designed for the theatre.

WORKS: Amongst others, illustrations for Byliny, O Dobrinii Nikitiche, St. Petersburg, 1906; Ilya Muromets, St. Petersburg 1912; Vasilisa Prekrasnaya, St. Petersburg, 1902; A.S. Pushkin, Tale of the Tsar Saltan and his son, the famous hero Guidon, St. Petersburg, 1905; A.S. Pushkin, Zolotoy petushok (The Golden Cockerel), 1906/07.

BIBLIOGRAPHY: Dulskij, P. and Mieskin, J., "Illustratsiya v dedskoy knige", Kazan, 1925. – J.J. Bilibin-Albom, Moscow 1952. – L.J. Bilibin-Albom, Moscow 1961. – Die graph. Kuènste", Vienna 1932, 11. – MIR ISKUSSTWA 3, 1900. – Gankina, E.E., "Russkiye khudozhniki dedskoy knigi", Moscow, 1963.

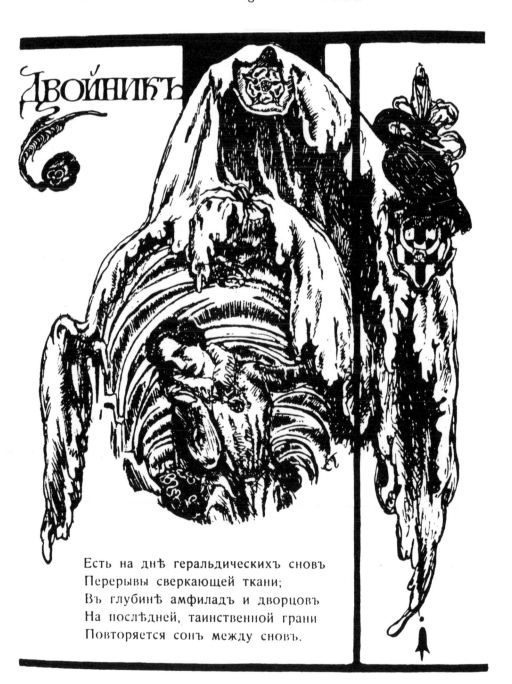

Есть на днѣ геральдическихъ сновъ
Перерывы сверкающей ткани;
Въ глубинѣ амфиладъ и дворцовъ
На послѣдней, таинственной грани
Повторяется сонъ между сновъ.

Ivan J. Bilibin, Illustration to Pushkin's fairy-tale "About the Tsar Saltan and his son, the famous hero Guidon". (dedicated to Rimsky-Korsakov), St. Petersburg. 24.4 × 31.4 cm.

Yevgeny E. Lanceray, Gibelle Bagour. Il- ▷ lustration in MIR ISKUSSTWA 1903.

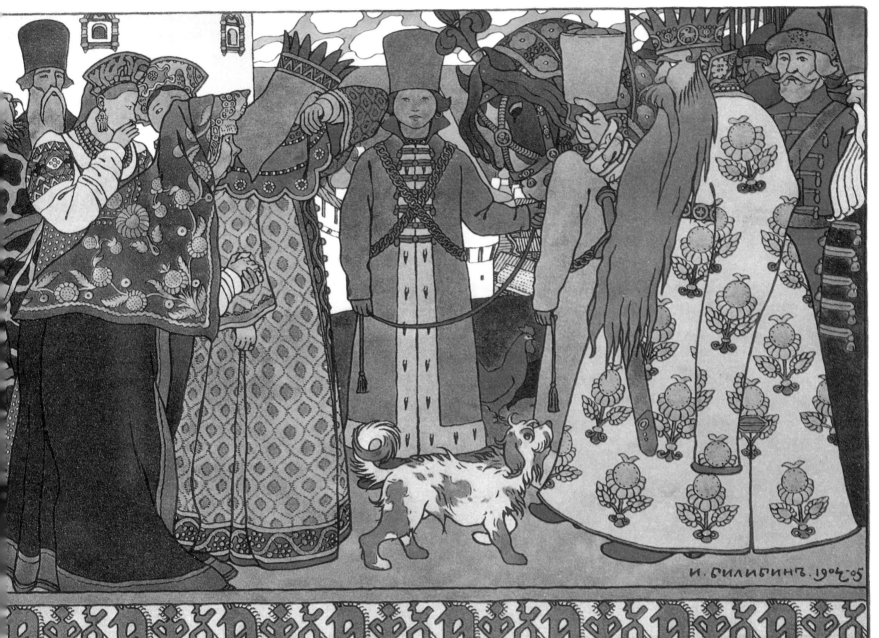

И. БИЛИБИНЪ. 1904-05

The fin-de-siècle generation especially admired Bilibin's children's books in which stories were told in a pictorial way. Kandinsky freely followed the same tradition in some of his Post-Impressionist works, so this is an appropriate place to look at the whole question of story-telling illustration as an art. Bilibin's narrative style was based on traditional popular Russian picture-books; events were recounted as a child might visualize them. Sometimes it was a single figure that was important, sometimes a dog

or, say, the pattern of flowers on a king's mantle. Sometimes one might have a whole landscape, the precise rendering of the flowers in the rosy foreground being as vital to the story as the wall-begirt city in the background. Or one could move easily into the realm of fantasy, representing the sun by a rider on a red horse. This sort of imagery appealed immediately to the imagination, whether of a child or of an adult.

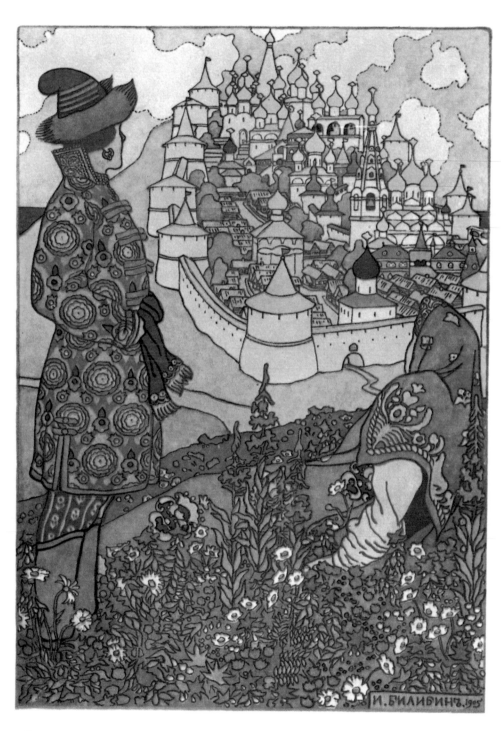

Ivan J. Bilibin, Illustration to Pushkin's fairy-tale "About the Tsar Saltan and his son, the famous hero Guidon". (dedicated to Rimsky-Korsakov). St. Petersburg 1905.

Ivan J. Bilibin, The Red Rider (Midday, or ▷ the sun). Illustration to the fairy-tale "Vassilissa, the Beautiful", St. Petersburg. 1902. 22.4 × 14.7 cm.

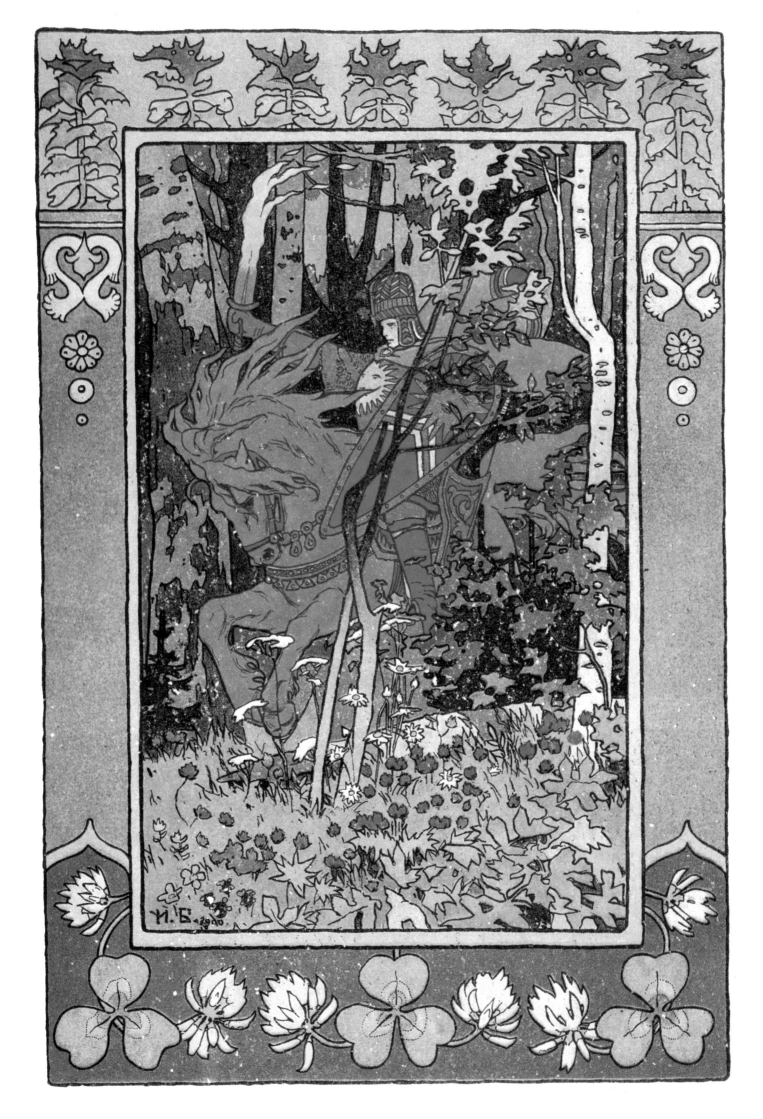

GENERAL BIBLIOGRAPHY

The works included in the bibliographies for the individual artists are all monographs. The following list is made up of general works which discuss the artists in a broader context.

GENERAL ACCOUNTS OF ART NOUVEAU AND THE PERIOD

F. Ahlers-Hestermann, Stilwende. Berlin 1941 (1956)

H. Bahr, Die Überwindung des Naturalismus. Dresden and Leipzig 1891

Id., Secession. Vienna 1900

O. Breicha and G. Fritsch (editors), Finale und Auftakt – Wien 1898–1914. Salzburg 1964

G. Busch, Worpswede gestern und heute. Bad Oeynhausen. No date

Ch. Chassé, Le Mouvement Symboliste dans l'Art du XIXᵉ Siècle. Paris 1947

W. Crane, Linie und Form. Leipzig 1901

I. Cremona, Die Zeit des Jugendstils. Munich/Vienna. No date (German edition). (Title of original edition, Il Tempo dell'Arte)

M. Denis, Théories 1890–1910. Paris 1920

W. Doede, Berlin – Kunst und Künstler seit 1870. Recklinghausen 1961

H.G. Evers, Vom Historismus zum Funktionalismus. Baden-Baden 1967

A. Fontaines, Mes Souvenirs du Symbolisme. Paris 1924

G. Fuchs, Mackintosh und die Schule von Glasgow in Turin, in DEUTSCHE KUNST UND DEKORATION 10, 1902

L. Gans, Nieuwe Kunst. De Nederlandse Bijdrage tot de Art Nouveau. Utrecht 1960

L. Hevesi, Österreichische Kunst im 19. Jahrhundert, zweiter Teil 1848–1900. Leipzig 1903

Id., Acht Jahre Secession 1897–1905. Vienna 1906

H.H. Hofstätter, Symbolismus und die Kunst der Jahrhundertwende. Cologne 1965

Th. Howarth, Ch. R. Mackintosh and the Modern Movement. London 1952

A. Humbert, Les Nabis et leur Epoque. Paris 1955

W. Juszcak, Wojtkiewicz i Nowa Sztuka. Warsaw 1965

W. Kayser, Der europäische Symbolismus. Duitse Kroniek, 1953

J. Kotalik, O trech unmelcích secese, in VYTVARNÉ UMENÍ 4, 1967

H.F. Lenning, The Art Nouveau. The Hague 1951

St. T. Madson, Sources of Art Nouveau. Oslo 1956

J. Meier-Graefe, Entwicklungsgeschichte der modernen Kunst, 3 Vols. Stuttgart 1904–1905 (new edition 1967)

E. Michalski, Die entwicklungsgeschichtliche Bedeutung des Jugendstils, in REPERTORIUM FÜR KUNSTWISSENSCHAFT 46, 1925

N. Pevsner, Pioneers of Modern Design. London 1936

E. Rathke, Jugendstil. Mannheim 1958

M. Rheims, Um 1900. Vienna-Munich 1965

R.M. Rilke, Worpswede. Leipzig 1905 (shortened new edition Bremen 1952)

F. Roh, Geschichte der deutschen Kunst von 1900 bis zur Gegenwart. Munich 1958

B. Ruettenauer, Symbolische Kunst. Strasbourg 1900

F. Schmalenbach, Jugendstil, ein Beitrag zur Theorie und Geschichte der Flächenkunst. Würzburg 1935

Id., Jugendstil und Neue Sachlichkeit, in KUNSTHISTORISCHE STUDIEN, Basle 1941

R. Schmutzler, The English Origins of Art Nouveau. THE ARCHITECTURAL REVIEW, 1955

Id., Art Nouveau – Jugendstil. Stuttgart 1962

P. Schultze-Naumburg, Worpswede, in KUNST FÜR ALLE 12, 1895

H. Seling (editor), Jugendstil – Der Weg ins 20. Jahrhundert. Heidelberg-Munich 1959 – with contributions from: H. Seling, K. Bauch, H.G. Sperlich, K.J. Sembach, H.H. Hofstätter, R. Baurmann, H. Platte, A. Hagner, B.C. Hackelsberger, E. Köllmann, H.U. Haedeke, G. Howaldt, G. Rudloff-Hille, R.G. Köhler

D. Sternberger, Über den Jugendstil und andere Essays. Hamburg 1956

A.B. Terpstra, Moderne Kunst in Nederland. 1900–1914

K. Umanskij, Neue Kunst in Rußland. Potsdam and Munich 1920

A.A. Wallis, Fin de siècle. London 1947

M. Wallis, Secesja, Warsaw 1967

O. Wulff, Die neurussische Kunst. Augsburg 1932

PAINTING AND GRAPHIC ART

M. Alpatov, Russian Impact on Art. New York 1950

A. Aurier, Le Symbolisme en Peinture, in MERCURE DE FRANCE II, 1891

B. Dorival, Les étapes de la peinture française contemporaine. Paris 1943

H.H. Hofstätter, Die Entstehung des Neuen Stils in der französischen Malerei um 1890. Freiburg 1955 (Doctoral thesis)

Id., Malerei, in: H. Seling, Jungendstil – Der Weg ins 20. Jahrhundert. Heidelberg-Munich 1959

Id., Geschichte der europäischen Jugendstilmalerei. Cologne 1963 (2nd edition 1965)

Ch. Holme, Modern Etching and Engraving. London, Paris, New York 1902

Id., Pen, Pencil and Chalk. London, Paris, New York 1911

A. Koeppen, Die moderne Malerei in Deutschland. Bielefeld and Leipzig 1902

D. Martin, The Glasgow School of Painters. London 1897

R. Muther, Geschichte der Malerei im 19. Jahrhundert. Munich 1893/94

Id., Geschichte der englischen Malerei. Berlin 1903

Id., Die belgische Malerei im 19. Jahrhundert. Berlin 1909

Id., Studien und Kritiken. Vienna, no date

J. Neumann, Die neue tschechische Malerei und ihre klassische Tradition. Prague 1958

M. Osborn, Der Holzschnitt, in, Sammlung illustrierter Monographien, edited by H. v. Zobeltitz, 16, Bielefeld and Leipzig 1905

F. Overbeck, Ein Brief aus Worpswede, in KUNST FÜR ALLE II, 1895/96

B. Polak, Het Fin de Siècle in de Nederlandse Schilderkunst. The Hague

J. Rewald, Von van Gogh bis P. Gauguin. Geschichte des Nachimpressionismus. New York 1956, Munich-Vienna-Basle 1957, Cologne 1967

A. Roessler, Neu-Dachau. Leipzig 1905

F. Schmalenbach, Die Frage einer Jugendstilmalerei, in NEUE ZÜRCHER ZEITUNG V. 27. 5. 1962

P. Sérusier, ABC de la Peinture. Paris 1942

H.W. Singer, Die Moderne Graphik. Leipzig 1922

H. Uhde-Bernays, Die Münchner Malerei im 19. Jahrhundert. (II. Teil 1850–1900) Munich 1927

THE ART OF BOOK DECORATION

F. Ahlers-Hestermann and E. Zahn, Facsimile Querschnitt durch die Jugend. Munich-Berne-Vienna 1966

W. Crane, Von der dekorativen Illustration des Buches in alter und neuer Zeit. Leipzig 1901

F.H. Ehmke, Drei Jahrzehnte deutscher Buchkunst, 1890 bis 1920. Berlin 1922

Id., 25 Jahre deutsche Buchkunst, 1890–1914. Leipzig 1915

Th. Goebel, Das moderne Buch. Leipzig 1910

O. Grautoff, Die Entwicklung der modernen Buchkunst in Deutschland. Leipzig 1901

F. Hermann, Die Revue Blanche und die Nabis. Zurich 1953

G. Hirth, Katalog der farbigen Kunstblätter aus der Münchener Jugend. Munich 1917

P. Hofer and E.M. Garvey, The Artist and the Book 1860 bis 1960 in Western Europe and the United States. Boston 1962 (2nd edition)

Ch. Holme (editor), L'Art du Livre. London, Paris, New York 1914 (Art of the Book)

Id., Modern Book Illustrators and Their Work. 1914

H. Jackson, The Printing of Books. London 1938

P. James, The English Book Illustrations 1800–1900. London 1947

E. Johnston, Writing, Illuminating and Lettering. London 1905

R. Kautzsch, Die neue Buchkunst. Leipzig 1902

E.H. Lehmann, Die Anfänge der Kunstzeitschrift in Deutschland. Leipzig 1932

H. Leitmeier, Die Bedeutung des Jugendstils für das deutsche Buch und W. Tiemanns Anteil daran, in GUTENBERG-JAHRBUCH, Mainz 1959

H. Loubier, Die neue deutsche Buchkunst. Stuttgart 1921

Id., Die Kunst im Buchdruck, in ZEITSCHRIFT FÜR BUCHGEWERBE 1898/II

G. Mann and Ch. Schütze, Facsimile Querschnitt durch den Simplicissimus. Munich-Berne-Vienna

A. Meiner, Georg Hirth, ein deutscher Verleger, in ZEITSCHRIFT FÜR BUCHGEWERBE 1925/II

A. Muthesius-Trippenbach, Das moderne englische Bilderbuch, in DEKORATIVE KUNST, 1902/V

G. Paul, Das Bilderbuch, in DEKORATIVE KUNST 1902/V

J. Pennel, Die moderne Illustration. Leipzig 1901

H. Platte, Buchschmuck, in, H. Seling, Jugendstil – Der Weg ins 20. Jahrhundert. Heidelberg-Munich 1959

J. Rodenberg, Deutsche Pressen. Eine Bibliographie. Zurich. Vienna, Leipzig 1925–1931

J. Schinnerer, Moderne Illustrationskunst, in DEKORATIVE KUNST 1913/XVI

F.A. Schmidt-Künsemüller, William Morris und die neuere Buchkunst, Wiesbaden 1955

E. Schur, Das neue deutsche Bilderbuch, in DEKORATIVE KUNST 1908/XII

E.J. Sullivan, The Art of Illustration. 1921

J.R. Taylor, The Art Nouveau-Book in Britain. London 1966

G. Thiem, Französische Maler illustrieren Bücher. Stuttgart 1965

W. Tiemann, Der Jugendstil im deutschen Buch, in GUTENBERG-JAHRBUCH Mainz 1951

E.R. Weiß, Das Buch als Gegenstand. 1911

W.v. Zur Westen, Exlibris, in Sammlung illustrierter Monographien No. 6, edited by H.v. Zobelitz. Bielefeld and Leipzig 1901

POSTERS

L. Duca, L'Affiche, in the series "Que sais-je" Vol. No. 153, Paris 1945 (2nd edition 1958)

A. Hagner, Das Plakat im Jugendstil. Freiburg 1958 (Thesis)

Dies., Plakat, in, H. Seling, Jugendstil – Der Weg ins zwanzigste Jahrhundert. Heidelberg-Munich 1959

S.R. Jones, Posters and their Designers, in Special Autumn Number of the STUDIO, London 1924

E. Julien, Les Affiches de Toulouse-Lautrec. Monte Carlo 1950

R. Koch, The Poster Movement and "Art Nouveau", in GAZETTE DES BEAUX ARTS, November 1957

V. Matajas, Die Reklame, Leipzig 1910

E. Maindron, Les affiches illustrées. Paris 1886

Id., Les affiches illustrées 1886 – 1895. Paris 1896

O. Mascha, Österreichische Plakatkunst. Vienna, no date

F. Myrbach, Die Fläche. Vienna 1904

J. Pennell, Les affiches étrangères illustrées. Paris 1897

M. Rickards, Posters at the Turn of the Century. London 1968

W. Rotzler, Die Plakatkunst zwischen 1883 und 1918, in GRAPHIS Year 13, 1957, p. 538 ff.

P. Ruben (editor), Die Reklame. Ihre Kunst und Wissenschaft. Berlin 1913/1914 (with detailed bibliography of advertising as a whole)

H. Sachs, Zwanzig Jahre deutscher Plakatkunst 1895 – 1915

H. Schardt, Paris 1900. Französische Plakatkunst. Stuttgart 1968

J.L. Sponsel, Das moderne Plakat. Dresden 1897

P. Wember, Die Jugend der Plakate, 1887 – 1917. Bestandskatalog des Kaiser-Wilhelm-Museums Krefeld. Krefeld (1961)

W.v. Zur Western, Dänische Künstlerplakate, in: ZEITSCHRIFT FÜR BÜCHERFREUNDE Year 11, 1907/08 p.1 ff.

Id., Das Plakat, in: ZEITSCHRIFT FÜR BÜCHERFREUNDE Year 7, 1903/04, p. 89 ff.

Id., Reklamekunst, in Sammlung illustrierter Monographien, Vol. 13, edited H. v. Zobeltitz, Bielefeld and Leipzig 1903

Les maîtres de l'affiche, Publication mensuelle contenant la reproduction des plus belles affiches illustrées des grands artistes français et étrangers. Paris 1896 – 1900, 5 Vols.

Les affiches étrangères illustrées, par M. Bauwens, T. Hayashi, La Forgué, Meier-Graefe, J. Pennell, Paris 1897

Album d'affiches from LA PLUME, Paris 1900

Mitteilungen des Vereins Deutscher Reklame-Fachleute. Founded 1910

Das Plakat. Mitteilungen des Vereins der Plakatfreunde 1910 – 1921, 11 Vols

Österreichische Plakate 1890 – 1957, publ. by the Bund Österreichischer Gebrauchsgraphiker. Vienna 1957

WRITINGS

R. Baurmann, Schrift, in H. Seling, Jugendstil – Der Weg ins zwanzigste Jahrhundert. Heidelberg-Munich 1959

G.A.E. Bogeng, Geschichte der Buchdruckerkunst. Hellerau 1928

H. Degering, Die Schrift. Berlin 1929

H. Delitsch, Geschichte der abendländischen Schriftformen. Leipzig 1928

O. Eckmann, Vorrede zu meiner Schrift. Offenbach 1900

F.H. Ehmke, Schrift, ihre Gestaltung und Entwicklung in neuerer Zeit. Hanover 1925

Id., Die historische Entwicklung der abendländischen Schriftformen. Ravensburg 1927

H. Jensen, Geschichte der Schrift. Hanover 1925

Id., Die Schrift in Vergangenheit und Gegenwart. Hamburg 1935

Ch. H. Kleukens, Die Kunst der Letter. Leipzig, no date (Insel No. 557) K. Klingspor, Über Schönheit von Schrift und Druck. Frankfurt

H. König, Wie entstehen Schriftformen, in ARCHIV FÜR BUCHDRUCKERKUNST. Leipzig 1900, Issue 11/12

G. Kühl, Zur Psychologie der Schrift. Offenbach 1904

R. v. Larisch, Über Zierschriften im Dienste der Kunst. Munich 1899

Id., Beispiele künstlerischer Schrift. Vienna 1900

Id., Beispiele Künstlerischer Schrift, in DEUTSCHE KUNST UND DEKORATION 1901/I

Id., Über Leserlichkeit von ornamentalen Schriften. Vienna 1904

St. Morison, Typenformen der Vergangenheit und Neuzeit. Hellerau 1904

Id., L'Art de l'Imprimeur 1500 – 1900. Paris 1925

E. Strange, Alphabets. London 1895

J. Tschichold, Geschichte der Schrift in Bildern. Basle 1940

D.B. Updike, Printing Types, their History, Forms and Use. Cambridge/Mass. 1922

H. Zapf, Zur Stilgeschichte der Buchstaben. 1950/51

MAJOR EXHIBITION CATALOGUES

A Collection of Posters, Royal Aquarium London 1894/95

Plakat-Ausstellung, Museum für Kunst und Gewerbe Hamburg 1896

Ausstellung der Druckkunst, Cracow 1904

Eugène Carrière et le Symbolisme, Orangerie des Tuileries Paris 1949/50

Um 1900 – Art Nouveau und Jugendstil, Kunstgewerbemuseum Zurich 1952

Morris-Drucke und andere Meisterwerke englischer und amerikanischer Privatpressen, Gutenberg-Museum Mainz 1954

Jugendstil, Museum für Kunsthandwerk Frankfurt a.M. 1955

Deutsche Dichtung um 1900 (Handschriften, Bildnisse, Drucke) Schiller-Nationalmuseum Marbach a.N.

L'Affiche – de Toulouse-Lautrec à Cassandre, Palais de Beaulieu Lausanne 1957

München 1869 – 1958 – Aufbruch zur modernen Kunst, Haus der Kunst Munich 1958

Aus der Zeit um 1900, Staatliche Kunsthalle Baden-Baden 1958

Les sources du XXe siècle – Les arts en Europe de 1884 à 1914, Musée National d'art moderne Paris 1960/61

Jugendstil – Sammlung K.A. Citroen Amsterdam, Hessisches Landesmuseum Darmstadt 1962

Die Nabis und ihre Freunde, Kunsthalle Mannheim 1964

Il contribuo russo alle avantguardie plastiche, Galleria del Levante Milan 1962

Secession – Europäische Kunst um die Jahrhundertwende, Haus der Kunst Munich 1964

Wien um 1900 – Kulturamt der Stadt Vienna 1964

Jugendstil – Vom Beitrag Darmstadts zur internationalen Kunstbewgung um 1900, Hessisches Landesmuseum Darmstadt 1964

Kunsthandwerk um 1900 – Jugendstil – Art Nouveau – Modern Style – Nieuwe Kunst, Katalog des Hessischen Landesmuseums No. 1 Darmstadt 1965

Europäischer Jugendstil, Kunsthalle Bremen 1965

De la "Jeune Pologne" jusqu'à nos jours – l'exposition des affiches (in Polish), Nationalmuseum Warsaw 1966

Deutsche Buchumschläge aus siebzig jahren, Gutenberg-Museum Mainz 1966

100 Seces nich Plakátu – 1887–1914, Moravian Galerie Brno 1966

Ceská Secese Umeni 1900, Hluboká (Frauenberg) 1966

Druckkunst des Jugendstils, Kunstamt Berlin-Charlottenburg and Kunstgewerbemuseum Zurich 1966

Pont-Aven und die Nabis, Galleria del Levante Munich 1966/67 Ceská Secese Umenéaci 1900, Moravská Galerie Brno 1967

Die Wiener Werkstätte, Österreichisches Museum für angewandte Kunst, Vienna 1967

Jugendstil – Art Nouveau, Auktionskatalog Kornfeld und Klipstein in Bernc 1968

JOURNALS
France:
L'Art Décoratif. Paris, 1898–1914
Art et Décoration. Paris from 1897
Le Courrier Français. Paris 1886–1894
Le Cri de Paris. Paris
L'Image. Paris
La Plume. Paris, 1889–1913
Revue des Arts Décoratifs. Paris, 1880–1902
Rénovation Esthetique. Paris, 1905–1910
La Revue Blanche. Paris, 1891–1903
Revue Wagnérienne. Paris 1885–1888
Le Rire. Paris
L'Ymagier. Paris
England/America:
The Architectural Record. New York and London, from 1891
The Architectural Review. London, from 1896
The Century Guild Hobby Horse. Orpington, April 1884, Jan. 1886 – Oct.1892. The Hobby Horse. London 1893/94

The Chap-Book. Chicago, 1894–1898
The Craftsman. Eastwood, New York, 1901–1916
The Evergreen. Edinburgh, Philadelphia. 1895–1897
Interiors. New York, from 1888
The Pageant. London 1896–1897
The Savoy. London, 1896
The Studio. London, from 1893
The Yellow Book. London 1894–1897
Holland/Belgium:
L'Art Moderne. Brussels, 1881–1914
Bouw en Sierkunst. Harlem, 1898–1902
Le Reveil. Ghent, from 1891
Van Nu en Straks. Brussels and Antwerp, 1892–1901
Germany:
Archiv für Buchgewerbe.
Avalan. Munich 1901
Dekorative Kunst und Dekoration. Darmstadt 1897–1934
Fliegende Blätter. Munich, 1844–1928
Hyperion. Munich
Die Insel. Berlin, 1888–1901/Leipzig, 1902
Jugend. Munich, 1899–1933
Die Kunst für Alle. Munich, 1885–1899, subsequently Die Kunst. Munich, 1899–1945
Die Kunst. Munich, 1899–1945
Die Neue Rundschau.
Opale.
Pan. Berlin, 1895–1900
Quickborn. Berlin
Simplizissimus. Munich 1896–1967
Zeitschrift für Innendekoration. Darmstadt, from 1890
Zeitschrift für Bücherfreunde.
Zeitschrift des Mitteldeutschen Kunstgewerbevereins zu Frankfurt a. M. (Kunstgewerbcblatt)
Austria:
Die Graphischen Künste. Vienna, from 1879
Das Interieur. Vienna, 1900–1915
Kunst und Kunsthandwerk. Vienna, 1898–1921
Ver Sacrum. Vienna, 1898/Leipzig, 1899–1903
Italy/Spain:
L'Arte. Rome, 1898–1901
Arte Italiana Decorativa e Industriale. Rome and Venice, 1890–1914
Joventut. Barcelona, 1900–1903
Novissima. Milan/Rome
Eastern Europe:
Apollon. St. Petersburg
Chimera. Warsaw
Czas. Cracow
Mir Iskusstwa. St. Petersburg, 1899–1904
Nasz Kraj, Lvov

REFERENCE WORKS
Encyclopaedia dell'Arte, Rome 1958 ff.
Encyclopaedia Britannica (Library Research Service, Chicago)

U. Thieme and F. Becker, Allg. Lexikon der bildenden
 Künstler etc. Leipzig 1908–1950, 37 Vols.
H. Vollmer, Allg. Lexikon der bildenden Künstler des
 XX. Jahrhunderts. Leipzig 1953–1962, 6 Vols

ACKNOWLEDGEMENTS

THANKS ARE DUE TO THE FOLLOWING INSTITUTIONS AND
INDIVIDUALS, WHOSE KIND GENEROSITY MADE THE
DRUCKKUNST DES JUGENDSTILS EXHIBITION IN
BERLIN POSSIBLE AND WHO CONSEQUENTLY ENABLED THE
PRESENT VOLUME TO BE PUBLISHED.

MUSEUMS AND PUBLIC COLLECTIONS
Aberdeen, The Art Gallery and Regional Museum
Amsterdam, Rijksmuseum – Rijksprintenkabinett
Amsterdam, Stedelijk Museum
Badeb-Baden, Südwestfunk
Basle, Kupferstichkabinett im Kunstmuseum
Berlin, Berlin-Museum
Berlin, Stiftung Preußischer Kulturbesitz, Kunstbibliothek
 der Staatlichen Museen
Berlin, Stiftung Preußischer Kulturbesitz,
 Kupferstichkabinett der Staatlichen Museen
Berne, Berner Kunstmuseum – Paul Klee-Stiftung
Bremen, Kunsthalle
Darmstadt, Hessisches Landesmuseum
Glasgow, Glasgow University Art Collections
Hamburg, Hamburger Kunsthalle
Helsinki, Musee d'Art de l'Ateneum
Mainz, Gutenbergmuseum
Mannheim, Städtische Kunsthalle
Munich, Staatliches Museum für angewandte Kunst
Munich, Städtische Galerie im Lenbachhaus
Munich, Staatliche Graphische Sammlung
Munich, Stuck-Jugendstil-Verein e.V. Museum Stuck-Villa
Münster/W., Landesmuseum für Kunst und
 Kulturgeschichte
Neukirchen/Schlesw., Stiftung Seebüll Ada und Emil Nolde
Oslo, Nationalmuseum
Otterlo, Rijksmuseum Kröller-Müller
Rotterdam, Museum Boymans-van Beuningen
Stockholm, Nationalmuseum
Stuttgart, Landesgewerbeamt Baden-Württemberg
Zurich, Kunstgewerbemuseum

Photo Credits

All the photographs in this volume were taken by Messrs. Schwitter AG, Basle, except the following: Klee-Stiftung Berne p. 195. – Kunsthalle Bremen p. 23, 103. – Kunsthalle Hamburg p. 56. – Messrs. Methuen and Co. London p. 61, 68, 69. – Kaiser-Wilhelm-Museum Krefeld p. 197, 207, 247. – Galleria del Levante Munich p. 34. – Staatliche graphische Sammlung Munich p. 185. – Stuck-Jugendstil-Verein e.V. Munich p. 82. – Nationalmuseum Oslo p. 115. – Bibliothèque Nationale Paris p. 26, 27, 37, 45, 46, 47, 48, 254, 255. – Foto-Bulloz Paris p. 279. – Nationalmuseum Stockholm p. 117. – Landesgewerbeamt Baden-Wurttemberg, Stuttgart, p. 187. – Foto Stefan Deptuszweski, Warsaw p. 266, 267, 268, 270, 276, 277, 281, 282.

List of the Vignettes Inserted in the Text

P. 6: Cancan, signed F.R. – P. 17: Medusa's head, signed by H. Schwaiger 1898, for Ver Sacrum. – P. 58: Paul Ranson, Initial 0 for the Marie legends. – P. 110: Playing the harp, signed by Kolo Moser for Ver Sacrum 1898. – P. 123: Book ornamentation by J. Auchentaller for Ver Sacrum 1898. – P. 126: Dog Simpl vignette, by Th. Th. Heine. – P. 222: Initial C by Kolo Moser. – P. 286: Book ornamentation by J. Auchentaller for Ver Sacrum 1898.

INDEX

Artists and page numbers printed in bold refer to illustrations in the text.

Abeking, Hermann **200**
Acker 102
Alastair 192–193
Alt 214
Aman-Jean, Edmond 20, **44–46**, 210
Andri, Ferdinand 218, 219ff.
Anquetin, Louis 21, 28, 34, **46**, 99
Apollinaire 194
Auchentaller, Josef Maria 210, 214ff., **218**
Aurier 22
Axentowicz 262

Bakst, Leon N. 252, **277–279**
Baluschek, Hans 151
Barlach 56
Bartholomé 210
Barwig 234
Bastien-Lepage 28, 120
Beardsley, Aubrey V. 7, 16, 28, 61, 68, **73–79**, 92, 94, 107, 157, 192
Beckmann 189
Bedford, Francis Donkin 72
Behmer, Marcus 156, **157**
Behrens, Peter 8, 12, 88, 123ff., **138–140**
Belwe 150
Benois, Alexander N. 252, **276**
Berchmans 97
Berger 218
Bernard, Emile 12f., 15, 19f., **21–22**, 23, 26, 28, 30, 32, 34, 46, 72, 99, 111f., 128, 251, 260
Bernard 42
Bernhardt 61, 82, 251f.
Bernheim-Jeune 38, 43
Besnard, Albert 46, **47–48**, 99, 136
Bierbaum 123f.
Bílek, František 257, **259**
Bilibin, Ivan Y. 252, **282**, **285**
Bindesboll 111
Bing 21, 50, 79, 99
Bistolfi 202
Blake 9, 16, 59f., 92
Blanc-Garin 102
Bleyl 154
Boccioni 201
Bocklin 9, 151, 162
Böhm, Adolf 214, **218**, 231, 233
Bonnard, Pierre 19f., 32, 34, 37, **38–40**, 43

Bonnat 28, 112
Bouguereau 166
Boulanger 43
Bourdelle 56
Brade 244
Bradley, William H. 60, 73, 78, **79–80**
Brangwyn, Frank 84, **86**
Brauer 170
Braune, Hugo L. 130–131
Brémond 47
Bruant 28
Bruckner 124, 132, 134
Brunellei 202, **203**
Bukowski, Jan 262–266
Bürck, Paul 162
Burne-Jones, Sir Edward C. 16, 60, 62ff., **66**, 71, 73, 94
Busch 16
Busse 161

Cabanel 47, 56
Cambellotti 202
Camoin 57
Carrière 9, 44, 210
Carolis, Adolphus de 201, **203–204**, 205
Cassirer 153, 189
Cézanne 21f., 32, 37, 58, 194
Chéret, Jules 19, **48–50**, 61, 116
Christiansen, Hans 11, 13, 160f., **162**
Christophe, Franz 170, 247
Cissarz, Johann V. 150, **151**
Clarke, Harry 61, **92–93**
Cobden-Sanderson 60
Cockerell 67
Colarossi 184, 252, 266
Colin 184
Constant 166
Corinth 136
Cormon 21, 46
Cottet 43
Crane, Walter 16, 61, 85, **86–87**, 104, 196, 210
Crépieux-Jamin 8
Crespin 102
Czeschka, Carl 210, 212, 238, **244–245**
Daumier 15
Dauthenday 8
Debicki, Stanislaw 268
Debschitz 154
Debussy 19
Degas 36, 48
Dehmel 124
Delacroix 47

Delaunay 194
Denis, Maurice 12, 19f., 22, 30, **32–34**, 37f., 40, 43, 98f., 112, 136, 251
Diaghilev 276, 278
Diefenbach 141
Diez, Julius 150, **162**, 163
Dill 126
Divéky, Josef von 246, 248
Doppler 149
Dorfler 192
Duchosal 196
Dufy 20
Dulac, Edmond 16, **54**
Duncan, John 73
Durand-Ruel 38
Durer 43

Eberle 244
Eckener 192
Eckmann, Otto 100, 123ff., 126, **132–135**
Ehmke, Fritz H. 125, 148, **149–150**
Eichler 126
Einstein 56
Endell, Fritz 124, **184–185**
Ensor 97, 107
Erler, Fritz 9, 111, 126, **170–171**
Eschke 128
Evans 86
Evenpoel, Henri 102–103
Exner, Nora married name **von Zumbusch 234**, 235

Fattori 201
Feldbauer 126
Feure, Georges de 50–51
Fidus 124f., **141–143**
Filiger 26
Finch 99
Fréderic 101
Friedrich 9
Freud 8, 209
Fuller 48ff.

Gallé 7
Gallén, Axel 111, **120–121**, 210
Gallimard 7
Gaskin, Arthur J. 66–67
Gauguin, Paul 14, 19, 21f., **22–25**, 26, 30, 34, 56, 98, 111f.
Geddes 73
George 125, 148
Georgi, Walter 175, **176**
Gide 19, 32
Gilchrist 59
Goethe 60

Gorki 157
Grasset, Eugène S. 19, **44,** 210
Greiffehagen 61
Griepenkerl 244f.
Gude 128
Guilbert 28, 48
Gulbransson, Olaf 112, 126, **192,** 193
Gussow 151

Habermann 245
Hackl 162, 166, 189, 196
Hagen 130
Haller 190, 194
Hals 21
Hamsun 111
Hardy 61
Harland 73
Hauptmann 128, 153, 157, 192
Hausenstein 164
Haustein, Paul 166, 169
Hearn 8, 242f.
Heckel 154, 189
Heine, Thomas Th. 126, **180–181,**
182
Herbo 99
Herterich 190, 260
Hesse 8
Heymel 157
Hirth 15, 125
Hocker 166, 173, 190
Hodler, Ferdinand 43, 97, **196,** 210
Hoelscher 190
Hoffmann, Josef 101, 196, 210, 214,
218, **238,** 239f.
Hofmann, Ludwig von 123f.,
136–137, 138, 196
Hofmannsthal 8, 56, 159, 205, 209, 243
Hogarth 9
Hohlwein, Ludwig 186–187
Hokusai 11, 260
Holbein 43
Holst, Roland R.N. 98, **104**
Holz 209
Holzel 126, 155, 184, 214
Hoppener H., known as Fidus, see
Fidus
Horne 59, 68
Horton, William T. 92
Hoytema, Theo van 107, **108**
Hubbard 60
Hyland, Fred 87–88

Ibels, Henri–Gabriel 34, **36**
Ibsen 40, 111
Image 59, 68
Ingres 9

Jammes 19
Jank, Angelo 173–174, 189
Jarry 38

Jettmar, Rudolf 234, 236, **237**
Jossot, Henri G. 55, 125
Jung, Moritz 212, **245–246,** 249

Kalckreuth 130, 141, 178, 184, 234
Kandinsky, Wassily 194, 252, 272,
273, 274f.
Karpinski 251
Kessler 56
Khnopff, Fernand 11, 97f., **101–102,**
210
Khuen-Belassi 252
Kinderen, A.J. der 104, **107**
King, Jessie M. 94, 95
Kippenberg 125
Kirchner, Ernst l. 153, **154–155**
Klee, Paul 97, 190, **194–195**
Kleukens, Friedrich W. 148, **150**
Klimt 214
Klimt, Gustav 9f., 97, 196, 209f., **214,**
218, 237f., 242, 244, 246
Klinger, Max 9, 136, **151–153,** 155,
196, 210
Knirr 194
Knowles, Reginald L. 88
Knowles 260
Kobliha, František 258, **259**
König, Friedrich 218, 226f., 229
Kokoschka, Oskar 58, 98, 189, 212,
214, **246,** 250
Kollwitz, Käthe 12, **153–154**
Kreidolf, Ernst 16, 86, **196–199**
Kupka 251, 259
Kurzweil, Max 214, **238,** 241

Lanceray, Yevgeny 281, 282
Langen 126, 180
Langhammer 126
Larisch 246
Larsson, Carl O. 111f., **116**
Laskoff 202
Latenay, Gaston de 52–53
Laval 30
L. E. 203, 207
Le Barc de Boutteville 40
Lechter, Melchior 16, 124f., 146f.,
148–149
Lefebre 30, 43, 101
Legros 47
Lehmbruck 189
Leistikow, Walter 7, 15, 112, 123ff.,
128–129, 136
Lemmen 97, 99, 125
Lepère 71, 184
Levy 189
Lewis-Brown 28
Lichtenfels 218
Lichtwark 246
Liebermann 136
Lilien, E.M. 144–145
Linton 86

Löffler, Berthold 212, **244,** 245f.
Loffz 196
Looschen, Hans 154
Lugné-Poe 32, 37f., 40
Luszczkiewicz 262

Macdonald, Margaret 94
Macke 194
Mackintosh 94
Mackmurdo, Arthur H. 59, 61, **68**
Maeterlinck 19, 107
Mahler 209, 246
Maillard 37
Maillol, Aristide 19ff., 34, 40, 43,
56–57, 58, 260
Makowski 251
Mallarmé 23
Manzel 149
Marc, Franz 194
Markart 46, 214
Marquet 57
Mataloni 202
Matisse, Henri 21, **57–58,** 102, 189
Matsch 214, 244
Maurin 43
Mayer de Haan 26, 30, 98
Mehoffer, Jozef 251, 265, **266**
Meier-Graefe 123
Meisenbach 16
Mellery 101
Menn 196
Messina 43
Metzner 234
Meunier 97
Micheli, Alberto 203
Mignol 97
Minne 108
Miró 20
Mondrian 107
Moreau 32, 57, 101f.
Moronobu 10
Morris, William 16, 59ff., **64–66,** 68,
71ff., 86, 97, 99, 125, 148, 203
Moser, Koloman 210, **218,** 223ff., 229,
238, 244
Mucha, Alfons 116, 251, **252–255,** 259
Mucha 254
Muckley, L. Fairfax 70, **71**
Münzer, Adolf 126, 172, **173**
Munch, Edvard 11, 15, 20, 22, 27, 58,
111, **112–116,** 136, 155, 157, 251
Munkascy 260
Munthe, Gerhard P. 119
Muther 130, 214

Natanson 19, 260
Nerman, Einar 118, **119**
Nibbrig 107
Nicholson, William 61, **82–83**

Niemeyer 178
Nijinsky 279
Nolde, Emil 155–157 Novalis 9

Obrist 154
Okun, Edward 270–272
Orlik, Emil 210, 242–243
Osthaus 141

Pankok, Bernhard 176, 177
Paul, Bruno 126, 182
Pechstein 189
Pennell 73
Picasso 20, 48, 112, 194
Piranesi 9
Pissarro, Lucien 60, 71–72
Poetzelsberger 166
Portaels 99
Powolny 244
Preetorius, Emil 186
Preisler 251, 259
Prévost 49
Princeteau 28
Pryde 61, 82
Przybyszewski 266
Purrmann 189
Putz, Leo 9, 126, 166, 168
Puvis de Chavannes 50, 120, 136, 196, 251

Rackham, Arthur 16, 54, 88–91
Ranson, Paul 15, 19, 30, 32, 34–35, 37f., 40, 99
Rassenfosse 97
Raupp 173
Reinhardt 112, 218, 242
Rembrandt 48
Renner 186
Repin 252
Ricketts, Charles 46, 59f., 68, 69, 71, 81
Rilke 7, 157f., 209
Rippl-Ronai, Joszef 56, 251, 260–261
Rizzi, Antonio 201, 203
Robinson, Charles 61, 94, 96
Rodin 210
Roller, Alfred 210, 218, 230, 232, 234, 245
Rosenberg, L.N., known as Bakst, see Bakst
Rossetti 59, 64, 66
Rouault 57, 102
Rousseau 43
Roussel, Ker-Xavier 32, 34, 37–38, 40, 43
Runge 141
Rumpler 218, 245
Ruskin 66, 68, 86

Saar 209, 217
Sattler, Josef 124, 182–183
Schickaneder 192
Schiele 58, 212, 214
Schmadel 16
Schmidt-Rottluff 154
Schmoll von Eisenwerth, Karl 190–192
Schnitzler 209
Schönberg 209
Schopenhauer 12
Schroder 125, 157
Schuffenecker 21ff.
Segantini 7, 210
Séguin, Armand 20, 26–27, 111f., 128
Seitz 162, 173
Sert 19, 42
Sérusier, Paul 19, 26, 30–31, 32, 34, 37f., 40, 72
Seurat 99, 107
Shannon, Charles H. 59, 61, 68, 71, 81, 125
Sharaku 260
Signac 99
Signorini 201
Sintenis 141
Skorgaard 111
Slevogt, Max 150–151
Slewinski 251
Spenser 67
Somov, Constantin A. 210, 252, 278, 280
Staeger, Ferdinand 191, 192
Stassen, Franz 140–141
Stauffer-Bern 153
Steiner 8
Steinlen, Theophile 46–47
Stenersen 116
Stoisavljevic 269
Stolba, Leopold 228, 234
Strahtmann, Carl 178–179
Strauss 7, 209
Strindberg 111
Sturge Moore, Thomas 80, 125
Swedenborg 8
Symons 73

Tagore 8
Taschner, Ignatius 244
Tauschek, Otto 245, 246
Terzi 206
Thijm 107
Thony 126, 180
Thoma 141, 180
Thorn Prikker, Jan 98, 108–109
Toorop, Jan 98, 106, 107
Toulouse-Lautrec, Henri de 7, 19ff., 28–30, 36, 38, 46ff., 61, 97, 108, 112, 155, 251

Uhde 210
Unger 245
Utamaro 260

Váchal, Josef 256, 259
Vallotton, Felix 15, 34, 38, 42, 43–44, 155, 184
Van de Velde, Henry 7, 28, 97f., 99–101, 108, 124, 210
Van Gogh 21f., 28, 46, 98f., 112, 260
Van Rysselberghe, Theo 34, 97, 99
Velasquez 46
Verhaeren 99, 107
Verkade 30, 32, 98, 108
Verlaine 20
Vinci 43
Viollet-le-Duc 44
Vogeler, Heinrich 16, 125, 157–159
Vogt, Baron, pseudonym Alastair, see Alastair
Volkert, Hans 184
Vollard 20, 38
Volpini 19
Von Stuck, Franz 9f., 97, 123, 127, 162–166, 189f., 194, 210, 273
Vuillard, Edouard 19, 32, 37f., 40–42, 43

Wacik, Franz 245, 250
Wagner 152
Wagner 210, 214, 238
Walker 19, 60, 66f.
Webb 64
Weber 184
Weisgerber, Albert 15f., 188, 189–190
Weiß, Emil R. 125, 141
Werkman 97
Whistler 9, 59, 112, 210, 260
Wilde 28, 68, 94
Wilhelm II 153
Wilke 126
Willumsen 111
Wojtkiewicz, Witold 251, 268
Wyczólkowski 262
Wyspianski, Stanislaw 251, 262, 266–267

Zandomeneghi 201
Zeymer 212
Zorn 47
Zumbusch, Ludwig von 166, 167